D1042351

ALSO BY AGNÈS POIRIER

Touché: A French Woman's Take on the English

LEFT BANK

LEFT BANK

ART, PASSION, AND
THE REBIRTH OF PARIS

1940–50

Agnès Poirier

HENRY HOLT AND COMPANY
NEW YORK

Henry Holt and Company
Publishers since 1866
175 Fifth Avenue
New York, New York 10010
www.henryholt.com

Henry Holt® and ® are registered trademarks of Macmillan Publishing Group, LLC.

Library of Congress Cataloging-in-Publication Data

Names: Poirier, Agnès, author.
Title: Left Bank / Agnès Poirier.
Description: New York, New York : Henry Holt and Company, 2018. |
 Includes bibliographical references and index.
Identifiers: LCCN 2017023902| ISBN 9781627790246 (hardcover) |
 ISBN 9781627790253 (electronic book)
Subjects: LCSH: Rive gauche (Paris, France)—Intellectual life—20th century. |
 Paris (France)—Intellectual life—20th century.
Classification: LCC DC752.R52 P65 2018 | DDC 944/.361—dc23
LC record available at https://lccn.loc.gov/2017023902

Our books may be purchased in bulk for promotional, educational, or business use. Please
contact your local bookseller or the Macmillan Corporate and Premium Sales Department at
(800) 221-7945, extension 5442, or by e-mail at MacmillanSpecialMarkets@macmillan.com.

First Edition 2018

Designed by Meryl Sussman Levavi

Map by Jeffrey L. Ward

Printed in the United States of America

1 3 5 7 9 10 8 6 4 2

To François

Paris was not weary of us. We were still handsome and admired; they smiled and turned on the street. The rooms were chill but they had proportion and there was more than a hint of another life, free of familiar inhibitions, a sacred life, this great museum and pleasure garden evolved for you alone.

—JAMES SALTER, *Burning the Days*

CONTENTS

e∾

III. THE AMBIGUITIES OF ACTION

e∾

IV. SHARPENING THE SENSES

CHRONOLOGY

❦

1939

August 23 Soviet foreign minister Molotov and his German counterpart von Ribbentrop sign a pact of nonaggression giving Hitler free rein to attack the West.

August 24 Jacques Jaujard closes the Louvre: four thousand treasures are being packed for safety secretly.

September 1 Germany invades Poland.

September 3 France and Great Britain declare war on Germany.

1940

May Hiding in Paris at Sylvia Beach's Shakespeare and Company bookshop, Arthur Koestler sends his manuscript *Darkness at Noon* to a London publisher.

May 10 Germany invades Belgium and northern France.

June 10 Mussolini's Italy declares war on France and Britain.

June 11 The French government flees Paris.

June 14 The German army enters Paris.

June 18 In an address broadcast by the BBC, French general Charles de Gaulle calls from London for France to continue the fight, urging all young men and women to join him in *résistance*.

June 22 Jean-Paul Sartre and Henri Cartier-Bresson are held prisoner and taken to war prisoners' camps in Germany.

June 23 Adolf Hitler poses for photographers in front of the Eiffel Tower.

1941

March Jean-Paul Sartre is back in Paris after escaping his prisoners' camp.

April–September Beauvoir, Sartre, and Merleau-Ponty start Resistance group Socialisme et Liberté but soon give up as many members prefer the more effective communist resistance groups. Sartre goes back to teaching philosophy at the Lycée Condorcet.

December Germany declares war on the United States.

1942

January *Sonderführer* Gerhard Heller, the Francophile and yet German censor of French literature, reads Albert Camus' *The Outsider* and authorizes its publication.

September The CNE, Comité National des Écrivains, the *résistant* writers' group, has its weekly meetings at the flat of writer Édith Thomas.

November The United States invades North Africa.

1943

June Jean-Paul Sartre's play *Les mouches* opens at the Théâtre de la Cité.

August The same week, Jean-Paul Sartre's seven-hundred-page philosophy treatise *L'être et le néant* (*Being and Nothingness*) and Simone de Beauvoir's first novel, *L'invitée* (*She Came to Stay*), the semiautobiographical story of a ménage-à-trois, are released.

September Picasso asks Hungarian photographer Brassaï, who lives in hiding in Paris, to take pictures of the works he has done under the occupation.

1944

June On June 6, D-Day starts at dawn. Henri Cartier-Bresson and Georges Braque listen to the news together on the wireless.

August The insurrection in Paris starts on August 16. Nazi commander von Choltitz signs his surrender on August 25 at 4:15 p.m.

September *L'épuration* (the purge) of collaborators starts.

1945

January Albert Camus, editor of *Combat*, sends Jean-Paul Sartre as a reporter to the United States for his first American trip and Beauvoir to report on life in Spain and Portugal.

July Alexander Calder works on a mobile exhibition with the help of Marcel Duchamp
 and Jean-Paul Sartre, whom he has just befriended.
August Marshal Pétain's trial for treason. Atom bomb is dropped on Hiroshima.
October Sartre gives his lecture "Is Existentialism a Humanism?" at Club Maintenant.
 Women faint.
 Elections in France. The French decide to bury the Third Republic.

1946

January Charles de Gaulle resigns.
April Arthur Koestler's *Darkness at Noon* is a fast bestseller in France.
May Richard Wright settles in Paris.
September Simone de Beauvoir starts research on *The Second Sex*.
December Boris Vian secretly publishes his first novel, *J'irai cracher sur vos tombes* (*I Spit on
 Your Graves*), under the pseudonym Vernon Sullivan, "a black American writer." Its
 sex scenes land its publishers in court.

1947

January Beauvoir, on a four-month trip to the United States, meets and falls in love with
 Nelson Algren.
March President Truman institutes the loyalty program.
April Jazz club and bar Le Tabou on the rue Dauphine opens its doors, soon branded the
 "Existentialist den."
June Albert Camus' *La peste* hits the bookshops in Paris.
 The U.S. secretary of state, George Marshall, outlines what would become the Mar-
 shall Plan in a speech to Harvard graduate students.
November Norman Mailer and his wife settle down in Paris for a year on the GI bill.

1948

January Alberto Giacometti exhibits his latest works, among them *Man Walking*. The cata-
 log is written by Sartre.
February The Czech coup shakes many Communists' faith in the Party.
March Sartre creates a political party, the RDR (The Democratic and Revolutionary Alli-
 ance), to unite the non-Communist Left and to promote an independent Europe.
June GI bill students Art Buchwald, Richard Seaver, Ellsworth Kelly, and Lionel Abel
 settle on the Left Bank.
August Theodore H. White goes to Paris to cover the implementation of the Marshall Plan.
September Saul Bellow and his family arrive in Paris.
November James Baldwin arrives in Paris with forty dollars in his pocket.
 Twenty-seven-year-old Garry Davis interrupts first session of the UN assembly to
 launch his movement "one government for one world."

1949

January The Kravchenko trial.
 Samuel Beckett finishes writing *Waiting for Godot*.
April Saul Bellow finally starts writing *Augie March*.
May Ellsworth Kelly finds his voice.
 Nelson Algren completes *The Man with the Golden Arm* and arrives in Paris for a
 four-month visit with Beauvoir.
 Juliette Gréco meets Miles Davis after his first performance in Paris. It's love at first
 sight.
June Release of the first volume of Beauvoir's *The Second Sex*.
July Fifteen-year-old Brigitte Bardot is chosen by *Elle* magazine to feature on its
 cover.
November Release of the second volume of Beauvoir's *The Second Sex*, which triggers a scandal.

CAST OF CHARACTERS

❧

Nelson Algren, American writer, born in 1909.

Dominique Aury, French writer, born in 1907.

James Baldwin, American writer, born in 1924.

Sylvia Beach, American bookseller and publisher, born in 1887.

Simone de Beauvoir, French philosopher and writer, born in 1908.

Samuel Beckett, Irish writer, born in 1906. Nobel Prize in Literature in 1969.

Saul Bellow, American writer, born in 1915. Nobel Prize in Literature in 1976.

Sonia Brownell-Orwell, British translator and publisher, born in 1918.

Art Buchwald, American journalist, born in 1925. Pulitzer Prize in 1982.

Alexander Calder, American sculptor, born in 1898.

Albert Camus, French writer, born in 1913. Nobel Prize in Literature in 1957.

Jean Cocteau, French poet, born in 1889.

Miles Davis, American jazz trumpeter, born in 1926.

Janet Flanner, American Paris correspondent for the *New Yorker*, born in 1892.

Alberto Giacometti, Swiss sculptor and painter, born in 1901.

Juliette Gréco, French muse and chanteuse, born in 1927.

Jacques Jaujard, French director of the Louvre during the Second World War, born in 1895.

Ernst Jünger, German writer, born in 1895.

Ellsworth Kelly, American painter, born in 1923.

Arthur Koestler, Hungarian-born British writer, born in 1905.

Norman Mailer, American writer, born in 1923. Pulitzer Prize in 1969 and 1980.

Jean Marais, French actor, born in 1913.

Adrienne Monnier, French bookseller and publisher, born in 1892.

Jean Paulhan, French publisher, born in 1884.

Pablo Picasso, Spanish painter, born in 1881.

Jean-Paul Sartre, French philosopher, playwright, and writer, born in 1905. Nobel Prize in Literature in 1964.

Irwin Shaw, American writer and screenwriter, born in 1913.

Simone Signoret, French actress, born in 1921.

Edith Thomas, French writer and archivist, born in 1909.

Boris Vian, French jazz musician and writer, born in 1920.

Theodore H. White, American journalist, born in 1915. Pulitzer Prize in 1962.

Richard Wright, American writer, born in 1908.

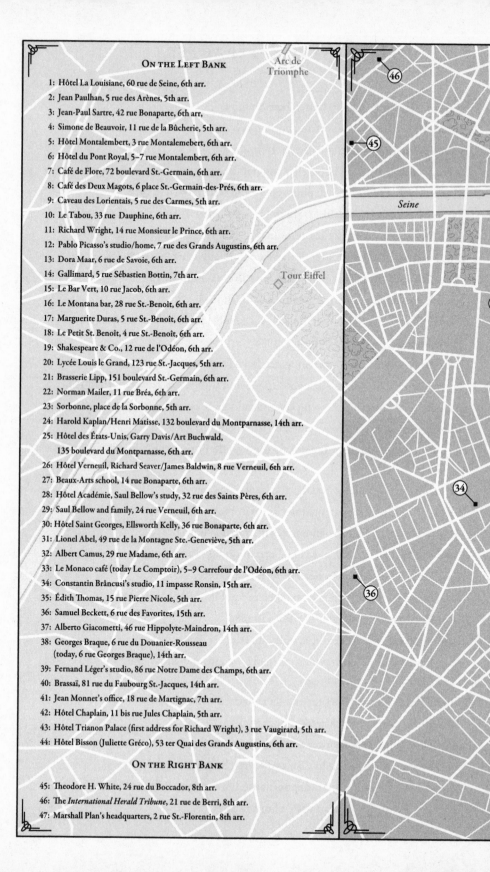

ON THE LEFT BANK

1: Hôtel La Louisiane, 60 rue de Seine, 6th arr.

2: Jean Paulhan, 5 rue des Arènes, 5th arr.

3: Jean-Paul Sartre, 42 rue Bonaparte, 6th arr,

4: Simone de Beauvoir, 11 rue de la Bûcherie, 5th arr.

5: Hôtel Montalembert, 3 rue Montalemebert, 6th arr.

6: Hôtel du Pont Royal, 5–7 rue Montalembert, 6th arr.

7: Café de Flore, 72 boulevard St.-Germain, 6th arr.

8: Café des Deux Magots, 6 place St.-Germain-des-Prés, 6th arr.

9: Caveau des Lorientais, 5 rue des Carmes, 5th arr.

10: Le Tabou, 33 rue Dauphine, 6th arr.

11: Richard Wright, 14 rue Monsieur le Prince, 6th arr.

12: Pablo Picasso's studio/home, 7 rue des Grands Augustins, 6th arr.

13: Dora Maar, 6 rue de Savoie, 6th arr.

14: Gallimard, 5 rue Sébastien Bottin, 7th arr.

15: Le Bar Vert, 10 rue Jacob, 6th arr.

16: Le Montana bar, 28 rue St.-Benoît, 6th arr.

17: Marguerite Duras, 5 rue St.-Benoît, 6th arr.

18: Le Petit St. Benoît, 4 rue St.-Benoît, 6th arr.

19: Shakespeare & Co., 12 rue de l'Odéon, 6th arr.

20: Lycée Louis le Grand, 123 rue St.-Jacques, 5th arr.

21: Brasserie Lipp, 151 boulevard St.-Germain, 6th arr.

22: Norman Mailer, 11 rue Bréa, 6th arr.

23: Sorbonne, place de la Sorbonne, 5th arr.

24: Harold Kaplan/Henri Matisse, 132 boulevard du Montparnasse, 14th arr.

25: Hôtel des États-Unis, Garry Davis/Art Buchwald,
135 boulevard du Montparnasse, 6th arr.

26: Hôtel Verneuil, Richard Seaver/James Baldwin, 8 rue Verneuil, 6th arr.

27: Beaux-Arts school, 14 rue Bonaparte, 6th arr.

28: Hôtel Académie, Saul Bellow's study, 32 rue des Saints Pères, 6th arr.

29: Saul Bellow and family, 24 rue Verneuil, 6th arr.

30: Hôtel Saint Georges, Ellsworth Kelly, 36 rue Bonaparte, 6th arr.

31: Lionel Abel, 49 rue de la Montagne Ste.-Geneviève, 5th arr.

32: Albert Camus, 29 rue Madame, 6th arr.

33: Le Monaco café (today Le Comptoir), 5–9 Carrefour de l'Odéon, 6th arr.

34: Constantin Brâncuşi's studio, 11 impasse Ronsin, 15th arr.

35: Édith Thomas, 15 rue Pierre Nicole, 5th arr.

36: Samuel Beckett, 6 rue des Favorites, 15th arr.

37: Alberto Giacometti, 46 rue Hippolyte-Maindron, 14th arr.

38: Georges Braque, 6 rue du Douanier-Rousseau
(today, 6 rue Georges Braque), 14th arr.

39: Fernand Léger's studio, 86 rue Notre Dame des Champs, 6th arr.

40: Brassaï, 81 rue du Faubourg St.-Jacques, 14th arr.

41: Jean Monnet's office, 18 rue de Martignac, 7th arr.

42: Hôtel Chaplain, 11 bis rue Jules Chaplain, 5th arr.

43: Hôtel Trianon Palace (first address for Richard Wright), 3 rue Vaugirard, 5th arr.

44: Hôtel Bisson (Juliette Gréco), 53 ter Quai des Grands Augustins, 6th arr.

ON THE RIGHT BANK

45: Theodore H. White, 24 rue du Boccador, 8th arr.

46: The International Herald Tribune, 21 rue de Berri, 8th arr.

47: Marshall Plan's headquarters, 2 rue St.-Florentin, 8th arr.

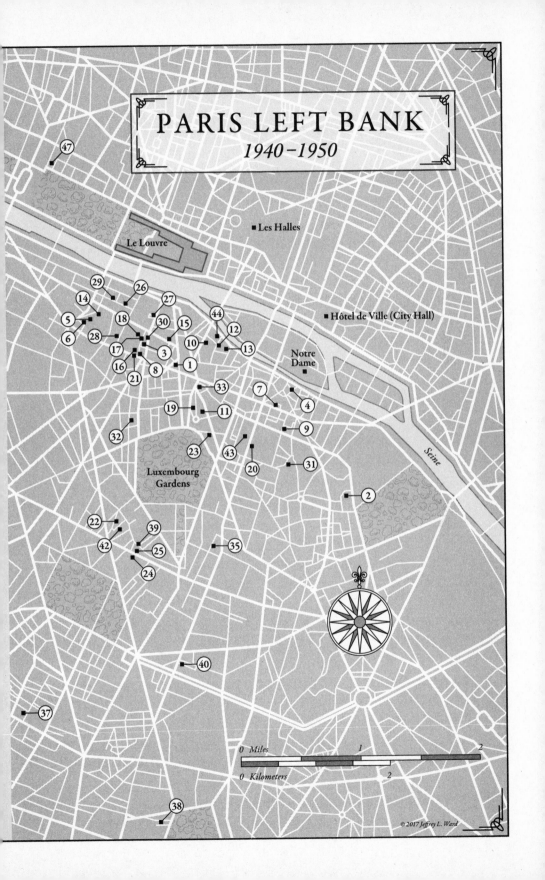

PARIS LEFT BANK
1940–1950

Les Halles

Le Louvre

Hôtel de Ville (City Hall)

Notre Dame

Seine

Luxembourg Gardens

0 Miles 1 2

0 Kilometers 2

© 2017 Jeffrey L. Ward

LEFT BANK

INTRODUCTION

LEFT BANK IS A PORTRAIT OF THE OVERLAPPING GENERATIONS born between 1905 and 1930, who lived, loved, fought, played, and flourished in Paris between 1940 and 1950 and whose intellectual and artistic output still influences how we think, live, and even dress today. After the horrors of war that shaped and informed them, Paris was the place where the world's most original voices of the time tried to find an independent and original alternative to the capitalist and Communist models for life, arts, and politics—a Third Way.

Those young men and women, budding novelists, philosophers, painters, composers, anthropologists, theorists, actors, photographers, poets, editors, publishers, and playwrights, shaped by the ordeals of the Second World War, did not always share the same political or cultural outlook, but they had three things in common: the experience of war, their brush with death, and the elation of the Liberation in Paris. And they promised themselves to reenchant a world left in ruins. *Left Bank* is the story of their life-changing synergy and explores the fertile fields of interaction among art, literature, theater, anthropology, philosophy, politics, and cinema in postwar Paris.

After four years of Nazi occupation and daily torment, Paris's galleries, boulevards, jazz clubs, bistros, bookshops, and the myriad daily newspapers and monthly reviews born in the last years of the war became forums for heated discussions, battle plans, and manifestos. Among the most influential periodicals: *Combat*, edited by Albert Camus; Jean-Paul Sartre and Simone de Beauvoir's *Les Temps modernes* (named after Chaplin's film

Modern Times); and of course, a few years later, the many Paris-based English-language magazines catering to an international crowd of ex-GIs and students flocking to the city. These flourishing publications, all edited within one square mile, boasted an audience well beyond Paris. When editorialists and artists shouted on the boulevard Saint-Germain, their cry echoed in Manhattan, Algiers, Moscow, Hanoi, and Prague. These intellectuals, artists, and writers were heard and followed by decision makers in Europe and elsewhere in the world precisely because they originated from Paris.

How could Paris regain such a high cultural standing so soon after the war? Germany was in eclipse, Russian and Eastern European cultural life devastated, Spain isolated by General Franco's regime, Italy busy recovering from a generation of Fascism, and Britain as marginal as ever to European intellectual debates. To paraphrase the Anglo-American historian Tony Judt, despite France's own relative decline, Paris's voice mattered more during the decade after the war than it had at any time since 1815, the peak of Napoleonic grandeur.

Together, in Paris, our band of brothers and sisters created new codes. They founded the New Journalism, which got its official name a decade later but was born then, in the smoky hotel rooms of the Left Bank, and forever blurred the lines between literature and reportage. Poets and playwrights slowly buried Surrealism and invented the Theater of the Absurd; budding painters transcended Socialist Realism, pushed Geometric Abstraction to its limits, and fostered Action Painting. Philosophers founded new schools of thought such as Existentialism while setting up political parties. Aspiring writers found their voices in Paris's gutters and the decrepit student rooms of Saint-Germain-des-Prés, while others invented the *nouveau roman*. Photographers reclaimed their authorship through photojournalism agencies such as Magnum; censored American writers such as Henry Miller published their work first in French; black jazz musicians, fleeing segregation at home, found consecration in the concert halls and jazz clubs of Paris, where New Orleans jazz received its long-overdue appreciation while bebop was bubbling up. Some in the Catholic Church experimented with Marxism, while a colorist and former art gallery owner turned couturier named Christian Dior intoxicated the world with the New Look in fashion design.

After 1944, everything was political; there was no escape. World citi-

zens of the Left Bank knew this, and they did all they could to question both U.S. policies and the Communist Party's views. Paris was, for them, both a refuge and a bridge to think in a different way. They opened up the possibility of a Third Way, ardently embracing the idealism of the United Nations and the glimmer of utopia in what would later become the European Union. Those pioneers also reinvented their relationships to others. They questioned, shook, and often rejected the institutions of marriage and family and adopted polyamory as an ambition in life. They campaigned for the right to abortion thirty years before it was legalized and consumed drugs, cigarettes, and alcohol with passion. Their heightened sexuality proved an inherent part of their creativity and permeated everything they did. They also proved, with only a few exceptions, to be very hard workers, workaholics even. They worked hard and played hard.

Women took on a central role. The *Mona Lisa*'s return to the Louvre after six years of hiding during the war heralded a new era in which *Elle* magazine was founded and edited by twenty-nine-year-old Françoise Giroud, who would become a government minister exactly twenty-nine years later. As Colette, the grande dame of French literature, passed away, so did the figure of the demimondaine. Bardot and Beauvoir became the two new faces of feminism to whom the world would soon surrender. In this predominantly male environment, only very strong women survived and made a mark. You had to be pugnacious in those years if you wanted to exist as an individual and not just as the escort of a great man. Women who refused to be just wives, or mistresses, more often than not exploited by their famous and unfaithful other halves, were almost all bisexual, and female Don Juans. Some were even on the quest for a Third Way into sex, as in politics. The *New Yorker*'s Paris correspondent Janet Flanner, who signed all her articles with the pseudonym Genêt, known before the war for her statuesque and beautiful female lovers, asked her liberal mother in a letter in 1948: "Why cannot there be a third sex, a sex not dominated by muscle or the inclination to breed?"[1] A good question in a decade bursting with testosterone.

All of them—male and female, artists and thinkers—set new codes and standards, achieved a string of undeniable successes, and left behind a litany of failures. Tony Judt addresses the latter in the academic work *Past Imperfect: French Intellectuals 1944–1956*.[2] His resentment and frustration pour from the pages like those of a spurned lover. Paris intellectuals had so

much power bestowed on them by circumstances and their own genius and yet failed, in his view, to change the world. "This contrast, the failure of French intellectuals to fulfil the hopes invested in them by their admirers, together with the influence exerted by the French intellectual life in other Western countries, had a decisive impact on the history of post-war European life." Tony Judt, himself shaped by French thinking, would never forgive Sartre & Co. for having let their contemporaries down when they needed them most. He even called his book "an essay on intellectual irresponsibility."[3] That they were expected to change the world in the first place raises the question: How did they arouse so much wild hope? *Left Bank* is as much about postwar Parisian intellectual irresponsibility as about political, artistic, moral, and sexual incandescence.

Though *Left Bank* offers a narrative of Paris between 1940 and 1950, it is not a work of fiction, nor is it an academic analysis; it is a reconstruction, a collage of images, a kaleidoscope of destinies based on a variety of sources and documents. Memory is a perilous terrain. Archives, for instance, provide facts but may not reveal the whole picture. Meeting in the flesh and interviewing some of the actors and witnesses of the period proved essential, but also frustrating. One says only what one wants to say, and one's truth is not the whole truth. Autobiographies and memoirs are the same: they are often as interesting for what they conceal as for what they reveal. Journals, diaries, and correspondence, written as events took place and not tampered with or rewritten years after, are almost as reliable as archives, like a stream of consciousness unpolluted by afterthought. However, objectivity and neutrality do not exist in personal recollections and relationships. As Richard Seaver, an American student in Paris in 1948 who introduced Samuel Beckett to the Anglophone world, wrote in the preface of his autobiography *The Tender Hour of Twilight*: "Time is not kind to the harried mind, filling it each passing day with the detritus of the moment, like silt at a river's mouth slowly covering the earlier levels and slyly reconstituting the terrain."[4]

I was therefore left cross-checking information through a multitude of sources, press cuttings, interviews, archives, photographs—as many and varied documents as I could lay my hands on. My days at the French National Library, also known as the Très Grande Bibliothèque, proved illuminating too—not only because of what I found there, but also because of the architectural experience it provides for researchers. It is probably the only truly

Stalinist building in Paris with its crushing scale, Kafkaesque maze of corridors, some of them leading nowhere, and metallic doors as heavy as gravestones—and thus offers the unexpectedly perfect setting for the study of postwar culture and politics.

Paris being Paris, many places have not changed since the 1940s, and I tried to find those "crime scenes," as I thought of them, hoping to capture the atmosphere of the time and to lay my hands on objects that had been touched by the ghosts I was stalking. Many of our protagonists lived in decrepit and cheap Left Bank hotels; those are still here today, but many have been transformed into luxury boutique lodgings. Except one: La Louisiane,[5] family-owned since the time of Napoleon. Beauvoir lived there for five years, between 1943 and 1948, and so did Jean-Paul Sartre, Albert Camus, Juliette Gréco, and many others. There may be free wifi today,[6] but the rooms at La Louisiane have not changed much since the 1940s. I booked myself in and slept between those evocative walls, reliving Beauvoir's words:

> Thursday, May 16, 1946. Spring is coming. On my way to get cigarettes, I saw beautiful bunches of asparagus, wrapped in red paper and lying on the vegetable stall. Work. I have rarely felt so much pleasure writing, especially in the afternoon, when I come back at 4:30 p.m. in this room still full of the morning's smoke. On my desk, sheets of paper covered in green ink. The touch of my cigarette and pen, at the tip of my fingers, feels nice. I really understand Marcel Duchamp when, asked whether he regretted having abandoned painting, he replied: "I miss the feeling of squeezing the paint tube and seeing the paint spilling onto the palette; I liked that."[7]

I never expected the past to assault, as it were, my every sense. I had expected a joust of ideas, endless intellectual disputes, but not for the past to materialize so clearly that I could touch it, smell it, even taste it.

For me, writing this story has been rather like walking into a house on fire. The live fire of the war, the furnace of emotions, the passion of politics, the spectacular fallings-out, the brutal sex, the nerve-racking frustrations, the insane and beautiful ideals, the plotting of big schemes—so many failures and some remarkable achievements. The subjects of this book might have failed in the end to prevent the Cold War from becoming the new world order; they did, however, set up many standards by which we still live, three-quarters of a century later.

PART I

WAR WAS MY MASTER

JULY 1938–AUGUST 1945

Our story does not begin in the stifling hot summer days of 1944, with the rumble of Allied tanks advancing along Parisian boulevards, the tears of joy pearling down young French women's faces, and thousands of complete strangers kissing in celebration. It would be tempting to start then, but it would also be misleading. To understand the absolute elation of the summer of 1944, one that is difficult to put into words almost seventy-five years later, we need to feel the profound pain that preceded it, both mental and physical. And the sense of unbearable shame that accompanied it. To understand the ecstasy of those days, one cannot avoid looking into the haggard eyes of Parisians in May and June 1940, nor can one escape confronting the cataclysmic days before the brief war that led to the fall of France and the Nazi occupation.

Postwar Paris writers, artists, and thinkers cannot be fully appreciated without plunging first into the turmoil of Nazi occupation, which not only formed them but also informed their actions and thinking throughout their lives. Each experienced the war differently, but all endured it one way or another—whether at its epicenter, Paris, or at a distance, stranded in Vichy France or North Africa, or, in the harshest possible way, in prisoner-of-war or concentration camps in Germany, under the bombs in London, or by proxy, vicariously riveted to the news on the radio in the safety of New York, or finally by resolving to put an end to it through active combat. All of them were somehow reborn, their characters redefined, in those years of the war, and they later adopted Paris as their home precisely because of what they had been through.

Years later, three overlapping generations of renowned Paris residents could individually say: "War was my master, and Paris my school of life."[1]

❧

THE FALL

ON THE BRINK

QUEEN ELIZABETH WAS WEARING AN ANKLE-LENGTH WHITE satin dress, long white silk gloves, a white satin pochette, and a wide-brimmed white hat. She was walking slowly, with French president Albert Lebrun, in a tailcoat, top hat, and white gloves, a few feet behind. King George VI and Queen Elizabeth of England's official state visit to Paris, in July 1938, was intended to impress Hitler by reaffirming the strong alliance between Britain and France. Newsreel operators placed along the route of the royal cortège filmed the black limousines approaching the Louvre, followed by mounted Republican Guards in full regalia, their elaborate sabers with inlaid brass scintillating in the sun. Britain's monarchs had chosen to pay a visit to the *Mona Lisa* and the *Venus de Milo*, to show the world that the *Entente* was still *Cordiale* and everything was as it should be. Except that Germany had annexed Austria just four months earlier.

The newsreel shows six men hovering around the royal party as they pass a series of early Impressionist paintings. Jacques Jaujard, the deputy head of the French National Museums, was among them. Tall, dark-haired, and slim, he was, at forty-three, a dashing albeit austere figure.

Jaujard did not believe in appeasement, he never had. While he showed the queen around the Louvre's Grande Galerie,[1] very few knew that he had already started to plan the evacuation of France's entire public art collections for when, not if, the Germans would invade Paris. He had supervised the expatriation of the entire Prado Museum's collection from Madrid to Switzerland, to shelter it during the Spanish Civil War. He had

already begun to elaborate contingency plans for this war, writing up lists and ordering thousands of wooden cases made to precise measurements.

There were very few people in the summer of 1938 who felt personally concerned by Germany's aggressive policies against its eastern neighbors, let alone who were preparing actively for war. Untroubled by the worries of a grown-up man spending his days and nights thinking how best to preserve the world's cultural heritage and thousands of years of civilization from a very uncertain future, the youth of Paris were more preoccupied by emulating their idol Charles Trenet, "Le Fou Chantant" ("the Singing Fool"), as the twenty-four-year-old musical prodigy was known. In the summer of 1938, Paris's teenagers wore blue shirts and white ties and hats just like Trenet, the man who made France *swingue*.

One of their philosophy teachers at the Lycée Pasteur in Neuilly, the plush western suburb of Paris, also felt completely unconcerned by world events. Like his pupils, the thirty-three-year-old Jean-Paul Sartre enjoyed listening to Charles Trenet. What he enjoyed even more was shattering social conventions. But war? War was not on his mind. He liked taking his students to cafés to discuss literature, something that was simply not done in 1938; nobody before had dared to breach the revered distance between a pupil and his teacher, and question the concept of hierarchy so directly. Sartre also liked to lend his pupils his personal books. Through this strange-looking man with a terrible squint, a buoyant intelligence, and a contagious laugh, they discovered the writing of Hemingway, Dos Passos, Steinbeck, and Faulkner.[2] Sartre was himself about to be published for the first time by the prestigious publisher Gallimard. He called his first novel *La nausée* (*Nausea*),[3] an unsavory title. *Le Figaro* and other conservative newspapers deemed it unpleasant, too bleak, nihilistic even, but all recognized the undeniable talent of its author.

La nausée was dedicated to "The Beaver," a word play in English on the name of his best friend, sparring partner, and lover, Simone de Beauvoir. "Beauvoir" sounds like "beaver" in English pronunciation, which is *castor* in French. In other words, Simone de Beauvoir became for her close friends "Le Castor" by way of English. Le Castor was, just like Sartre, a brilliant thirty-year-old philosophy teacher, though rather more beautiful. They lived together—that is, they lived in the same shabby hotel, the Hôtel Mistral, 24 rue de Cels, just behind Montparnasse Cemetery, though not in the same room.

Beauvoir and Sartre were attractive teachers and great listeners and

never passed moral judgments. Unsurprisingly, their students became their most ardent admirers, often developing a crush on them. Instead of scolding them, Beauvoir and Sartre returned their affection. There were the very blond sisters Olga and Wanda Kosakiewicz, there was Jacques-Laurent Bost, called "le petit Bost" as he was the youngest of a family of ten children, and there were Bianca Bienenfeld and Nathalie Sorokine. They were all infatuated with Simone. Beauvoir and Sartre had agreed that their relationship was *essential* while other relationships they might have on the side were to remain *contingent*. Their life together, and not together, formed ripples in an ever-growing pool. New entrants to Beauvoir and Sartre's circle usually accepted the premises of their contingent relationships with their mentor-lover, and an astonishingly large number would remain on friendly terms after passion had consumed itself. Then they often fell for another member of the group. Transparency was not universally shared between the members of what would be later known as the "Sartrean family," and many small secrets allowed such a system to work. For instance in 1938 and 1939, while she was in love with Bost, Beauvoir was having a passionate affair with Bianca (Bost knew about Bianca but Bianca did not know about Bost). Sartre then started courting Bianca in January 1939 after Beauvoir had ended her affair with her. Beauvoir and Sartre were not only lovers and mentors; they also provided for these student-lovers of theirs. They worked hard and paid for everyone's lodgings and food. Their world was one of knowledge and foreplay in which politics and world affairs played the tiniest of parts. They were philosophers and thought of themselves as above politics.

Samuel Beckett did not have much time for politics either. He had just turned thirty-three and liked sleeping till noon. On April 18, 1939, he wrote to his friend Thomas MacGreevey back in Dublin: "If there is a war, as I am sure there must be soon, I shall place myself at the disposition of this country."[4] Beckett wanted to be useful; he had time on his hands and had not yet found his voice. He was living in the shadow of another Irish writer, James Joyce, for whom he had briefly worked as secretary, and he was at pains to actually produce something he thought worthy. There was of course *Murphy* (1938), a novel that he had written in English and that he'd have loved his friend Alfred Péron, an English teacher, to translate into French, but when the two young men met every Tuesday for lunch, they ended up playing tennis rather than talking about work. Apart from *Murphy*, Beckett had a few poems (some in French) and some translation work to show, but not

much else. He read a lot, though, and along with his admiration for this French philosophy teacher's book *Nausea*, which he thought "extraordinarily good,"[5] he liked the work of an older writer, Louis-Ferdinand Céline, particularly his novel *Voyage au bout de la nuit* (*Journey to the End of the Night*). Beckett lived very modestly on his occasional translating and teaching income, supplemented by a monthly allowance from his brother Frank in Ireland. At least if there was a war, he could be of some use.

While Jean-Paul Sartre, Simone de Beauvoir, and Samuel Beckett were either happily ignoring world affairs or envisaging what their future role in a war could be, Jacques Jaujard was already fully engaged in action, following his instinct. He had confided to Laure Albin Guillot, a sixty-year-old celebrity photographer, that he would soon do an inventory of the museum's art collection, a rearrangement of some kind. The terms remained purposely vague. Whether he privately told her the extent of his plans is uncertain. Perhaps he wanted one of the most talented French photographers of the 1930s to immortalize artworks that might soon be destroyed or vanish forever.

He could have asked another, younger photographer, the thirty-one-year-old Henri Cartier-Bresson, known at the time only as Henri Cartier. Cartier-Bresson was the well-known name of Parisian industrialists and he did not want his comrades in the Communist Party to realize that he was the son of *grands bourgeois*. However, Jaujard might have been wary of asking the official photographer of the Communist newspaper *Ce Soir*, edited by Aragon, especially as Soviet Russia and Nazi Germany had just agreed to sign a pact of nonaggression. Besides, Henri Cartier was busy working for the film director Jean Renoir. Since 1936 he had been enjoying his role as Renoir's assistant director, not only on Communist propaganda documentaries but also films such as *La règle du jeu* (*The Rules of the Game*), which portrayed a world on the brink—the world of the pleasure-seeking French bourgeoisie oblivious to the world around them.[6]

On August 24, 1939, the day after the Soviet foreign minister Molotov and his German counterpart von Ribbentrop had signed the pact that gave Hitler free rein to attack the West, Jacques Jaujard ordered the Louvre to be closed for three days. Officially, for repair. In fact, for three days and three nights, two hundred Louvre staff, students from the Louvre art school, and *grand magasin* employees from La Samaritaine carefully placed four thousand world treasures in wooden cases. Luckily, *The Wedding at Cana* by Veronese could be rolled around a cylinder. So could Jacques-Louis

David's *The Coronation of Napoleon*. But Delacroix's *Crusaders*, Géricault's *The Raft of the Medusa*, and all the Rubenses were too fragile and had to be hauled on a special open truck made to transport set designs and murals from France's state theater company, the Comédie-Française. *The Raft of the Medusa*, weighing nearly one and a half tons, stood in the open-air truck covered only by a giant blanket.

Masterpieces were categorized in order of importance: a yellow circle for very valuable ones, a green circle for major artworks, and a red circle for world treasures. The white case containing the *Mona Lisa* was marked with three red circles. In a letter to the curator who was in charge of traveling with *La Joconde* but did not yet know the full burden of his responsibility, Jaujard broke the news by telling him: "Old friend, your convoy will be made of eight trucks. I have to tell you that the Chenu truck which will be departing from 5 rue de la Terrasse, with the plate number 2162RM2, contains a case with the letters MN written in black. It is the *Mona Lisa*."[7] Leonardo da Vinci's finest work was traveling in an ambulance specially fitted with elastic rubber-sprung suspension.

Private cars, ambulances, trucks, delivery vans, and taxis were requisitioned. A convoy of 203 vehicles transporting 1,862 wooden cases set out one morning in late August to eleven castles in France where they would wait, anonymous and secure, for what would come. Grand châteaux on the Loire such as Chambord and Cheverny were used, but Jaujard also requisitioned more inconspicuous and privately owned estates conveniently "lost" in the French countryside, far from any strategic locations. Every convoy had a curator and staff attached to it. Their mission: to look after the art collections in their new homes for as long as it was necessary. Whole families were displaced and relocated. For those dedicated museum employees, it was an adventure that would last more than five years.

The eleven-foot-tall *Winged Victory of Samothrace* was the last piece to go into hiding, at three o'clock on the afternoon of September 3, the precise time that France declared war on Germany. Then, in the next few weeks, the entire national public collection was taken to safety. Every museum in the country used the plan of evacuation Jaujard had used for the Louvre, each work being treated in order of artistic and historical importance. By autumn 1939, every single artwork of significance had been put in safekeeping. The news, quite inevitably, filtered out. Raymond Lécuyer, in *Le Figaro*, wrote of "the exodus of paintings," praised the dedication of the national

museums' keepers, many of them retired veterans from the Great War, and apologized to his readers for being elusive about the whole operation. He could not be specific, nor could he give names, dates, or places, but he wrote: "May [it] be, however, a comfort for you to know that the world's art heritage is safe from the scientific enterprises of German barbarism."[8]

Having fulfilled his duty to history, Jaujard retreated to his office in the Louvre overlooking the Tuileries Gardens. He was now bracing himself for the inevitable. It might take months, but the Germans would soon be in Paris, he was certain of that. Jaujard may have been ready but, unfortunately, the French army was not.

TWILIGHT

Instead of immediately fulfilling their duty of assistance to Poland, Britain and France bided their time and did not engage in offensive military operations, allowing the German army to concentrate on invading and crushing Poland without having to fight on two fronts at once. There was something decidedly strange about this war. The French called it the "Drôle de guerre," the Americans and the British the "Phony War." If the French army had attacked head-on, immediately after the declaration of war, the German army could not have held out for more than one or two weeks—at least that is what the German general Siegfried Westphal stated years later during the Nuremberg trials. In September 1939, Britain and France had a combined 110 divisions to Germany's 23.

Both France and Britain, however, were busier making life difficult for the German and Austrian citizens living on their soil, such as Arthur Koestler in France and Stefan Zweig in Britain, than confronting Hitler on the ground. In October, the Hungarian-born antifascist intellectual Koestler was arrested and interned at the Le Vernet detention camp in the French Pyrenees,[9] while the celebrated Austrian author Zweig, now a UK resident, was forbidden to travel more than five miles from his home in Bath.

Some Parisians left immediately after the war was declared. Janet Flanner, the formidable Paris correspondent of the *New Yorker* since 1925, a lesbian who was as well known for her beautiful lovers as for her steely writing, decided to go back to the United States. She told her French lover Noeline, or Noel Haskins Murphy, as she was officially known, that she would write and come back soon. Noeline, a six-foot-tall "stunning woman

with high cheekbones and hay-coloured hair, a veritable Viking, a blend of Garbo and Dietrich,"[10] would look the shadow of herself when they next met in December 1944.

The fifty-eight-year-old Pablo Picasso, horrified by the bombings of Guernica in April 1937, left Paris on September 2 for Royan, a seaside resort in southwestern France, sixty-one miles north of Bordeaux. He rented a villa[11] for his mistress Marie-Thérèse Walter and their daughter, Maya, about to turn four, and lived with his new love, the photographer Dora Maar, at the Hôtel du Tigre. He soon rented a studio space on the third floor of the Villa les Voiliers with a beautiful sea view. Royan failed to inspire him, though. Picasso was no wildlife or landscape artist. He may have felt relieved at first to be away from Paris, but the vivid light of the Poitou region did not suit him. He kept busy sketching and even writing to fight his anxiety about the war. The seafood at the local market inspired a few paintings, but he drove back to Paris regularly to get supplies of brushes, paints, canvases, and sketchbooks. The November 15 opening of his first American retrospective at New York's Museum of Modern Art (MoMA) in New York, called "Forty Years of His Art," which should have been a great satisfaction, felt very far away, almost unimportant.[12]

Others had decided to wait and see, such as Jean-Paul Sartre and Simone de Beauvoir, who had remained in Paris, teaching, and occasionally changing hotels, their lovers and students in tow.

While everyone in Western Europe was adjusting to this "phony war," the largest army in the world, as the French army was described in newspapers at home and abroad, was utterly unprepared, a victim of traditionalism, ignorance, arrogance, and paralysis. One eyewitness account of the time clearly understood the collapse of French soldiers' morale, the total failure of the French high command, the demented military strategies focused on the Maginot Line and the so-called "impenetrability" of the forest of the Ardennes, and the fantasy worlds inhabited by the French bourgeoisie and the working class. Marc Bloch was a veteran of the Great War, a professor of medieval history at the Sorbonne and founder of the Annales School.[13] He volunteered to serve in 1939 at the age of fifty-three. The French high command's utter incompetence and inability to adapt to modern times was not the only cause of the fall of France, wrote Bloch in 1946's *Strange Defeat*, published posthumously. The way in which the

state, its government, and France's political parties relayed the most inane optimistic messages to the country, hinting that defeat was inconceivable, while acting in the most timid way toward Hitler, prevented a clear and cool-headed look at reality. He accused the working class of coward pacifism while the bourgeoisie only sought egotistical pleasures in life. What Marc Bloch described was the complete moral collapse of an entire country—as Renoir had done a few months earlier in his film *La règle du jeu*, showing the unbearable lightness of the French elite, an innate insouciance shared by Jean-Paul Sartre and Simone de Beauvoir.

Immigrants, and foreign Jews in particular, like Arthur Koestler, could not afford the luxury of insouciance. Having been released in early 1940 from the internment camp at Le Vernet thanks to the tireless campaigning of his lover, the sculptor Daphne Hardy, who alerted the British authorities, Koestler first tried to get French papers in Paris in order to stay in France. On May 1, thinking ahead, he also sent a manuscript to a London publisher. His novel, translated from German by Hardy, was called *Darkness at Noon*, and it told the story of an old Bolshevik tried for treason by the very government he had helped create. In Paris, Koestler stayed at the homes of different friends. One of them was the fifty-three-year-old Sylvia Beach, owner of the celebrated Shakespeare and Company bookshop at 12 rue de l'Odéon in the 6th arrondissement.[14]

Beach, a friend of the writers Ezra Pound, Ernest Hemingway, and André Gide, had improvised as a publisher in 1922 in order to bring James Joyce's *Ulysses* into the world. She still lived above her bookshop, just like Adrienne Monnier, her former lover and best friend, and the owner of the bookshop just opposite hers, at 7 rue de l'Odéon. Sylvia and Adrienne were the souls of what some of their friends called "Odeonia," a kingdom of culture, international fraternity, and tolerance. They belonged to a bygone era, and in May 1940 Odeonia felt like a besieged city. Adrienne was seeing Gisèle Freund, a thirty-two-year-old from Berlin who had done her PhD thesis at the Sorbonne on photography in France in the nineteenth century. Freund busied herself taking portraits of all the writers still passing through Odeonia; of Jewish descent, she was also seriously considering fleeing to Argentina, where she had friends and family.

The few American writers still in Paris in 1940, such as Henry Miller, as well as the artist Man Ray, were starting to flee to the south, and from there to safer countries. Arthur Koestler was clinging to the hope of get-

ting French papers. At Sylvia Beach's flat, "he was reading Stendhal's *Le rouge et le noir* (*The Red and the Black*) when a four-leaf clover resting on an upper shelf 'fell right between his eyes.' Adrienne kissed his eyes and assured him it was an omen that he would be safe."[15]

LA DÉBÂCLE

"The new phase of the war"—the euphemism used by some—began at daybreak on Friday, May 10, 1940. German tanks had entered Belgium and the Battle of France had begun. However, French newspapers had dedicated their headlines to the governmental crisis in London, which would soon bring Winston Churchill to power. With dawn came the air raid sirens, startling a city that had heard no daytime alert since the first weeks of the "Phony War" eight months earlier. The rubicund, jolly, and overweight A. J. Liebling, a special reporter for the *New Yorker* who had replaced his colleague Janet Flanner, looked out from his hotel room on the Square Louvois, opposite the French National Library. He stood there alongside his French neighbors, all spectators, framed in the opened windows of every building. Everyone stood in their nightshirts or stark naked, looking up at the sky. A few hours later that day, Corporal Henri Cartier-Bresson, stationed in Metz with the Third Army in the Photographic and Film Unit, had just enough time to bury his Leica in the courtyard of a farm in the Vosges region before being sent on a mission.

On Wednesday, May 15, the day the Germans made a decisive thrust that would split the Allied armies a few days later, Samuel Beckett volunteered to drive an ambulance. Ireland was a neutral country in the war but he wanted to participate in the way other foreign writers had done in previous conflicts, just like Ernest Hemingway, who had enlisted to go to the Italian front as a Red Cross ambulance driver in World War I at the age of eighteen. "Beckett took out a heavy vehicle licence, but heard nothing."[16] In truth he wanted to join his best friend, Alfred Péron, now in Brittany, who had been posted as a liaison officer with a British ambulance unit.

On Thursday, May 16, panic hit the correspondents of Paris's foreign newspapers and French politicians. That night, Liebling saw slick-haired, sullen young men in pullovers speeding through the night on fast motorcycles. "They had the air of conquerors."[17] Probably German spies on reconnaissance missions.

On Saturday, May 18, the seventy-three-year-old General Weygand replaced General Gamelin as the French army's supreme commander, while the eighty-four-year-old Marshal Pétain was invited to join the government. Though both were arch-right-wingers, royalists, ardent Catholics, and anti-parliamentarians, they canceled each other out in strategic and military terms. As A. J. Liebling described it to his American readers, Pétain was "incapable of conceiving any operation bolder than orderly retreat," while "Weygand believed in unremitting attack."[18]

On Tuesday, May 21, the head of the French government, Paul Reynaud, announced to the Senate that the Germans had reached the northern town of Arras and that "France was in danger." A week later, Belgium's King Leopold III capitulated, leaving the British and French armies in a worse position still. Winston Churchill was stung: "Without prior consultation and upon his own personal act, the Belgian King surrendered his Army, and exposed our whole flank and means of retreat."[19] Operation Dynamo, better known as the evacuation of Dunkirk, had started. Britain needed to get its troops back. It started very badly, but disaster turned into "triumph" when almost 338,000 soldiers (among them 26,500 French soldiers) were evacuated by June 4. That day Winston Churchill rejoiced, but he also warned the British public: "Wars are not won by evacuations."[20]

On June 6, taxis became scarce, hotels were deserted, telephone services restricted, and restaurants and cafés lowered their metal shutters. Communication with the outside world was breaking down, making life difficult—especially for foreigners. Samuel Beckett could no longer draw money from his Irish account at the bank, nor could he get the papers he wanted.[21] A. J. Liebling, though, managed to obtain a safe-conduct.

On June 10, Mussolini's Italy declared war on France and Britain. The French and British governments had been hoping the fascist dictator would stay neutral after they had wooed him with territorial concessions in Africa to expand Italy's colonial empire. In Paris, the American ambassador to Paris, the forty-nine-year-old William C. Bullitt, was seen laying a wreath of roses at the statue of Joan of Arc at the place des Pyramides, in view of Jacques Jaujard's office in the Louvre.

William Christian Bullitt Jr.—a former news correspondent in Europe, Yale graduate, man of the world with a taste for beautiful women, talented writer, and ambassador to the Soviet Union between 1933 and 1936—was also an ardent European and a keen Francophile. His mother, a German

Jew named Horowitz, had made sure that her son was perfectly trilingual, as fluent in German and French as in American English—a gift that soon came in handy.

His friend President Franklin D. Roosevelt, to whom Bullitt spoke every day on the phone since he had been appointed the president's man in Paris in 1936, asked him to leave the city. Bullitt cabled the White House in Washington: NO AMERICAN AMBASSADOR IN PARIS HAS EVER RUN AWAY FROM ANYTHING AND THAT, I THINK, IS THE BEST TRADITION WE HAVE IN THE AMERICAN DIPLOMATIC SERVICE. Indeed, Gouverneur Morris stayed throughout the French Revolution, Elihu B. Washburne braved the Prussian occupation of Paris during the Commune in 1870, and, although within range of the kaiser's artillery, Myron T. Herrick did not flee Paris in 1914. Bullitt was not alone in wanting to stay: five thousand of the thirty thousand U.S. citizens who lived in or near Paris, the largest American community in Europe, also refused to leave.[22]

On the evening of June 10, Parisians retreated inside their homes and gathered around the radio. Those who stayed up after midnight heard Roosevelt's speech, relayed from London, in which he described Italy's war declaration as a stab in the back. Earlier that day, in Royan, Picasso had painted the head of a woman, looking decidedly somber. A. J. Liebling did not hear Roosevelt's speech: he had left Paris a few hours earlier. On leaving he was more broken-hearted than scared. It had never occurred to him that Hitler might one day destroy France, "the historical continuity of intelligence and reasonable living," without which "nothing anywhere can have meaning until it is re-established." Liebling was angry, too, at French cowardice. There were many cowards in June 1940. Liebling had had lunch that week with a notorious French journalist who wrote for a dozen Parisian newspapers of varying political leanings under a dozen different pseudonyms. He had told his American colleague: "What a terrible mistake to have provoked those people, my dear! What madness to concern ourselves with Poland!" He had cried like a baby while stuffing asparagus into his mouth, then shouted: "Peace, quickly, quickly!"[23]

Liebling was not the only one fleeing Paris—thousands of Parisians and refugees from the north of France were also in transit. So was Arthur Koestler, still without any legal papers. Hidden by friends who passed him on in turn, hiding him for one night each, obtaining a travel permit to Limoges for him—Koestler saw no alternative but to enlist in the Foreign

Legion, which since 1831 had granted men of all creeds and nationalities a
new life and a new identity. Koestler enrolled for five years and legally
ceased to exist. He was now Albert Dubert.

Simone de Beauvoir left too. The father of her student and now ex-lover
Bianca Bienenfeld gave her a lift. He dropped Simone off at Poèze, near
Angers, at the cottage of a friend, Madame Morel. Simone de Beauvoir
admitted later not feeling much connection with the historical events
unfolding. She listened to news bulletins on the radio, of course, but she
also spent her days reading detective novels and discussing sexuality with
Madame Morel. Young women kept falling in love with her, and Madame
Morel had called her a "wolf trap"—in other words, a lesbian. Simone had
started wearing a headband that looked a little like a turban. Her lover, le
petit Bost, had commented on her new hairstyle: "You look like a lesbian,
a cocaine addict and a fakir too."[24]

The forty-two-year-old American heiress and art collector Peggy Gug-
genheim could see the refugees dragging their belongings through Paris, but
she was too busy buying paintings from artists desperate to leave Paris before
the Nazis reached it to care much. For a quarter of a million dollars, she
acquired a collection that would come to be worth more than $40 million.[25]
After striking many bargains, Guggenheim fled south toward Arcachon,
where her friends the Spanish painter Salvador Dalí and his muse and wife,
the Russian-born Gala, had rented a villa and were welcoming friends "in
transit."

On the morning of June 11, Samuel Beckett, along with those Parisians
who had not yet left, woke up to the smell of soot. Ammunition factories
around the capital city, blown up by the French authorities, had been burn-
ing through the night. "The high brilliance of the sun had been reduced to
a sulphurous glow."[26] The head of the French government, Paul Reynaud,
was preparing to flee to Tours on the river Loire with his government. In
order to spare France's capital, Paris was officially declared an "open city,"
which meant the French government was abandoning all defensive efforts
in the hopes that the German army would respect the international con-
ventions of war by which open cities are protected from bombings. How-
ever, one could never be sure with the Nazis. Before leaving, Reynaud went
to see his friend the American ambassador Bullitt and asked him to try to
persuade the Wehrmacht not to destroy Paris. Bullitt, the last foreign

ambassador still present in Paris, was in effect made provisional governor of the city, in the absence of all French authority.

On June 12, Samuel Beckett and his "French girl,"[27] Suzanne Déchevaux-Dumesnil, who had decided at the last minute to go with him, boarded a slow, crowded train at the Gare de Lyon toward Vichy, where he knew people who could, he hoped, lend him some money. Nobody was aware yet that Vichy would become the headquarters and capital of unoccupied France. In Royan, Picasso was painting another sinister-looking head of a woman.

At first, the Wehrmacht agreed to enter the city peacefully. However, the shooting of German officers by French patriots near the Porte Saint-Denis, outside Paris, enraged General Georg von Küchler, the German 18th Army commander, also known as the "Butcher of Rotterdam" for having demolished that Dutch city just a few weeks earlier. He ordered as retaliation an all-out air and artillery assault on Paris at eight o'clock the following morning. There were only a few hours left for Bullitt to save Paris from the fate shared by Rotterdam and another capital city, Warsaw. Bullitt managed to persuade two French officials to meet their German counterparts at Écouen, twelve miles north of Paris, to settle terms for the handover. With the document signed, von Küchler called off the bombardment of Paris. An American had saved the City of Light.

While the city was being spared Nazi barbarism, pigeons had taken over all the great open spaces, and in the deadly silence their cooing filled the ears of the few remaining Parisians. Posters had been pasted up on the walls to advise its 2.8 million inhabitants to stay right there. There were few left to read them. On June 14, at dawn, Sylvia Beach and Adrienne Monnier looked out their small windows toward the Carrefour de l'Odéon and saw German army trucks roaring down the boulevard Saint-Germain. They had entered Paris. One minute they weren't there, the next Paris was swarming with them. One minute Jean-Paul Sartre was a philosophy teacher in Paris and Jacques-Laurent Bost was his student; the next, Sartre and Cartier-Bresson were prisoners of war and le petit Bost badly wounded.

"THE CITY WITHOUT EYES"

German cars, trucks, wagons, and cavalry poured through the streets, while giant swastika banners started draping public buildings. "The deadly

silence of a dead city had given way to the ear-splitting roar of Nazi planes flying very low over the city, day and night, throwing vulture shadows into every room. The avenues became autostradas for German officers in high-powered cars. The *feldgrau* was everywhere."[28]

Parisians watched the Germans with blank stares. The Germans did not understand at first; they felt ignored, as if they were transparent. They soon called Paris "the city without eyes."[29] Paris's spirit had disappeared just as the Germans thought they had caught it in their steely embrace. They had turned Paris and its inhabitants to stone.[30]

In Vichy, the French writer Valery Larbaud, whose work had inspired James Joyce's *Ulysses* with its interior monologues, kindly helped Beckett out and gave him cash. Beckett and Suzanne then set off on foot and slept in barns and on shop floors on their way to Arcachon, where their American friend Mary Reynolds, Duchamp's mistress, had a house and, they hoped, could accommodate them for a few days. They found her house was more than full with Peggy Guggenheim and other friends. Dalí and Gala's villa was also crowded with artists and writers, Man Ray and Marcel Duchamp among them, but Beckett and Suzanne eventually managed to rent a room in a boardinghouse, the Villa Saint George, 135 bis boulevard de la Plage. Duchamp and Beckett, fanatical chess players, spent much of the time playing the game in a seafront café.

On June 18, in an address broadcast by the BBC, Charles de Gaulle, a French general unknown to the majority of French people, called for France to continue the fight, urging all young men and women to join him in *résistance* from London. Four days later, though, Marshal Pétain capitulated and signed an armistice with Adolf Hitler. As A. J. Liebling wrote the same day: "De Gaulle had spoken for France; Pétain always seemed to speak against her, reproachful with the cruelty of the impotent."[31]

On June 22, while armistice negotiations were finalized at Compiègne, Henri Cartier-Bresson was taken prisoner and sent to Stalag VA in Ludwigsburg in Germany with the identification number KG 845, along with another twenty-three thousand French prisoners. Jean-Paul Sartre had been captured the day before, his thirty-fifth birthday, and was to be transferred to Stalag XIID near Trier. In Arcachon, getting some fresh air on the seafront, Samuel Beckett and Marcel Duchamp overheard a fat lady with gold rings on every finger welcoming the armistice: "Ah, we're going to be able to eat cakes again."

இ๑

THE CHOICE

LIVING WITH THE OCCUPANTS

Adolf Hitler could not resist visiting his most spectacular new possession and came to Paris on a special sightseeing tour on June 23. A heroic music piece especially composed for the occasion was broadcast on Berlin radio as the Führer posed for the photographers in front of the Eiffel Tower. The image nailed down the new reality.

With Hitler came the first German high dignitaries, Paris's new rulers. The best Parisian hotels were requisitioned to accommodate them.[1] One of the dignitaries settling in Paris in his new quarters was Count Franz Wolff Metternich, a forty-seven-year-old aristocrat and a scholar of Renaissance art and architecture. Appointed head of *Kunstschutz* (art protection) for the Rhineland and occupied France, he soon made his way to the Louvre to meet Jacques Jaujard. On August 16, a black chauffeured limousine bearing Nazi Germany's insignia slowly approached the main entrance. The knock at the door Jaujard had been expecting for exactly a year had finally come. Metternich was ushered into Jaujard's grand office. The two men looked at each other in silence, Jaujard keeping his hands behind his back. They looked similar—both very tall and thin, both in their midforties, both patriots. Each man weighed the other. Perhaps they had more in common than they realized. Jaujard wrote in his diary that Metternich, on learning that the Louvre was empty, had looked almost relieved.[2] Jaujard then told Metternich that France's entire art collection had been taken to safety and showed him his books. He had decided that

transparency was probably the best way to deal with Count Metternich. Like many Prussian aristocrats, Metternich was not a Nazi Party member. His task was to protect art in occupied France, and this was precisely, and quite literally, what he intended to do. There would be little he could do to safeguard private collections, especially those of French Jews like the Rothschilds, but he would try to shield France's public collections from looting and from the irrepressible envy of his superiors for as long as he could, and he would offer cover for everyone who, like Jaujard, had the protection of art at heart. On this August morning, Jaujard and France had made an unlikely alliance. Neither man needed to speak. Their duty was to art and mankind only.

When Pablo Picasso saw the German soldiers enter Royan in the summer of 1940, he realized that there was no reason for him to stay; he might as well be in the eye of the storm and face the devil. It would have been easy for him to go abroad to the United States, Britain, or Latin America, where he had many friends and admirers, but he went home, to Paris. From August 25, he started doing what everyone else did, queuing for food, and walking instead of waiting for the irregular and always crowded bus and métro services. There was no fuel for his Hispano-Suiza car, so he stored it in his garage, and there was very little coal to heat his huge Left Bank studio at 7 rue des Grands Augustins, so he wore extra layers. Every morning he walked the two and half miles from his home, 23 rue de la Boétie, which he had shared with his now estranged wife, Olga, to his studio and back in the evening before the midnight curfew, after a meal at the Café de Flore.

Whether under the bombs in London or in occupied Paris, young men and women had to adapt to the Nazi Occupation while trying to keep on living. Simone Signoret, born Kaminker, was desperate to find a job. In September 1940, Simone was nineteen and the family breadwinner, with two young brothers and a father who had "disappeared," probably to London. Her mother could not support the family on her own. When Corinne, a former classmate and the eldest daughter of the celebrated journalist Jean Luchaire, heard that Simone was looking for a job, she kindly asked her papa. Corinne had left school at fifteen and had become a movie star, but she was always helpful. Papa Luchaire, a handsome thirty-nine-year-old with sleek black hair, offered Simone a job as his personal

assistant—he had just been appointed editor in chief of a new daily news-paper, *Les Nouveaux Temps*.

In her new job, with a monthly salary of 1,400 francs,[3] Simone had to answer the phone and filter calls. A lot of people were asking Luchaire for help in those days, but there was one caller she was ordered to put through immedi-ately: Otto Abetz, Hitler's ambassador in Paris and an old personal acquain-tance of Luchaire's. Otto spoke to his friend every day. Jean Luchaire had chosen to "collaborate" with France's occupants even before Marshal Pétain officially asked the French to do so in an address on October 30, 1940. How-ever, he also regularly called Otto to get someone out of prison, obtain new papers for another, facilitate an escape to Marseille and then to New York via Lisbon or Casablanca, or give people jobs without asking questions. He knew that Simone's father was Jewish and had in all likelihood fled to fight with de Gaulle in London, but nonetheless he took her on.

In the 1920s, in what already seemed like another life, Luchaire had been a highly regarded journalist, the artisan of Franco-German rap-prochement, an ardent pacifist, and a supporter of the socialist Front Pop-ulaire. He had founded the progressive daily *Les Temps* in 1927. Thirteen years later, however, Luchaire, or "Louche Herr," as he had been derisively nicknamed, found himself on a darker side of history, deliberately choos-ing to satisfy the occupying force's every whim, while simultaneously help-ing those he could.

One evening in October 1940, Simone went to the theater for the first time in her life, alone and using a ticket her boss had given her. A hand-some young man in a brown duffle coat caught her eye. Simone was not interested in the play, and neither was he. Intriguingly, the tall, beautiful young blond woman who accompanied him kept smiling at her.

The twenty-four-year-old man was Claude Jaeger, his theater compan-ion Sonia Mossé. Claude wanted to become a film director; Sonia was a poet's muse. Her height and her blond hair made her look Aryan; in fact she was Jewish. She was the anonymous face in many pictures taken by Dora Maar and Man Ray. At the end of the play they approached Simone, chatted briefly, and all agreed to meet the following day at the Café de Flore, in Saint-Germain-des-Prés. Simone had never been to the Left Bank: it was another world.

At the Flore, people introduced themselves only by their first name. They were jobless actors, writers, and sculptors and painters without a gallery. Conversations were not loud; the air was serious, books stood between glasses, and the lighting was decidedly dim. There was not a single German in the café, but all had foreign accents. Men wore corduroy jackets, turtlenecks, dirty trench coats, their hair a little too long, while women wore no makeup. Nobody was dressed fashionably, but everyone had style.

Simone did not belong to this milieu, yet she immediately felt at home, as she later recalled in her memoirs.[4] She also felt torn. A young woman ought not to pass her late afternoons at the Flore among people who were wanted by the Gestapo, many of them Communists or Trotskyites, when she had just spent the rest of her day answering Otto Abetz's calls, working for the well-known collaborator Jean Luchaire.

Parisians not only had to learn to live with the occupiers, they had to get used to the many restrictions imposed on them. By autumn 1940, all private cars were prohibited. Buses ran on alcohol or charcoal but not on gasoline. In the métro, Parisians and Germans were packed together. The alternative was to walk or cycle, but bicycles were very rare and an absolute luxury in 1940. Stealing one was the easiest way to get to ride one. The Germans had introduced food rationing for Parisians, limiting their daily intake to 1,300 calories—enough to survive, not enough to rebel. The cafés were open but served only poor imitations of what they used to offer a few months earlier. Meat was already so scarce that traditional French dishes and specialties had disappeared from menus. The famous *andouillette* at Closerie des Lilas was gone.

Just like Picasso, Parisians started coming home. In October, Samuel Beckett and Suzanne returned from Arcachon to their spartan one-bedroom flat at 6 rue des Favorites in the 15th arrondissement. They were lucky: there was still heating and hot water in their building. Suzanne, like most Parisian women, became a forager, adept at finding butter here, eggs there, meat, fruits, and vegetables elsewhere. A few days later their Swiss sculptor friend Alberto Giacometti had returned to his studio where he lived in Montparnasse, and Alfred Péron, demobilized from the French army, had resumed his teaching post in the Lycée Buffon, a ten-minute walk along the rue de Vaugirard from Beckett's flat. They had what passed for lunch several times a week.[5]

Marshal Pétain, the leader of Vichy France, which was independent of

the occupied zone, had not wasted time in following the Nazi lead. Beginning October 3, 1940, French Jews were banned from holding administrative, financial, and commercial positions. This triggered the formation of resistance groups. Beckett's friend Alfred Péron decided at once to join the first underground group set up in Paris, made up mostly of academics and intellectuals with a link to the Musée de l'Homme, such as the art historian Agnès Humbert.[6] Samuel Beckett helped by collecting information he heard on British radio and passed on useful notes to Péron, who in turn passed them to Agnès Humbert, one of a few behind the first clandestine sheet, *Résistance*, published beginning December 1940.[7]

Simone de Beauvoir was keeping busy teaching, reading, and writing, but politics was still not on her mind. She was missing Sartre, held prisoner in Germany. She taught at the Lycée Duruy next to the Rodin Museum in the morning, studied Hegel at the National Library on the rue de Richelieu in the afternoon, and tirelessly edited her first novel in the evening in warm cafés. She had decided to call it *L'invitée* (*She Came to Stay*), the story of a ménage à trois. Her nights were carefully planned: she spent two nights a week with her student Nathalie Sorokine in her room at the Hôtel Chaplain and Saturday nights with Jacques-Laurent Bost, now back in Paris and recovered from his injuries, at the Hôtel du Poirier in Montmartre. The rest of the week, Bost was sharing a room with his new lover Olga, one of the Kosakiewicz sisters, at the Hôtel Chaplain. Such sexual promiscuity may well be partly explained by the freezing temperatures, outside and inside hotel rooms. Beauvoir was working hard to support all three young women and also helped Bost financially.

THE GOOD GERMANS AND THE BAD FRENCH

German officers with specific missions kept arriving in the French capital. On November 8, the day of his thirty-first birthday, *Sonderführer* Gerhard Heller boarded the train for Paris. Heller, born in Potsdam, had learned French at school, studied in Pisa and at Toulouse University. He loved languages and literature. Never a fully fledged Nazi Party member, he had not taken the oath to Hitler, whom he found repulsive. However, he liked Otto Abetz, Hitler's ambassador in Paris. Abetz assigned Heller to the *Gruppe Schrifttum* (literary section) of the *Propagandastaffel* (propaganda unit), whose offices were at 52 avenue des Champs-Élysées.

Heller was responsible for nothing less than all of France's literary publishing. "The Otto list" drew the red line French publishers were advised not to cross. This list, written up by Abetz, banned a thousand books by antifascist, Jewish, and Communist writers. The works of Thomas Mann, Stefan Zweig, Louis Aragon, and Sigmund Freud disappeared from the shelves of libraries and bookshops. Heller astutely let French publishers carry out their own censorship. In a few months, Heller had struck an implicit deal with Left Bank publishers: do not give my superiors or me any reasons for suspicion and I may occasionally cover you. Heller loved literature more than he loved Hitler and was going to prove it. "In a sense, he had joined the Left Bank literary scene, if in a new and strange manner. If so many literary stars of the pre-war anti-fascist left wing survived the German years unharmed, Heller and the mentality he represented deserve some credit."[8]

Before being destroyed, banned books were stored in an old garage on the avenue de la Grande Armée, near the Arc de Triomphe. There Heller saw mountains of the very books he had cherished as a student; their destruction filled him with disgust. "I understood only later the nature of my feeling in this garage full of books about to be burnt, thanks to Jean-Paul Sartre who was himself quoting Karl Marx when he later wrote 'Shame is a revolutionary feeling.'"[9]

Meeting Gallimard's charismatic Jean Paulhan also changed Gerhard Heller. Gallimard, France's most important and prestigious publishing house, had quickly decided to make a pact with the devil in order to save itself. Always an eclectic house, it had a "house fascist," Pierre Drieu La Rochelle. Abetz had brought Drieu to Germany as early as 1934; he had played a key role in Nazi propaganda in France. A deal was struck. Gallimard's influential *Nouvelle Revue française*, edited by Jean Paulhan, was taken over by Drieu La Rochelle. The review was so influential that it was inevitable that Otto Abetz should want to control it. Abetz had once reportedly declared: "There are three forces in France: Communism, High Finance and the NRF."[10] However, in exchange, Gallimard could continue publishing books under the supervision of Jean Paulhan.

Jean Paulhan's tiny office was just next to Drieu La Rochelle's. Six feet away, while Drieu embraced collaboration with the Nazis, Jean Paulhan was starting to run a *résistant* cell of writers and planning to publish anti-

fascist novelists, come what may. The charismatic fifty-six-year-old Paulhan even occasionally proposed texts to Drieu La Rochelle's *NRF*, and Drieu would accept because, if anything, they shared an absolute passion for literature and poetry. A poem by the Communist sympathizer poet Paul Éluard filled five pages in the February 1941 issue of the *NRF*, alongside an homage to James Joyce and a tribute to the Jewish philosopher Henri Bergson, who had just died.

Shrewd old Gaston Gallimard was using Drieu La Rochelle as an acceptable façade for the Germans, and while Gallimard felt compelled to publish anti-Semitic and fascist trash, it also published Simone de Beauvoir, Jean-Paul Sartre, Albert Camus, James Joyce, Paul Claudel, Ivan Turgenev, Raymond Queneau, Paul Morand, and even Louis Aragon, a Communist, a *résistant*, and the husband of Elsa Triolet, a Jewish antifascist.

In fact, Jean Paulhan was now a member of the Musée de l'Homme group,[11] one of the very first resistance groups operating in Paris, just like Samuel Beckett's best friend Alfred Péron and Agnès Humbert.[12] And he was hiding the duplicating machine, which served to print tracts and mimeographed news bulletins, right in his tiny Gallimard office. He had also started a clandestine publication called *Les Lettres françaises*.

Gallimard's example was going to offer a strange blueprint for many businesses and institutions having to deal with the Germans during the Occupation. Gallimard compromised itself with the Nazis, appearing to trample upon principles the house had seemed to hold dear, precisely for them to be maintained even in a small part. At the time, Gaston Gallimard felt it was the only possible approach. Others chose to close down all activities and join de Gaulle in his resistance efforts in London. Gaston Gallimard elevated ambiguity to an art form instead. By choosing to endure, Gaston Gallimard had paved the way to an "acceptable" form of existence under Nazi duress.

There was of course another option for writers and artists who felt they could not live in a country occupied by the Germans, but who could not muster the moral strength to take an active part in the combat alongside de Gaulle. The Emergency Rescue Committee, the private American program that aided refugees, helped many celebrated artists and writers flee to the United States via Marseille. They were accommodated at the Bel Air Villa while their evacuation was being facilitated. Two hundred artists,

writers, and intellectuals benefited from the program. Many of them were Jewish artists, but not all of them. There were the Surrealists André Breton, Victor Brauner, Max Ernst, Roberto Matta, Jean Arp, André Masson, Marchel Duchamp, but also Marc Chagall, the philosopher Hannah Arendt, and the writer Anna Seghers.

For those who had chosen to stay in Paris, 1941 would be a turning point.

TAKING SIDES

Samuel Beckett started to do more than just convey information he heard on the British radio to Alfred Péron. Jeanine Picabia, daughter of the painter, had formed a cell called Gloria. Beckett agreed that his apartment at 6 rue des Favorites could be used as a drop for information collected by others. Beckett would "collate the information, typing it out and translating it into English as briefly and concisely as possible . . . on one sheet." At a second drop "a member of the group known as 'the Greek' would put the sheet of paper which Beckett had brought onto microfilm for its transfer to the unoccupied zone and from thence to England."[13]

For the young Simone Signoret, choices had to be made. She could no longer bear to work for a Nazi collaborator during the day while spending her evenings with her anti-Nazi friends at the Flore. Eight months after starting her job and emboldened by her time spent at the Flore, Simone decided to leave Les Nouveaux Temps and told her boss that she was going to be an actress. Jean Luchaire laughed at her audacity, and at her youth. She was bluffing, of course. She had not found another job, and she had not discussed it with her mother.

Before leaving, she turned back and looked at Luchaire and with the impudence of youth said to her boss: "You will all get shot for treason after the war." He laughed again and wished her luck. It was spring 1941, and Simone became, as she put it, a full-time "florist." "Florists" arrived in Saint-Germain-des-Prés around noon and had lunch at Chez Rémy, rue des Beaux-Arts, or Chez Chéramy, rue Jacob, where the boss would let customers eat with rationing tickets or on credit. They went back to the Flore around two for an ersatz coffee with saccharine, left again to go for a stroll in the neighborhood between three thirty and five thirty, then returned at

six to meet those they had left at three thirty. They ordered lemonade, just one, and made it last until dinnertime.

Simone would lament how unproductive her day had been, but in fact the Café de Flore was a school of life where she and her friends learned everything. They learned from the "Charlatan," as the Flore's twenty-year-olds used to call Picasso. They learned from the Russian Jewish painter Chaïm Soutine, who asked them to buy his paints for him as he feared that the lady in the shop, whom he had known all his life, might denounce him. They learned from the Swiss-Italian man with curly hair, the anxious-looking and kind Alberto Giacometti. Simone and her friends were even learning from those who were no longer there, those who had suddenly disappeared, such as Sonia Mossé. Disappeared, deported, hiding, or fighting. The great forty-year-old French poet Jacques Prévert was the great absentee, not yet back in Paris, but newcomers like Simone would "learn" Prévert from the others' memories of him. Spending one's days at the Flore was not wasted time. It was a university.[14]

When Jean Paulhan was arrested by the Gestapo on suspicion of resistance activities, his archrival and Gallimard house fascist Drieu La Rochelle managed to have him freed. Others from the Musée de l'Homme cell were less lucky. Agnès Humbert was arrested and taken first to the Cherche-Midi prison and then to the Fresnes prison before being deported to Germany, and its founders, the anthropologists Anatole Lewitsky and Boris Vildé, were executed.

One evening at the end of March 1941, Simone de Beauvoir found a note slipped under the door of her hotel room, in Sartre's handwriting: "I'm at the Café des Trois Mousquetaires." Beauvoir ran into the street toward the café. Sartre had tricked the camp's authorities and had been released under a fake identity. He was changed, he could not stop talking. It was not the kind of romantic reunion she had dreamed of. On learning that Simone had signed an affidavit declaring she was not a Jew, he gave her a stern look. And how could she buy food on the black market? Action was the only word he now cared for. Their friend the philosopher Maurice Merleau-Ponty was also back in Paris. Together, they organized themselves and federated other writers into a resistance group, Socialisme et Liberté. Simone was surprised at Sartre's vehemence. During the summer of 1941, they

cycled together into Vichy France to establish contacts with potential members south of the Occupation line. However, it seemed that the sticking point was the nature of the resistance action the group would carry out. Sartre favored words over bombs. Soon, many of his colleagues wanted to join the more effective and better-organized Communist resistance groups. This was the end of Sartre and Beauvoir as leaders of the Resistance. Sartre went back to teaching at the Lycée Pasteur, and soon after at the Lycée Condorcet. He never signed the affidavit, though. Sartre and Beauvoir went back to their students, to their words, to their complex and diverse relationships, but they were changed forever and they would fight the occupants, only not with guns.

Jean Bruller, better known as Vercors, took a similar approach; his underground publications would soon have as dramatic an impact as bombs. Bruller was known in the late 1920s for his children's books. A pacifist until 1938, Bruller joined the Resistance as soon as the armistice was signed. His job was planning escape routes for British prisoners of war. He took the alias Vercors, the name of a part of the French Alpine foothills near Grenoble, which would come to be associated with the most fearless French résistants.[15]

In the summer of 1941, thirty-nine-year-old Bruller was on a short trip to Paris, walking down the rue du Vieux Colombier, when he bumped into the well-known literary critic André Thérive.[16] Thérive was the opposite, politically, of his younger colleague Bruller. Quick-witted, "sharp as a mongoose,"[17] he was a reactionary but, more important, an anarchist. Too independent and free-spirited to belong to or serve any political group, he was no collaborationist. Thérive had just read a book that had shaken him; he had it with him and wanted to give it to Bruller.

The book in question was Ernst Jünger's *Gardens and Roads*, his diary of his time as captain in the Wehrmacht during the Battle of France. Ernst Jünger, a German nationalist writer who profoundly disliked the Nazi Party, offered a complex image of the German officer. His diary revealed, in essence, a sensitive man, caring and refined, reading Casanova's memoirs, the letters of Erasmus, short stories by Herman Melville, André Gide, and Herodotus while his Wehrmacht unit thrust forward through Belgium and France. Ernst Jünger's book would soon be banned by the German

occupiers, probably for its humanity and underlying criticism of the Nazis. While it was available, though, *Gardens and Roads* proved very popular. His curiosity piqued, Jean Bruller thanked Thérive and later read the book. He was shocked and alarmed by Jünger's sincerity. "Would not the average French reader imagine that the kindly Jünger represented the behavior and intentions of all Germans?"[18]

There was no room for a good German officer, Bruller thought. There was no room for complexity and subtlety; this was war and war had to be fought, Germans defeated, and France liberated. He felt prompted to write a kind of response. In just a few weeks he wrote *Le silence de la mer*, the story of an old French man and his niece obliged to house a German officer in their home during the war. The officer, a former composer, wants nothing more than to strike up a friendly relationship with his French hosts, but they refuse to talk to him. Crushed, defeated by such resounding silence, the officer enrolls to go and fight on the eastern front.

Bruller and his *résistant* friends decided to publish *Le silence de la mer* as a book. "Thus began the most unusual publishing house of the Left Bank, then or ever."[19] The men found a courageous printer whose inconspicuous printing plant just off the boulevard de l'Hôpital in the 13th arrondissement specialized in death notices offered the safest option. Bruller wanted an elegant one-hundred-page book, printed on fine paper. In a time of paper rationing, extreme danger for clandestine work, and general scarcity, it was, in Bruller's eyes, paramount to be as professional as one could possibly be. They called their publishing house Les Éditions de Minuit (Midnight Editions), and Vercors designed the star that would soon symbolize the *résistant* publishers.

Each week, Vercors brought the printer eight pages, which were destroyed as soon as the type was set. He then went to drop the printed pages to a cache on the boulevard Raspail where a friend took them for binding. It took weeks to print and bind the first three hundred and fifty copies. Vercors had a copy passed on to Jean Paulhan at his office at Gallimard in February 1942 and from there it was duplicated and reached London and New York. One morning in London, the book dropped onto the desk of Sonia Brownell at *Horizon* magazine. She read it immediately and passed it on to her boss Cyril Connolly, who translated it as *Put Out the Light* and published it as fast as he could in 1944. In New York, *Life* magazine serialized it. It was so successful in France and

abroad that Les Éditions de Minuit asked other celebrated writers to provide texts to be published. Aragon, Paul Éluard, Jean Guéhenno, and Jean Paulhan all published texts and poems under *noms de résistance*. Each book, four and a half by six and a half inches, had on its second page the words "In France, there are writers who refuse to take orders." Paul Éluard became Les Éditions de Minuit's chief literary adviser, while living in hiding at the antiquarian bookseller Lucien Scheler's shop at 19 rue de Tournon.[20] Les Éditions de Minuit expanded its horizons beyond French writers and published a translation of John Steinbeck's novel about a village in northern Europe occupied by a foreign army, *The Moon Is Down*.[21]

Life for the American citizens who had chosen to stay in Paris even after Germany declared war on the United States in December 1941 was becoming more and more difficult. And dangerous. Sylvia Beach decided to hide all her books and close her bookshop: a German officer had threatened her after she refused to sell him anything. Along with the other Americans in Paris, Beach had to report to her local police station every week. "The Gestapo kept track of me, and they'd come to see me all the time."[22] Sylvia and Adrienne were freezing. Adrienne had installed a woodstove in her bookshop but her flat was glacial, too cold even to read or write. The two women would combine their ration tickets and take it in turn to cook a hot meal for two with only one ration of coal, which they used at midday or dinnertime. Chocolate, sugar, wine, and coffee were available only on the black market, at ten times their prewar prices.[23] Even worse, women were not allowed tobacco rations, unlike men.

On September 24, 1942, three hundred fifty American women, including Sylvia Beach, were rounded up and taken to the zoo in the Jardin d'Acclimatation, in the Bois de Boulogne, and into the now empty monkey house. "We were the only monkeys," Sylvia later commented drily. This strange cohort of women—artists, bourgeois wives, dancers, and spies— were then driven to the northeastern French town of Vittel, in the Lorraine region, where they were kept under house arrest, accommodated in one of the once grand old spa hotels. They lacked freedom, but they were better fed than in Paris. Sylvia bided her time while friends back in Paris did their best to obtain her release.

Tension rose tangibly in Paris after the United States officially entered the war in December 1941. Major General Carl Oberg of the SD (*Sicher-*

heitsdienst, the much-feared Nazi Party's security service) took over Paris. The forty-five-year-old was a true SS, having joined the ranks as early as 1931. He also looked the part: shaved head, rimless steel spectacles, and a long black leather coat over his black uniform. As *Höherer SS und Polizei-führer*, Oberg was taking over from the Wehrmacht the policing of the occupied zone. He had two missions: to send Jews from France to die in Poland and to destroy the French resistance. With the roundup of more than thirteen thousand Parisian Jews (one-third of them children) on July 12, 1942, Oberg became known as the "Butcher of Paris."

A few weeks later, Alfred Péron was arrested. A coded telegram sent straightaway by Péron's wife allowed Samuel Beckett and Suzanne to destroy any incriminating documents and leave Paris at once before other members of the *résistant* cell Gloria were arrested. They first took refuge just outside Paris in Janvry with Nathalie Sarraute, the Jewish Russian-born novelist, also in hiding under a fake identity.

In 1942, every action had a meaning and consequences. In May, Jean Cocteau attended an exhibition of Hitler's favorite artist, the sculptor Arno Breker, at the Orangerie. Picasso did not. Cocteau was not cautious. Neither was the movie star Arletty, madly in love with the German officer Hans Jürgen Soehring, with whom she lived on the seventh floor of the Ritz, next door to Coco Chanel and her own German beau, Hans Günther von Dincklage. On August 24, 1942, *Life* magazine launched the first in a series of American press campaigns against French collaborators, publishing a blacklist of the "Frenchmen condemned by the underground for collaborating with the Germans." It included America's French darling Maurice Chevalier, Arletty, and the playwright Sacha Guitry.[24]

PARIS ON THE HUDSON

In the summer of 1942, Apollinaire's young American translator, the ardent Trotskyite Lionel Abel, had returned from Chicago to New York. The thirty-year-old literary critic for the *Nation* had been in Chicago for a year on the prestigious Writers' Project, and now, back in New York, he dreamed of only one thing: to meet the French Surrealists who had found exile in New York. Before approaching them, though, he went to seek advice from his friend the art history professor Meyer Schapiro. One had to be careful—the Surrealists and their leader André Breton had an aura

akin to Hollywood stars, and Lionel did not want to make a faux pas. At Professor Schapiro's, Abel met the slender and handsome twenty-seven-year-old New York painter Robert Motherwell, who also dreamed of paying a visit to André Breton, who lived nearby, at 265 West Eleventh Street.

Abel already had his foot in the door of Surrealism thanks to another exiled Surrealist from Paris whom he had befriended, the thirty-one-year-old painter Roberto Matta. Matta and his young American wife, Ann, lived on Twelfth Street, between Fifth and Sixth Avenues, in a modest but elegant three-room flat. Matta had managed to bring a few cases of absinthe back from France to share with New York visitors. "This is not anisette, this is the real thing!" he would warn his guests, laughing.[25]

An audience with the pope of Surrealism was arranged for Lionel Abel and Robert Motherwell; the young Americans were not disappointed. "Breton took us both with him to the 18th century. The movements of his hands when he talked were graceful, his voice musical, his diction perfect, and his sentences always in syntax: he never failed to use the subjunctive as required."[26] A few weeks later, Roberto Matta invited both Lionel Abel and Robert Motherwell to a party: Matta had just finished painting a very large canvas and would name it during the evening. Marc Chagall, the Surrealists André Masson, Yves Tanguy, Marcel Duchamp, and Kurt Seligmann, the composer John Cage, the art gallery owner Pierre Matisse (son of the painter), and of course His Surrealist Highness André Breton were there, too.

Now part of the group, Abel was asked by André Breton to help him edit a new Surrealist magazine called *VVV*. They worked on the first issue together but their relationship lasted only a few months. If Breton was a very compelling and fascinating figure, he could also behave like Zeus, hurling bolts of lightning down from his throne. Abel, an upright New York Jewish intellectual, also had some difficulty with the intense promiscuity displayed by the French Surrealists. Somebody was always breaking up, divorcing, stealing another man's wife or another woman's husband, or sleeping with a third party, and all within their circle. The Parisian Surrealists in New York had re-created their sexual *ronde*, just like in Arthur Schnitzler's controversial play *Reigen*, known as *La ronde* or *Hands Around*. Somebody somewhere was always going to fall in love and be heartbroken, repeatedly, with a different person each time but within the group. For instance, Matta broke up with his wife Ann, but she would

accept a divorce only if he fathered her a child. He reluctantly agreed and she went on to have twin boys. Matta left her as soon as his sons were born and immediately married one of his lovers, Patricia Connolly, who was also having an affair with the gallery owner Pierre Matisse. André Breton's wife Jacqueline left him for a young American painter, David Hare, a friend of Robert Motherwell. And so on.

A friend of Abel's, the twenty-four-year-old Chicagoan Harold Kaplan, was also in New York. He had enrolled in the army the month Paris fell into Nazi hands, dreaming of following in the steps of Ernest Hemingway and E. E. Cummings as an ambulance driver. But the U.S. Army had found another use for him, at its little-known Office of Facts and Figures in New York. Young Kaplan's academic knowledge of both French culture and language and his love of Marcel Proust, on whom he wrote his PhD thesis, qualified him to join the radio team in New York whose broadcasts, in French, were aimed at France and French-speaking North Africa. Useful, as General Eisenhower was about to invade North Africa in November 1942. And who better to speak to the French from New York, with his mellifluous baritone voice and commanding tone, than André Breton? Kaplan was as "mesmerized"[27] by the Surrealist as Abel was.

French exiles in New York could find solace from the bleak world events by going to the movies and to the opera in Manhattan. In December 1942, while movie theaters were starting to show *Casablanca*,[28] a film that "makes the spine tingle and the heart take a leap,"[29] according to the *New York Times* critic Bosley Crowther, the Metropolitan Opera was putting on a rather special production[30] of Donizetti's *The Daughter of the Regiment*.[31] Every night, on stage, the French-born soprano Lily Pons waved the French Resistance's Cross of Lorraine instead of the Tricolor and, in a scene that did not belong in Donizetti, sang "La Marseillaise." A few bars into "Allons enfants de la patrie," the young baritone Wilfred Engelman, in the small part of a corporal, would step forward holding high the flag of the United States next to the Free French banner. The New York audience, surprised at first, erupted in wild cheers every night.

TAKING RISKS

In Paris, the mood in cinemas—the ones not exclusively reserved for German officers—was more subdued. However, a film had just been released

on December 3 whose subtext left nobody indifferent. *Les visiteurs du soir*, directed by Marcel Carné and scripted by the poet Jacques Prévert, was set in medieval France in order to pass German censorship, but the allegory with occupied France was striking. The French star Arletty and a new-comer from the stage, the thirty-four-year-old Alain Cuny, played the parts of the devil's envoys, sent as minstrels, to ruin the nuptials of a baron's daughter to a local warlord. While minstrel Arletty seduced the groom, minstrel Cuny lured the bride. But love struck the bride and the minstrel. The enraged devil turned the two lovers into statues. Beneath the stone, however, one could hear their hearts beat, like France under German rule.

Marcel Carné, the most famous French film director at the time, had chosen to stay in Vichy France and to continue to make films. His choice had raised many eyebrows, especially among the French actors and film directors who had fled to Hollywood, including Jean Gabin, Jean-Pierre Aumont, and Jean Renoir. Carné had to abide by all sorts of restrictions and, of course, German censorship. However, he also continually bypassed them. Carné used Arletty, a huge star who attracted crowds and was in a very public relationship with a German officer, as a front, much as the publisher Gallimard used Drieu La Rochelle. Carné needed all the help he could get in case his set designer, Alexandre Trauner, and his music composer, Joseph Kosma, both Jewish and banned from their jobs, were discovered working for him under pseudonyms. Carné and Jacques Prévert did not hesitate to hire aspiring actors spending their days at the Café de Flore, most of whom did not have any legal papers, along with Communists wanted by the Gestapo or *résistants* in hiding. Simone Signoret got a small part that way—a gypsy in *Les visiteurs du soir*.[32]

Les visiteurs du soir drew large crowds and quietly galvanized the French in their third year of Nazi occupation. After the invasion of North Africa by the U.S. Army in November 1942, France was completely occupied, and the mirage of the so-called Free France under Vichy rule had disappeared once and for all.

In fact, Paris was now seething with underground activity.

The CNE, the Comité National des Écrivains, the *résistant* writers' group, had been dissolved after the Gestapo had executed its leader, Jacques Décour, in May 1942. Claude Morgan had been asked to restart

it, and he contacted the thirty-year-old Édith Thomas, who had enjoyed a moment of fame when Gallimard had simultaneously published her first two novels in 1934.[33] By September 1942, Édith was working by day at the National Archives, where she had landed the "absurd" task of compiling long-forgotten documents for future improbable studies that would never see the light of day, while by night she opened her flat to the recomposed Comité National des Écrivains. Every week, French writers arrived two by two, on foot or by bicycle, among them Jean-Paul Sartre, François Mauriac, Paul Éluard, Jean Paulhan, Claude Morgan, and Raymond Queneau. From her window, she watched them approach 15 rue Pierre Nicole in the 5th arrondissement, a very quiet street off the rue Saint-Jacques. Her flat was on the first floor, and luckily there was no concierge, so people could come and go much more discreetly than in other Parisian buildings. For Édith, every one of these meetings proved a miracle: "Those writers were Catholic, atheist, Communist, liberal, Existentialist, and yet they all trusted each other intimately. There never were any traitors among us."[34]

Of the great names of French literature who gathered in her home every week, Édith Thomas had a particular fondness for the poet Paul Éluard. "Serene, gentle, handsome with a medieval face,"[35] a close friend of Pablo Picasso and André Breton, Éluard was a poet whose talent, a little like Picasso's painting, always transcended categorization, fashions, and eras. His twenty-one-quatrain poem "Liberté"[36] had reached London and New York, where it had been published to great acclaim. The Royal Air Force was dropping tens of thousands of copies of it over France during its nightly raids.

It began:

> On my schoolboy's copy-books
> On my desk and the trees
> On the sand on the snow
> I write your name

and ended:

> On the steps of death
> I write your name

On health returned
On danger averted
On hope without memory
I write your name

And by the power of one word
I start again my life
I was born to know you
To name you

Liberty.

Henri Cartier-Bresson, a prisoner of war for almost three years, caught one of those flying "Liberté" poems dropped by the RAF as he crossed the French-German border at night, after his third escape attempt. He walked along the Moselle canal into France, stole civilian clothes, managed to get a train ticket and fake identity papers, and went into hiding for three months in a farm near Loches, twenty-six miles southeast of Tours.

Paul Éluard was one of those *résistants* who was often completely oblivious to danger but who always seemed to have luck on his side. Many others were less fortunate, executed after just one small act of defiance. Others, following in the steps of Gallimard and Marcel Carné, resorted to cultivating ties with collaborationists in order to help their underground activities. Such was the case of the twenty-nine-year-old aspiring writer Marguerite Duras, a civil servant at the Book Committee by day and a conspirator by night. She had found a flat at 5 rue Saint Benoît, right at the corner of the boulevard Saint-Germain at the Café de Flore, where she settled with her husband, Robert Antelme, a civil servant at the Préfecture de Police. One of her neighbors, who lived in the flat two floors above hers, was the pro-Hitler collaborationist Ramon Fernandez. He and his wife held a salon on Sundays where people like Drieu La Rochelle and Gerhard Heller were regular visitors. She sometimes went. However, her flat, with a bed in every room, often all occupied by visiting friends in need of a hiding place, became a hub for Communist *résistants* on the move.

By the spring of 1943 the Allies' attacks on factories all around Paris were gathering pace. On April 4, 1943, more than a hundred American B-17s bombed Paris in daylight for the first time, targeting the Renault

car factory, which was producing tanks and armored vehicles for the Wehrmacht.

Jean-Paul Sartre was working furiously on his second play, *Les mouches* (*The Flies*),[37] while finishing his major philosophy treatise *L'être et le néant*[38] (*Being and Nothingness*). Jean Paulhan had convinced Gallimard to publish the 700-page essay even if the commercial prospects were extremely limited. However, three weeks after it came out in early August, sales took off. Gallimard was intrigued to see so many women buying *L'être et le néant*. It turned out that since the book weighed exactly one kilogram, people were simply using it as a weight, as the usual copper weights had disappeared to be sold on the black market or melted down to make ammunition.[39] *Les mouches* opened at the Théâtre de la Cité.[40] Both in his play and in his philosophical essay, Sartre was developing the idea of *libre-arbitre*, free choice and free will, one's freedom and responsibility. Like Prévert and Carné had in *Les visiteurs du soir*, Sartre had transposed the action to a faraway time and place. He had chosen ancient Greece. Through a reworking of Aeschylus's *Oresteia,* Sartre had managed to talk about occupied France. At the opening of the play, a handsome thirty-year-old, a sort of Gallic Humphrey Bogart, introduced himself to Sartre. His name was Albert Camus. Like Simone de Beauvoir seated a few rows down, Camus could feel the audience gasp when the word *liberté* was uttered on stage. The clandestine Communist-leaning *Les Lettres françaises* saw in *Les mouches* a satire of Vichy and an apologia for freedom, while the theater reviewer for the Berlin newspaper *Das Reich* called the play an incredible affront and "defiance."[41]

A few weeks later, Gallimard finally published Simone de Beauvoir's first novel, *L'invitée* (*She Came to Stay*), with its scandalous story of a love triangle. Set in contemporary occupied Paris, it told the slightly fictionalized, or semiautobiographical, account of Beauvoir's relationship with Sartre and the Kosakiewicz sisters, Olga and Wanda. Causing tremendous gossip, the novel seeded Sartre and Beauvoir's legend.

In September 1943, Picasso asked the Hungarian photographer Brassaï to come and visit him. They had not seen each other for eleven years. Picasso wanted Brassaï, and Brassaï alone, to take pictures of the works he had done under the Occupation. The Nazis might have banned Picasso from exhibiting, publishing, and selling his work, but he was nonetheless thinking

ahead. A timid hope was in the air that fall: the Battle of Stalingrad had stopped the German army once and for all in the east; the Allied armies had won a string of battles in North Africa, had liberated Sicily, and were now advancing in Italy. Mussolini had just surrendered and the RAF was pounding factories, seaports, and major railway yards in France. A ground invasion by the Allies, on either France's Atlantic coast or the Channel beaches, seemed more and more likely. The question was when.

Picasso had changed. He had lost almost all his hair, but his eyes were as ever black diamonds. Picasso's studio, as large as the hold of a ship, with its wooden beams and walkways, contained more than a hundred statues, some of them huge heads of women, once in dazzling white plaster, as Brassaï had seen them before the war, but now cast in bronze. Where on earth had Picasso found bronze in occupied Paris, at a time where the Germans requisitioned every piece of brass to make cannons? "Oh, that, it's a long story," Picasso said, evading the question. Sculpture had been occupying all his days and nights. Transforming his bathroom into a sculpture room, he had made *Man with a Lamb*. Brassaï could go about the studio as he pleased, Picasso told him; he had a hundred fifty sculptures to photograph and no time to lose.

While Brassaï got to work on Picasso's sculptures, beginning with a striking bronze skull looking like a monolith with its eyeless sockets, emaciated cheekbones, and chewed nose—a recurrent theme in Picasso's work during the war—many *résistants* decided to "disappear" for a while, and collaborators to flee—or not.

At Gallimard, Drieu La Rochelle, disenchanted by the ways of the world, had deserted his office and given up on editing the *NRF*, whose last issue had been released in July 1943. Urged by his old friends, and even his new German friends like Gerhard Heller, who offered to supply safe-conducts and visas, to leave the country, Drieu preferred to stay in France, even if the socialist-fascist revolution he had so ardently wished for had not taken place. Drieu had retreated to the solitude of his spacious home on the avenue de Breteuil with its panoramic view over Paris and the Invalides' golden dome under which Napoleon lay. Drieu was now spending his days reading religious texts on Confucianism, Hinduism, and even Judaism. The world of this dandy who had embraced one political fad after another in the first half of the twentieth century, the same way he had col-

lected women, was a far cry from the world inhabited by Paris teenagers, such as sixteen-year-old Juliette Gréco.

The young Juliette was not disenchanted with a fantasy world that was not to be after all; she was in a prison cell in the infamous Fresnes Prison just outside Paris. Arrested in the spring of 1943 with her older sister, Charlotte, Juliette was finally released in the autumn, alone. She did not know yet that her sister and her mother, both active in the Resistance, had been sent to the Ravensbrück concentration camp. Without any money, no home to return to, and wearing just the navy blue cotton dress and straw sandals she'd had on the day she was arrested, she stepped out of the prison into one of the coldest autumns on record. She started walking the eight miles back into Paris and thought hard. She suddenly remembered her mother's friend Hélène Duc, a celebrated theater actress, who lived in a decrepit and discreet boardinghouse at 20 rue Servandoni, near Saint-Sulpice church. Night had fallen and the narrow Servandoni street was plunged in darkness when Juliette knocked at the door. Hélène Duc opened it, looked at Juliette, and understood immediately. After quickly checking to see that nobody else was in the street, she let Gréco in. "I stayed in bed for the next two years," she said later.[42] With nothing to wear, hungry and cold, Juliette Gréco would indeed spend long hours under the covers. Male friends, aspiring actors and art students, gave her some of their clothes. They were far too big, so she rolled them up: shirts, sweaters, jackets, trousers, the lot. In the streets and cafés, heads turned; a new fashion was about to be born.

Unlike Drieu La Rochelle, indulging in suicidal thoughts, Juliette Gréco and her generation were simply trying to survive the war. And like the budding actress Simone Signoret, Juliette, who wanted to become a tragedian, was going from audition to audition to obtain small parts in plays and films. Her drama teacher managed to get work for her as an extra at the Comédie-Française. Juliette was there on November 27, 1943, on the opening night of *Le soulier de satin* (*The Satin Slipper*), an eleven-hour play by Paul Claudel. Gréco was on stage, hidden, like many other extras, under a huge sheet. They had to rise slowly and then dive and rise again, to create the movement of a giant wave. The celebrated actor Jean-Louis Barrault had reduced the play to a five-hour performance, which enthralled the critics. Such a production in occupied Paris was an almost unheard-of endeavor.

Jean-Paul Sartre was frantically working on his next play, so much so

that he finished *Huis clos* (*No Exit*) in just over two weeks. He had written it for Olga's sister, Wanda, another student lover of his, who wanted to become an actress. There were three characters in the play, two women and one man, and the action took place in hell. Sartre asked the handsome young man who had introduced himself to him a few months earlier at the opening of *Les mouches* to direct his new play. Albert Camus had never directed a play before, but as soon as he met the beautiful Wanda he accepted. He did not know that Sartre and Wanda were lovers, but did it matter, after all? Camus decided to do the rehearsals in Wanda's room at the Hôtel Chaplain, 11 bis rue Jules Chaplain, near the Luxembourg Gardens. It was handy, for all kinds of reasons, both practical and amorous.

Sartre had immediately liked Camus and, thanks to him, the social horizon of both Sartre and Beauvoir expanded. They also befriended the older Surrealist writers Michel Leiris and Raymond Queneau, who in turn introduced them to Picasso. In the winter of 1943, Beauvoir and Sartre often joined the group of friends who visited Picasso in his studio every morning. They now lived very close, having moved hotel again after friends from the Café de Flore recommended the Hôtel La Louisiane, 60 rue de Seine. One of the three large, round rooms with a rooftop view was suddenly available. Beauvoir managed to get it, while Sartre settled into a smaller and rather spartan room with no shelves for his books. Beauvoir was enchanted by her new lodgings: "Never had any of my bowers been so close to my dreams. I was thinking of living there until the day I died."[43]

In the morning, Picasso's studio turned into a salon, with Brassaï often hovering in the background, arranging and rearranging paintings and sculptures and checking the light for his photography. The poet Jacques Prévert visited often in October and November 1943. He seemed nervous about the shooting of *Les enfants du paradis* (*Children of Paradise*), which he had scripted for the film director Marcel Carné. *Les enfants du paradis*, set in Paris in 1828, tells the story of Garance and the four men in her life: mime, actor, swindler, and aristocrat. They all love her but she loves only one. Like all true love stories it ends badly. The cast included Arletty in the leading female role and 1,800 extras, among whom were as many collaborationists imposed by Vichy as *résistants* in need of a front. The situation of Joseph Kosma and Alexandre Trauner—both Jewish and working on the film under pseudonyms—was getting more precarious with the ever-growing number of people involved in the production of this

three-hour epic film. They could be denounced at any time, be arrested, and deported to Germany.

In the winter of 1943, hunger and cold hit Parisians harder still. Picasso could not obtain any coal, even on the black market, and Brassaï simply could not get his fingers to operate his camera. While Picasso found himself a secondhand leather jacket lined with lamb's wool at the flea market,[44] Brassaï made himself a hut in his own living room. With temperatures dropping to near zero in early December 1943, Parisian interiors were literally freezing. One morning Brassaï found Alfred, his frog, frozen to death in his tank. "I loved Alfred. His ugliness was almost sublime, like the times we were living." So, in order not to face a similar fate, Brassaï took large photographic reproductions from a past exhibition of his and built himself a little shack in his flat. Inside, he placed an armchair, his typewriter, a small camp stove, a lamp, and a kettle.[45]

Despite the hunger and the cold, Brassaï could see that Picasso was somehow energized by a new presence in his life. And he was not entirely surprised to bump into the young Françoise Gilot one morning. Brassaï knew her. He had met her three years earlier at another painter's studio, that of the Hungarian Jew Endre Rozsda, where her fervent admiration for both painting and painters was obvious. "She made me think of Bettina Brentano, the eighteen-year-old madly in love with Goethe, who lived only for poetry and poets. Bettina had the devil in the flesh."[46] To Brassaï it seemed that it was Françoise Gilot who seduced Picasso as much as Picasso who seduced her. Everything in her fascinated and attracted Picasso: her pouting lips, her Greek nose, the mole on her cheek, her asymmetric green eyes, her arched eyebrows, and her tiny waist. He may still have lunch with Dora Maar, who lived a hundred yards away at 6 rue de Savoie, but it was both the end and the beginning for Picasso. Françoise heralded a new phase in his art. And as the terrible year 1943 drew to a close, Paris and Parisians, too, were waiting for an end and a beginning.

e◦

THE FIGHT

LIVING RECKLESSLY

Early one freezing morning in January 1944, Jacques Jaujard walked over the Pont des Arts toward the Louvre gardens, transformed three and a half years earlier into vegetable plots[1] to feed Parisian schoolchildren, and mulled over the telephone conversation he had had the night before with Quartus.

Quartus was a well-chosen *nom de résistance* for the forty-three-year-old Alexandre Parodi. Just like Quartus, the first-century Athenian martyr, Parodi was a child of the elite, the son of a professor of philosophy and himself a high civil servant. Parodi had immediately rejected the armistice of June 1940 and gathered trusted French civil servants around him. Together they set up the Comité Général d'Études under Jean Moulin, the emblematic figure of the French Resistance. This committee of experts and lawmakers, thinking ahead, were devising the legislation of the future liberated France and of a new French republic. After Moulin was arrested, tortured, and killed by the Gestapo in July 1943, Alexandre Parodi became the head of the clandestine Free French administration in occupied France.

The protection of France's art collections was as dear to Charles de Gaulle and Alexandre Parodi as it was to Jaujard, who had tirelessly fought to save them from Nazi greed. It had not been easy. The most valuable artworks had to be moved from castle to castle and from the cellars of small provincial museums to other secret depots more than once, especially after November 1942 and the invasion of North Africa by the Allied

forces and the subsequent end to the Free Zone in the south of France. Jaujard had managed to send not only hydrometric measuring equipment but also water pumps, fire extinguishers, and electric heaters to every place that stored the most fragile artworks of the national collections. With the agreement of his unlikely ally Count Wolff Metternich, who covered his activities as much as he possibly could, Jaujard had ordered that all the Rubenses, Tintorettos, Delacroix, Titians, Poussins, and the *Mona Lisa* leave the Ingres Museum at Montauban, where they had recently arrived, to be dispatched farther north and divided up among small castles in the Périgord region. The *Mona Lisa* had arrived at the Château de la Treyne, where André Chamson, an archivist-paleographer by training, a novelist by *métier*, and an improvised keeper of France's treasures by force of circumstance, lived with his family.

By now Jacques Jaujard was feeling exhausted and beleaguered. The brutal dismissal of his silent ally Count Wolff Metternich in September 1942 had made his personal mission even more difficult and dangerous. A month before the count's removal, Marshal Pétain had personally authorized a Nazi commando to take from the Pau Museum the priceless polyptych *Adoration of the Mystic Lamb*, a masterpiece of Flemish primitive art that Belgium had entrusted to France for safekeeping during the war. Jaujard and Metternich had immediately protested to their respective hierarchies. Metternich, relieved from his post at once, had been sent on the first train back to Bonn and to his art history teaching, while Pétain's culture minister, the collaborator Abel Bonnard, had told Jaujard on the phone: "I'll make you crawl and one day I'll make you disappear. Do you understand what I am saying?"[2]

Jaujard could, however, rely on the complete loyalty and abnegation of his thousands of employees posted throughout France guarding some of the world's most valuable treasures with their lives, which was the subject of his phone call with Quartus. Allied bombing was going to intensify in the next weeks and months (in preparation for the D-Day landings), and Jaujard and his employees had to clearly mark the different places where paintings and sculpture were hidden so that the Allied bombers could spare them. Quartus did not say more; he said that one of his agents, with the *nom de guerre* Mozart, would soon make contact with Jaujard directly.

A state of general recklessness and audacity permeated those first months of 1944: everyone could feel that momentous events were being

carefully planned but did not know exactly when they would occur, death could strike at any moment, the German occupants were restless and crueler still, everyone lacked essentials, everyone was hungry, cold, and yet hopeful.

One afternoon, Mozart knocked at the door of Jaujard's office. At the sight of the liaison agent, Jaujard froze. Mozart was a forty-year-old platinum blonde, a 1930s movie star named Jeanne Boitel. She asked questions in order to gather information and report back to Quartus and left Jaujard in a daze for the rest of the day. In his diary that night he wrote: "Man has a brain, a heart, a sex and a stomach. They do not necessarily get along well, and the brain is not always the dominant organ."[3] Jaujard was not the only one struck by the encounter—within a few days Jeanne and Jacques were lovers. As *résistants* and as lovers (Jaujard was married and had children), they both led double "double lives." And they were by no means the only ones in Paris.

Albert Camus' plays *Le malentendu* (*The Misunderstanding*) and *Caligula*, about to be published by Gallimard, were doing the rounds of celebrated theater directors in Paris. *L'étranger* (*The Outsider*), published in 1942, closely followed by *Le mythe de Sisyphe* (*The Myth of Sisyphus*), had established Camus, barely thirty, as a rival to the thirty-nine-year-old Jean-Paul Sartre. Marcel Herrand, an actor-director who was currently filming in *Les enfants du paradis*, organized a reading of *Le malentendu* at his home. The twenty-two-year-old actress Maria Casarès, who had one of the supporting roles in *Les enfants du paradis*, was in attendance. A mesmerizing Spanish beauty whose Republican parents had found refuge in France, Casarès already had strings of male admirers. Camus came to the reading alone. His wife, Francine Faure, a concert pianist, lived far away, in the safety of their hometown, Algiers, in North Africa.

During the reading, Camus and Casarès looked at each other from across the room. "Both were foreign conquerors. And she had the charm of a sorceress."[4] There was no courtship. They became lovers a few hours after their encounter and would spend as much time together as they could. At night either she walked to his place, 1 bis rue Vaneau, where he stayed unknown to the police and the Gestapo at the novelist André Gide's empty flat, or he walked to hers, at 148 rue de Vaugirard.

Sonderführer Gerhard Heller, the German censor of French literature, had stopped wearing a military uniform, to his great relief. Now invisible

in the Parisian crowd, he enjoyed walking in Paris at night, to purge himself of his own double "double life." Heller walked for long hours to chase away his rising anxiety and to fight a profound existential malaise. Here was a young man whom the tragic caprices of history had brought to where he had always wanted to be, Paris, living among writers he venerated. Not only was he living among them, he also exerted the ultimate power over their writings. He had, too, the ability to protect them from the Gestapo and, sometimes, from certain death.

Heller never officially met Camus, and had he bumped into him he would not have introduced himself. Somebody else would later tell Camus that Heller had read the manuscript of *The Outsider* in January 1942, starting in the afternoon and not putting it down until four o'clock in the morning, and that a few hours later he had phoned Gaston Gallimard's secretary to approve its publication, granting as much paper as needed and offering to help smooth any difficulties that might arise.[5]

Sometimes his compatriot Ernst Jünger joined him in his aimless wandering. Heller and Jünger were "good German officers" in morally untenable positions. A celebrated novelist, a Francophile opposed to Hitler and yet an army captain in the Wehrmacht, Jünger worked for the chief of military staff, Carl-Heinrich von Stülpnagel. Among his tasks: the translation into German of the farewell letters written by the thousands of civilian hostages executed by the Germans in retaliation for the French Resistance's actions. After such dreary work, Ernst Jünger would set out in the streets of Paris to chase rare editions at the *bouquinistes*, those secondhand booksellers whose stalls line the Seine, and then go and have dinner with Parisian friends such as Jean Cocteau.

In his memoirs, written almost thirty years later, Heller tried to explain the unexplainable.

> It is difficult to understand, and certainly to accept that we lived happily when, right next to us, people were famished, hostages executed, Jewish children sent to concentration camps. I knew all this but I didn't have the power nor enough conviction and courage to resist such atrocities directly. I was simply trying, in my capacity, to protect as best as I could what I believed were France's true values and talents whose existence depended partly on me. I lived in a kind of blessed island, in the middle of an ocean of mud and blood.[6]

During his night walks, Heller also had what he later called "brief encounters." He admitted to two,[7] one with a charming fifteen-year-old gamine he called Reinette whom he met regularly for months until one day in the summer of 1943 she disappeared without a word. A young Frenchman, Jacques, also about fifteen, soon replaced Reinette in Heller's heart. "We looked at each other, and we smiled. I invited him to walk with me." Heller took the working-class teenager, who had a job as a delivery boy, to the opera on Christmas Day 1943. They attended a performance of Richard Wagner's *The Flying Dutchman*. Their hand holding and kissing were Gerhard's secret life. During the day, though, he sat in his office at the German Institute, 57 rue Saint-Dominique, with his secretary and German fiancée, Marie-Louise, who was typing his correspondence and reports in the little room next door.

Like Camus, Sartre would later learn that his play *The Flies* had been able to run in Paris thanks only to Heller's intervention. When his colleagues from the *Propagandastaffel* pointed to the controversial nature and rebellious spirit of Sartre's play, Heller wrote a report to reassure them that it had "nothing to do with the Resistance but was a play about ancient Greece," nothing more. However, neither Heller nor clandestine *résistant* newspapers and the collaborationist press were fooled: Sartre's play was heard as a call for insurrection.

Heller increasingly spent time walking up and down the rue des Arènes in the 5th arrondissement where Gallimard publisher and in-house *résistant* Jean Paulhan, a man he deeply admired, lived at number 5. Jean Paulhan's house was a very distinctive and striking neo-Gothic building on one of the oldest streets in Paris, winding around the Roman arena, les Arènes de Lutèce. Paulhan's front door stood directly opposite a discreet portal into the arena and its gardens and could offer both the perfect escape route for a *résistant* and an efficient observation post for the Gestapo. Heller had strong suspicions that his leather-clad colleagues might arrest Paulhan. Heller would walk down the rue des Arènes most mornings and evenings to check that there was no agent from the *Sicherheitsdienst* waiting to ambush his friend. Like Paul Éluard, in hiding with other *résistants* in the psychiatric asylum of Saint Alban, 350 miles south of Paris, Jean Paulhan would soon need to go to a safe place. Too many people knew of his clandestine activities.

HIDING, DISAPPEARING, AND FLEEING

Samuel Beckett and his partner Suzanne had spent the last eighteen months at the Hôtel Escoffier in Roussillon-en-Provence, a little Provençal village where Madame Escoffier was catering for a full house of refugees. Beckett had quickly found work as a farm laborer and handyman. It paid for their hotel and food bill. In this forced retreat, and rather boring and uncomfortable life, Samuel Beckett had at last found his voice. He had written *Watt*, "a book which broke a silence." And "for the first time, Beckett achieved his characteristic style, a syntax full of reservations and uncertainties, denials and admissions that something else might be the case, with a superb use of the comma."[8] His only link to the events that were shaking the world was the radio in Madame Escoffier's kitchen. The whole village would drop by to listen to the news from London.

In the spring of 1944, the tide of history was clearly starting to turn, and collaborationist writers flocked to the German Institute and Heller's office in the rue Saint-Dominique. They needed *ausweise* and visas. Louis-Ferdinand Céline, a virulent anti-Semite and a literary genius, a radical pessimist as he called himself, or simply a nihilist, knew he would need to flee but when he visited Heller, he said loudly, for everyone to hear: "Heller, you're an agent of Gallimard and the private secretary of the *résistant* Jean Paulhan. Everybody in Paris knows that!"[9] This did not make Heller's life any easier with his stern colleagues from the SD (*Sicherheitsdienst*, the much-feared Nazi Party's security service).

Jean Paulhan often wrote Heller small notes and letters asking him to intervene and free people from detention, or allow captives to slip through the net. Heller complied and braved more than once his fear of the SD, and argued with them. Why make unnecessary martyrs? Heller asked them. The SD usually let go of Heller's French friends, but not always.

Albert Camus was rehearsing Sartre's latest play, *Huis clos* (*No Exit*), which he had agreed not only to direct but also to star in, alongside Wanda Kosakiewicz. It was an important play that would have a formidable impact—Camus was certain of this. However, when Olga Barbezat (née Kechelievitch), the other actress in the cast, was arrested on February 10, Camus refused to go on with the rehearsals. There were considerations for

Camus outside of solidarity: he did not feel he was good enough to act or direct. Besides, he was no longer in love with Wanda, and Maria Casarès now occupied all his thoughts (and nights). Sartre accepted Camus' resignation gracefully and moved forward swiftly. He gave his play to the director of the Théâtre du Vieux Colombier, Raymond Rouleau, who read it immediately. A couple of hours later, the play's rehearsal was scheduled to resume the next morning, this time with a professional cast and *metteur-en-scène*; rehearsals did not take place in an actress's hotel room anymore but in the more serious atmosphere of a real theater.

The Allied bombing of the city's outskirts and industrial quarters was intensifying. The Germans were arresting people in broad daylight, not only at night, as they had been. On March 8, Hélène Berr was stopped and picked up by the SD as she walked home to the rue de Grenelle, in the 7th arrondissement. The twenty-two-year-old Jewish woman, a student of English literature, had started writing a diary after meeting Paul Valéry two years earlier. She was taken to the transit internment camp of Drancy, along with her parents. On March 27, her twenty-third birthday, they were put on the train to Auschwitz.[10] The same day, Nathalie Sorokine, the tall Russian beauty who was a student and occasional lover of Simone de Beauvoir, came rushing back to La Louisiane, where she stayed in a room just below Beauvoir's. Her Jewish boyfriend, Jean-Pierre Bourla, a former student of Sartre's, had just been arrested, along with his father and sister, and taken to Drancy. Sonia Mossé[11] had also disappeared from the Café de Flore, where she was a regular. Her friends learned of her fate only months later.

The first few months of 1944 were a time of frantic somnambulism. "Everybody was going about their day like sleepwalkers, carrying their fate over their shoulder like a sling bag, toothbrush and soap in one's pocket, just in case of an arrest. We all lived in transit, between two round-ups, two hostage-takings, and two misunderstandings."[12]

This aspect of the Occupation is essential to understanding the spirit of those years, and how it marked and shaped the generations who lived through it. The concept of enemy is real and absolutely clear only when separated from us by "a barrier of fire," as Sartre wrote. And this was mostly the experience of American and British soldiers. In Paris there was also an enemy, one of the vilest nature, but it was faceless. It was not the German officer who offered his seat on the métro to women and elderly

people, it was not the lost German soldier who politely asked his way, it was not the simple German soldiers who had become part of the furniture. Those who actually saw the face of that enemy rarely came back to tell the tale. Sartre compared this faceless enemy to an octopus, which would take away the country's best men at night and made them disappear, as if guzzled up by an invisible monster. "It seemed that every day around us, people were silently swallowed from beneath the earth."[13] One day you would call a friend and his phone would ring and ring and ring in his empty flat; you would knock at a door but nobody would come to open it. "If the concierge forced the door open, you would find two chairs, close together, in the entrance hall, with German cigarette butts scattered on the floor."[14] Wives and mothers would seek some news at the SD's torture chambers on the avenue Hoche, where they would be courteously received; but at night, on that same avenue, screams of terror and pain would be heard from the cellars' air vents giving onto the sidewalks. Everybody in Paris had a friend or a relative who had been arrested, deported, or killed. Yet nobody talked about it much, out of dignity or caution. People would say: "They took him away."

The photographer Brassaï had also vanished and temporarily abandoned his work at Picasso's studio. He, too, had had to flee his home and stay with friends, with fake identity papers he had obtained through acquaintances. As a former officer in the Austro-Hungarian army, he had received a mobilization order. A foreigner and a deserter in Paris in 1944 could never be too cautious. He had found a warm shelter from the absurdity of life at La Grande Chaumière[15] and had been going there almost every day since Christmas. Since its opening in 1904, this art school offered free drawing and sketching sessions with live models in heated rooms. Who could ask for anything more in Paris in 1944?

When Brassaï knocked again at 7 rue des Grands Augustins, on Tuesday, April 27, Picasso himself opened the door, half awake, unshaven, and still in his slippers. Just before Brassaï's arrival, the sprightly Jean Marais had woken Pablo up, arriving with his dog, a broomstick, and an urgent request: "Can you make a sumptuous scepter out of this stick?" Marais was rehearsing the part of Pyrrhus in Racine's *Andromaque* at the Théâtre Édouard VII. He had planned to appear on stage almost naked, with just a leopard skin around his waist and a scepter to show his rank. "I need it to be truly barbarous and spectacular, and I need it for tomorrow. Is this

possible, Pablo?" Picasso was still contemplating the broomstick when Françoise Gilot, now officially introduced to his friends as his new love, the actor Alain Cuny, and Jean Cocteau arrived together.

Cocteau and Picasso had known each other for twenty-eight years. Cocteau had been coming to see him more often lately. The old friends frequently had lunch at Le Catalan; they were a constant source of inspiration to each other. They also bickered. Picasso complained that "Cocteau was always trying to imitate me," while Cocteau often pointed out that "Picasso was trying his hand at metaphysics, but knew nothing about it."[16] However, Cocteau understood that, like him and their friend Apollinaire, Picasso, too, was a poet—but one who, unlike Cocteau, had not compromised himself during the war.

Cocteau had a great weakness and a great strength: he refused to take the war seriously, at least in public. He smoked opium on perhaps too regular a basis and often seemed oblivious. He continued going to openings and high-society events without any concern as to where the invitation came from or from whom, Otto Abetz, Gerhard Heller, or the *résistant* Jean Paulhan. To him it was irrelevant. He metaphorically and literally lived in a bubble, on the first floor of 36 rue Montpensier, giving onto the Palais Royal gardens with their arcades and candelabra dating back to Cardinal Richelieu.

The collaborationist press hated Cocteau for his homosexuality, and he had been beaten up more than once by young collaborator thugs as he walked down the streets. His lover Jean Marais had even slapped the face of Alain Laubreaux, the theater reviewer of the pro-Nazi weekly newspaper *Je Suis Partout*, who had trashed Cocteau's play *La machine à écrire* (*The Typewriter*) without even seeing it. This was brave of Marais: Laubreaux had powerful connections with the Gestapo.

That Tuesday, April 27, 1944, the fifty-five-year-old Cocteau looked as slender and young as ever, without a silver thread in his hair. He was gearing up to direct a film, which the eccentric genius Christian Bérard would design and in which Marais would take the lead role. He was thinking of calling it *La belle et la bête* (*Beauty and the Beast*). Picasso liked the sound of it. After the morning visitors had gone, Brassaï could go back to photographing Picasso's war production, a seemingly endless task.

Gerhard Heller was right to fear for his friend Jean Paulhan's safety.

Serving as a private sentinel, posted at the little entrance of the Roman arena just opposite his front door, he was now also able to keep an eye on a nearby building at 7 rue de Navarre, where the writer Jean Blanzat was hiding the high priest of French letters François Mauriac. In fact, with his panoramic view Heller was guarding three *résistant* French writers at once. On May 6, a letter of denunciation accusing Jean Paulhan of being Jewish proved enough for the SD to act. Alerted in time by Heller, Paulhan fled over the rooftops.[17]

Three weeks exactly after Paulhan escaped torture and deportation to Germany, Sartre's *Huis clos* opened at the Théâtre du Vieux Colombier. Set in hell—that is to say, in a hotel room—two women and a man discover the bitter experience of being judged by others. Sartre's most famous play intended to show that our acts in life define who we are and how others look at us. The three characters expected hell to be a torture chamber, but they soon realize that they are each other's hell. The older woman is attracted to the younger woman, who in turn is attracted to the young man, who is in no mood, at first, for seduction games. In real life, the young Russian-born actor Michel Vitold was Simone de Beauvoir's lover and the young actress Gaby Sylvia the theater director's wife.

"We never were freer than during the German occupation," Sartre wrote a few months later. "Since the Nazi venom was poisoning our very own thinking, every free thought was a victory. The circumstances, often atrocious, of our fight allowed us to live openly this torn and unbearable situation one calls the Human Condition."[18]

PARIS WHEN IT SIZZLES

In the early hours of June 6, 1944, Albert Camus and Maria were braving the midnight curfew, cycling downhill somewhat drunkenly after leaving the flat of the celebrated theater director Charles Dullin in Pigalle, where there had been another fiesta. "Fiesta" was the term coined in the spring of that year by Sartre, Beauvoir, Camus, and a cohort of their friends who now partied all night in the face of the occupants. They could not stand it anymore; something had to give. With Albert on the saddle and Maria on the handlebar, the pair were whizzing through the place de la Concorde in darkness while a 150,000-strong Allied force, led by American,

British, and Canadian soldiers, was about to land on the beaches of Normandy. Operation Overlord was under way, the largest air, land, and sea operation ever undertaken. On the boats, young men, most of them still teenagers, carried eighty pounds of equipment on their backs. The majority had never seen Europe's shores. As the boats approached the beaches, some prayed, others gritted their teeth, but all had learned by heart what was expected of them: as soon as the boat ramps go down, jump, swim, run, and crawl in the sand, up to the cliffs two hundred yards in front of you. Until they reached the relative safety of the cliffs, they had no protection but God's. Hell was upon them—a different kind of hell from the one that Parisians had known for four years.

On the same day, Henri Cartier-Bresson, discreetly back in Paris after escaping his prisoner of war camp in Germany a year earlier, had an appointment with Georges Braque. The Alsatian publisher Pierre Braun was starting a series of small monographs on great artists and wanted their portraits taken in the intimacy of their studio. Cartier-Bresson was overjoyed. A few months earlier he had met Matisse in his Vence studio, near Cannes, and had captured the painter "cutting through light," working hard on a new thing, collages and découpages, paper cutouts, in other words "painting with scissors."

Now it was time to shoot Georges Braque, the father of Cubism. Cartier-Bresson arrived around noon at the painter's studio in the Montsouris area, south of Montparnasse, at 6 rue du Douanier-Rousseau.[19] The two men were chatting away, the radio purring in the background, when they suddenly both stopped midsentence. Cartier-Bresson would always remember Braque's expression at the very instant he realized what he had just heard on the BBC, the default setting of most wireless devices in Paris at the time. The Allies had landed. After a long pause the sixty-two-year-old painter slowly walked to a bookcase from which, according to the historian Pierre Assouline, he pulled a book given to him by Jean Paulhan and handed it to Cartier-Bresson without a word: *Zen in the Art of Archery* by the German philosopher Eugen Herrigel.[20]

A week later, when *Le malentendu*, Camus' second play, opened at the Théâtre des Mathurins with Maria Casarès in the leading role, Parisians did not know much about the Allies' progress on the ground. In Picasso's studio, Brassaï couldn't focus on his photography, and morning visitors were too elated to talk about anything else, but information was scarce, especially

with the Germans jamming the BBC radio frequencies. The only certainty was that the towns of Bayeux, Isigny, and Carentan had been liberated and that the Allies' armies and aviation were firmly holding their ground against the Wehrmacht and the Luftwaffe. Parisians had even stopped talking about food shortages and power cuts, even though the situation on that front had suddenly become much worse since Paris's supply lines had been cut by the Allied landings.

Parisians were now starving and in greater danger than at any time during the Occupation. The archivist-*résistante* Édith Thomas had stopped receiving the writers from the Comité National des Écrivains in her flat— too many had been arrested. One morning in the first days of July she looked inside her kitchen cupboard and smiled: she had "enough dry noodles and white beans to withstand a long siege."[21] Parisians mostly fed on optimism and hope, though. They had begun flocking to the bird stalls along the banks of the Seine to buy millet and hemp seeds. The birds had almost all been eaten and did not need it anymore.

A week later, near the métro exit of Réaumur-Sébastopol, the German police rounded up Albert Camus and Maria Casarès. Men were body-searched while women were only asked to show their papers. Camus had the proofs of the clandestine newspaper *Combat* in his briefcase. He managed to give them to Casarès just before being searched. They were allowed to go, but it was time to leave Paris and lie low. Camus immediately cycled to Verdelot, a five-and-a-half-hour ride sixty miles east of Paris, and found shelter at a friend's cottage, where he gorged on his favorite food, Maizena cornstarch.

Then came Bastille Day, July 14. Patrolling the city or guarding Nazi offices, German soldiers were on edge, their hands firmly holding their rifles but their fingers increasingly febrile around the trigger. They looked mean. In fact, they were frightened. Parisians had decorated their city in their own particular way, as if a silent rallying cry had spread through the city. On the boulevard Saint-Michel, at the crossroads with the rue Soufflot, on a balcony, someone had hung clothes to dry: a navy blue overall, a bright white tablecloth, and a bloodred scarf, all blowing and floating in the air.[22] In the bright summer morning light, the vision was startling. Nearby, a florist had only blue delphiniums, white lilies, and red roses to sell. Women had dressed in the same way, wearing only the three national colors, and in workmen's upper pockets, three pencils, blue, white, and red, were often seen sticking

out. For the first time in four years, Parisians started looking at each other again, searching, seeking a sense of fraternity.

Despite being assured by Roosevelt and Churchill that his provisional government would be France's next, Charles de Gaulle had been given no guarantee that Allied armies would help liberate Paris. In pure military and strategic terms, de Gaulle knew that Paris was not a priority, even if politically there was no greater stake, even for the Allies. He could not be too sure of Supreme Allied Commander Eisenhower's plans and even less of Roosevelt's.

He and the French Resistance were planning ahead, making contingency arrangements in case they received no military help from the Allies. Field hospitals and first aid stations were organized by arrondissement, mobile units made up of doctors, nurses, and stretcher bearers were given supplies so they could operate independently. To think that the Forces Françaises Intérieures[23] (FFI) and the Free French army, most notably Leclerc's 2nd Armored Division and its 14,500 men, could defeat the Wehrmacht alone was to believe in miracles and in one's own destiny. De Gaulle believed in both.

But the Germans intended to leave with a bang, a big bang. Hitler wanted Paris destroyed, Paris in ruins. General Dietrich von Choltitz, whom Hitler had personally named commander of Gross-Paris on August 7, had instructed army engineers to set demolition charges throughout the city. Tons of dynamite were laid under every one of Paris's forty-five bridges, its power station and water-pumping plant, and its most famous monuments. The Eiffel Tower, the Louvre, the Arc de Triomphe, the Élysées Palace, the Opéra, the Hôpital des Invalides with Napoleon's tomb, the Palais du Luxembourg, and the French Senate were all marked for destruction.[24]

That week, Gallimard's house fascist, Drieu La Rochelle, bumping into a friend on the avenue de Breteuil, near the Invalides, said: "I've made my decision, I'm leaving." A few hours later he was attempting suicide. Gerhard Heller leaped on his bicycle, arrived at his bedside, and whispered in Drieu's ear: "I'm slipping a passport for you under your pillow." The passport had a visa for Spain and Switzerland. But Drieu was fixed on a one-way journey to hell. That night, Gerhard Heller packed his Paris diaries of the last four years, together with a manuscript entrusted to him by Ernst Jünger titled "Peace." He put the documents in a small tin suitcase and set off toward the Invalides, a small shovel in his hand. The air was muggy;

Heller could feel the sweat pearling down his brow. He spotted a tree on the esplanade, looked at the distance and angle between the rue de Constantine, rue Saint-Dominique, and rue de Talleyrand, made a mental note, counted his steps, and started digging discreetly. He felt the urge to—literally—bury his Paris life in order to save himself.

"WHAT IS AN INSURRECTION? IT IS THE PEOPLE IN ARMS"

Wednesday, August 16, 1944, heralded a week of momentous change, a week of danger and of fraternity, one that would leave its mark on generations. That Wednesday, the journalists and editors of the pro-German publications *Pariser Zeitung, Je Suis Partout*, and *Le Pilori* had vanished during the night. Resistance publications had immediately moved into their now empty offices.[25] Radio Paris, the notorious pro-German radio station, had also disappeared. The insurrection had already started on the airwaves.

Later in the day the different branches of the French Resistance met. Allied forces were not on their way to the capital and the communist leaning FFI (Forces Françaises Intérieures) had not agreed on when to start the insurrection. For the Gaullists, Charles de Gaulle's followers, it was imperative to remain cool-headed and not to risk thousands of civilian casualties and the complete destruction of their capital city. They wanted to wait long enough to give the Free French army the chance to arrive on time and drive away the German occupants.

Supervising operations from the catacombs below the place Denfert-Rochereau, a stone's throw from Montparnasse, Resistance commanders, mostly in their early twenties, were restless. Alexandre Parodi, de Gaulle's right-hand man in Paris, managed to persuade them to wait for at least twenty-four hours. In many different parts of Paris a general strike was starting to bear fruit, enabling thousands of civil servants from the Hôtel de Ville—the town hall—and various administrations to join the ranks of the underground fighters and get their hands on weapons.

On Friday, August 18, Parisians woke up to see Resistance posters with the crossed French flags pasted on every wall. It was a general mobilization order for all former officers and officer cadets, calling on "all able-bodied men and women to join the ranks" and "strike the Germans and Vichy's traitors wherever they could be found." The French Resistance was presenting

itself as France's one and only legitimate army with de Gaulle at its head. The Gaullists were trying to proceed in an orderly manner and gather as many young men with military training and knowledge of firearms as possible before risking the lives of Paris's civilians. They had managed to rein in the Communists for yet another day.

The uprising began on Saturday, August 19, at dawn. Around two thousand armed men had locked themselves in at the Préfecture opposite Notre Dame and started shooting at German soldiers and tanks. Almost on cue the people of Paris, resorting to an old tradition, started building barricades. Cobblestones, trees, old bicycles, odd pieces of furniture—everything and anything was used throughout the city. The insurrectionists' mission was to stop German armored vehicles at all costs. The FFI started occupying key buildings such as Paris's various arrondissement town halls, ministries, printing works, and newspaper offices. Free French forces and the Paris police were working hand in hand. For Parisians this was a most welcome but also rather unsettling vision: the Paris police, who had been under German orders for four years, had been responsible for rounding up thirteen thousand French Jews in July 1942, who were eventually deported to concentration camps in Germany.

The confusion and panic of the twenty-thousand-strong German force was palpable. German snipers posted on rooftops were taking aim at civilians. Bullets whistled and flew over Parisians' heads—often fatally. Seventy-five years later, the bullet holes are still there on the buildings.

Pablo Picasso heard a bullet miss him by just a few inches. Fearing for the safety of his nine-year-old daughter, Maya, and her mother, Marie-Thérèse Walter, he left his studio at once. He ran, squatted, took shelter behind trees and in doorways, and looked up at the roofs of the buildings before crossing every street. He finally arrived at 1 boulevard Henri IV, at Marie-Thérèse and Maya's. He would stay with them and paint. He had taken with him a print of Nicolas Poussin's *The Triumph of Pan*.

On Sunday, August 20, French, American, and British flags could be seen everywhere, but the situation was still critical. Half of Paris was now in the Resistance's hands, but for how long Parisians would be able to hold their position against German tanks remained uncertain. In the morning, at Allied headquarters in Cherbourg, Charles de Gaulle confronted Eisenhower, who finally had to admit that he had no intention of sending his troops to Paris—it was not a strategic priority for the Allies. Charles de

Gaulle threatened to order General Leclerc, commander of the French 2nd Armored Division (known as the 2nd DB) of the Allied forces, to begin his division's descent on Paris at once. Positioned in Normandy, 130 miles from Paris, General Leclerc had no intention of waiting for the American High Command's permission and, ready to risk a court martial, he immediately sent a small advance party to reconnoiter.

Embedded with the 2nd DB was the *New Yorker*'s A. J. Liebling, still as unfit but as sharp an observer as ever. There was no other place the American reporter wanted to be. From the beginning, Liebling had viewed the Second World War almost exclusively as "a campaign to free France. It was the world of France that Liebling wanted fiercely to restore."[26] For this, he could not have been on a better tank than General Leclerc's, but time was pressing. How long would it take Leclerc to reach the gates of Paris?

On Monday, August 21, Parisians picked up the first editions of Resistance newspapers printed in a single-sheet format. *Combat, Libération, Le Front National, L'Humanité, Le Populaire,* and *Le Parisien Libéré* had emerged from clandestine printing factories and were sold by fearless young street vendors. The different editorials exhorted Parisians to "hold the siege and keep attacking the enemy in every possible way." The words of *Combat*'s editorial signed by Albert Camus particularly struck readers: "What is an insurrection? It is the people in arms. What is the people? It is those within a Nation who will never kneel."[27] Back in Paris, and now the editor of *Combat*, Camus was sleeping and writing in his tiny office at 100 rue Réaumur.

On Tuesday, August 22, A. J. Liebling arrived in Montlhéry, a village twenty miles southwest of Paris, with the U.S. 4th Infantry Division and Leclerc's "2nd DayBay," as he called it. A few hours earlier, Eisenhower and General Bradley, the American field commander, had ordered the U.S. 4th Infantry Division to help Leclerc liberate Paris. Liebling was staring up at the medieval tower of Montlhéry when he heard an American voice say "Good morning!" It was a Signal Corps lieutenant from the East Coast. "Come over here!" The young lieutenant handed a pair of binoculars to the *New Yorker* reporter. Paris was there, in the same place he had left it four years, two months, and fifteen days before.

For the photographer and escaped prisoner Henri Cartier-Bresson, now was the time to document the insurrection and show it to the world, time to leave the farm in the Loire-et-Cher region where he had been

hiding since his encounter with Georges Braque on D-Day. He carefully packed his Leica and took as many rolls of film as he could, along with a shirt or two, and hopped on his bicycle. Using only little country lanes, he reached Paris at night after a nine-and-a-half-hour ride, a 110-mile journey.

On the morning of Wednesday, August 23, after a few hours of sleep on a friend's sofa, Cartier-Bresson set off to the Resistance's photographers' pool on the rue de Richelieu, next to the French National Library. Robert Doisneau, four years his junior, was there too, with his Rolleiflex. Each of the twenty photographers was given a few *quartiers* to cover. Cartier-Bresson was in charge of Saint-Germain-des-Prés, Ménilmontant, and Batignolles.[28]

Cartier-Bresson left immediately with a group of young FFI toward Sacha Guitry's grand home near the Eiffel Tower. The playwright, known for being overtly friendly with the Nazi occupants, kept his cool when he saw the young *résistants* bursting into his imposing and beautiful mansion. Guitry naively thought that his popularity would protect him, but the FFI's rifles and guns were still warm from firing at German snipers. Collaborators like Sacha Guitry were as important to the Resistance as the German occupants. They were the symbols of French ambiguity and immorality, and deserved to be judged and sentenced accordingly. The young FFI wanted to take Guitry for interrogation to the 7th arrondissement town hall, 116 rue de Grenelle, and no, they would not give him time to dress. Henri Cartier-Bresson immortalized the moment when Guitry, in his yellow-flowered pajamas, jade-green crocodile pumps, and Panama hat, was escorted through the streets. It looked like a parade, one that was meant to awe Parisians and shame the playwright, and it lasted the twenty-five minutes it took them to reach the town hall. The interrogation started in room 117. "Why did you have dinner with Hermann Göring?" asked a young FFI. "Out of curiosity," replied Sacha Guitry. Wrong answer.

While Guitry was transferred to Fresnes Prison, General von Choltitz was taking a phone call from Berlin at the Hôtel Meurice. Holding the receiver as far away from his ear as he possibly could, he heard the voice distinctively enough. It was screaming. It was Adolf Hitler. The Führer was furious and ordering him to blow up Paris's bridges and burn the city to the ground. Von Choltitz knew about destroying cities; he had supervised the ruthless destruction of Rotterdam in May 1940. This time, however, he knew the situation was hopeless and that saving Paris would later play in his favor.[29]

Loosely affiliated with the U.S. 4th Infantry Division, Ernest Hemingway was twenty miles south of Paris with his own little liberating army. He called it the "Hem division." Made up of regular and less regular French and American fighters, the group consisted of sixteen men traveling in a convoy of four jeeps. Hemingway, on an assignment for *Collier's* magazine, had collected his very own band of brothers on the road from Brittany. When they reached the top of a hill and had a good, clear view, Hemingway asked the driver to stop the jeep. He grabbed a pair of binoculars and adjusted the focus. He scanned the horizon, then stopped moving. "I had a funny choke in my throat and I had to clean my glasses because there now, below us, gray and always beautiful, was the city I loved best in all the world."[30]

"THIS IS THE DAY THE WAR SHOULD END"

The U.S. 4th Infantry Division let Leclerc enter Paris first. A small vanguard of Leclerc's tanks reached the square of the Hôtel de Ville at 9:20 p.m. on August 24, 1944. The Radiodiffusion de la Nation Française, which had radio operators nearby, called on the priests of Paris to ring all the church bells. At 11:22 p.m. the 258-year-old lowest-pitch bourdon of Notre Dame Cathedral, the thirteen-ton bell known as Emmanuel, Notre Dame's largest, rang out in F sharp so loudly that it could be heard at least five miles away.[31] Every church in Paris relayed the news to Parisians.

The writer and art critic Léon Werth, to whom Saint-Exupéry dedicated his children's novel *Le petit prince*, recalled the moment in his diary: "I did not know that History existed. I did not believe in History. And suddenly, History was hitting me in the face."[32] The thirty-year-old Gaullist and *résistant* Yves Cazaux noted: "The incredibly grave sounds belching out from Notre Dame stunned us. With Notre Dame's bells rose a more profound voice, which seemed to be saying 'reflect, pay your respects, the moment is superb but it is also terrible.'"[33]

Then came Friday, August 25. At dawn, the young composer Maurice Jarre, then nineteen, suddenly woke up in the two-room flat he shared with his aunt on the avenue d'Orléans, the large artery linking the south gate of Paris to Notre Dame. He could feel tremors. The whole building was shaking. "We thought it was the German Armoured Division sent by Hitler to help von Choltitz squash the Paris insurrection. We thought we

were finished. We were petrified. The roaring sound became greater and greater. I opened the window and crawled onto the balcony. I looked. When I realized what it was, it took my breath away. Leclerc's 2nd Armored Division was entering Paris. There were no words to describe what we felt at that instant in time."

Jean-Paul Sartre, leaving his room at the Hôtel La Louisiane on the rue de Seine in haste, ran toward the boulevard Saint-Michel. The philosopher was one among hundreds of thousands of Parisians now crowding the pavements to get a glimpse of their liberators. The Free French and the Spanish Republicans enlisted with Leclerc's 2nd DB started pouring into the boulevards, coming from the south gate of Paris. American, British, and Canadian soldiers from the U.S. 4th Infantry Division were entering the city from the east gate of Paris, from the Porte d'Italie to the northeast. Sartre watched Leclerc's Free French on their tanks rolling down toward the Seine: "They looked, screamed, smiled. They waved at us with their fingers forming the V of Victory and we could all feel our hearts beating as one. There were no civilians, there were no soldiers, there was one free people."[34]

It was the details that moved people most. Every tank of Leclerc's 2nd DB bore the name of a Paris street, a *quartier*, or a Napoleonic victory such as Austerlitz, Jena, or Wagram. One tank, baptized simply PARIS, had a live snow-white rabbit proudly resting next to the driver's hatch and enjoying the attention. On another was a portrait of Hitler with the word *merde* written across it. Another had a banner reading DEATH TO THE ARSEHOLES![35] As for the Spanish Republicans, they had named their tank GUERNICA.

While a convoy of Paris firemen climbed up on top of the Eiffel Tower and the Arc de Triomphe to raise the French flag, von Choltitz was still at the Hôtel Meurice, negotiating the terms of his surrender with the French Resistance commanders. Escorted to the Police Préfecture and then to Leclerc's headquarters, set up at Montparnasse train station, von Choltitz signed his surrender at 4:15 p.m., along with more than twenty cease-fire orders. Paris was still fighting the hard core of SS units who had sworn to kill German "traitors" such as von Choltitz and continue the carnage among civilians.[36] Charles de Gaulle arrived fifteen minutes later. On seeing the signature of the Communist Rol-Tanguy, head of the FFI, next to that of von Choltitz and Leclerc on the official rendition paper, de Gaulle gave Leclerc a stern look. The Communists seemed to be stealing the show.

Ernest Hemingway and his Hem division had arrived, too, driving straight from the Porte d'Orléans to the rue de l'Odéon. Stopping at number 12, facing number 7, he yelled "Sylvia! Adrienne!" Sylvia was the first to respond. "I flew downstairs; we met with a crash; he picked me up and swung me around and kissed me while people in the street and in the windows cheered."[37] Adrienne watched the scene from above. "I saw little Sylvia down below, leaping into and lifted up by two Michelangelesque arms, her legs beating the air. Ah, yes, it was Hemingway, more a giant than ever, a caveman with a shrewd and studious look." "What can I do for you ladies?" asked Hemingway. Could he and his men go and check the rooftops, please? There had been rumors of hidden German snipers nearby; Sylvia and Adrienne had heard shots and saw from their windows passersby shot like rabbits. The Hem division hurried up, guns in hand, and came back twenty minutes later. "All clear, ladies." "A drink?" replied Sylvia,[38] but when she turned her head toward the door the American novelist had vanished. She leaned over the window; he was jumping into his jeep, waving good-bye. "Au revoir!" On his way to the Hôtel Scribe, where war reporters embedded with Leclerc's 2nd DB and the U.S. 4th Infantry Division were all meeting, the Hem division stopped once more, this time in front of 7 rue des Grands Augustins. Picasso was not in—he was still with Maya and Marie-Thérèse. The concierge asked Hemingway if he wanted to leave something with his note. Without a pause, Hemingway went straight to his jeep and came back with a wooden case full of hand grenades on which he wrote "To Picasso from Hemingway" and handed it to the concierge.[39]

At 6:30 p.m. the Palais du Luxembourg finally fell to the Resistance. Earlier in the afternoon, they had taken the German headquarters, the much-hated *Kommandantur*, on the place de l'Opéra.

The century's most talented photographers and film operators found themselves in Paris on August 25 and 26, 1944. Their pictures and their films would travel the world, making the liberation of Paris one of the most iconic events of the Second World War. Strategically and militarily, the liberation of Paris was only a footnote in the war's history; however, it carried a sense of poignancy, which photography deeply enhanced. French photographers had help from American war photographers and film operators in immortalizing the street battles of that day. Robert Capa, on assignment for *Life*, and Lee Miller for *Vogue* had just arrived. So had David Seymour, also known as Chim, and the playwright Irwin Shaw. Those

heroic hours not only marked forever all those who were privileged to live them; they would also profoundly affect everyone who lived them by proxy, through reading war reporters' articles, looking at the pictures and news-reels. The photographers', film operators', and reporters' work was incredibly difficult and dangerous, and the people who saw and read their work could not believe the risks Parisians were taking. Civilians were swarming the streets while fighting was still going on. One moment a young soldier was kissed by a pretty Parisienne, the next he was shot in the chest by a sniper's bullet.

Thirty-one-year-old Irwin Shaw, a radio playwright born in the Bronx, a handsome man, built like a bull but with the eyes of a deer, saw Paris for the first time on that afternoon of August 25. His small Signal Corps camera unit was made up of two cameramen, a driver, and himself, all of them PFCs, Private First Class soldiers, the third-lowest army rank. Their jeep, decked with flowers and gifts from the people in the little towns on the road to Paris, carried a small store of tomatoes and apples and bottles of wine that had been tossed to them as they slowly made their way through the crowds.[40]

Shaw and his unit were on their way to the Opéra, where they had been ordered to report back and leave their rolls of films at the Allied headquarters, when they heard the sound of artillery fire. Tanks from the 2nd French Division were attacking the headquarters of the German Naval Forces on the place de la Concorde. On the horizon, four huge columns of smoke swirled into the sky. Shaw's unit stopped to capture the scene, but where to film it from? They needed to get on a rooftop. A man, an actor, who had overheard their conversation, took them to a theater nearby, the Comédie-Française, the hall of which had been transformed into a crude hospital. Shaw and his cameraman climbed up the grand staircase toward the roof, passing the busts of the great actors and actresses of France adorning each landing. "On the roof, we were sniped at once as Drell was finishing taking his pictures with the fussy, lens-adjusting deliberation that is so exasperating at moments like this. The bullet made a nasty, sudden whistle between us."

Back in the theater hall, Irwin Shaw could not help but be transfixed by the scene playing out in front of him. "The nurses were all actresses, most of them from the Comédie-Française company. They were very pretty and dressed in light, soft dresses; the effect, with the sharp contrasts

of the light and shadow, the white gleam of the wounded bodies, was that
of a painting by Goya for whom the models had been picked by Holly-
wood's Samuel Goldwyn." Shaw walked to one of the dead men lying on
the marble floor. A very young blond French boy had been shot through
the temple. "He had a thin, handsome, sunburned, healthy-looking face.
He had a streak of rouge lipstick on his cheek, like all the soldiers in Paris
that day, and there was a dark wine stain down the front of his khaki wool
shirt."[41]

Irwin Shaw did not know that Jean-Paul Sartre was at this same
instant sitting in the stalls inside the theater. The French philosopher had
been asked by the Comité National des Écrivains to go and guard the
Comédie-Française with his life (but without a gun). Had Irwin Shaw
waited a little he would have bumped into Albert Camus, on a visit to
Sartre. Later in the afternoon, Camus found Sartre dozing off on his
red velvet seat and woke him up: "Hey, Jean-Paul, you're finally in sync
with the events!" The tone was amicable, but the irony was not lost on
either man. Camus had been an active *résistant* while Sartre had been an
armchair one.

Shaw and his unit had to report to the Hôtel Scribe and hand over their
rolls of film for developing. On the rue de Rivoli, where the firing had
stopped, Shaw and his unit walked down the middle of the street. On seeing
these GIs going unharmed and taking it as a signal of victory, thousands of
people flocked out from the side streets, applauding, cheering, kissing them,
men and women alike, indiscriminately. "The smell of perfume from the
crowd was overpoweringly strong, and the variety of rich, sweet odors, as
kiss followed kiss, was dazzling and unreal to a soldier who had been
living in the field, in mud and dust, for two months."[42]

Simone de Beauvoir and her little family of former and current lovers
and students had agreed to spend the evening together in the room that le
petit Bost and Olga shared at the Hôtel Chaplain, just behind the Luxem-
bourg Gardens. As usual, each brought the little food they had managed
to save and shared it. That night, dinner was mostly potatoes, which they
cooked on an improvised stove without butter or salt.[43] They were com-
paring their memories of the momentous day. Beauvoir was still reeling
from the death of a young Leclerc soldier, shot in the chest by a German
sniper right in front of her door at the Hôtel La Louisiane. Then some-
body thought of switching on the radio, already tuned to Radiodiffusion

de la Nation Française. The speaker was at the Hôtel de Ville and he was trying to make himself heard over the very noisy crowd. Charles de Gaulle was about to address the nation. Beauvoir and her young friends looked at each other and listened. De Gaulle spoke to a crowd that had never seen him in the flesh: "There are minutes which go beyond our poor lives. Paris! An outraged Paris! A broken Paris! A martyred Paris! But, a liberated Paris! . . . Since the enemy that held Paris has capitulated into our hands, France returns to Paris, to her home. She returns bloodstained, but resolute. She returns enlightened by immense lessons, but more certain than ever of her duties and of her rights."

In his bedroom at the Hôtel Scribe, Irwin Shaw was listening to the voices of the crowd down below, an endless swelling mixture of cheers, song, and high, feminine laughter. As he fell asleep, he remembered what he had heard a GI say earlier that afternoon: "This is the day the war should end."

ONLY THE PEOPLE CAN CROWN A MAN

On Saturday, August 26, word that de Gaulle would be marching down the Champs-Élysées with Leclerc's 2nd DB spread fast. De Gaulle knew that in France, only the people can crown a man. He wanted to be that man. The U.S. Army agreed to fly a few planes to protect Paris and the march from the Luftwaffe.

The French general urgently needed to assert his control over the Resistance's different factions and especially over the Communists, whom he distrusted. Roosevelt and Churchill wanted to be certain not only that de Gaulle had the people with him but also that he had a strong grip on the Communist *résistants*. They would recognize his government only if and when they were convinced he had achieved both. While the French were busy gorging on their recently recovered freedom and celebrating with their liberators, de Gaulle had already started a silent war against the French Communists. However, because they represented half of the Resistance, having proved both their valor and their organizational skills during the war, Communists were highly regarded in the country. De Gaulle would need to navigate carefully.

Simone de Beauvoir had hopped on her bicycle and rode toward the place de la Concorde. In the crowd, she lost sight of Olga and Wanda, who

managed to get to the top of the Champs-Élysées while she stayed at the bottom. Sartre had chosen to watch the events from a balcony of the Hôtel du Louvre giving onto the rue de Rivoli, right opposite Jacques Jaujard's office.

Jacques Jaujard had invited his lover Jeanne Boitel but also many friends from the Comité National des Écrivains to watch history pass his windows. Among Jaujard's guests was a twenty-four-year-old curly-haired redhead named Anne-Marie Cazalis. She was the youngest member of the Comité National des Écrivains[44] and had won the Paul Valéry award for her poetry a year earlier. Braving her vertigo, Anne-Marie chose to sit on the giant ledge below Jaujard's office windows. A hundred yards west, Ernest Hemingway was walking toward the rue de Rivoli from the Ritz while Henri Cartier-Bresson was loading yet another Agfa roll into his Leica at the corner of the rue de Castiglione. A. J. Liebling was not going to miss the event for anything but was still debating where best to position himself. How he wished he could follow the action from a restaurant terrace serving champagne; he was exhausted and emotionally drained. Albert Camus and Maria Casarès, holding hands and kissing, would follow the flow wherever it went. Camus had just written the next day's editorial: "Four years of a monstrous history are ending, and with it an unspeakable struggle during which France was fighting both her shame and her rage."[45]

The American magazine *Life* put it this way: "Paris is like a magic sword in a fairy tale—a shining power in those hands to which it rightly belongs, in other hands tinsel and lead. Whenever the City of Light changes hands, Western Civilization shifts its political balance. So it has been for seven centuries; so it was in 1940; so it was this week."[46]

After inspecting Leclerc's troops, de Gaulle started walking down the Champs-Élysées with Parodi on his left. Around him were Free French soldiers, *résistants* of all political inclinations including the Communist FFI, their guns on their hips, gendarmes in their uniforms, even a bailiff with his golden chain around his neck, a symbol of the republican ritual. There was madness all around. Indescribable chaos and confusion. De Gaulle recalled this moment in his memoirs: "Ah, this is the sea! An immense crowd, perhaps two million souls . . . At this instant in time, something is happening, one of those miracles of the national conscience, one of those gestures which, sometimes, through the centuries, come and illuminate France's history."[47]

Having reached the bottom of the Champs-Élysées, at the place de la Concorde, de Gaulle climbed into an open car and headed toward Notre Dame through the rue de Rivoli, the crowds parting in front of him as the Red Sea did for Moses. De Gaulle had just passed below Jacques Jaujard's windows, and the Hôtel du Louvre's balcony where Sartre was standing, when gunshots went off. Many in the crowd threw themselves flat on the pavement; others, confused and less accustomed to fighting, ran in all directions, easy prey for diehard collaborators and German snipers firing from the roofs. With lightning speed, the young Anne-Marie Cazalis climbed up from the ledge into Jacques Jaujard's office and threw herself under a table. A young man collapsed at her feet, shot in the chest, dead.

In front of the Hôtel de Ville, American and British war reporters and photographers were waiting for de Gaulle, ready to report back to Washington and London. De Gaulle inspected troops again in front of the cameras, ignoring the Communist FFI, then walked to Notre Dame for a short mass. Along the way there were more gunshots, more snipers; people ran for cover while de Gaulle walked tall across the Seine on the Pont d'Arcole. The bullets whizzed around him as he marched on. Inside the cathedral he lowered his voice and exchanged a few words with Leclerc: "Let's keep the mass short and get rid of those snipers." After an extremely fast service of fifteen minutes, interrupted by the sound of machine guns fired in retaliation by Leclerc's men, positioned in the cathedral's galleries, de Gaulle left Notre Dame and went straight to talk with Eisenhower over the phone: "I need your help to clean Paris of its few remaining enemies. Two American divisions should do." That day there were three hundred civilian casualties, and the two collaborators who had attempted to kill de Gaulle in front of Notre Dame were found and executed.

In a week, 700 *résistants* and 2,800 civilians had lost their lives; 3,200 German soldiers had been killed and 12,800 taken prisoner. That night Édith Thomas wrote in her diary: "It is finished, it is beginning. In the eternal sway of history. The moment we have so much desired has finally come, but what will it be?"[48]

Amid this "orgy of fraternity," as Simone de Beauvoir called it, this debauchery of joy, there were ugly scenes in the streets of Paris. In the rue de Seine, the street where she lived, Simone came across the revolting spectacle of a naked woman humiliated by an uproarious mob. The woman was accused of having slept with the enemy. Many other women were

shaved in public and sometimes beaten up for the same alleged crime. Beauvoir, whom Albert Camus had just hired to write about those historic days for *Combat*, wrote of the "medieval sadism" of such rituals. She was relieved each time she saw the FFI protecting those women from the lynching crowds. Robert Doisneau and Henri Cartier-Bresson refused to take pictures of the shamed women. They loved the people, but not when they became a mob.[49]

Charles de Gaulle's provisional government ordered the disbanding of the command structure of the Communist Forces Françaises Intérieures, in effect ordering *résistants* to disarm or to enroll in the Free French army for the duration of the war. Jean Cocteau's dashing partner Jean Marais enrolled immediately. It was never too late to be a patriot, and many Frenchmen who had lived through the four years of the Occupation with the shame of the armistice but had not had the courage to join the Resistance or go to London seized the opportunity to clear their conscience.

Those days were heavily charged with tension, danger, and emotion and suffused with carnal desire and eroticism. When the Germans had taken Paris on June 14, 1940, they compared the city to a woman who had turned to stone. When the Free French and the Allies liberated her four years later, they brought her back to life. That week Picasso, ensconced right in the heart of the battlefield, did not choose to paint another *Guernica*. He had been studying Poussin's *The Triumph of Pan*, of which he drew an ink sketch and then painted a gouache, a watercolor, and an oil. Always his own man and never a slave to events, Picasso was in fact in tune with history. That week he left behind the mournful *natures mortes* and skulls he had painted for four years. The sixty-three-year-old was in love again, with the twenty-four-year-old Françoise Gilot; Paris was being liberated, he was bursting with life and joie de vivre and was going to let the world know. With his *Bacchanales*, inspired by Poussin, Picasso was at once modern and archaic. While the tanks were shaking the buildings all around him and gunshots were going off continuously on the boulevard Henri IV at the tip of the Île Saint-Louis where he painted, Picasso was unleashing his erotic euphoria.

Now that Paris was safe and rid of its snipers, he could leave Marie-Thérèse and Maya, knowing they would be safe. A crowd was waiting for him at his studio. Picasso had, despite himself, become the standard-bearer of liberated Paris and the symbol of fortitude during the Occupation. He

received everyone, from simple GIs to heads of international museums, from known and unknown fellow artists to students curious to meet him in the flesh. He basked in universal glory, answering reporters' questions and genially posing for pictures. "For weeks, Picasso's doors were wide open. His studio became a fairground and a brothel. Mixing in this heady fraternity, were international reporters, photographers, superb North American girls from the U.S. and Canadian armies, GIs with their little French girls on their arms, very thin young women wearing the scars of years of privation, students in white socks and black turtlenecks, old beauties from the Moulin Rouge wearing feather boas at eleven in the morning, and some 'aristocrack' as Picasso called them."[50]

Fraternity was everywhere. In the streets, in bars, Gaullists, Communists, Catholics, and Marxists sang together—they had fought together and swore that nothing could separate them. In the streets, children were chanting a new song: "We will not see them again, it's over, they're finished."[51] But what about those French citizens who had connived with the Nazi occupants and were still there?

$\mathcal{C}\!\!\!\sim$

THE DESIRE

FIRST, THE PURGE

Paris's hundred shades of soot and grime suited its spirit and matched its troubled spirit. Unlike London or New York, Paris had faltered, it had sinned. In 1944 the monuments and buildings of Paris may have been riddled with bullet holes, but its physical scars were insignificant in comparison with London's open wounds, where whole neighborhoods had been wiped from the map during the Blitz. Paris had been spared because France had capitulated, yet the pain ran deeper for the cowards than for the brave. Paris owed its untouched beauty to mental defeat; in 1944 Paris was in ruins, in many more ways than one. And so was everyone who had run away or stayed without fighting. Not to mention those who had collaborated with the enemy.

In early August 1944, a thousand collaborators had fled France, including the writer Louis-Ferdinand Céline[1] and the editor Jean Luchaire, Simone Signoret's former boss, and they were now all living in Sigmaringen Castle, standing by the Danube river 150 miles west of Munich, waiting for the apocalypse. Others naively thought that they could just hide and bide their time until the people's wrath had abated. On September 14, the anti-Semitic writer Robert Brasillach was finally found hidden in his mother's attic and arrested for "conspiring with the enemy." The Communists wanted his head and he knew it. The Communists were the most ardent advocates for revenge, a sentiment they instilled into their readers, day after day, with inflammatory editorials. Of the thirteen newspapers now authorized to be printed, they represented almost half of the national

press with, among others, *L'Humanité*, *Libération*, *Ce Soir*, and *Le Front National*. In this way they managed to work the people up to an incandescent rage. The actress Arletty was kept under house arrest following her love affair with a "Fritz" and was allowed out just to reshoot a few scenes of *Les enfants du paradis*. Her neighbor at the Ritz, Coco Chanel, now sixty and in a relationship with Hans Günther von Dincklage, was also arrested but was released a few hours later. Churchill was a friend from the time when Coco had been the Duke of Westminster's mistress, and there was speculation that he had intervened. As soon as she was released, Coco and her German beau packed and left for Switzerland. They would not set foot in France for the next eight years.

There were dilemmas. What to do with the grande dame of literature, Colette? At seventy-one, she was among the many tricky cases the French conscience would have to deal with. Colette had been writing for collaborationist publications such as *La Gerbe* and *Le Petit Parisien* while hiding her young Jewish husband, Maurice Goudeket, in her flat. She probably wrote for collaborationist newspapers in order to have friends in the right places should she need their help to free friends in danger. Luckily for Jean Cocteau, the Communists considered him a member of a persecuted minority because he was a homosexual. His mingling with Nazi officers at high-society events was forgotten.

The purge (or *épuration*, as it was known in France) became a murky affair, and the discrepancy in punishments opened up a national debate on the nature of revenge and justice. Never more public than among writers and journalists, the debate tore friends apart. On September 9, 1944, the first issue of the Communist-leaning *Les Lettres françaises* printed on its front page a manifesto signed by more than fifty French writers, among them Paul Valéry, François Mauriac, Paul Éluard, Albert Camus, Jean-Paul Sartre, Louis Aragon, André Malraux, Jean Paulhan, and Raymond Queneau. "Let us remain united in victory and freedom as we were in sorrow and oppression. Let us remain united for the resurrection of France and the fair punishment of the imposters and traitors . . ."—except nobody agreed on what represented fair punishment. Camus, at first, sided with the Communists, demanding a ruthless purge, while others such as Mauriac and Paulhan asked their colleagues to "forgive and forget."

Apart from those few who had joined the Resistance early and actually risked their lives—those noblest were the most forgiving—the major-

ity of French intellectuals and the population at large were of two minds about collaborators. The more passive they had been during the Occupation, the more revengeful they proved toward alleged *collabos*. The personal shame they felt at their inaction made them all the more aggressive. The Occupation had been a laboratory of moral ambiguity as in no other period in France's contemporary history. The coexistence, for four long years, of heroism, passivity, cowardice, and duplicity is, three-quarters of a century later, something France is still trying to come to terms with.

Sartre tried to explain the phenomenon to his British friends in a short essay written in the autumn of 1944.

> Somebody who was asked what he had done during the Terror in 1793 replied: "I lived . . ." It is an answer we could all give today. The same daily and ordinary necessities made us all share the same space. We bumped into the German occupants everywhere, on the streets, and in the métro where we literally rubbed shoulders. Of course, we kept our resentment and our hatred for them intact but those feelings had become somehow abstract. With time, an indescribable and shameful solidarity had emerged between Parisians and those foreign troops. A solidarity that wasn't in any way sympathy, but rather a biological habituation.[2]

In other words, the enemy had become too familiar to really become an object of hate. Besides, by sustaining even the minimum economic activity in the country, everyone was contributing to serve the enemy. A subtle venom poisoned every enterprise. Every choice was bad and yet one had to make decisions. Downing tools and ceasing all activity was not an option, or the whole country would have perished. "The enemy were like leeches, sucking our blood; we lived in symbiosis."[3]

And what to say of those who had left France in 1940? Had it been nobler to leave or to stay? To leave at once and join de Gaulle in London was one thing, as Sartre's schoolmate the philosopher Raymond Aron did; but to flee to New York like André Breton and many other non-Jewish Surrealists? Those who stayed never quite forgave those who left, though the reunion between old friends was very moving at first.

Raymond Aron came back from London and fell into Simone de Beauvoir's arms at the Café de Flore. He had joined de Gaulle in London

from the very beginning in 1940. In the evening, at the terrace of the Rhumerie, boulevard Saint-Germain, Aron would tell Beauvoir and Sartre about their life under the Blitz. Beauvoir discovered "historical events that were ours but that we hadn't really known about. Our joie de vivre was tempered by the shame of having survived."[4]

"A country that fails its purge is about to fail its renovation," warned Albert Camus in an editorial. On learning that the thirty-five-year-old anti-Semitic writer Robert Brasillach had been sentenced to death, Camus felt deeply disturbed. Although leading figures of the daily press and radio had been executed, no other creative writer had been sentenced to death. Camus signed a letter along with Paul Valéry, Jean Paulhan, Cocteau, Vlaminck, and Colette in which they asked de Gaulle to pardon the writer. However, even de Gaulle had to yield to the Communists' demands occasionally. They had asked for five thousand collaborators' heads, as a fair retribution for their sacrifice, and they would get Brasillach's. For many people in France the Communists had the moral high ground, as they had paid with their blood in greater quantity than the Catholics, the Socialists, and the Gaullists—or so went the legend they had successfully built. They had branded themselves "the Party of the 75,000 Shot,"[5] a gross exaggeration[6] but one that would not be challenged by historians until decades later. On February 6, 1945, Robert Brasillach faced a firing squad of twelve men without flinching, a red scarf around his neck and a picture of his mother in his inside pocket. To the young soldiers who were about to shoot him he said "Courage!" and then, as the first bullet hit him in the chest, he managed to shout "Vive la France!"

Simone de Beauvoir had attended Brasillach's trial and, unlike her friend Camus, had not signed the petition asking for his pardon. She had too many friends who had been denounced by collaborators like Brasillach and who had not yet returned from Germany. She did not possess the force or the heart to forgive. In his writing, throughout the war, Brasillach had called for people to be shot and killed. Did not he deserve the punishment he not only wished on others but also efficiently encouraged?[7] For Simone, Brasillach was the hangman, not the victim. Sentencing him to death was not inhuman, but just. Reflecting on this particular case in his memoirs, de Gaulle considered that Brasillach's talent had been an aggravating factor. Talent enhances one's responsibility.

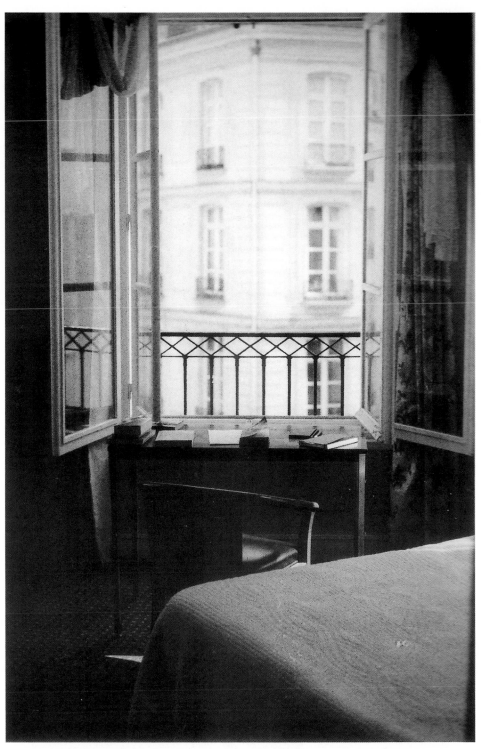

Room 10, also known as the round room, at Hôtel La Louisiane, Paris.
Inhabited in turn by Simone de Beauvoir, Jean-Paul Sartre, and Juliette Gréco.

© Agnès Poirier

Jean Cocteau, Jean Marais, and their dog during the 1940s
© Patrick Mesner/Gamma-Rapho

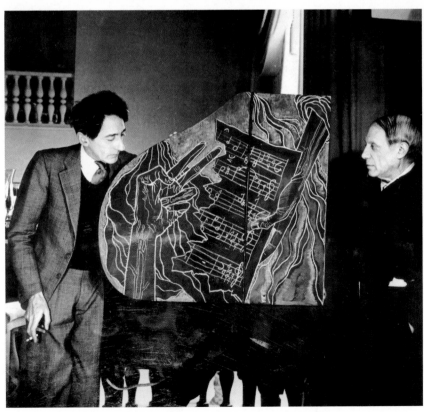

Jean Cocteau and Pablo Picasso in Paris in 1943
Collection Valentine Hugo © Segalat/Gamma-Rapho

*Miles Davis and Juliette
Gréco in Paris in 1949*
© Jean-Philippe Charbonnier/
Gamma-Rapho

*Claude Luter at the
Club Saint-Germain
in the 1950s*
© Succession Willy Ronis/
Diffusion Agence Rapho

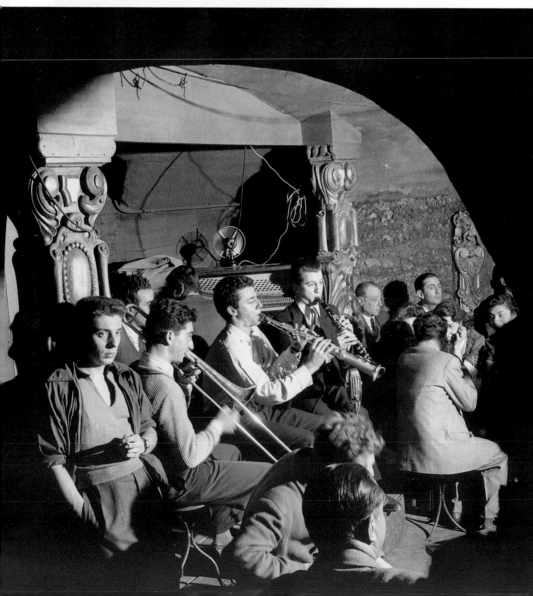

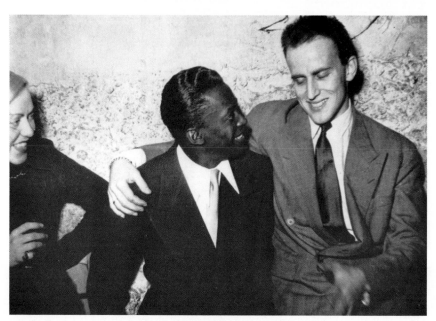

Michelle Vian, Miles Davis, and Boris Vian

© Droits réservés Archives Cohérie Boris Vian

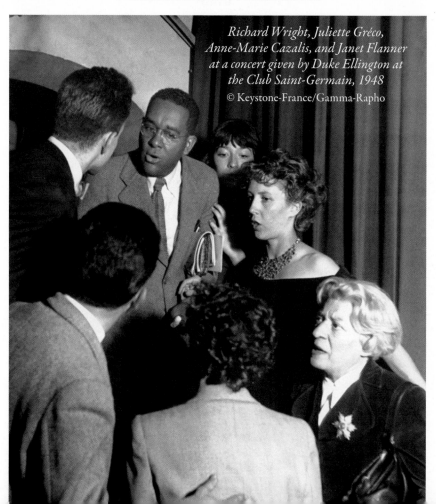

*Richard Wright, Juliette Gréco,
Anne-Marie Cazalis, and Janet Flanner
at a concert given by Duke Ellington at
the Club Saint-Germain, 1948*

© Keystone-France/Gamma-Rapho

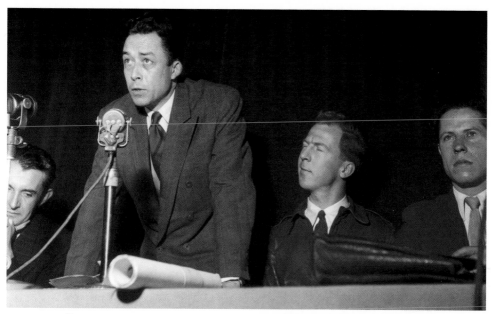

Albert Camus speaking at a rally with Garry Davis in Paris, December 1948
© Keystone-France/Gamma-Rapho

*Arthur Koestler in the
late 1940s*
© Ergy Landau/Gamma-Rapho

Norman Mailer in 1948
Library of Congress, Prints and
Photographs Division, Van Vechten
Collection, LC-USZ62-42506

Saul Bellow in 1948

*Simone de Beauvoir and
Jean-Paul Sartre on a
cruise ship in 1947*
© Keystone-France/
Gamma-Rapho

Nelson Algren
© Apic/Hulton Archive/Getty
Images

Irwin Shaw
© Nina Leen/The LIFE Picture
Collection/Getty Images

Agnès Poirier with Juliette Gréco at her home in Saint-Tropez, January 2014
© Grégoire Bernardi

PHILOSOPHER REPORTERS

Encouraged by Sartre, Beauvoir decided to quit teaching once and for all. At the age of thirty-six, she was embarking on a full-time writing career, a longtime dream. Beauvoir felt a little lonely, though. Camus had sent her "petit Bost" to cover the war on the eastern front for *Combat*. He had, in fact, poached almost all of Beauvoir and Sartre's former students to write for *Combat*. "In the morning, when I opened the newspaper, it felt like reading my own private correspondence."[8]

Albert Camus aimed even higher when he thought of asking Sartre himself to go on a five-month American tour for *Combat*. The U.S. State Department had invited a dozen French writers and reporters on an official visit to the United States, as a way of "getting to know each other," a way of making new friends. Camus called Sartre at the Café de Flore one morning: "Would you like to go on behalf of *Combat*?" Sartre almost jumped for joy. "I never saw him so happy,"[9] wrote Simone de Beauvoir later; "American literature, jazz, and films had nurtured our youth." Later, Camus also offered Beauvoir the chance to report from a two-month trip to Portugal and Spain.

French journalism was more interested in understanding and influencing the world than in simply reporting the facts, and this would, from now on, be its greatest asset and greatest liability, proving joyfully and viciously partisan. Communist newspapers such as *Ce Soir*, edited by the *résistant*, novelist, and poet Louis Aragon, and *L'Humanité*, the Communist Party publication, used all their might to promote their ideology and to attack all those who did not think like them, including Camus, Sartre, and Beauvoir.

Like Camus, many writers and philosophers had become journalists. The French press was filled with editorialized pieces rather than plain reportage. This made news highly politicized, cerebral, intelligent, literary, and often personal, which Parisians welcomed. Newspapers might have been limited to one sheet for lack of paper, but in the little space they had, they went right to the point. Mostly written by *résistants* who had risked their lives to keep the country informed during the war, the French press was highly regarded, not only at home but also abroad. "Everything Camus writes today in *Combat* is incised with meaning," wrote Janet Flanner. "The new Republic has started off with something the old did

not have—the most intelligent, courageous and amateur press which venal, literate France has ever known. The new press of Paris alone lives up to the Resistance slogan 'Les Durs.' It is indeed hard, and pure."[10]

Albert Camus' editorials and partisan journalism infuriated as many readers as they attracted. Using the collective and unanimous "we," he would write: "What did we want? A virile, clear-sighted and respectable press." For him, journalism could never be impartial and should not claim to be. "Information cannot be passed on without a critical analysis." Camus demanded a personal tone and style of his journalists. It was right to distinguish between opinion pieces and reportage; however, one should know that objectivity did not exist. In his eyes, a journalist was nothing less than a day-to-day historian. In the first weeks of *Combat*, Camus set out clear ethical and moral principles for his team of journalists.[11] He now rejected Marxism. What he wished for France was both a collectivist economy and liberal policies. He did not explain, though, how the two systems could work together.

Édith Thomas, too, had embraced journalism. Her comrades had asked her to become the editor of *Femmes françaises*, a Communist weekly aimed at French women readers. Like the good soldier she was, Édith had accepted her new mission without a word. But the truth, which she confided to her diary, was that she did not believe men and women should have different publications, nor should they be addressed differently. As a Communist and *résistante*, she found the gender differentiation old-fashioned and condescending to women. First, she started to hire good writers, whatever their political inclination. She asked Jean Paulhan, who had gone back to his tiny office at Gallimard, to recommend someone for the review section. He replied: "Dominique Aury is the woman you need." In the autumn of 1944, the thirty-seven-year-old Aury was on the editorial committee of Gallimard; she was a writer mostly interested in religious history and seventeenth-century poetry. With Jean Paulhan, she shared a passion for the Marquis de Sade. Like Paulhan, but unlike Édith, the demure-looking thirty-seven-year-old woman was viscerally anti-Communist. Édith did not mind as long as she was talented. And she was. Édith assigned her to write the magazine's literary reviews. There were, however, many submissive minds on Édith's editorial committee, wives of eminent Party members who did not know anything about journalism and were more interested in criticizing Édith's eclectic editorial choices

than anything else. "Too much mediocrity, too much suspicion, too many lies,"[12] Édith wrote in her diary on a damp and cold December evening. The day after, she quit her job and was hired almost immediately at *Le Parisien Libéré*, a non-Communist daily newspaper edited by *résistants*. Édith kept seeing Dominique Aury, though. Dominique had resigned from *Femmes françaises* on the same day as Édith, out of solidarity.

Apart from the feverish preparations for Sartre's trip to New York and Beauvoir's trip to Portugal and Spain, scheduled a few weeks later, Christmas 1944 was a little dull for the Sartre and Beauvoir family, and New Year's Eve at Albert Camus' apartment was somewhat subdued. Camus' wife, the beautiful Francine, had finally returned from Algiers, and things were not going very well between them. Camus was as passionately in love with Maria Casarès as ever and was not going to give her up. Sartre was drinking heavily, while Francine played Bach on the piano until two in the morning. As the party drew to an end, Albert walked toward Simone with a warm smile and a book with a red and black cover in his hand. He wanted her to read Arthur Koestler's *Darkness at Noon*, which had appeared in the United States in 1940 but had not yet been published in French. Back in her room at the Hôtel La Louisiane, as the first light of the new year filtered through the curtains, she put Koestler's book on her small bedside table. After a few hours of sleep, she started reading. "I did not put it down until I had reached the end. I read it in one breath."[13]

THE HOMECOMING

Among the exiles making their way back to Paris in the winter of 1944–45 were Samuel Beckett and Janet Flanner, the latter taking over for A. J. Liebling as Paris correspondent for the *New Yorker*, or rather resuming the job she had held for twenty years until the war broke out. Samuel Beckett and his partner Suzanne had opened the door of the flat on the rue des Favorites with a mixture of dread and longing. It had been four long years since the day they left their Paris home in a rush, fleeing the Gestapo. Unsurprisingly, their home had been broken into, and some pieces of furniture, personal effects, and kitchen utensils were missing. Depressed by the sight, Beckett and Suzanne booked themselves into the Hôtel Libéria, 9 rue de la Grande Chaumière, next to the art school and opposite Beckett's favorite restaurant, Wadja.

Janet also chose to stay in a hotel, more exactly at the Hôtel Scribe with her fellow foreign correspondents. She knew that she could have a hot bath there every morning between eight and ten, and this alone was incentive enough to live there for a while. The day after her arrival she had bumped into Ernest Hemingway, who confessed breaking the news to her former girlfriend Noeline about Janet's current Italian lover.[14] Noeline, the formerly statuesque blonde, was now a shadow of herself. The war had ravaged her looks. Devoured by regrets, Janet had decided to stay three nights a week with Noeline.

Paris was rainy, cold, muddy, and hungry. As Janet Flanner typed on her old Remington, "nourished by liberation, warmed by the country's return to active battle, Paris is still, physically, living largely on vegetables and mostly without heat."[15] A week's ration for a family of three was half a pound of fresh meat, three-fifths of a pound of butter, and one-third of a pound of sausage. No wonder the attacks against de Gaulle's cabinet at the Consultative Assembly in November focused on supplies rather than high politics. Eight hundred thousand of the most skilled French factory workers were still slave laborers in Germany and could not fill the now open but empty factories. In Paris, a dozen métro stations were closed for lack of electricity, and gas for cooking was rationed to ninety minutes at lunchtime and an hour at dinnertime—that meant no gas to heat one's morning ersatz coffee of burnt barley, which explained why everyone went to cafés to get a *petit noir*. In December 1944, Parisians, in their overcoats, sipped their carrot and parsnip stew, the only vegetables available in any quantity.

Things were better for the happy few who could get into the restaurant of the Hôtel Scribe. Jacques-Laurent Bost had just come back from Holland and as a war correspondent could take Simone de Beauvoir there for lunch. They had fresh eggs, white bread, jam, and Spam.[16] A feast. Simone discreetly filled her pockets with sugar, the new gold. Apart from lunch at the Scribe, spending long hours in bed reading and making love, staying in cafés for hours rubbing shoulders with your neighbors, and drinking slightly more than usual in the evening were the best ways to keep warm and cheat hunger in the first months of 1945. Parisians had never felt colder or hungrier since the Prussian siege of Paris in 1870, when their grandparents had eaten rats, cats, and mice to survive. Paris's streets were covered with snow; ski clothes, if you had them, had replaced pajamas as nightwear.

Parisians had been waiting for the return of another kind of exile. In early spring, the Allies had crossed the Rhine; their speed was now breathtaking. They were about to reach many of the concentration camps. War prisoners were slowly making their way back home, soon followed by the first deportees. On April 22, 1945, Janet Flanner took the métro from Opéra to the Gare de Lyon. She had been briefed that the first contingent of women prisoners would arrive later that day by train. There were three hundred of them, who came in exchange for German women held in France. They had been interned at the camp of Ravensbrück, fifty miles north of Berlin. The name did not really ring a bell with Parisians, but it did with the American reporter. Janet took her place among the crowds awaiting their loved ones with timid smiles and welcoming bouquets of lilacs and other spring flowers. Gendarmes were keeping them a few feet away from the entrance to the platform, where Charles de Gaulle was standing. A solitary and commanding figure, he was the incarnation of heroic Free France welcoming back to its bosom all those betrayed by cowardly Vichy France—a poignant task. His own niece, the twenty-four-year-old Geneviève de Gaulle, a *résistante* from the very first hours of the armistice in 1940, interned at Ravensbrück in 1944, was not part of the convoy. All he knew was that she was still alive. Janet Flanner looked at her watch as the train slowly ground and screeched into the station; it was exactly eleven o'clock in the morning.

The women were leaning out the windows of the train. Seeing their faces, the crowd, now allowed on the platform, froze in fear and horror. Their flesh had a gray-greenish halo and all had red-brown circles around eyes that seemed to see but not take anything in. De Gaulle walked toward them and started shaking their hands. The crowd began moving, now anxiously searching for their loved ones among the poor, wretched women. "There was almost no joy; the emotion penetrated beyond that, to something near pain."[17] De Gaulle knew that the Ravensbrück Kommandant had carefully selected these three hundred women because they were the most presentable. Eleven had died en route. "As the lilacs fell from inert hands, the flowers made a purple carpet on the platform and the perfume of trampled flowers mixed with the stench of illness and dirt."[18] Many of the women suffered from dysentery and were covered with typhoid lice.

This painful homecoming heralded a long series of such returns. As the Allies and the Red Army were about to free the concentration camps

one after the other, a whole new horror, the dawning realization of the Holocaust, was about to engulf the free world. Not a day passed without Beauvoir and Picasso thinking about their many dear disappeared friends. Alfred Péron, Samuel Beckett's best friend, had survived concentration camp life and was now in transit from Mauthausen to Switzerland, looked after by the Red Cross. On May 1, he died of exhaustion.

The Gaullist administration realized very quickly that the reception facilities of the Gare d'Orsay[19] were not up to the task. Deportees were in such poor health, exhausted and disoriented, that they needed a specific reception and accommodation center. De Gaulle requisitioned five luxury hotels on the Left Bank, among them the Hôtel Lutétia, in Saint-Germain-des-Prés, an Art Nouveau palace that had been occupied by the *Abwehr* during the war. It had 350 rooms, which would be used as dormitories, with a total of a thousand beds, for the deportees just back from Germany. Volunteers from different Resistance associations, boy scouts and youth movements, as well as doctors and nurses working extra shifts, ran the deportees' center at the Hôtel Lutétia night and day. Sometimes coaches arrived in the middle of the night with two thousand deportees at a time. The fittest were registered, asked questions, seen by a doctor, and sprayed with DDT in a nearby bakery that had been repurposed for the task, before being ushered to a room where they could rest. Volunteer teenagers helped the weakest directly from the coach to a room and a bed. The deportees would then be fed in a meticulous way, with the small quantities of food their bodies could stand after years of starvation. Some were extremely contagious. A chambermaid and a teenager looking after the deportees' clothes died after contracting typhus.

The eighteen-year-old Juliette Gréco did not volunteer, but she did, like thousands of Parisians, go to the Lutétia every day from the end of April through the summer, in the wild hope of finding her mother and older sister Charlotte, who had disappeared three years earlier, arrested by the Gestapo. Simone de Beauvoir, too, went to the Lutétia, to try to obtain some information about her former students and friends, deported to Germany. So many had died or did not survive their transfer back home. Her petit Bost had returned to the front to report on the liberation of the camps and had entered Dachau an hour after the U.S. Army. He had been unable to file his copy, he wrote to her. He felt completely paralyzed in

front of his typewriter. "Once again, I felt ashamed of being alive. Death was haunting us, but I thought, with disgust for myself, that those who do not die accept the unacceptable."[20]

Finally, one afternoon, Juliette Gréco saw both her sister and her mother in the crowd at the Lutétia. None of the women spoke. Juliette took Charlotte by the hand and walked her to her little hotel room on the third floor of 16 rue Servandoni, while their mother was looked after by family friends. "For the first few weeks, I fed my older sister milk and tiny pieces of food the way you do a kitten."[21] Gréco had been told that when they liberated Dachau, U.S. soldiers, thinking they were doing the right thing, had distributed bread, sausages, and Spam to deportees, who had died just after eating them. Getting accustomed again to freedom, life, and its pleasures would take a long time.

THE FIRST FREE SPRING IN FIVE YEARS

In April 1945 the first rays of sunshine finally heralded a new spring, the first free spring in five years. Seated at café terraces, Parisians could feel the warmth of the sun on their cheeks. The month of April was dazzling, wrote Simone de Beauvoir, returning from her trip to Portugal and Spain. She had brought back in her suitcases a hundred pounds of groceries—ham, chorizo, Algarve cakes, sticky sugar, eggs, tea, real coffee, and real chocolate—and was handing them out generously to friends, lovers, and strangers. She had purchased many clothes, too, folkloric sweaters, Spanish scarves, and multicolored fishermen's shirts from Faro in Portugal, one for Camus, one for le petit Bost, and one for Michel Vitold, a talented thirty-year-old Russian-born actor and her current lover. She kept for herself the most treasured acquisition: brown crepe-soled shoes. People stopped her in the street, not because they recognized her but because they wanted to know where she had found such wondrous shoes.[22]

American films started to reach Paris's cinemas. Howard Hawks's 1940 screwball comedy *His Girl Friday*, with Cary Grant and Rosalind Russell, gave many Parisians their smile back, at least for an evening. But the film that really struck everyone was the three-hour epic *Les enfants du paradis*, penned by Prévert, directed by Carné, and interpreted by Arletty, Pierre Brasseur, and the new young stars from the French theater

Jean-Louis Barrault and Maria Casarès. Its making and its story embodied perfectly the moral contradictions the French had endured and were still facing.

Prévert wrote the central part of Garance for Arletty, who was still France's biggest star even after her scandalous love affair. Garance and Arletty were one and the same woman, the epitome of the Parisian: strong, independent, witty, impudent, mysterious, the kind who casts spells, whose laugh ricochets, the kind who loves life and whom life loves. Prévert's dialogues were instant classics. At one point, Garance tells the mime art-ist, Baptiste, who is desperately in love with her: "I am what I am. I love those who love me. That is all. When I feel like saying yes, I do not know how to say no." The film had such an impact with audiences because it encapsulated the moral maelstrom felt by so many in France. It was easy to see in Garance and Arletty a metaphor for France, a woman who gave her-self a little too freely even if her heart remained pure and faithful. How ironic that Arletty had been arrested for sleeping with the enemy. With typical impudence, Arletty had told the young *résistants* who had interro-gated her: "My heart belongs to France but my arse is international!" (*"Mon coeur est français, mon cul, lui, est international!"*).

The death of President Roosevelt in April 1945 caused more personal grief among the French than the deaths of their own recent great men. Janet Flanner heard a café waitress "naively touching the sublime" when she said of his death: "C'est ennuyeux pour toute l'humanité" ("It is trou-blesome for the whole of humanity").[23] The Paris press wrote of the Ameri-can president with sober magnificence, sincere superlatives, and spirited Gallic headlines: VIVE ROOSEVELT! (*Libération-Sud*) and "The great voice which directed American political destinies has been silenced, but its echo continues in French souls" (*Le Monde*).

Two events improved the general mood considerably. On April 30, Hit-ler's death, followed a week later by Germany's unconditional surrender, triggered scenes of jubilation in the streets of Paris. All those who, like Janet Flanner, had not been lucky enough to witness the elation of the Liberation in August 1944 were determined to experience V-E Day celebrations as intensely and fully as they possibly could. For Janet, it was a way of catching up with history and of being reunited with her French family.

Janet went first to the place de la Concorde: "The babble and the shuffle of feet drowned out the sound of the stentorian church bells that clanged

for peace, and even the cannon firing from the Invalides was muffled by the closer noise of feet and tongues that were never still." Simone de Beauvoir and a group of a dozen friends were there too. There were two noticeable absentees from Beauvoir's little troop, though. Sartre was still in the United States and Bost was still in Germany. "We got off the métro at Concorde, there was a human tide, we could hardly walk. We were in fact carried by this human wave. A force seemed to be pushing us all toward Opéra."[24] The tricolor flags were flapping in the wind, and "La Marseillaise" could be heard from every street corner.

Simone and her friends passed just below Janet Flanner's hotel room windows at 1 rue Scribe. From her observation post, Janet would see, later that day, the Parisians "filling avenues from curb to curb." Some had brought the little food they had at home for improvised frugal picnics, but the marching Parisians were mainly living "on air and emotion." Neither Janet nor Simone mentioned in her diary whether she had heard the French-born soprano Lily Pons[25] sing the French national anthem from the balcony of the Opéra for the crowds that night. Lily Pons, the New York Metropolitan Opera's star soprano since 1931, had deeply moved New Yorkers in December 1942 when she sang "La Marseillaise" during the performances of Donizetti's *The Daughter of the Regiment*, waving a flag with the Cross of Lorraine. Pons was, along with Marlene Dietrich, among the few artists who had put their careers on hold for the whole of 1944 in order to tour France, Europe, and the Middle East entertaining Allied troops.

After writing down her impressions of the day, Janet went out again around midnight and walked toward the Champs-Élysées. The crowds had thinned and only the young remained, "long lines of boys and girls, arms high and holding hands, like long lines of noctambulistic paper dolls."[26] The young dominated the day and night. "It was the new post-war generation, running free, celebrating peace with a fine freedom which their parents, young in 1918, had certainly not known."[27] Looking at her much younger companions, Simone de Beauvoir noted: "The war is finished but it remains in our arms like a cumbersome and big corpse and it seems that there is nowhere we can bury it."[28]

The morning after, Beauvoir, still in bed, started contemplating the newspapers spread on the floor in front of her. She had bought all the now historic editions she could lay her hands on. While the *Paris Herald Tribune* had chosen the one-word headline VICTORY, French newspapers seemed

instead to be focusing on the demise of the Nazi enemy. The Gaullist *Les Nouvelles du matin* dedicated its whole front page to a drawing of a female figure symbolic of France with wings, laurels, and Allied flags under the headline LA GUERRE EST FINIE. As for the satirical weekly *Le Canard enchaîné*, it could not help celebrating the victory with a cartoon of Hitler, dead and at heaven's gates, pinning a Star of David on God's chest to start a New Order.

CROSS-FERTILIZATION

With the end of the war, the urge to travel, discover, understand, and embrace a new free world brought a fresh wave of foreign artists and writers to Paris. A cross-fertilization began to take place, transcending all kinds of boundaries and connecting philosophy and journalism, intellectuals of different nationalities and artists of different disciplines. Christian Zervos, the arts editor and founder of *Cahiers d'Art*, was hoping to relaunch his magazine with a bang: Picasso had promised a double cover,[29] but the painter was playing hard to get. Zervos, from his office and art gallery at 14 rue du Dragon, was nonetheless plowing on, relying as always on his personal flair to commission articles and art reviews from unlikely people and yet-unknown talents. He was interested in a couple of Dutch painters, the brothers Bram and Geer van Velde, and had asked an Irishman named Samuel Beckett to write a text on them. Beckett liked a new challenge and he particularly loved the van Veldes' art, especially Bram van Velde's. Eleven years older than Beckett, Bram was "a painter almost as unsuccessful and devoid of support from the exhibiting establishment as Beckett himself was from the publishing."[30] He and Bram even resembled each other: tall, thin, bony, and taciturn. The brothers had their paintings exhibited at both the Édouard Loeb art gallery and Galérie Maeght, and Zervos was hoping to interest the public, or at least the connoisseurs, in their art. Beckett called his essay "La peinture des van Velde ou le monde et le pantalon" [The Painting of the van Veldes or the world and the pair of trousers].[31] The title referred to a joke he would use again in 1957 in his play *Endgame* about the tailor who unfavorably compares the botched job God made of the world in seven days with the perfect pair of trousers he crafted in a somewhat longer period.

His art review was not an art review. His opening line said it all: "To

start with, let's talk about something else." And what about? The doubts of the art amateur, and the mistakes of art critics. "There is no painting, just canvases. And those canvases, not being sausages, are neither good nor bad," wrote Beckett, before adding, "what you will ever know of a painting is how much you love it, and perhaps, if it interests you, why you love it." Beckett unusually mentioned politics in his essay, saying that the van Veldes were more interested in the human condition than in painting.

Walking up the boulevard Saint-Germain, Henri Cartier-Bresson had noticed Beckett coming out of Zervos's gallery and had thought to himself, "good face, funny walk."[32] Cartier-Bresson had not had the heart or the courage to follow his fellow war correspondents and photographers to Germany. Circumstances had made him play at being "war reporter" during the liberation of Paris, but he did not wish to go to the front. He did not view himself as a "tourist in disaster land" or a "voyeur aristocrat"[33] like others. He was not interested in war as such. In 1945, he chose to focus on the faces of those who were making or about to make history in Paris: Jean Paulhan, Édith Piaf, Simone de Beauvoir, Christian Dior, Paul Éluard, Pablo Picasso, and Igor Stravinsky, among many others. Cartier-Bresson himself, though only thirty-seven, was going to make headlines. The Museum of Modern Art in New York (MoMA) had thought him dead for months and had planned to organize his life's retrospective. But Cartier-Bresson was alive and well, and after recovering from the shock of that news, MoMA decided to go ahead anyway and planned the event for 1946. It would be the first of many retrospectives for Cartier-Bresson. Despite his relatively young age, his extensive traveling in the 1930s had made him a veteran photographer who had seen and photographed more than most artists. He had shared a flat with the black poet Langston Hughes in Mexico and dated a Mexican woman, Guadalupe Cervantes. He had lived in New York in Harlem, co-renting with the writer Paul Bowles and dating an African American woman. Everywhere he had gone, he had blended into the landscape and melted into the local crowd, taking pictures all the way. In other words, the Museum of Modern Art had a wealth of material to choose from for the exhibition.

The world's greatest chameleon artist, Picasso, the man with seven lives, was yet again reinventing himself and his art. He looked different: he had cut his famous shock of black hair. "One cannot be and have been,"[34] said Picasso, greeting his old friend Brassaï on Saturday, May 12, 1945.

Picasso now said *tu* to his friends and sometimes declared, by way of explanation, "We're all the same age now, are we not?"[35]

Young artists who had somehow pupated during the war and were now hungry to act and create, looked up to older artists they felt had not only resisted but had held high the banner of universalism in arts. The twenty-one-year-old dancer and choreographer Roland Petit went to see Prévert with an idea for a three-ballet show called *Le rendez-vous*. A defector from the Paris Opéra Ballet, Petit had formed a dance company and wanted the very best for his show: Prévert would write the story line, Joseph Kosma would compose the music, Mayo would design the costumes (all three had been among the talents behind *Les enfants du paradis)*, Picasso would create the giant stage curtain, and Roland Petit wanted Brassaï to make three décors with giant reproductions of his black-and-white photographs. Petit, with the impetuousness of youth, gave them three weeks to do it. And so they did. On June 15, *Le rendez-vous* opened at the Théâtre Sarah Bernhardt and the young Marina de Berg made a strong impression in the part of "The world's most beautiful girl." There were many well-known figures in the stalls: Camus, Sartre, Beauvoir, Cocteau, and Marlene Dietrich all sat in the same row. This was not a coincidence. As Beauvoir explained: "We went out furiously to every opening, every cultural event. The fact that we all met then and there, together, despite our political differences, proved the solidarity that we so ardently wished to continue. Those openings and premières became demonstrations."[36] Fittingly, as Picasso's beige and mauve curtain went down at the end of the show, applause, boos, and shouting erupted in equal measure. "Since Picasso had joined the Communist Party on October 5, 1944, his work had the same effect on a certain fringe of the public as the *muleta* on a bull."[37] Although he had joined the Party out of friendship rather than belief, he was influencing the young generation to do the same. Juliette Gréco, who dreamed of becoming a tragedian, enrolled in the Communist Youth Movement just like tens of thousands of other young people in the country. She immersed herself in the work of authors approved by the Party. Some had talent: Aragon but also Federico García Lorca and that young woman she sometimes bumped into on the rue Saint-Benoît, Marguerite Duras.

Sartre had delayed his return from the United States after meeting the beautiful Dolorès Vanetti, a friend of Claude Lévi-Strauss, the anthropologist working as the French cultural attaché in New York. Vanetti was

of Italian Ethiopian origin and had been educated in France before fleeing to New York with her American husband in June 1940.[38] The couple were friends of the French exiles André Breton, Fernand Léger, Max Ernst, Alexander Calder, and Marcel Duchamp, and also John Dos Passos, among others, and Sartre got to meet them all through her. "Dolorès gave me America,"[39] Sartre later wrote. Among Dolorès's friends he particularly warmed to Alexander Calder, whom he visited at his studio in Roxbury, Connecticut. Sartre was fascinated by the artist's mobiles and Calder by the philosopher's wit and ideas.

Calder so missed Paris, where he had spent his formative years in the late 1920s and early 1930s, that he dreamed of going back and living there with his family. He just needed a Parisian project to make his dream come true. Perhaps Sartre could take part? Marcel Duchamp suggested he put on a show at his friend Louis Carré's art gallery. No sooner said than done. Calder started producing a series of small-scale works that he could ship via the new international airmail system. On July 16, Calder packed thirty-seven miniature mobiles into six small cartons and sent them to Louis Carré for his consideration. Carré's appetite whetted, he asked Duchamp and Calder for more in a telegram: WOULD ALSO GLADLY EXHIBIT MOBILE SCULPTURES AVAILABLE ALL SIZES AND COLOURS.[40] Thinking ahead, Calder suggested that Sartre might write the catalog, to which Carré replied, "Excellent idea!"

Calder's friend Richard Wright was just leaving New York with his family to spend the summer in Montreal, having heard nothing yet about their application for French passports. He wrote in his diary: "Montreal is the closest I can get to Paris." Richard and his wife, Ellen, had been taking French lessons in Brooklyn twice a week and wanted to put their newly acquired language skills to use. He was receiving mail from his French publishers. Albin Michel was going to publish *Native Son* and *Uncle Tom's Children,* and Gallimard had picked up *Black Boy.* Three of his books were to hit Paris bookshops within a year. Surely, they would create a stir and trigger some important debates, or so he imagined. Wright was understandably hoping that their success with the French public would pave the way for his triumphal arrival in Paris.

The Bastille Day celebrations in Paris, the first free July 14 since 1939, lasted three days and three nights. It was Picasso's favorite day of the year. Seldom a landscape artist, he made an exception for the occasion and

painted, on a very small canvas, the riverbank with Notre Dame in the background and French flags floating in the wind. "The extreme smallness of the painting made me think of Hokusai, who masterly painted on rice grains,"[41] wrote Brassaï in his diary. Another event earlier that week made Picasso and many Parisians emotional. The Louvre had finally reopened on July 10 with its first postwar exhibition called, simply, "Great Masterpieces." Its collections were only now completely repatriated from their different hiding places. Not one piece had been damaged, thanks to their savior in chief, Jacques Jaujard, and the thousand anonymous keepers who had guarded them with their lives.

Three weeks earlier, Georges Salles, the new head of the Louvre Museum, had invited Jacques Jaujard. He wanted his famous predecessor to come and greet an old acquaintance. On Sunday, June 17, the two men walked down to the museum's warehouse, where a white poplar case marked with three red dots was waiting, surrounded by a close guard of five men and one woman—Louvre workmen, art historians, and curators. Everybody shook hands. Georges Salles looked at Jacques Jaujard and then nodded at the curator Germain Bazin to open the case. Jacques Jaujard squatted down to get a closer look. Waterproof layers of protection were carefully removed, one by one, until the last one, a thin sheet of fire-retardant fabric woven from asbestos fibers, appeared. Germain Bazin stopped and looked up at Jaujard and Salles before tearing it open. Jaujard nodded again. The face of the *Mona Lisa* slowly appeared. No words were exchanged between the men—the only sound came from the clicking of photographer Pierre Jahan's camera. Jahan was almost dancing around them and around her, taking the historic picture that would immediately travel the world. *La Joconde* was finally home.

ONE FINAL TRAITOR TO JUDGE

There was one thing left to do before Parisians could close the chapter of their history that the war had occupied. They had to judge an eighty-nine-year-old fellow Frenchman who had led them collectively to the brink of infamy. His name: Marshal Philippe Pétain. In a dramatic and ironic clash of events, Pétain's trial opened the day Charles de Gaulle ruled that the French poet Paul Valéry, who had just died, would be given a state funeral, the first for a poet since Victor Hugo in June 1885. Paris-based foreign

correspondents found themselves filing copy on two great Frenchmen at once, but two great Frenchmen who had taken very different paths in 1940. The soldier had chosen ignominy while the poet had joined the clandestine Resistance and his fellow *littérateurs* of the Comité National des Écrivains. While in Vichy, Pétain had dismissed Valéry from his Paris university post. De Gaulle reinstated him.

Janet Flanner, Anne-Marie Cazalis, and Albert Camus were among the thousands of silent Parisians who lined the streets just before midnight as Paul Valéry's body was escorted from the church of Saint Honoré d'Eylau near the Arc de Triomphe to the beat of muffled military drums. Valery's body lay on a torchlit outdoor catafalque wrapped in the French flag and situated between the Trocadéro and the Eiffel Tower. The poet was guarded by his students while Parisians paid their respects. Two huge floodlights at the feet of the Eiffel Tower projected a big V during the night. V for Valéry, V for victory. The man who had been an ambassador for French letters in the world, conveying the image of a Cartesian and classic France, was given a republican apotheosis.

After a short night, Janet Flanner rushed back to Pétain's trial at the Court of Justice, ensconced on the Île de la Cité between Notre Dame and the Sainte-Chapelle (holy chapel) built in the 1240s. It had taken her some time to get used to the French justice system's own peculiar customs and sartorial traditions. "The red and black robes recalled the face cards in the trial scene of Alice in Wonderland, but in the Paris trial scene there was no gentle humor, no awakening from a dream."[42] The courtroom could seat six hundred people, far too few considering the world's interest. The French Ministry of Information had chosen to resort to a system of allocating tickets to the foreign press by lottery.

The presiding judge asked all the French politicians present at the trial to answer two crucial questions: "Do you think Marshal Pétain has committed treason and what do you think treason consists of?" For Janet Flanner, "of all the testimony of the big political figures, what Léon Blum had to say against Pétain was the most intellectual, clear (if complex), and unequivocal."[43] And Blum's definition was best: "An absence of moral confidence was the base of the Vichy government, and that is treason. Treason is the act of selling out."[44]

The trial was in its final stage when the news of the bombing of Hiroshima and Nagasaki reached Paris. Sartre and Beauvoir were horrified

but declined to make their disgust public. Communist newspapers were hardly moved by the events in Japan. Albert Camus was the only French journalist to express the absolute revulsion he felt at the events, in an editorial published on August 8 in *Combat*. "The world is what it is, that is to say not much . . . Civilization has just reached the ultimate stage of savagery . . . We will soon have to choose between collective suicide or an intelligent use of science."

On August 14, the day the Pétain trial ended, the BBC reported riots in front of the Court of Justice. In fact, all was calm and quiet on the boulevard du Palais. Calm, like any August in Paris. For the first time since 1939, Parisians had been able to resume their summer transhumance, leaving the capital to go back to their families' bastions in the countryside or at the seaside. Most of them awaited the verdict on the radio. It took seven hours to reach, and when it came, at four in the morning, it seemed to satisfy the country. Death for high treason. Charles de Gaulle commuted the sentence to life imprisonment on the island of Yeu, twelve miles off the Atlantic coast.

When Alexander Calder heard the news on his transistor radio in his studio in Roxbury, where he was doing some welding for his Paris show, he paused for a moment and thought of Sartre and his Parisian friends. There were a few other bastards in France like Pétain who deserved to be sent far, far away. *Thank God for de Gaulle*, he thought, and he resumed his welding. Spurred by the restrictions on parcel size imposed by the U.S. Postal Service, he had begun creating large works for Louis Carré's gallery that were collapsible and could be reassembled upon their arrival in Paris, the place he longed for.[45]

PART II

MODERN TIMES

A PHILOSOPHY OF EXISTENCE

THE SECOND WORLD WAR, BOTH ON THE GROUND AND IN people's minds, had finally ended. The V-E Day celebrations in May 1945, followed by Marshal Pétain's trial and death sentence and the capitulation of Japan after the Hiroshima and Nagasaki bombings in August 1945, had offered some closure on what had been the darkest five years for millions of young adults. If the war was over, its corpse remained. There was nowhere to bury it, as Simone de Beauvoir keenly felt. However, by dissecting it and understanding it, the generations shaped by the ordeals of the war could perhaps be able to learn from it, free themselves, and bounce back to life.

There was no longer any room for complacency and ambiguity. One had to take sides, speak up, act, and perhaps risk sounding brash and reckless. One had to engage, to engage fully and absolutely, with the society one lived in and the world around it. It was the lesson learned from the war: indifference bred chaos. It was time to stare at the reality with lucidity in order to change it. To experiment with life, love, and ideas, to throw away conventions, to reinvent oneself, and to reenchant the world were the new mottos of Paris's young.

In the autumn of 1945, Paris was grimier than before the war and yet its lights were on again, its nightlife bearing little resemblance to any other. "The orgy of fraternity" described by Simone de Beauvoir lingered on, but so did food rationing. With a monthly wine ration reduced to one liter per

person, nightlife was fueled by the elation of freedom and the fire of political discussions. Game and poultry were back in shop windows, but at three times their prewar price only the nouveaux riches could afford them.

In the autumn of 1945, France was about to vote in the first elections since before the war. The aim was clear: to kill the Third Republic and its 1875 constitution and refound the Republic. The Third Republic had failed to bar Marshal Pétain from power in July 1940 and was forever tainted by collaborationist Vichy. When Marshal Pétain declared himself head of the French state in 1940, the Third Republic had in effect been killed. It was now high time the French buried its corpse.

LES TEMPS MODERNES

In September 1945, together with their band of students and friends, Simone de Beauvoir and Jean-Paul Sartre were working night and day finalizing the first issue of their journal *Les Temps modernes*. They had launched the idea at the end of 1944, choosing the title as a tribute to Chaplin's *Modern Times,* and, apart from Camus who was too busy editing *Combat,* they could rely on almost everyone else to write for them—Communists, Catholics, Gaullists, and Socialists: their schoolmate and liberal philosopher friend Raymond Aron, the Marxist phenomenologist Merleau-Ponty, the anthropologist and art critic Michel Leiris, the Gallimard supremo Jean Paulhan, and even Picasso, who had agreed to design the cover and logo, along with a new generation of writers who were submitting articles and ideas such as Jacques-Laurent Bost. The British writer Philip Toynbee would contribute a Letter from London, while novels and essays the committee particularly liked would be serialized prior to their publication or with a view to attracting a potential publisher. *Les Temps modernes* would be a laboratory of new ideas and a talent scout rolled into one. Simone de Beauvoir had personally approached the minister of information, the Gaullist and *résistant* Jacques Soustelle, to ask for an allocation of paper.

Gallimard had agreed to finance the journal and to give the team a little office where they could hold their editorial meetings. The first issue was planned for October 1, 1945. Jean-Paul Sartre was made the head of the publication, "Monsieur le Directeur," and he thought it important to make himself available to everyone. This would be democracy and public

debate in action. He committed to receiving anyone who asked to see him at the magazine's office at 5 rue Sébastien Bottin every Tuesday and Friday afternoon between five thirty and seven thirty. This commitment was printed at the beginning of the magazine, along with the telephone number Littré 28-91, where they could be reached. Sartre had decided to dedicate the first issue of *Les Temps modernes* "To Dolorès," in all simplicity. Simone did not blink an eye.

In the first issue, Sartre announced loud and clear what *Les Temps modernes*[1] stood for. It was to be the megaphone that would carry their thoughts far and wide.

> Every writer of bourgeois origin has known the temptation of irresponsibility. I personally hold Flaubert personally responsible for the repression that followed the Commune because he did not write a line to try to stop it. It was not his business, people will perhaps say. Was the Calas trial Voltaire's business? Was Dreyfus's condemnation Zola's business? We at *Les Temps modernes* do not want to miss a beat on the times we live in. Our intention is to influence the society we live in. *Les Temps modernes* will take sides.[2]

The tone was set, the thinking promised to be muscular and the writing fearless.

The first issue opened with a story from a collection soon to be published in France. The short story, "Le feu dans la nuée" ("Fire and Cloud") by the black American writer Richard Wright, with its title taken from *Uncle Tom's Children*, shocked French readers with its "negroes," its lynch mobs in the deep American South, and its criticism of religion. "Fire and Cloud" not only introduced a gifted new writer to French readers but also shed light on racial discrimination in America in lyrical and violent language, superbly translated by Marcel Duhamel. It was followed by an article on poverty, inflation, and famine by Raymond Aron; a psychiatrist's commentary on collective psychosis in time of war and how war introduced a festering anxiety in everyone; an account of the Pétain trial by Raymond Aron; reportage on the V-E Day celebrations in New York; and Philip Toynbee's Letter from London. This first issue concluded with an article by Sartre titled "The End of the War," in which he wrote: "Peace is a new beginning but we are living an agony. We go from war to peace through

different stages, different shades. War has left everyone naked, without illusions; they now can only rely on themselves and this is perhaps the only good thing that has come out of it."[3]

The first issue of *Les Temps modernes* made a strong impression on readers in Paris and abroad. The tone was original, the reportage read like literature, the style was uncompromising, and the analysis pugnacious. *Les Temps modernes* shocked with its pessimism, yet it also felt new. It was not the nihilism of the 1920s with suicide as a lifestyle choice—this new pessimism was less passive, often prompting immediate action. *Les Temps modernes* enriched whoever read it; it also provoked and disturbed them profoundly.[4]

As the journal hit the newsstands, Gallimard released another work by Sartre, the first two volumes (*The Age of Reason* and *The Reprieve*) of a three-part novel titled *Les chemins de la liberté* (*The Roads to Freedom*). The novel revolved around Mathieu, a Socialist philosophy teacher, and his group of friends, whose lives are redefined by their actions (or lack of actions) during the Nazi occupation. Like Beauvoir in *Le sang des autres* (*The Blood of Others*), Sartre was addressing the issue of commitment or, as they called it, *engagement*. Simone de Beauvoir's second novel, *Le sang des autres*, about the nature of freedom, had come out a few months earlier. Praised by reviewers and dedicated to her former student and lover Nathalie Sorokine, it told the story of Hélène and Jean, a young couple during the Occupation, and the consequences of their actions for themselves, for others, and for the course of history. To resist or not to resist the German occupants was a central question in which passivity as much as resistance appeared a radical choice. Simone was on the same wavelength as Sartre and together they were developing what they referred to as a philosophy of existence. The press gave it a different name: Existentialism. Young people flocked to it because of all the varieties of atheism, it placed men and women at the heart of their lives and that of society. Responsibility for their actions as much as for their inactions, for their commitment or lack of it, was theirs and theirs alone. No more excuses; men and women were what they did or what they did not have the courage to do. Sartre's philosophy also offered new, modern freedoms expressed through jazz music, American literature including pulp fiction, all kinds of popular culture usually looked down on, sexual experimentation, and innovation in the arts. This greatly attracted young minds.

Wherever you walked in Paris in October 1945, bookshop windows displayed Beauvoir's and Sartre's latest novels side by side, while newsagents sold *Les Temps modernes*. The three publications were discussed in cafés, in newspapers, and on the radio. There was suddenly no escaping the sometime couple.

In fact, after just a few issues, *Les Temps modernes* had not only managed "to break down the divide between literature and journalism," it had also "acquired, throughout Europe, and parts of North America, a reputation for being fresh, stimulating,"[5] and, more important, thought-provoking. The bimonthly Sunday afternoon editorial meetings were now an established routine for everyone and they would soon often take place at Sartre's new home. His eighteen years of hotel life was coming to an end while Beauvoir's was going to last another two years at La Louisiane. His mother, Anne-Marie Mancy, had recently lost her husband, a stepfather with whom Sartre had never gotten along well, and he had agreed to live with her. She had found an apartment at 42 rue Bonaparte, on the corner of the place Saint-Germain-des-Prés, with a view over both the church and the Café des Deux Magots. On the morning of Sunday, May 12, 1946, Sartre took his two brown leather suitcases and reached the fourth floor of this typical sandstone pre-Haussmann building, slightly out of breath. The maid, the good old Alsatian Eugénie whom he had known for years, helped him settle in. He looked around; he liked it there. He chose the living room with its south view over the square as his study, his office, and his boudoir. It was not very large but could host the weekly editorial meetings. In any case, it was never bad when people sat close to each other; the proximity created a certain warmth. He had identified a little corner near the second window where he would put a tiny desk, in fact a bridge table, for Simone so she could come and write in the afternoon. They had ceased to be lovers years ago; Simone was a "grande amoureuse," while he was more interested in the chase than in the sexual act, but they had many other ways of intimate communion, and writing together was one of them.

Les Temps modernes' editorial meetings, which Simone called "the highest form of friendship," increasingly dragged well into the night, by which time heated intellectual arguments subsided into general laughter. The journal considered its public very seriously. Every Tuesday for two hours, "readers' conferences" took place at *Les Temps modernes'* little office at Gallimard. Simone de Beauvoir attended almost every one of them. As

promised at the magazine's outset, whoever among the magazine's readers wanted to meet with a member of the editorial committee could do so. The Tuesday visitors came to discuss articles, seek advice, or submit texts, either comments or letters, in the hope they would get published. Abbot Gengenbach, a "half-defrocked priest," became a regular visitor. "A Surrealist, he drank heavily, cursed the Church, and went out with women. He then locked himself up for a few weeks in a monastery to make amends."[6] The abbot used to come to the office to submit texts, "some of them actually good," and request money. One day he forlornly asked Beauvoir: "But why does André Breton hate God?" On another Tuesday afternoon the receptionist rushed to Simone's office: a reader whose text had been turned down by the editorial committee had just cut open his wrists.

EXISTENTIALISM, THE NEW PHILOSOPHY
THAT MAKES PEOPLE FAINT

On October 29, 1945, Sartre was racing against time, as usual, finishing writing notes for the talk he was giving that night titled "Is Existentialism a Humanism?" He was due at eight thirty at Club Maintenant, a lecture hall and former *hôtel particulier* of Princess d'Essling, behind the Grand Palais. Sartre did not have time to change—he never did—besides, he was certain there would not be many people attending despite small advertisements in the press. He and Beauvoir left the Café de Flore late and arrived slightly out of breath at the rue Jean Goujon in the 8th arrondissement. They found the right room, but when they opened the door they were greeted with "Go away, you're too late, there is no room left." The lecture hall was packed with people standing up and sitting on the floor. The organizers had to help them get through the crowd so Sartre could start his lecture.

A very tall, thin blond man with a pale face was standing, crushed between a fat middle-aged woman and a young female student with a ponytail and a black turtleneck. His name was Boris Vian, and the twenty-five-year-old would soon immortalize this memorable evening in his first novel, *L'écume des jours* (*Foam of the Days*). The room was overcrowded and too hot. Sartre loosened his tie slightly and started explaining his idea of *engagement* and moral responsibility in a very accessible way. Soon after he had started talking, a woman fainted, and then another.

Fortunately, somebody thought to open the windows, but Beauvoir's and Sartre's reputation was practically sealed that instant. Existentialism had struck and claimed its first two victims. Here was a new philosophy powerful enough to make people faint. As soon as *Samedi Soir*'s account was published the next day, word spread and youngsters flocked to buy Sartre's seven-hundred-page, one-kilo treatise *L'être et le néant*, much as their mothers had run out to buy it two years earlier to use as a weight. *L'être et le néant* became a fashionable book, and Existentialism would soon inspire a cult following. Or, as Janet Flanner saw it with her deprecating humor: "Sartre is automatically fashionable now among those who once found Surrealism automatically fashionable."[7]

In its account of the evening, the Communist-leaning *Samedi Soir* had referred to Simone de Beauvoir as "La Grande Sartreuse" and "Notre Dame de Sartre." It was meant as an insult; it made her laugh. The newspaper also revealed that, although they were a couple, her relationship with Sartre was not an exclusive one, and that they had never married. This shocked half of France and electrified the other half. In a matter of days, the scandalous couple were being chased by photographers; people stared at them and whispered as they passed. And yet Sartre did not change his routine, at least not at first. He continued to dress the way he had always done—that is to say, without paying much attention to it—he worked in cafés, had dinner out with either Beauvoir or his mistress du jour without trying to hide the way he lived.[8] This, of course, caused even more fury among the bourgeois, who hated the vision of France and French bourgeoisie that Sartre's novels and new journal were projecting back at them. Sartre was accused of "sordid realism" and "miserabilism."[9]

Sartre took fame in his stride, not that he looked for it—rather the opposite. This sudden glory felt to him idiotic and a high price to pay. He had wanted to write novels, to be a writer, to be a genius living in obscurity like Baudelaire. Events had decided otherwise and sentenced him to be an outspoken intellectual living in the glare of public attention. Nobody would ever remember what he wrote but only what he was and what he said—in other words, he would be remembered as a public intellectual, not quite the same thing as the great writer he had once wanted to be. "From now on, he would put the absolute in the ephemeral, he would lock himself up in the present and in the time he lived in, he would accept to perish entirely with his epoch,"[10] wrote Beauvoir. What extraordinary clairvoyance and

lucidity. Indeed, *Les chemins de la liberté*, his second novel, would be his last work of fiction. Sartre would sacrifice himself to commenting and trying to influence the world.

Simone de Beauvoir resented this sudden fame less than Sartre; she was also less exposed than him. She had always liked the immediacy of life, its many physical and sensual pleasures, friendships and conversation, gossip too. Their journal's first issue had provoked so many reactions, so much anger and so much praise, that they both threw themselves into producing the following ones. However, some Communist writer friends suddenly declined to write for *Les Temps modernes*. They had been told not to by the Party. What of the Resistance spirit that was supposed never to die? In fact, verbal abuse started flaring up in some corners. The Catholic daily *La Croix* laid into Sartre's *L'être et le néant*: "This atheist existentialism is a far greater danger than the eighteenth-century rationalism and the nineteenth-century positivism put together."[11] The Communists branded Existentialism "a sordid and frivolous philosophy for sick people."[12] They attacked Sartre personally, claiming that his dirtiness was both physical and moral and that, just like a pig, he wallowed in dirt. As two bourgeois who had decided to disavow their social origins, Sartre and Beauvoir understood the bourgeoisie's violence against them, but they were deeply hurt by the Communists' reaction.

Editorial meetings became heated affairs. Beauvoir always disagreed with the art critic Michel Leiris about poetry, and Raymond Aron soon refused to publish any pro-Communist articles and comments. Camus had approached him to join *Combat* and he was seriously considering it. "In this period of renaissance, still hesitant and slow-boiling, there were many new questions, challenges to be met, mistakes to correct, misunderstandings to dispel, and criticisms to reject. Our debates had the intimacy, urgency and warmth of family quarrels,"[13] wrote Simone in her diary. Beauvoir and Sartre thrived on dissent and debate. Now that their journal had shaken up public conscience, there was no stopping them.

The journal's December 1945 issue did not disappoint. In an uncompromising introduction, Beauvoir explained the nature of Existentialism: "If Existentialism upsets and worries some people, it is not because it is a philosophy of despair but rather because it demands that people live in a state of constant tension. Why so exacting, though? Why insist that

people leave their comfort zones?"[14] Then came an extract from Jean Genet's forthcoming *Pompes funèbres* (*Funeral Rites*), which opened with the line "To me, sausages and pâtés tasted like corpses." Genet, still largely unknown, and whose early poetry and novels Sartre and Cocteau had championed, was deemed a pornographic author. Readers were also given the first pages of Sartre's first critical essay, *Réflexions sur la question juive* (*Anti-Semite and Jew*); Nathalie Sorokine, now pregnant and married to an American GI, the screenwriter Ivan Moffat, wrote a piece based on her own experience flirting with American GIs in Paris called "Nuits sans importance" ("Meaningless nights") in which she in fact revealed that she had prostituted herself in exchange for cigarettes, coffee, and milk. There was also an analysis of the British social reformer William Beveridge's book *Full Employment in a Free Society*, a theater review of Camus' *Caligula*, a Letter from America by an ex-GI returning home from France, chilling witness accounts of a former *Lagercapo Stubendienst* (an inmate assigned to barracks orderly duty) in concentration camps, and a roundup of British and American views and comments on the forthcoming French elections.

By Christmas 1945, Beauvoir was in need of a break. Le petit Bost had just returned from reporting in the United States for *Combat* and would follow her to the French Alps. She packed her suitcase, booked herself a couchette in the overnight train from the Gare d'Austerlitz to Megève, and on the way bought a copy of *Les Lettres françaises*, which had just published a vitriolic attack on Sartre and Existentialism. On its front page, an article by the Communist apparatchik Roger Garaudy claimed: "On a reactionary philosophy. A false prophet: Jean-Paul Sartre."[15] Sartre's independence made him an enemy of the Communists. The Communists in fact feared Sartre, who was becoming increasingly popular with the young.

The sight of the snowy mountains lifted Beauvoir's mood and she climbed the path toward the Chalet Idéal-Sport, carrying her heavy suitcase, with renewed energy. Bost, Olga, and Wanda were arriving by the next train. For a week, while the indolent Kosakiewicz sisters never left the sundeck of the chalet, Simone and Bost would race merrily down the slopes. She was looking forward to 1946. She had been asked to give a series of talks on Existentialism in North Africa, starting in Tunis, and was going to travel by plane for the first time.[16]

THE VIEW FROM BROOKLYN

From Brooklyn, the thirty-seven-year-old star of black literature Richard Wright was delighted by *Les Temps modernes'* decision to publish his short story as its first serialized piece of fiction. Reactions had been encouraging, and his French publishers were planning to use the commotion it had created to promote his forthcoming books. He had not met Beauvoir or Sartre yet but he felt an affinity with his Left Bank admirers. They shared a certain anger at the world, though Wright was even angrier than his French counterparts—or, as his friend the black American writer Ralph Ellison had put it, "agitated to a state of almost manic restlessness." Wright agreed with his friend's judgment. He wrote in his diary: "Why can't I just sit like other people? What is gnawing at my gizzard? It is because I'm in such contradictory circumstances; a plantation Negro living in New York, a peasant who is an artist of sorts, a Negro married to a white girl, a Communist who cannot stand being a member of the Communist groups?"[17]

Wright lived in Brooklyn among the black middle class, what the blacks from Harlem called "the People on the Hill." He was married to a white American woman of Russian and Jewish origin, Ellen Poplowitz, and they had a three-year-old daughter named Julia. Reviews had compared him to Steinbeck and Dostoyevsky. In other words, he was a successful and admired writer with his life firmly rooted in America. He had no personal connection with Paris or France. The grandchild of African American slaves who had worked in the cotton fields in Mississippi, Richard Wright had heard stories as a boy about black American servicemen fighting in France during the First World War. He knew that France's General Foch had given the highest military distinctions to African American soldiers when their own General Pershing had denied them the right to use bayonet rifles against the white Germans.[18] And as a teenager, Wright had devoured French literature: Dumas, Balzac, Flaubert, Anatole France, Maupassant, Pierre Loti, Rabelais, Voltaire. Marcel Proust had dazzled him, Aragon's Stalinist poem "Front Rouge" in 1930 had shaped his politics, and André Gide's *Retour de l'URSS* (*Return from the USSR*) in 1936 had cured him of his Communism.

Fame had been both a blessing and a curse for Wright. He was now receiving a lot of mail from shocked fellow African Americans who disap-

proved of his marriage to a white woman. A Southern black woman had written to him that he had set a bad example. He ought to have married a colored woman—"there are all shades among us," the woman had argued—and he should have shared his wealth with his own race. "I did not marry a white woman," he retorted in his journal on January 17, 1945, "I married the woman I loved."[19] A week later he added: "I'd say that one could live and write like the way I do only if one lived in Paris or some out of the way spot where one could claim one's whole soul. And I cannot do that here now."[20] Richard Wright wanted to leave his color at home and not be exclusively defined by it; he wanted to be free from race consciousness. On March 11, 1945, Wright and his wife had submitted a passport application to go to Paris.

INCUBATING NEW IDEAS, TALENTS, AND LITERARY GENRES

With Sartre touring American universities and giving talks on Existentialism, Simone de Beauvoir could not afford to stay away from Paris for too long, and after a couple of weeks spent in Tunisia lecturing about the philosophy of existence and visiting the Sahel desert, she returned to the helm of the magazine, with editorial meetings taking place once a week in her hotel room or at the journal's tiny office at Gallimard. She particularly wanted to help and promote new and young writers. She kept encouraging Violette Leduc, who was working on a novel.

Leduc was an odd one. She had fallen for Simone after reading *She Came to Stay* in 1944, which had revealed Simone's bisexuality. An unwanted and unloved child never officially recognized by her father, Violette had spent the war years living off the black market, trafficking and schlepping heavy loads of meat and butter from Normandy to Paris restaurants every week. She was angry, rebellious, and amoral and had decided to channel her raw energy and spite into her writing. One afternoon, Violette had appeared in front of Beauvoir's table at the Café de Flore with a manuscript in her hand; it was titled *L'asphyxie* (*In the Prison of Her Skin*). Beauvoir had been immediately struck by Violette: "She was tall and blonde, elegant with a face that was brutally ugly but bursting with life."[21] Simone had promised to read her manuscript. She was hooked from the first sentence: "My mother never held my hand." Simone asked her to rewrite the

second part; Violette did it at once. Simone then offered the revised man-
uscript to Camus who, in parallel to his work for *Combat*, edited a collec-
tion of novels by first-time writers at Gallimard. Beauvoir also chose an
extract to be published in the November issue of *Les Temps modernes*. A
new angry and original voice was born. Both Sartre's new protégé, the
thief turned poet Jean Genet, and Jean Cocteau recognized in Violette
Leduc a sister in arms.

Beauvoir had introduced Violette Leduc to another writer who had just
had her first piece accepted in *Les Temps modernes*—Nathalie Sarraute.
Sarraute, née Tcherniak, a Russian Jew married to a Frenchman, eight
years older than Beauvoir, had spent the war years in hiding, under false
identities, moving from one place to another. She had herself sheltered
Samuel Beckett and Suzanne Déchevaux-Dumesnil in September 1942
when they had been forced to leave their Paris home immediately after
the Resistance network Gloria was uncovered by the Gestapo. The anti-
Semitic laws of 1941 had deprived Sarraute of her *métier*, that of lawyer, so
she had turned to writing. Both Sartre and Beauvoir, who had warmed to
this woman with her "disquieting subtlety,"[22] had resolved to help her find
a publisher. Sarraute was currently writing her first *"anti-roman,"* as Sartre
had swiftly named it with his talent for formulas, which she had titled
Portrait d'un inconnu (*Portrait of a Man Unknown*). *Les Temps modernes*
decided to publish extracts in the hope of attracting the interest of a
publisher.[23] The term "anti-novel" stuck. Also widely known, ten years later,
as *le nouveau roman*, this literary form, subordinating plot and character-
ization to a vision of the world, was a product of the laboratory of ideas
that Sartre and Beauvoir's monthly review encouraged.

Simone de Beauvoir spent her evenings with her new friend[24] Boris
Vian, engineer, jazz trumpeter, former Zazou,[25] translator of American
thrillers, and aspiring writer. Simone laughed at the way Vian was still
dressing, *à la Zazou*, in blue jeans and checked shirts from the U.S. Army
surplus. They both liked to drink and to listen to jazz. Six years earlier, a
barely twenty-year-old Vian had married his sweetheart, a pinup blonde
named Michelle; they had had a boy, Patrick, whom they entrusted to her
parents. Neither of them had any aspiration or talent for parenting, and
they were not going to pretend otherwise. They liked inviting their friends
to "tartine parties"[26] when they could lay their hands on bread. Sometimes

they simply asked their friends to come with their own rations. Just before the October 1945 elections the Gaullist government had taken bread off ration, astutely trading bread for votes—except that by January 1946 the newly elected deputies, facing a wheat shortage, reintroduced bread rationing. The French were allowed only three slices per person per day more than the Nazis had permitted in 1942, the worst of all the war years.[27]

At one such soirée in January 1946, Beauvoir and Vian talked until dawn, a "fleeting moment of eternal friendship"[28] as she recalled. Vian was making a living as an engineer and was dying of boredom during his office hours. He was also literally dying of a lung condition he had had since his childhood; he knew he would not live to forty. Life was going to be very short and he had resolved to make the most of it. To do this, he almost had to give up on sleep. In January 1946, life for Vian really began only at six in the evening and continued until the wee hours of morning, when he slept a few hours before going to work. He was, however, hoping that a writer's advance he got from Gallimard thanks to his friend Raymond Queneau would soon allow him to quit his day job. He had an idea for a first novel, he teased Simone, in which he might write about her and Sartre. Sartre and Beauvoir had become a living and philosophical gold standard, especially for Boris Vian's generation.

In Sartre's absence, Beauvoir had been particularly struck by two unpublished autobiographical works by David Rousset, the short *L'univers concentrationnaire*[29] and the eight-hundred-page "novel" *Les jours de notre mort* (*The Days of Our Death*). Both revealed for the first time, in great detail, with sangfroid and in-depth analysis, the machinery of the concentration camps. Rousset, a *résistant* and former Paris correspondent of the American magazines *Time* and *Fortune*, was bearing witness in a cool and thus extremely powerful way to his two years spent at Buchenwald and Neuengamme camps. It would be another year before Primo Levi would write his own memoirs of survival in Auschwitz, *If This Is a Man*. *Les Temps modernes* published extracts of both David Rousset's forthcoming books in its March and April issues, to great acclaim and general stupefaction. Offers from foreign publishers started flooding in, such was the power of the journal at home and abroad. Simone wanted Sartre to meet Rousset, a real character, who had regained his prewar corpulence and was now a chubby thirty-four-year-old with only one eye (the result of a prewar tennis game that went terribly wrong).

Sartre finally came back from the United States at the end of April 1946. Simone had so many things to tell him, so much to give him to read. She had worked hard, and partied hard, while he was away, and she had one manuscript ready and another started. She needed his advice. They spent their first evenings together in the smoky, noisy basement bar of the Méphisto, the only place where members of the public would not harass them. The doorman let in only people he knew and they were almost all writers and philosophers. Sartre read the last draft of Simone's novel *Tous les hommes sont mortels* (*All Men Are Mortal*) in one go. She had been writing and rewriting it since 1943. It told the story of a young actress, not unlike their darling Olga, and of an immortal man she gets involved with. It dealt, in fact, with Simone's obsession with the passing of time and death closing in on her. After turning the last page, Sartre smiled at her. She could send it to Gallimard, he told her. She was relieved. She then told him about an essay she had started writing *Pour une morale de l'ambiguïté* (*The Ethics of Ambiguity*), but she stopped midsentence: Sartre was not looking well. Was it the noise, or the smoke? He had difficulty swallowing, he said, his ears were buzzing, and he felt feverish. "Let's go," said Simone, and they walked back to the Hôtel La Louisiane, avoiding the boulevard Saint-Germain and taking the little streets instead, rue Jacob and then rue de Seine. The fresh air restored his spirits for a while, but something was wrong.

The following morning Simone called the doctor, whose visit bore bad news: Sartre had mumps. He had to remain in quarantine. The doctor spread a thick black ointment on Sartre's face and neck. He looked at himself in the mirror and they both burst out laughing. The doctor gave Simone a list of things to buy at the pharmacy. She took her bag and left Sartre to ponder his new *condition humaine*. Or was it *condition masculine*? The doctor had told him to look at his testicles regularly, as the mumps might cause them to swell.

In the very animated rue de Buci, Simone looked around her with a smile. The street stalls and grocery windows were full of goods—a far cry from the spring of 1945. Women were admiring cauliflowers, asparagus, the first strawberries, and lilies of the valley in little tin pots.[30] Prices remained steep, so there was more admiring than buying. A new banknote had just come out, but it remained a rare sight in Parisians' purses. The "fancy 500 Francs note was stamped with the portrait of the melancholy

poet Chateaubriand holding his head, as well he might,"[31] noted Janet
Flanner.

EXISTENTIALISM GOES GLOBAL

Time magazine dedicated five pages of its 1945 issue to "the literary lion
of Paris who had bounced into Manhattan." The caption under the flatter-
ing portrait of Sartre that ran with the article read PHILOSOPHER SARTRE.
WOMEN SWOONED.[32]

American women may have swooned, but they did not pass out, as
they had at Club Maintenant. Marcel Duchamp, seated in the first rows
of Carnegie Hall in New York, had exclaimed: "We are now before Sartre
Cathedral."[33] The literary critic Lionel Abel, also seated in the first rows at
Carnegie Hall, not far from Marcel Duchamp, had had the chance to
meet the philosopher for lunch beforehand, at a French restaurant on
West Fifty-Sixth Street. The lunch had been organized by the anti-Stalinist
and Trotskyite-leaning magazine *Partisan Review*. Lionel Abel and the phi-
losopher Hannah Arendt had been invited as guests but were also expected
to serve as interpreters for the French philosopher. Abel did not exactly
swoon when he met Sartre, but he could not take his eyes off him, either.
Sartre had "the most interesting modern face," he wrote. "Short, stocky,
thick-wristed and broad-chested, the thrust of his shoulders gave one a sense
of physical power; his speech was sharp, crisp, virile, while his complexion
was an unhealthy gray."[34] The *Partisan Review*'s editors, Philip Rahv and
William Phillips, wanted to make sure that they were all on the same wave-
length and that Sartre would continue to attack Stalinist influence when
he returned to Europe, as they were doing in America.

What they did not realize was that Sartre was even more suspicious of
American capitalism than he was of Stalinism. But Sartre did not want to
bruise his American friends too much, delighted as he was by his trip—he
loved New York and its adoring crowds. He wanted to enjoy the moment
as long as he possibly could, a desire Sartre confided to the *New Yorker*'s
"Talk of the Town" columnist just after his talk at Carnegie Hall, showing
his childlike happiness, and his wit: "Two phrases only are necessary for a
whole evening of English conversation, I have found: 'Scotch and soda' and
'why not?' By alternating them, it is impossible to make mistakes."[35] The
truth was that Sartre, like Beauvoir a few months later, was both fascinated

and repulsed by America and American culture. He was already thinking about *Les Temps modernes'* special double summer issue, which he wanted to dedicate to the United States. Sartre, who loved America in so many ways, was also lucid, seeing through the American "founding myths: happiness, progress, realism, optimism, triumphant motherhood, and freedom."[36]

Albert Camus was to follow closely in his friend Sartre's footsteps and was packing his suitcase for America. Camus was considered the third Existentialist musketeer. He didn't think he had much in common with his friends' "modish new philosophy," as Janet Flanner put it in the *New Yorker*, but the association certainly did not bother him, at least for the time being. After all, Existentialism mania had feverishly gripped New York's intellectual and student circles. Newspapers and magazines were full of it, trying to explain it to their readers. It scared many people, though, who deemed it a little too gloomy.

Richard Wright was not scared; he was impatient, and a year had passed without any news of his passport application. One afternoon in March 1946 he had received a call from Dorothy Norman, columnist for the *New York Post*, Alfred Stieglitz's lover, and the wife of a millionaire. She was throwing a party for Sartre and would love him to come. Wright was excited; though his short story had been published in the first issue of *Les Temps modernes*, he had never met Sartre in the flesh. The evening was a great success; he warmed to Sartre immediately and, just as important, he met the French cultural attaché Claude Lévi-Strauss, who promised to resolve his passport problems. "Leave it to me," the anthropologist and diplomat told him. Six weeks later, on April 25, Lévi-Strauss presented him with an official invitation from the French government to come and visit Paris. France would pay for his fare and first month's expenses.

Even the U.S. State Department in Washington was taken by Existentialist fever. All these French events, activities, talks, lectures, and articles in the U.S. press got the State Department slightly concerned, or perhaps simply curious. On the morning of January 31, 1946, Frederick B. Lyon, head of the foreign activity correlation division, had written to the FBI director, J. Edgar Hoover, to inquire about a certain Camus whose newspaper *Combat* had published inaccurate and unfavorable reports about America.[37] Could a preliminary investigation be made? There was no file on Camus yet at the FBI. Washington agents had to resort to reading the press, and more particularly an article written by Hannah Arendt pub-

lished in the *Nation* early in February, to get slightly more familiar with Existentialism and Albert Camus. They also learned that both Camus and Sartre had refused the Legion of Honor. Suspicious. On his visa application Wright had asserted that he had never been a Communist sympathizer. This provoked hilarity among his close friends but the FBI took his word for it.

Invitations for talks kept landing on Beauvoir's and Sartre's desks at *Les Temps modernes*. After the success of Sartre's American tour, the whole world now wanted to hear about Existentialism. Countries would have to take it in turn: lectures and signings in Switzerland, Italy, and Scandinavia were planned for the spring and the summer. New friends from afar were also making their way to Paris.

In May 1946, Richard Wright, his wife, Ellen, and their daughter, Julia, left New York Harbor on board the SS *Brazil*, an old cargo boat transformed into a troopship and now a passenger liner. The black American writer felt so impatient to reach the other side of the Atlantic that he had not been able to repress a thought that would have astonished many immigrants. He kept his unusual and shocking sentiment for his diary: "I felt relieved when the ship sailed past the Statue of Liberty."[38] Such was his resentment at America, such was his excitement at discovering a new world. The overnight train ride from Le Havre to Paris on May 9, 1946, proved shocking. Wright could not take his eyes off the forlorn scenery: "There was rubble everywhere."[39] As for the French, they looked poor, thin, and hungry. Wright felt strangely privileged, almost part of an upper class. He felt that to the French he was not black, he was simply rich, well fed, and American.

At dawn on May 10 the train pulled in at the Gare Saint-Lazare. A fresh breeze welcomed the little family as they stepped onto the platform. Wright had prayed and hoped for a triumphant arrival in the City of Light. His wish would be granted. Being a guest of the French government, he was greeted by an official from the Ministry of Foreign Affairs. Also on the platform was Douglas Schneider from the American embassy, with not one but two black limousines waiting outside the station. This was unexpected. In fact, smelling the potential for trouble and aware of its compatriot's ambivalence toward America, the State Department had asked its embassy people in Paris to ingratiate themselves to the Wrights in as many ways as possible. Limousines at dawn would probably impress. They were right.

To complete the welcome committee, a journalist from *Combat*, Camus' friend Maurice Nadeau, was there, too, with a question for the celebrated writer: What were his first impressions? A little early for this, replied Wright, laughing it off. In truth, he "felt confused and important and scared."[40] The American diplomat asked Wright if he wanted a brief tour of the city before going to his hotel; it was early and the traffic should be good. One limousine was filled up with suitcases and trunks, the other with Wright and his family. The "Paris by dawn" tour, through the place de la Concorde, along the Champs-Élysées, the riverbanks, Notre Dame, and the Louvre, had its effect. Wright was at a loss for words. All he could repeat was "How beautiful! How absolutely beautiful!" The limousine finally drove up the rue Monsieur le Prince and turned left toward the Hôtel Trianon Palace, 3 rue Vaugirard, overlooking the Sorbonne.

On Sunday, only two days after his arrival, Wright had been invited to attend the editorial meeting of *Les Temps modernes* at Sartre's new home. There could not be a more direct introduction to intellectual life in Paris and its strange mores for an American recently arrived from Brooklyn with only a smattering of French. The Paris sky was cloudy when, from their respective hotel rooms and lovers' dens, the contributors to the review made their way to the place de Saint-Germain-des-Prés. Boris Vian, whom Simone had invited to join the writers' team, had forgotten his umbrella but had thought of bringing his trumpet: one never knew, it could prove useful. A trumpet could lighten somber moods, ease heated political arguments, reconcile enemies. Simone had stopped at the Café des Deux Magots on the way to buy cigarettes, and she had a bottle of cognac in her bag. Though they were meeting at six, discussions often dragged on for hours. Everybody liked a little pick-me-up, especially after one of Merleau-Ponty's strenuous and long expositions on phenomenology. Sartre's mother had baked doughnuts, and the maid, Eugénie, had conspicuously placed a bottle of plum brandy from her beloved Alsace on Sartre's desk.

When Wright arrived, the cigarette smoke in the room was already so thick that he had difficulty distinguishing Simone's turban in the fug. The conversation focused on the special double summer issue dedicated to American society, politics, and literature. Wright not only would help and advise on the content; his own work would also take center stage. *Les Temps modernes* intended to commission many articles from American journalists and writers rather than just publish French opinions on the

United States, one after the other. American voices would in fact be pre-
dominant. Sartre asked Dolorès Vanetti in New York to be, in effect, the
magazine's liaison officer in the United States, commissioning writers
directly, collating pieces, editing, and translating them. Boris Vian volun-
teered to write about Negro spirituals, and Simone mentioned serializing
Black Metropolis by St. Clair Drake and Horace R. Cayton, a study of race
and urban life and a sweeping historical and sociological account of
the people of Chicago's South Side from the 1840s through the 1930s.[41]
She also wanted to publish extracts from *Jazzmen* by William Russell and
Stephen W. Smith, *The Book of American Negro Spirituals* by James Wel-
don Johnson, and *Generation of Vipers* by Philip Wylie, a biting portrait of
the American woman. It was agreed that the art critic Clement Greenberg
would be commissioned to write a long piece on American art from 1900
onward.

Boris Vian had slipped into his trumpet case the manuscript of
L'écume des jours,[42] which he had just finished typing on his engineering
company's paper. Would he dare give it to Simone after the editorial meet-
ing? In his novel, two characters were philosophers, one called Jean-Sol
Partre and the other the Duchesse de Bovouard. The puns and wordplays
on Existentialism were aplenty: Sartre's thick philosophy treatise *L'être et
le néant* was referred to as "Lettre et le néon" [*The Letter and the Neon*], "a
catalog of lighting appliances." During the editorial meeting at Sartre's,
Vian sometimes fell silent and looked around him: he knew he was out of
place. Unlike everybody else, he absolutely and resolutely refused to be
serious. He had a taste for the absurd, for paradoxes, *contre-vérités*, and
above all irreverence. He would soon come across, in such a politicized age
and milieu, as apolitical and therefore would often be looked down on as
just an *amuseur*, a musician, a dreamer. In fact, Vian was not indifferent to
the age he lived in, quite the opposite, but unlike the other people in the
room he knew he was living on borrowed time.

After the meeting, as everyone said good-bye, Vian insisted on walking
Simone back to her hotel and summoned up the courage to entrust his
manuscript to her. She smiled at him knowingly and promised to read it
quickly. Simone was an efficient and fast reader with a very sharp eye.

Back in her bed in her round room, and not at all fazed by the effects
of alcohol, Simone started reading Vian's novel, a love story of a dying
young woman with a water lily in the lung and her adoring and eccentric

young husband. She read it in a few hours and was struck by "its great truth and profound tenderness."[43] Beyond the wordplays, the almost self-indulgent use of paradoxes, she saw a fragility, a poetry, and a beauty that would make it a bestseller and a classic, but only ten years after Vian's death. The young writer, whom very few people could make out during his life-time apart from Raymond Queneau, Beauvoir, and Sartre, did not live in the present tense. He had his eyes firmly set on posterity. His posthumous success would vindicate him.

Simone and Sartre greatly enjoyed Vian's impudence, and they prom-ised to say a kind word to Gallimard and to support his novel. They also gave him a monthly column in *Les Temps modernes* called "The Liar's Chronicle" and agreed to publish extracts of *L'écume des jours* in their October issue. Their decision ruffled a few feathers among their young colleagues, who considered Vian too much of an outsider. He preferred to live on the Right Bank, was an engineer by training, played the trumpet, and mocked the Existentialists in his columns. Still, he had style and talent, the most important things.

The morning after she read Vian's novel, Beauvoir walked to the Café de Flore. She still used the café as her mailbox. Richard Wright soon joined her, and together they worked on the content of the U.S. double issue. Richard Wright had spent only a week in Paris and already the culture shock was making his head spin. Every day he took notes about the practical and not so practical differences. "The knobs were in the centre of the doors! Sand-wiches were a rough slab of meat flanked by two oblong chunks of bread. Hot milk was used in coffee instead of cream. The women were beautiful and unashamed of being women. There was an openness in France, an intensity too."[44] Wright took to walking the streets at night; he loved their serpentine narrowness, and the yellow lamppost lighting transformed the city into a mysterious theater set. He had also been busy researching figures and data. He learned that there were twenty thousand black people in the country, mostly from the West Indies and Africa but also including five hundred black Americans, ex-GIs, studying under the GI Bill of Rights in Paris. The thing that most surprised him was that he did not feel black in Paris: he felt simply American, and just that, for the first time in his life.

Wright was bewildered, though, to see how modestly and uncomfort-ably Parisians lived. Hotels, in which he realized many people dwelled for lack of available housing, were decrepit, to say the least, and the bathroom

and toilet on the landing had to be shared. He had no idea what Parisians had lived through. In fact things were not that bad, as Janet Flanner told her *New Yorker* readers at the end of May 1946: "Shop windows are no more shabby but now excellently dressed. In other words, Paris is now like an old woman with some natural color flushing her cheeks."[45] Transport was improving hugely too. You no longer needed to be pregnant or ill to get a taxi or to apply for the right to do so at the nearest police station. There were now five thousand taxis in Paris. Twenty-seven more of the closed métro stations had just been reopened, which saved hours of walking. There were downsides, though: "Some of the antique green autobuses have lumbered back on the job, all with new routes and numbers, thus mixing confusion with satisfaction."[46]

Constantly in demand, Richard Wright was giving talks and endless interviews. An American official from the U.S. embassy had half-jokingly warned him: "Do not let these foreigners make you into a brick to hurl at our windows!"[47] What might he say about racism in the United States? The embassy was concerned and scrutinized every interview he gave the French press, like the Communist *Samedi Soir*'s long piece in which Wright merely offered his first impressions of France. Wright knew he was being watched; he was careful.

CHAPTER SIX

❧

LUST AND EMANCIPATION

"WAS IT THE WEIGHT OF WAR ON MY TOO YOUNG SHOULDERS?"
Claude Lanzmann asked in his memoirs. "Was it the precarious equilib-
rium of those years between life and death? This new freedom of mine
meant that I needed to prove my own existence with sometimes gratuitous
acts."[1] The experience of war and the feeling of having cheated death for
four years were key to postwar Paris intellectuals' and artists' unquench-
able thirst for freedom in every aspect of their lives. Whether born into
the working class or the bourgeoisie, they wanted little to do with their
caste's traditions and conventions or with propriety. Family was an institu-
tion to be banished, children a plague to avoid at all costs. However, these
were the hardest notions to do away with, and while Jean-Paul Sartre and
Simone de Beauvoir managed to stick to their initial plan of "no marriage,
no children," or simply "no children" for Arthur Koestler, for the sake of
art and life experimentation, others, usually men, decided to carry on the
hypocrisy of their elders by marrying and then enjoying a secret and very
free other life on the side. It did not make them particularly happy, though,
and men like Camus and Maurice Merleau-Ponty who chose trompe l'oeil
existences crushed many lives around them.

Strong and remarkable women were also hungry for freedom in all its
forms. Simone de Beauvoir and Janet Flanner, Édith Thomas and Domi-
nique Aury, were among the many women who called men's bluff and
decided that they, too, would live according to their desires and ambitions
without any restraints. Financially independent, intelligent, bold, curious
about life's pleasures and sensations, not afraid of the danger of repeated

illegal abortions, those feminist pioneers offered a model of emancipation for many generations to come. Heterosexuals, homosexuals, or bisexuals, on the subject of sex they had "a Greek amoral point of view."[2] Juliette Gréco, Françoise Sagan, and Brigitte Bardot were all the little sisters of Simone de Beauvoir.

"FAMILY, I HATE YOU"

Camus was missing Maria Casarès enormously. When she had heard a few months earlier that Francine Camus was pregnant, she had broken up with him. Camus had always told Maria that Francine was no more and no less than "a sister" to him, but the idea of a pregnant sister understandably irritated the young woman. Maria was twenty-two, she had plenty of male admirers, and the success of *Les enfants du paradis* had made her a star. Why should she let Camus spoil the fun? She would break a few new hearts while he changed diapers. Camus tried to forget Maria and buried himself in his work. He went to the rehearsals of his latest play, *Caligula*, every day at the Théâtre Hébertot. The leading role had been given to a young and very handsome unknown actor; his name was Gérard Philipe and he was going to be Caligula, the tyrannical Roman emperor who transcended good and evil in search of his own absolute freedom. For Camus, *Caligula* told the story of the most human and tragic of mistakes: to think that one's own freedom can be exerted at the expense of everybody else's.

On September 5, 1945, Francine gave birth to twins, Catherine and Jean, while Camus was at rehearsal. Camus was elated at first but the feeling did not last long. His mother-in-law and sister-in-law had arrived from Algiers to help Francine with the babies, but he did not feel at ease in his new role. What he resented most was the lack of time for his work and the silent demands made on him by his wife. He now started to understand and greatly envy Beauvoir and Sartre's pact: no children, ever, together or with anybody else. Arthur Koestler had told his English girlfriend, Mamaine Paget: marriage, yes, children, no.[3] Mamaine had accepted, even if reluctantly. Perhaps Francine would have accepted it too? Without the burden of children, Beauvoir and Sartre could lead very rich and productive lives. They worked hard, they played hard, they had an iron discipline, writing fourteen hours a day, going out every evening, cultivating a large

family of loyal friends and lovers, living in hotel rooms with no issues of domesticity, and spending every penny they earned—was not this the only, and truly revolutionary, way for a writer to live? Camus deeply admired them for it, and profoundly resented his own situation.

There was no turning back, though: the children had been born, he was a father and a husband, he could not rewrite the story. He would simply have to cheat and lie the way the bourgeois had always done. He wasn't proud of the thought, but it was a question of personal survival. He had work to do, things to say, battles to fight, an oeuvre to produce, and that was more important than everything, absolutely everything, and everyone, else. He had begun writing a novel that he wanted to call *La peste* (*The Plague*), but there was no time to finish it. He dreamed of a hotel room where he could write, where he could be alone, where there would be no in-laws, no babies screaming, no smell of vomit and diapers. And in the evening, Camus wanted to dance again. He loved dancing, just as Sartre and Merleau-Ponty did.

Camus took every opportunity to leave home. His twins had just been born when he accepted his American publisher Alfred A. Knopf's invitation to tour the United States to coincide with the U.S. release of *The Outsider*. Sartre's enthusiasm for America had piqued Camus' curiosity. In New York, Camus, more puzzled than fascinated by American culture, was looking for a key into this new world. The key would be named Patricia. Five days after the publication of *The Outsider* to glowing reviews,[4] the thirty-three-year-old Albert Camus met the twenty-year-old Patricia Blake. Like Dolorès for Sartre, Patricia was going to give America to Camus. Patricia was one of those "long-legged [American] dames"[5] Camus admired. But she was also more than that.

The daughter of a doctor, a pianist in her spare time, Patricia had just graduated from Smith College. She had read Lenin and Marx, was attracted to Communism, and loved Proust. She was pretty, fair-haired with blue eyes, and earned thirty-five dollars a week as a copy editor at *Vogue* magazine. The day after their first encounter they were lovers, and soon Patricia's girlfriends at *Vogue* were calling Camus "the young Humphrey Bogart." Patricia was in love, Albert was smitten. He lived in a Central Park West duplex flat lent to him by an admirer. Patricia would visit almost every day and they would often go out to dinner in Chinatown,

which fascinated him. After dinner, they often ended up in a nightclub. Camus loved dancing; it was his way to cheat death. He had put on weight, looked ill, and was coughing up blood; the truth was he thought he would not make it back home. Patricia mistook his intensity for passion. In fact, despite his feelings for Patricia, he longed to go back to the many flaws of Paris and Europe, to a place where people did not just "pretend to live," a place where "conversations were full of wit, even bad, full of irony, of passion and its string of lies."[6]

Like Sartre, Camus did not forget to bring back new world riches to the old world, and the last few days were frantic with buying everything that Parisians lacked or that was so scarce it cost a small fortune. He came back with a crate of sugar, coffee, powdered eggs, rice, chocolate, flour, baby foods, canned meat, soap, and detergent weighing two hundred pounds. As soon as he reached Paris, however, he thought about exporting back to New York another kind of nourishment: he bought a subscription to *Les Temps modernes* for Patricia. An ocean might have come between them but the conversation would go on as brightly as it had in "Black Harlem, Jewish Brooklyn and vulgar Cony Island."[7] Back home, relations with Francine were cold, to say the least. She was silently resentful; he was silently offended and angry. He had been happy with Patricia, and the only way to remain happy was to write. *La peste* was awaiting.

Camus found ways to escape his family that were deemed socially acceptable. On August 5, he deserted Paris with his family, and settled into the Château des Brefs, the property of his publisher Gallimard in the Vendée region. The place was so big that Camus was given a room where he could work far away from crying children and a wife who was doing her utmost, but often failing, not to sulk. Camus started almost every day by writing to his darling Patricia. On August 12, he commented: "This is a beautiful and vast old house, furnished with antiquities and old tapestries with ancestors looking at you from their frames. I have found peace here, that is to say that I write for ten hours a day without being disturbed, and I'm finally finishing *La peste*."[8] On August 21, in another letter to Patricia, Camus announced that he had finished his manuscript at long last, but did not know whether to call it *La peste* or *La terreur*. He could have called it *Totalitarianism*, the subject of his novel. As a token of his undying love, Camus sent Patricia Sartre's one-kilo philosophy treatise *L'être et le néant*.

ALBERT, SIMONE, AND ARTHUR

Albert Camus, and indeed Jean-Paul Sartre, often fell for pretty students and groupies. It was easy. Those young lovers were enthusiastic, malleable, a little naive perhaps, and would recover in no time once the affair with the great man had ended. If Maria Casarès stood apart, herself a seductress and as ambitious for her art as Albert Camus was for his writing, Camus nonetheless feared intelligent women. Brought up in a male chauvinist French North African culture, he had difficulty reconciling desire and intellect in his relations with women. He needed to dominate one way or another.

In December 1945, Beauvoir and Camus often had dinner at Lipp, opposite the Café de Flore on the boulevard Saint-Germain. They would then end up in the basement bar of the Hôtel du Pont Royal, right next to Gallimard's offices. Simone was now too well known a public figure to spend time in the Café de Flore without being interrupted. She liked the discretion of the Pont Royal bar, whether during the day or at night, except that writing on the wine barrels that were used as tables was not an easy task. She did not know how to place her legs; opening them wide in order to hug the barrel was not her idea of elegance.[9] In the evening, she and Camus chatted at the Pont Royal until closing time and then strolled happily, if not slightly tipsily, to her hotel room at La Louisiane, where they talked and drank some more. Coal was still severely rationed in the winter of 1945 and it was very cold in Simone's room;[10] drinking helped keep them warm.

Beauvoir was attracted to Camus and Camus to Beauvoir. He admired her as a free-spirited and independent woman, and he desired her: she was five years older and beautiful, she was elegant, chic, and fiery, and under her carapace he knew she was also warm and passionate. However, he was frightened of her intelligence; he feared that it might even turn him off. What kind of pillow talk did one have with Beauvoir? he wondered.[11] She had no reservations about him. Nothing in him could turn her off, except perhaps his moralizing, but he usually kept that for his readers. He had confided to her his marital problems and his many frustrations. "He wanted to speak and write the Truth!" she wrote in her diary. "The chasm between his oeuvre and his life ran deep. When we were together, he was funny, cynical, a little coarse, bawdy even. He opened up and gave in to his impulses."[12] Beauvoir had seen clearly the paradox lying at the heart of

Camus' existence. He was one of France's public moral thinkers, and yet the private man could not reconcile his longing for truth with his thirst for freedom. After two in the morning, fueled by alcohol, Albert liked meditating on love: "One must choose in love: lasting or burning!" Simone loved his "kindness and his hunger for passion." If Beauvoir and Camus ever had an affair, it was during those nights of December 1945.[13]

If Camus might, in the end, have felt too intimidated by Simone de Beauvoir's piercing intelligence and beauty,[14] Arthur Koestler was immediately inflamed by it. Unknowingly, Camus had been their go-between. Thanks to Camus, Beauvoir had read *Darkness at Noon* before anyone else in France and had warmed to Koestler's mind and personal history. From Bwlch Ocyn in Wales, where he had settled a year earlier with Mamaine Paget, Arthur Koestler had not missed a beat of French political and intellectual life and, at forty, he was impatient to dive back into the Parisian whirlpool, especially following the phenomenal success of the French edition of *Darkness at Noon*. An invitation he could not refuse arrived in the post in September 1946. The theater director Jean Vilar was inviting him to watch the rehearsals of his play *Le Bar du crépuscule, une bouffonnerie mélancolique (Twilight Bar)*[15] and to attend the first night on October 23, 1946. It had been six years since his desperate flight from Paris in a legionnaire's uniform and under a fake identity;[16] how satisfying to come back as a conquering hero and literary champion.

Koestler, alone for two weeks before Mamaine's arrival, had not waited to be introduced by common acquaintances. He had gone straight to *Combat*'s office, entered the editor in chief's little cubicle, and extended his hand to Camus with a warm smile. Then he had gone to the bar of the Hôtel du Pont Royal, where he knew he would find Sartre and Beauvoir, and waited for them to turn up. On seeing them, he had walked up to them and had said, "Bonjour, je suis Koestler."[17] On both occasions, the rapport between the Hungarian Jew turned English literary lion, the Algerian-born writer, and the Existentialist philosophers was instant.

A week later, Koestler had introduced Mamaine to Sartre and Beauvoir, and they all often met at Sartre's flat or at the Flore for lunch. On October 23, Mamaine wrote to Celia: "Sartre is simply charming and while he's talking one feels that existentialism must be the thing, though always without having much idea what it is. He and K. get on very well and we both get on like

a house on fire with Simone de Beauvoir."[18] A few hours later that very night, Koestler would also get on like a house on fire with Simone.

Late that evening, the two couples bumped into each other at the bar of the Hôtel du Pont Royal. Mamaine was tired and went to bed, leaving Koestler with Beauvoir, Sartre, and Jean Genet. Back at the hotel, she could not sleep. She wrote to her sister to pass the time. "K shows no sign of coming in, which worries me rather as he must be terribly drunk by now (3 a.m.), hence this rambling letter, as I cannot think of what else to do." Koestler would be another few hours. He was with Simone, in her round room in the Hôtel La Louisiane, making love furiously to the French philosopher whose passion he had felt from the moment he had met her. She had in turn been attracted to his intensity, his all-devouring energy and blazing intelligence, but she had also sensed in him a certain violence. They had been curious about each other, and had perhaps wanted to test themselves against each other, like boxing champions in the same weight class. As the door shut behind them, he almost ripped off her clothes. She was not entirely surprised to find him rough, very rough. And when he left her at dawn to join Mamaine, who had finally fallen asleep, Simone knew there would not be another night with Koestler. She had realized, by the way he ravished her, that Koestler was a violent and impulsive man, a world-weary seducer. He seemed to be using women in his life like props. Had she not heard him say just that to Mamaine the other night? "You're my only prop," he had said. Simone de Beauvoir was nobody's prop.

MAMAINE, JEAN-PAUL, AND ALBERT

A week later, on October 31, Camus and his wife, Francine, Koestler and his girlfriend Mamaine, and Sartre and Beauvoir met for dinner "in an Arab bistro to eat some Arab food." From there they went to a *bal musette* "with blue and pink neon lights and men dancing on stage with girls in very short skirts." The evening and night were to prove so memorable that Mamaine wrote to her sister the day after to tell her everything in detail. "For the first time in my life I danced with K, and also saw the engaging spectacle of him lugging the Castor (who has I think hardly ever danced in her life) round the floor, with Sartre (who ditto) lugged Madame Camus." The new friends were having a good time, and the night was young, so Koestler invited them all to a Russian nightclub. The Sheherazade was really

not Camus, Sartre, and Beauvoir's kind of place, but Koestler's energy was irresistible. On entering the nightclub, they were plunged into almost total darkness with violinists playing soulful music in their ears. The Parisian friends all looked at each other in embarrassment.

Koestler ordered enough champagne, vodka, and Russian hors d'oeuvres (known as *zakuski)* for a regiment, and everybody started relaxing. "Sartre got very drunk almost at once, Beauvoir also got drunk and K got drunk too (we drank vodka and champagne in large quantities). Francine Camus (who is extremely beautiful and nice) also got tight. Camus and I did not get drunk, though we nearly did." Not surprisingly, when a pickpocket snitched his wallet with 13,000 francs in it, Koestler did not feel a thing. Time flew by. Sartre knew he was giving a talk, which he had not written yet, to thousands of people at UNESCO the following day, but he was having too good a time to leave. Suddenly the violinists surrounded their table and began playing "Ochi Chornya" ("Dark Eyes"), one of the most famous Russian sentimental songs. On hearing the first notes, Koestler took his head in his hands and started weeping uncontrollably.

The friends patted Koestler on the shoulder and someone said, "Is it time for an onion soup?" In the street, walking toward Les Halles, the "belly of Paris" as Zola had called it, the men started soliloquizing. Camus kept repeating, "If only one could write the Truth!" Sartre was giggling, thinking aloud, "And in a few hours, I'll be addressing a crowd about the writer's responsibility!" And Koestler, behind them, exclaimed: "We must absolutely agree on politics or I do not see how we could be friends!" Seated in front of an onion soup, the imperious Koestler insisted on ordering oysters and white wine to wash it all down. "By that time, Sartre was simply roaring drunk, and awfully sweet and funny. He kept pouring pepper and salt into paper napkins, folding them up small and stuffing them into his pocket."[19]

Camus, laughing and referring to the UNESCO talk, told Sartre: *"Tu parleras sans moi!"* (You'll have to speak without me). Sartre burst out: *"Je voudrais bien parler sans moi!"* (I wish I could speak without me, too!). When they finally looked out the window it was broad daylight. The three couples said good-bye and very unsteadily went on their way. Crossing the Seine at the Pont Neuf, Simone leaned on the bridge and began sobbing over the tragedy of the human condition. "I do not understand why we do not throw ourselves into the water!" she told Sartre. Now also weeping, he

replied, "Well, let's do it!" At a different bridge, the Pont Royal, Koestler and Mamaine had also wept profusely, but not over the human condition. Simply because of the river's "incredible beauty" with "those lovely lemon-green and yellow poplars with their black trunks, and the houses reflected in the water by the early morning light."

Beauvoir could not remember later how they got back to their respective beds. Eight hours later, the worse for wear, looking rather pale, she was seated in the front row at UNESCO's big amphitheater for Sartre's lecture. Sartre appeared on stage: "his face was ravaged." Sartre had slept only two hours. When his alarm went off, he got up and walked with great difficulty to his pharmacy where he grabbed a tube of Orthédrine. It was full; he swallowed all the pills. Orthédrine was a stimulant drug, widely available in pharmacies, on which the *résistants* who had used it during the war had bestowed a kind of magic aura.

No amount of pills could distract Sartre from his feelings for Mamaine, whom he had been taken by. She found him charming and very amusing. "Of all the people I have met with K, I like Sperber[20] best, and Sartre," she wrote to her sister Celia that week. However, Sartre was not the only one to have a crush on Koestler's girlfriend. There was Koestler, of course, but there was Camus, too. He had found Mamaine exquisite. And Camus particularly liked beating Sartre in the seduction game. Whom had Mamaine fallen for, Sartre or Camus? The things that happened that night wouldn't be revealed until a few months later.

"I LOVE YOU AS A MAN LOVES A WOMAN"

Although both had resigned from the Communist *Femmes françaises* at the end of 1945 and did not share an office anymore, Édith Thomas and Dominique Aury had remained close. The two women were very different. They had come from diametrically opposed political milieus. Dominique came from the extreme Right and Édith from the extreme Left. Yet both had ended up as *résistantes* during the war, Dominique through patriotism, Édith through idealism. Dominique was a seductress, a smooth operator, flexible, extremely polite and discreet. Édith loved truth and authenticity while Dominique reveled in secrets and sometimes lies. But they shared three overriding qualities: intelligence, generosity, and humor. From their

very first encounter, they became friends. The two were in awe of each other, for different reasons. Dominique admired Édith, and Édith was fascinated by Dominique. Édith knew Dominique had a lover with whom she shared a great physical passion, but she did not know who the man was. Albert Camus?[21] Dominique was so discreet that it was impossible to know for certain. As for Édith, she was as desperately lonely as ever.

Édith had grown very harsh, both with herself and with others. At thirty-seven she was too ashamed of her body to risk seduction; she had almost turned the page on men, on sex, and on love; in fact she had only lost her virginity at the age of thirty-two, in "more pain than pleasure," as she had confided to her diary.[22] She had had very few and very brief encounters since, and all had been unsatisfactory. "I'm like a whore in so far as all men are the same to me: I cannot love any of them. I'm as lucid as one can be."[23] She far preferred friendship to love. Dominique, the only person she had let come close, seemed to be the only one to see the sensitive and luminous beauty in Édith.

After months of close friendship, Dominique had decided to reveal her true feelings for Édith. A seductress, a conqueror of both men and women, Dominique knew how to snare her prey. On October 27, she invited Édith to have a coffee. "As soon as I arrived, Dominique told me: 'Édith, this is an ambush.' She looked pale and troubled, almost ill. 'I love you as a man loves a woman.'" Édith recounted the exchange and her feelings about it in her diary immediately after returning home.

> What to do? Oh God (who does not exist), what to do? I have for her a profound affection and esteem. We share the same feelings about people and books. I love her delicacy and her intelligence. If she were a man, I would be elated by her love. If I were a man, I would love her. But I'm a woman and she's a woman. What to do? Why am I always putting myself in awkward situations?[24]

Édith could not conceive of sex between two women, not out of prudishness but simply because it had never occurred to her that she could one day be concerned by it personally. In fact, she did not have anything against homosexuality. "For me, there is no evil nor any good, no vice nor any virtue in homosexuality. So why refuse it? I have in fact a Greek amoral point of view."

A few hours later, on the same day, Dominique walked up the stairs to Édith's flat on tiptoe and as quietly as possible slipped a letter under Édith's door. It was another declaration of love, using the respectful *vous* and not the familiar *tu*.

> Édith, my love. Forgive me, as I could not keep silent any longer. I would like to be standing next to you still, and to tell you that I love you, and to kiss you. I do not know how to control myself anymore. Your softness confuses me. You do not know what it feels like to be burnt, and to have under my lips your hands so soft, or your soft black hair, or your cheeks' downy hairs, there, just above the ears. Édith, I have never loved a woman the way I love you. I have never loved a girl for whom I also had admiration, respect and this combatant camaraderie based on tenderness and which is so powerful in time of war. To have held you in my arms even for a second this morning made me wobble, and reach for the wall for support. I kiss both your hands, Édith.[25]

Not used to such a display of emotions, both surprised and tormented by it, Édith quickly fell into the trap Dominique had laid for her. The day Sartre dragged himself on the stage of UNESCO for his talk on the responsibility of writers, the same day Koestler, Mamaine, Camus, and Francine spent entirely in bed, two women on the other side of the Luxembourg Gardens also chose not to leave the bedroom. One was initiating the other in carnal pleasures she had never thought possible. Dominique played the bad boy and Édith the vulnerable *jeune fille*. Dominique had promised that their liaison would not affect their friendship. She knew she could not remain faithful to one lover, she could not make any promises of the sort, but she was and would always remain a very loyal friend. Their first afternoon and night together transfigured Édith. She threw herself headfirst into their affair. "I'm burning. I'm like a small bundle of dry wood, a handful of straw. I'm thirsty. Am a lone walker in the middle of the desert. I'm hungry. Will you be my orchard, my water spring? Or will you be like fire, consuming everything and leaving me mortally unsatiated?"[26]

Walking together past the statues of queens of France in the Luxembourg Gardens one frosty November morning, after another torrid night during which Dominique played the "passionate teenage boy" and Édith

"his first ever mistress," Édith tried her best to appear distant and cool: "Dominique, I could never stand the presence of a man in my life and I fear this is what is going to happen again." Dominique's eyes welled up with tears: "Oh, Édith, are you telling me that I'm going to lose you? Tell me what I should do, I'll do everything you want me to do." By the end of November, Édith had totally fallen under Dominique's spell. She was now the one writing desperately passionate letters.

For such a rigorous mind, one that had always cherished doubt and rejected certainties, Édith proved particularly unrestrained, perhaps even naive, in her passion for Dominique. "I'm not going out tonight to meet Stephen Spender, I just want to keep feeling your kisses on my skin. Could this time be love, my love?"[27] Édith sometimes wrote several times a day to Dominique: "I only want you, Dominique, you, alone in the desert, a desert made of sand and white bones, just for you. I don't understand a thing about love if it's not whole and absolute. My destiny is to love a human being the way I love you, so that there is only one being inside me, filling me up."[28] For months to come, Édith and Dominique would share a passion that would transport Édith to a state of delirious ecstasy. Did she know it could not last? Dominique may have left her mysterious male lover for Édith but she was a born huntress, and after passion subsided she always chased other prey. If her torrid affair with Arthur Koestler, whose collection of articles *The Yogi and the Commissar* she was translating into French, was going to be short-lived, her relationship with Jean Paulhan, which had been slow-burning for months, would eventually overshadow her feelings for Édith. Édith sensed it and feared it.

SARTRE AND BEAUVOIR: ROLE MODELS

The young Anne-Marie Cazalis might have been presented with the Valéry award for best newcomer in poetry at the age of twenty-three, but what she wanted most in life was not to become the next Paul Valéry. She wanted to be Simone de Beauvoir, to live in Saint-Germain-des-Prés and work as a journalist. Like many people her age, she had read *L'invitée* (*She Came to Stay*) in 1943. The story, fictionalized but still recognizable, of Beauvoir and Sartre's ménage à trois with their former student Olga Kosakiewicz had electrified a whole generation. And Cazalis had fallen under the spell. "I had never thought one could live so freely. Simone had earned

the right to live like this, and thanks to her, this freedom was given to my generation, like a gift."[29] Cazalis started writing bits and pieces for *France Dimanche*, nothing important or even very interesting, but it was a start and it meant she was often outside, roaming the streets looking for stories and people to interview.

One day, while walking down the rue Saint-André-des-Arts, she noticed a curvy young brunette. The teenager was wearing a black turtleneck and jodhpurs, and her eyelids were lined with heavy black kohl. She was beautiful, she ate gherkin and mustard sandwiches, and, Cazalis later learned, despite her attire, she never rode horses.[30] Her name was Juliette Gréco. The two young women soon became inseparable friends. In the evening they often met at the Méphisto, a bar that stayed open until one in the morning and had a secret basement where only the lucky few were admitted. Cazalis had heard that Beauvoir, Sartre, Camus, and the journalists from *Combat* used it as one of their headquarters. One had to press the bell for a long time, and Cazalis and Gréco were not always let in. When unlucky, they spent their evenings at Jacques Prévert's local, Le Bar Vert, 10 rue Jacob. The girls particularly relished the graffiti in the phone booth. One read: "When you hear *'Allo?'* doesn't it make you think of the Seine?"[31]

In October 1945, Claude Lanzmann had just been accepted to Louis-le-Grand's Hypokhâgne preparatory class. The twenty-year-old had spent the last five years in the town of Clermont-Ferrand and the Auvergne region risking his life as a French *résistant*. He also happened to be Jewish, not that it actually meant much to him until 1941 and Vichy's anti-Semitic laws. Lanzmann and his friend Jean Cau were among the most gifted students of their class. Both men had an equal passion for literature and women but little appetite for studying, and they soon came up with a grand scheme. Jean Cau was convinced that in order to become a writer, one needed to start by being the private secretary of a celebrated author. "For him, it was a Balzacian rite of passage."[32] One afternoon, Lanzmann found his friend bent over a desk in the Lycée's library with an ardent gaze. He was writing, or rather composing, a dozen letters, to among others Malraux, Aragon, Sartre, Gide, Mauriac, and Paulhan. Days, weeks passed. Finally, one morning, the Lycée's supervisor gave Cau a letter. It was the only reply he would get from all the luminaries he had contacted. It was from Sartre.

Lanzmann and Cau carefully opened and read the letter with moist hands. Sartre was inviting Cau to meet him any day of the week he liked at the Flore, between two and three o'clock in the afternoon.

They met; Sartre liked the young man, and his first secretariat was organized from the Lycée's library. In truth, neither Cau nor Sartre had any idea what "secretariat" really meant and how it could help the philosopher. "Cau invented the method and its purpose, forcing Sartre, little by little, to put some order in his diary and finances"[33]—in other words, in his life. Sartre was known for spending his money freely. Insisting on being paid cash for his work, he liked carrying huge wads of banknotes and always paid at restaurants and cafés, never letting anyone else foot the bill, and left huge tips for the waiters. His generosity was astounding and attracted many friends in temporary or chronic financial difficulty. Sartre would discreetly pay for former students' abortions, cover the rent of his past and present lovers, make loans to impoverished writers—the people indebted to him were legion. In fact, Sartre had no desire to own anything and, true to his word, never would. Cau quickly realized that his main activity would be to free Sartre from his increasingly busy social life and from all the *profiteurs* so that he could have long stretches of time during the day to concentrate on his writing. Cau abandoned his studies, found a small room in a dingy hotel on the rue des Écoles right next to the Sorbonne in the 5th arrondissement, and moved a little desk into Sartre's flat where, every day from ten in the morning until one in the afternoon, he answered the phone, replied to the mail, and managed Sartre's diary. Sartre's life became very organized. At one thirty he left to have lunch at Lipp, or the Flore, returning at four thirty. Simone would then turn up around five and write on her little bridge table with its green cloth and they would work side by side until at least eight o'clock, even nine, then go and have dinner. Sometimes, to loosen his fingers and relax, Sartre took to the piano and practiced a Beethoven sonata or a Bach prelude. They drank tea through the afternoon from their respective thermos flasks, an old habit from their hotel days, and smoked like chimneys, Sartre his pipe, Beauvoir her cigarettes.[34] Meanwhile, Jean Cau was waiting for an opportunity to introduce the pair to his friend Claude Lanzmann. Lanzmann would later make a great impression on the philosophers, particularly on Simone.

Sartre and Beauvoir fascinated young people like Hollywood stars; they had a special aura. It was not, however, a one-way relationship. Sartre

and Beauvoir constantly learned from the young. It was an enriching exchange for all involved. Boris Vian, who was educating both Sartre and Beauvoir in jazz, often took them to the latest jazz clubs, like the one that had just opened in the shadow of the Pantheon, Le Caveau des Lorientais, in the basement of a hotel[35] at 5 rue des Carmes in the 5th arrondissement. The owners of this modest hotel, a Breton couple named Pérodo, thought it a good idea to ask their many regular jazz musician guests to play for the young people of the Latin Quarter every evening from five to seven. The basement was badly ventilated, but for two hours nobody should suffocate: they would leave the doors open and the youngsters would simply feel a little hot. To be granted the prefecture's authorization, the Pérodos had argued that all profits from the jazz club would be given to the badly damaged town of Lorient, which had been almost razed by Allied bombing during the liberation. The Pérodos offered the cheapest entrance fee on the entire Left Bank;[36] they set out to attract the young, and so they did.

The opening of the club did not go unnoticed. Juliette Gréco and Anne-Marie Cazalis soon made it a daily routine to meet in the rue des Carmes at five o'clock each afternoon. "For five francs, one could get in *and* have a glass of orangeade with saccharin! At a time when we were all penniless."[37] They also secretly hoped to bump into Beauvoir and Sartre. The twenty-two-year-old French clarinetist Claude Luter—a blue-eyed, fair-haired young man six feet tall with a penchant for reading Tarzan comic books—was another attraction. Starry-eyed young girls rushed to the "Lorientais," as Claude Luter and his musician friends were soon nicknamed, as much for their athletic allure as for their music. The black American trombone player Tyree Glen, visiting Paris, noticed Luter during an afternoon session and went to talk to him. He was surprised that such a young man should adopt the New Orleans style. They spent the night talking about New Orleans jazz and Sidney Bechet, whom Luter and his Parisian friends would resurrect from oblivion in just a couple of years and put back on the international stage.

Claude Luter was as broke as his adoring fans. Sometimes he had to take his clarinet to the pawnshop and wait a few days to receive payment for his various gigs in order to get his instrument back and return to performing. Neither he nor Juliette Gréco nor Anne-Marie Cazalis could afford decent meals. They lived off coffee and tartines at the Café de Flore until five in the afternoon, when they'd get their orangeade at the jazz club.

Juliette Gréco had moved to the Hôtel Bisson, 53 ter Quai des Grands Augustins, next to Michel Leiris. Unlike the art critic's, her tiny room of a home had no grand views over the Seine, just a little window giving onto a dark and filthy courtyard.

WOMEN'S EMANCIPATION

It was *la rentrée* in Paris, the period in early September when Parisians come back rested and suntanned from their provincial family homes, children count their pencils and wipe the dust from their satchels, and reviewers sharpen their wits for the new season of novels, films, and plays. *La rentrée* was always a time for new projects, and Simone had one. Just before their summer holidays, Sartre had suggested to her a possible topic for an essay: women's condition—in other words, what it meant to be a woman. Simone liked the idea and would draw on her experiences. She was no longer a debutante; at thirty-eight, she could take more risks in both subject and form.

At first, she thought the task would be easy and that this study would be almost like an exercise in style; she envisaged a very short essay. Simone had been brought up by her father, who had hoped for a boy. Seeing her intellectual and academic abilities, he had pushed her, so her experience was different from that of many other women. "I had never had any feeling of inferiority, no one had ever said to me, 'You think that way because you are a woman'; the fact that I was a woman, my femaleness, had never bothered me in any way. 'In my case,' I said to Sartre, 'it hasn't really mattered.'" Sartre urged her to reconsider: "But still, you weren't brought up in the same way as a boy: you should take a closer look."[38] She did. Every morning she went to the National Library on the rue de Richelieu.

There, on the beautiful but hard wooden benches of the oval room, bathed in the warm September sun filtering through the glass skylight, Simone had an epiphany. "It was a revelation. This world was a masculine world, my childhood was nourished by myths concocted by men, and I hadn't reacted to them in the same way I would have done if I had been a boy. I became so interested that I gave up the project of a personal confession in order to focus on the condition of woman."[39] This was not going to be a short and quick essay. She had started researching *The Second Sex*, a book that would shake the world.

Simone had so far lived her life as she pleased by breaking social conventions, so researching this subject was also a journey of self-discovery. She would understand in the process why she fascinated younger women. Her life was a model of emancipation, one that the younger generation aspired to and one that she was going to analyze in great detail, not shying away from sexually explicit content.

At exactly the same moment, Édith Thomas was working on historical biographies of remarkable women through the ages. Her two latest novels,[40] which had finally been published at the end of 1945, had encouraged her to pursue this direction.

Having published seven novels since the age of twenty-two without ever enjoying real success, she thought changing literary genres, from fiction to nonfiction, might prove liberating. After all, she had just been appointed chief curator at the Archives Nationales with access to a vast wealth of historical documents and material.

She interested two publishers, one in a portrait of Joan of Arc,[41] another in a collection of profiles of feminist pioneers from the Second Republic of 1848.[42]

Dominique was now working as a feature writer and critic for *L'Arche*, a literary magazine. She wanted to help Édith in every way she could. She saw in Édith a champion of women's rights or, as it was called then, *la condition féminine.* "All the heroines in Édith Thomas's novels refuse, at their own peril, the ordinary condition of women. They refuse to live for and through somebody else. They want to be autonomous."[43] Bolstered by Dominique's support, Édith embarked on those new editorial projects, while finishing a collection of short stories she would call *Ève et les autres.* There was an overall theme in these short stories: women reclaimed their independence from their husbands and from God, and asserted their ambition to be free and to fulfill all their desires in life.

Thomas was an excitable and feverish writer and often got carried away by ideology. Simone de Beauvoir's brilliance lay, on the contrary, in a rigorous intellectual approach combined with a cool and superbly concise style. And while posterity chose to remember only one of them, it is striking that both women, of similar age, were coming to grips with the same existential dilemmas at the same time just a few streets away from each other: how to

be free and a woman, how to be independent and autonomous in a man's world.

Many women around Simone had not mustered the courage to break free. This was the overwhelming norm in the middle class. Simone only had to look at the thirty-year-old English rose Mamaine Paget, Arthur Koestler's partner and wife-to-be. Orphaned at a young age, along with her twin sister Celia, she had been educated at exclusive English and French boarding schools paid for by relatively well-off cousins. Intelligent, polyglot, cultured, pretty, and feminine, the sisters had turned heads in their late teens at the chic opera soirées of Glyndebourne, in the south of England. However, all they could apparently aspire to was to become socialites or "wives of." The alternative, to break away from their milieu, would have required an incredible determination, a steely character, and even a certain degree of madness. Mamaine did not have this in her. She was soft in a good way, sensitive, caring, a little mischievous certainly, but not rebellious. Mamaine was everything Simone de Beauvoir and Édith Thomas had refused to be and had fought hard not to be. Mamaine, like Francine Camus, was going to be a wife whose talents would lie in fostering her husband's career without ever getting the credit for it. This imbalance, this injustice, and the hypocrisy surrounding it would both poison their marital and family lives and ruin their health.

Mamaine had been the secret behind her husband's success since she met him at a party given by Cyril Connolly in his London flat in Bedford Square in January 1944. This became especially true once he decided to write and publish in English. Mamaine was Koestler's translator, editor, and copy editor, and the one he constantly bullied and occasionally made love to, though not exclusively. It was the second time he had switched languages. As a student he had gone from Hungarian to German, and he had now decided to leave German aside. He also had a history of relying heavily on the women in his life to translate, research, type, and edit his work. His current success, *Darkness at Noon*, had been written in German on the eve of the war and translated into English by his then British girlfriend, the sculptor Daphne Hardy, who had passed the manuscript on to Macmillan in London.

There were some advantages for the women who ran Koestler's work and life. Through Koestler, Mamaine lived a scintillating life and met the

greatest intellectuals and writers of her time, who often fell for her, and very occasionally she for them. On February 15, 1946, she wrote a postcard to her sister Celia from the dining car of a train leaving Lausanne in Switzerland: "Dear Twinny, yesterday I lunched with [Tristan] Tzara,[44] who asked me to go to Vienna with him as a guest of the [Russian] government; he's a Stalinist of the deepest dye."[45]

The couple also regularly entertained renowned guests: the recently widowed George Orwell had come to spend Christmas with his eighteen-month-old son, Richard, and had rather embarrassingly asked Mamaine's sister Celia to marry him (desperately, Orwell had asked a string of young women to marry him). There was also the "extraordinarily witty and charming" philosopher Bertrand Russell and his third wife; after one too many drinks, Russell had issued fantastic predictions. "Russell said that as the Catholic population of America was increasing by leaps and bounds the United States would one day be Catholic-controlled, and we should then be faced with a new choice: Stalin or the Pope."[46]

Mamaine had agreed to move in with Koestler a year earlier and to live in Wales at Bwlch Ocyn. Arthur did not like London and somehow the Welsh hills reminded him of Austria. He had promised marriage, a promise he took seven years to deliver, perhaps because of his refusal to have children, which she had eventually and reluctantly accepted. Their daily life could be austere. Having to do all the domestic chores, occasionally helped by a "moronic servant," Mamaine also did all Koestler's secretarial work.[47]

For the younger generation just after Mamaine's, who were born in the late 1920s and early 1930s and who were children during the war, autonomy was much more desirable than domestic life and worth taking risks for. It might have been the air of Saint-Germain-des-Prés, the return of real and strong coffee to their cups, or their adoration for Simone de Beauvoir, but Juliette Gréco and her friend Anne-Marie Cazalis were not going to be anyone's submissive other halves. It was not only a question of working and earning one's living but also, as Édith Thomas had said about her heroines, one of self-reliance and not feeling dependent on anyone else in order to feel whole. Those younger women also firmly intended to enjoy a very free sex life, just like Dominique Aury and Simone de Beauvoir. Gréco and Cazalis found *Combat*'s young and not so young journalists, who spent their nights at the Méphisto bar on the boulevard Saint-Germain, very attractive. "Between two jives, they disappeared from Paris for a few days,

traveling to the Black Forest to go and interview Martin Heidegger. The German philosopher would puff on his porcelain pipe and declare: 'the atomic bomb is the logical consequence of Descartes' and would then dismiss his French visitors."[48] Despite their admiration, Gréco and Cazalis were not going to throw themselves at these journalists. They were, in fact, *gamines fatales*. They decided to take men as seriously as men usually took them.

One evening in February 1946, the thirty-eight-year-old phenomenologist Maurice Merleau-Ponty, who was also a terrific dancer in his spare time, noticed a raven-haired teenager with doe eyes at the Méphisto. He approached her. Her silence and seeming indifference intrigued him greatly. The married Merleau-Ponty had just fallen for Juliette Gréco, aged nineteen. She was not entirely insensitive to his charm, though, and the Creole black pudding they served at the Méphisto helped.[49] She was very hungry in those days, with very little money to live on, but was too proud to tell anyone. She felt instant sympathy for people who shared their dinner with her. Merleau-Ponty was also a professor of philosophy, and in her book that was the closest one could get to God—that is, if God existed. The day after her first encounter with him she bought the February issue of *Les Temps modernes*; she had heard he had a long opening essay in it titled "Faith and Bad Faith."

A THIRD WAY

WANTED: NEW BLOOD FOR A NEW POLITICS

It was a time to take a position, as *Les Temps modernes* had stated in its inaugural issue. French women had cast their vote for the first time in the first national election since before the war in October 1945, and Albert Camus had called for readers of *Combat* to vote for the non-Communist socialists for want of a better choice. He admired Charles de Gaulle but was wary of a general's meddling with politics in time of peace. He supported many of de Gaulle's choices and policies but could not resolve to trust the party behind him. Camus wished, in fact, to find a new path, midway between the reformist nationalism of de Gaulle and the Communist Party's internationalism. He dreamt of a humanist socialism, of new blood in politics, a fresh, harsh, and pure new elite coming from the Resistance to rule over an old country. He dreamt of social justice and of individual freedoms. Many in France shared the same dream; unfortunately, no party represented their aspirations. The non-Communist socialists were too divided, exhausted, and compromised a party to represent this new demo-cratic élan.[1] So Camus advocated a complete renewal of the political class at the helm of the country; he deeply disliked the old generation of politi-cians, even the courageous ones like Léon Blum who had been persecuted by the Vichy government. He called the old guard of politicians *"coeurs tièdes"* ("lukewarm hearts").[2] The younger one was, the purer and less com-promised. Camus wanted a virile and virtuous République. Beauvoir and Sartre agreed with him.

However, this political independence not only was challenging to

define beyond "neither Communist nor nationalist," it was also difficult to achieve. The idea was not that new. It had reemerged in Europe in the 1920s and more recently, in 1938, an obscure British politician and future prime minister named Harold Macmillan had even theorized his own version in a book titled *The Middle Way*. Stuck between a rock, the Gaullists, and a hard place, the Communist Party, the Third Way, as desired by free-spirited Left Bankers such as Camus, was in fact brave and even revolutionary in a country that was traditionally so polarized. The challenge was to consider social democracy as the only desirable and possible revolution. Its powerful detractors, on both sides of the political divide, accused Sartre, Beauvoir, and Camus of being empty, nihilistic even. The Communists branded them traitors, attacked them for having abandoned the ideals of the Left, and for promoting a soft-faced capitalism. And the Gaullists hated them for betraying the enlightened bourgeoisie and playing into the hands of the Soviet army. For Camus, those criticisms did not stand up. He was not promoting a tired compromise between left and right, socialism and capitalism, but a complete renewal of social democracy. Camus considered himself a Dur (tough), not a Mou (soft), and to resist the pressure and comfort of belonging to either camp, while fighting off their constant ferocious attacks in the press, demonstrated real fortitude. In fact, looking at the first free elections' results since before the war, Camus had reason to be quietly optimistic. It seemed as if the French electorate was split equally. This meant paralysis, to start with, but for Camus it also showed there was room for a third force to expand. Camus, Beauvoir, Sartre, and their friends would from now on dedicate themselves, body and soul, to enabling that alternative force to rise.

The world, and especially London and Washington, had also waited with a keen interest for the election results, or "with unusually flattering attention," as Janet Flanner put it. What did France choose? It first decided, overwhelmingly, to kill the Third Republic and its 1875 constitution and to create a Fourth Republic. And whom did the French choose to write their new Republic's constitution: the Socialists, the Communists, or the Gaullists? The Socialists, an eclectic mix of worn-out and fresh politicians who spent more time bickering than agreeing among themselves, wanted, on the whole, a radical change, but not a revolution. The Communists, powerful, respected for their role in the Resistance, and disciplined, wanted a revolution, and the nationalization of credit, in other words, the end of

the Banque de France. The Gaullists, or the rightist Popular Republicans, wanted a more modest change. French voters chose the three of them almost equally. As Janet Flanner put it to her *New Yorker* readers: "France's Fourth Republic is starting out like a woman with three hands, two Left and one Right, the Communists and the Socialists being on the side closer to her newly reawakened revolutionary heart and the Popular Republicans on her other, purse-carrying side."[3] In other words, what France now had was a National Assembly incapable of agreeing on the nature of the country's future institutions, and a head of government, General de Gaulle, increasingly frustrated by party politics.

Nevertheless, three months later, on January 20, 1946, the news of Charles de Gaulle's resignation came as a shock to everyone, even for his opponents. It was clear that the Gaullists, favoring a Fourth Republic with two chambers and an executive power led by a president, would never be able to agree on future institutions with the Communists and the Socialists who wanted one chamber with all the powers and no president. Disillusioned by party politics, France's savior retired, leaving "French morale in a state of empty gloom."[4] Yet perhaps, as Sartre thought, this was in fact a great service the general was doing his country. With de Gaulle off the scene, France could perhaps move on and try to go forward. Except that a quiet malaise, made up of the disillusion that had set in since the high hopes of the Liberation in the summer of 1944, was gnawing at people. The ambitions and spirit of the Resistance were losing ground. With de Gaulle gone, who would contain the rise of the Communist Party, which since the election had become France's first party by a small margin?[5] De Gaulle's party vowed of course to continue his oeuvre and to keep defending his ideas even with him gone; however, Washington was especially concerned.

THE RISE OF THE COMMUNIST PARTY IN
THE ARTS WORLD

The Communist Party not only was France's first political party, it had also a kind of spiritual power over the youth and the intelligentsia. It was a conscience, and a magnet. Many argued it was like a church, albeit an atheistic one, and a church that controlled its image. It had perfected the arts of propaganda and was successfully courting renowned public figures

to bolster its image. Great artists of international fame had joined ranks and become fully fledged party members. Picasso's decision to join in October 1944 had a considerable impact in France and abroad.

A year later, his fellow painter Fernand Léger's decision to join had a similar impact. The sixty-five-year-old mustachioed painter and master modernist had sailed on a liner from New York to Le Havre at the end of 1945, wondering how he would find the French capital after his six-year absence.[6] He had taught at Yale University during his American exile and had decided to keep on teaching art students, but this time in his own personal university, in the studio he had managed to keep through the war at 86 rue Notre Dame des Champs in the 6th arrondissement, a hundred yards from the Luxembourg Gardens' giant sequoias he so loved. Two hundred fifty ex-GIs on the GI Bill of Rights program, which allowed them to study abroad and receive a monthly stipend, quickly enrolled to be his students.[7] They were eagerly awaiting the return of the *Tubist* in chief, as he had once been called by the Parisian art critic Louis Vauxcelles.

Had Léger felt he needed to join the Communist Party to compensate for his absence during the war? Was it a case of bad conscience, or true conviction, or perhaps both? Just as it had with Picasso, the Party used the news to maximum effect; it reverberated widely, making headlines worldwide. Here was yet another famous artist bestowing some of his genius and talent upon the Communist cause. In truth, both Picasso and Léger were greater than the Communist Party, and each was to remain very much his own man, but their joining nevertheless had an impact on other artists, young people, and public opinion at large.

The Party was intent on invading every nook and cranny of public life, and the art world was at the forefront of its battle of ideas. The idea of Communist art (and Communist artists) as the only morally acceptable kind was gaining some ground within a small clique of Communist leaders in both Paris and Moscow. The party clearly intended to take advantage of the commotion of the immediate postwar art world to start occupying the ground.

In 1946, "the art world was caught in powerful cross-currents: Individual vs. Community, Pessimism vs. Optimism, Disillusion vs. Engagement, Abstraction vs. Figuration, Insurrection vs. Conservatism, Colour vs. Monochrome, Canvas vs. Mural, Instinct vs. Reflection, Body vs. Mind, Archaism vs. Modernity, Realism vs. Unrealism."[8] If Communists and the

Left in general took center stage in the arts world, the public conversation about the arts was still, however, a fluid one in which politics did not loom *too* heavily. "War had touched everyone without exception and divergences in art were based on one's conception of the individual's place in the world, rather than on one style vs. another."[9] Everybody seemed to agree that culture and the arts had to play a major role in rebuilding a free world on new foundations. The *résistants* had written a manifesto in 1944 in which access to culture was proclaimed as a fundamental human right, and this still enjoyed a broad consensus.

The French poet Louis Aragon, the Communist Party's supremo of all things artistic, and of propaganda, liked docile artists. Léger and Picasso, too flamboyant and too independent, could never be told what to say, think, or paint. Aragon was thinking of grooming morally irreproachable young artists for the promotion of the Communist cause. Two of them in particular, the painters André Fougeron and Boris Taslitzky, had perfect credentials: they were both former *résistants*, and Taslitzky had been imprisoned at Buchenwald. Aragon was playing with the idea of welding aesthetics with morality, and he needed malleable artists to shape it. He had even started, very discreetly, putting his idea into practice through the curation of new arts exhibitions in Paris, as a way of testing the water.

Simone de Beauvoir had made a note not to miss the opening of the Musée d'Art Moderne's new exhibition on February 15, 1946. Called "Art et Résistance," it opened in Paris before touring the United States, the Soviet Union, and Britain. The visit left a strange aftertaste. Instead of art produced during the war, it displayed a disparate selection of artworks especially commissioned for the show, and shockingly it completely overlooked Abstract art. Aragon and the Communist Party were, in fact, behind this. How could you show the ties between art and the Resistance after the fact! Mad and dishonest, thought Beauvoir. Picasso, Bonnard, and Matisse, who had been amicably nudged to do so, were officially supporting the exhibition. With such patronage, Parisians had flocked to see it. How could Matisse endorse such a travesty, Beauvoir wondered? Had it simply been a case of being nice to people who had asked nicely? Or, like his friend Picasso, had the seventy-six-year-old maestro had other things on his mind? In 1946, Matisse's oeuvre was mutating. He seemed to be breaking away from everything he had done before. Attracted by much bigger spaces, by light, his work gave out a primitive joie de vivre. His paper

cutouts, serigraphies, and tapestries all celebrated a golden age, turquoise-blue sky and indigo-blue sea, birds, and light. "He shared with his times a taste for the transcendental."[10] Both the Catholic Church and the Communist Party were trying hard to capture this new artistic effervescence, which could be defined as a quest for a new transcendence, a new spirituality.

The Catholic Church had not exactly shone during the war, and here was an opportunity to renew its image. Unlike the Communists, the Church was not looking to impose a new aesthetic, but it wanted to embrace modernity and be seen as relevant to the times. A Dominican Father in particular, Pierre Couturier, had spent his life questioning the Church's artistic choices and advocated a revolution of mentalities, no less. "Believing the Church should open its doors to non-believer or non-Christian artists, and that creation itself was an act of faith,"[11] he commissioned art from Bonnard, Léger, Braque, Matisse, and two Russian and Jewish artists, Lipchitz and Chagall, for the redecoration of the church at Assy, near Chamonix. A few months later, Abbot Morel had also organized an exhibition of "Sacred Art" at Galérie René Drouin and had chosen to exhibit modern artists without any ties to Christian circles: Bonnard, Rouault, and Braque.

The Catholic Church was embracing abstract art with surprising honesty and real curiosity at a time when the Communist Party was rejecting it, trying instead to debase art with ideology and morality, which didn't go unnoticed. These developments were frequently reported on, and in great detail.

Denise René's art gallery and the Salon des Réalités Nouvelles set up in 1946 were the epicenters of abstract art in Paris. There, debates, schisms, and confrontations were taking place almost daily. René was not afraid of controversies and polemics: from a family of *résistants*, she had sheltered the first clandestine meeting of the CNR (Comité National de la Résistance) in 1943 in the basement of 124 rue de la Boétie in the 8th arrondissement. As they always were these days, Les Durs (the tough) were at war with Les Mous (the soft). Aragon was lying in wait. In fact, abstract art was divided within itself and also had to withstand continuous attacks from the omnipotent Communist press. Paris art galleries and newspapers' arts pages had become the scenes of critical carnage.

The artists who could spar with the Communists, and call their bluff, were the Surrealists. They belonged to the older generation who, even though in their fifties, still had vigor. They were not, however, above reproach.

Parisians hadn't forgotten the many Surrealists who had gone into exile in New York during the war. And if some of them denounced the nature of Stalinism, many also chose to remain in the United States. Roberto Matta, Victor Brauner, Francis Picabia, André Masson, Joan Miró, Yves Tanguy, and Max Ernst either stayed in America or became American citizens.

The artistic and cultural effervescence and battle of ideas seething in Paris was watched and followed closely by foreign observers. In London, Cyril Connolly, the editor of *Horizon*, had translated and published *Les Temps modernes*' manifesto, written by Sartre, and made it his own and his generation's. A few months later, a *Horizon* special issue about France came out, introducing Left Bank thinkers, some for the first time in translation, to an English readership. For the people at *Horizon*, "France stood for civilisation itself." Connolly had made no bones about the "lassitude, brain fatigue, apathy and humdrummery of English writers" and artists. Paris by contrast "blazed with intellectual vitality and confidence. Its writers, galvanized by four humiliating years of occupation, now stood ready to ignite the torch that would light the way to freedom, choice and rational reform."[12] It was true that London had withdrawn from intellectual debates and its intelligentsia were happy to leave Paris the honor of holding the torch. Philip Toynbee tried to explain the feeling among the British intelligentsia in his dispatches from London in *Les Temps modernes*: "We do not have any philosophy. These days, our lack of fanaticism is the evidence of our apathy."[13] A few months later, Toynbee added: "Things have come to a point where France and Flaubert are playing as big a role for British intellectuals as Russia and Stalin for the Communists."[14]

This "symbolic handover" from London to Paris gave Sonia Brownell both power and purpose. She had already made herself indispensable in the *Horizon* office—it was at her prompting that Connolly had rushed to meet Simone de Beauvoir a year earlier—but she would soon commission new authors and new pieces. She worked closely with Peter Watson, the coeditor of *Horizon*, a homosexual and a French speaker, two qualities for which she usually fell. She was not the only one. The photographer Cecil Beaton was pursuing Watson even though he thought he had the "charming face of a codfish."[15] Peter was also sleek, subtle, and a smooth operator, but he had vision, too. He was the one who commissioned *Horizon* articles in Paris on artists barely known in Britain, like the Swiss painter Balthus and the Italian painter Giorgio Morandi. He had persuaded Daniel-Henry

Kahnweiler to report on the contemporary art market and the art critic Michel Leiris to write about his friend Alberto Giacometti. Through Leiris, Watson commissioned Giacometti to make a chandelier for his home, or perhaps for the office in Bedford Square—he had not decided yet where he would hang it.

COMMUNISM THE ITALIAN WAY

On matters of art and politics, Beauvoir and Sartre were increasingly at loggerheads with Communists; there could be no ideological entente with them. They could go on arguing, but they had reached an impasse. This was a difficult and even painful situation: their relationship with Communism felt essential to these two bourgeois who had chosen to betray their own class. Neither Beauvoir nor Sartre was, however, ready to bargain their freedom, *esprit critique*, and independence for the sake of acceptance into the Communist fold. They had recently met Italian Communists such as Elio Vittorini, the editor of the monthly review *Politecnico*, and had felt a real affinity: "At least with them, you could talk!"[16] They decided to prepare a special Italian issue of *Les Temps modernes*, in which they would explain why Italian Communism was so much more inclusive and less dogmatic than its French counterpart. The new friends all agreed to meet in Milan over the summer.

At the end of June 1946, Beauvoir and Sartre were on the night train bound for Italy. They were firmly set on understanding why Italian Communism seemed so much more inclusive and flexible than its French counterpart. They were also going to Italy to do book signings, give talks, and, if at all possible, enjoy a little sightseeing.

After their publisher Bompiani publicly put some distance between himself and the Existentialist couple, whom he as a conservative now deemed too controversial, Elio Vittorini, their new friend, contacted the other big Italian publishing house, Mondadori. The opportunity was too good to be missed and the keen publisher sent his own son, Alberto Mondadori, to give Sartre and Beauvoir a substantial advance in cash to seal their partnership. Mondadori senior also instructed his son to be the philosophers' chauffeur, and to offer to drive them wherever they liked in his brand-new cabriolet. Beauvoir and Sartre greatly appreciated the gesture and asked Alberto to drive them to Venice, then Florence,

and, finally, Rome.[17] There they met the writer and painter Carlo Levi, whose first novel, *Cristo si è fermato a Eboli* (*Christ Stopped at Eboli*), had just appeared. Depicting his forced exile by the fascist regime in the Basilicata region, the deep south of Italy, the novel triggered a national debate about the extreme poverty of the Italian south. After reading a few pages, Beauvoir decided to publish extracts in the autumn issues of *Les Temps modernes*.

Simone de Beauvoir soon developed a clear analysis of the political difference between the French and Italian Left: "In France, national unity, having been achieved through the fight against foreign occupants, consequently weakened after peace had returned, with Right and Left going their own ways." Nationalism had in fact proved a shaky foundation for national unity.

> In Italy, the nationalists *were* the fascists. Everyone who had fought fascism wanted democracy and freedom. All non-fascists had the same aims, which were based on principles, rather than events, and therefore survived after the war ended. In Italy, liberals, socialists and Communists were all fighting together against the nationalist Right and in favor of the end of monarchy and a new republican constitution. The sincerity of the Italian Communist Party's republican and democratic positions was never in doubt.[18]

The Molotov-Ribbentrop pact of 1939 had tainted French Communists. For two years, until Hitler broke the nonaggression pact, French Communists were of two minds about resisting the German occupants. Their hesitation made people suspicious, and they never could wash the opprobrium away, even after wholeheartedly committing to the Resistance and indeed becoming its most active members between 1941 and 1944. The non-Communist French Left always had their reservations about them, and their suspicion, once the war over, came back with the force of a boomerang. Who were the French Communists taking their orders from? Was the umbilical cord with the Soviet Union more important than that with France?

The Italian Communists, having fought Fascism since the early 1920s, were not stained by the Molotov-Ribbentrop pact in the way their French counterparts were. Besides, Antonio Gramsci, one of their leaders and thinkers, who had been incarcerated by the fascists in 1926 ("We must stop

this brain from functioning") and died of illnesses contracted during his imprisonment in 1937, had somehow created "a dazzling synthesis between Marxism and Bourgeois Humanism."[19] In France, the Communist Party was going in the opposite direction: taking its orders from Moscow and the Comintern, abiding by the Stalinist dogma. Retractors claimed they were serving the interests of the Soviet Union and not France.

The rising tension within the French Left between non-Communists and Communists had in fact claimed its first victims within the editorial team of *Les Temps modernes*: Raymond Aron had slammed the door and left to join *Combat*. Aron considered *Les Temps modernes* too lenient with the Communists, while Sartre and Beauvoir considered Aron too much on the Right.

Churchill, now retired, had spoken frankly three months earlier in his famous Fulton Speech in the United States of "these anxious and baffling times." A shadow had fallen upon the editorial committee of *Les Temps modernes* and the Paris Left Bank, as indeed it had "upon the scenes so lately lighted by the Allied victory."[20] Churchill had spelled out what everyone was feeling.

> Nobody knows what Soviet Russia and its Communist international organisation intends to do in the immediate future, or what are the limits, if any, to their expansive and proselytising tendencies ... From Stettin in the Baltic to Trieste in the Adriatic, an iron curtain has descended across the Continent ... Warsaw, Berlin, Prague, Vienna, Budapest, Belgrade, Bucharest and Sofia, all these famous cities and the populations around them lie in what I must call the Soviet sphere.[21]

In July, Beauvoir and Sartre parted ways in Milan. Simone kept only a rucksack and sent the rest of her books and clothes back to Paris. She was so much looking forward to hiking in the Dolomites.[22] Luckily, le petit Bost would be able to join her later; she was elated to discover a new mountainous region of Europe. Meanwhile, Sartre was off on a three-week holiday with Wanda Kosakiewicz. He did not intend to be idle for three weeks, though: this would be a working holiday. He had two plays in mind that he wanted to write fast: *Morts sans sépulture* (*The Victors*) and *La putain respectueuse* (*The Respectful Prostitute*).

AMERICA: I LOVE YOU, I LOVE YOU NOT

Between the beginning of 1945 and the summer of 1946, Sartre had visited the United States twice. He had stayed for almost six months in total, had a New York girlfriend, and had extensively toured the country and lectured at the most prestigious universities. Simone de Beauvoir would soon follow in his footsteps. He had met many people and made many new friends. Some of the American writers Sartre had met had even settled in Paris, like Richard Wright, one of many black American writers and artists to make the journey to France in the late 1940s. American artists were also following him back to Paris.[23] Alexander Calder was aboard the first transatlantic direct flight from New York, which TWA had started operating a few months earlier.

Sartre had written Calder's forthcoming exhibition catalog. He had spent only two afternoons in his Roxbury studio in Connecticut and yet it was as if he had lived among Calder's work all his life. Or perhaps the little peacock mobile Calder had given Sartre, made of cuts from flattened license plates, allowed Sartre to spend more time in Calder's universe and understand it better than most. "Sculpture suggests movement, painting suggests depth or light. Calder suggests nothing. He captures true, living movements and crafts them into something. His mobiles signify nothing, refer to nothing other than themselves. They simply *are*: they are absolutes."[24] And to conclude: "Calder's mobiles are at once lyrical inventions, technical, almost mathematical combinations and the tangible symbol of Nature, of that great, vague Nature that squanders pollen and suddenly causes a thousand butterflies to take wing."[25]

Sartre was fascinated with America. The young man in him had fed on American literature, films, and jazz. Steinbeck, Faulkner, Hemingway, Dos Passos, Sidney Bechet, Louis Armstrong, Cole Porter, George Gershwin, Duke Ellington, to name but a few, held no secrets for him. He loved Americans and America and, especially, American popular culture, which he knew intimately, but his love and fascination were typically lucid.

He felt compelled to share his America with French readers, warts and all, in *Les Temps modernes'* first double summer issue of 1946. Its publication, with many specially commissioned pieces from avant-garde American writers and an uncompromising introduction by Sartre, had created quite a stir.

I saw men chased within the heart of their conformist happiness by a nameless obscure malaise. Those men are tragic precisely because they fear to be tragic, because they lack tragedy in and around them. In America, there is the myth of equality and there is racial segregation; there is the myth of freedom and there is the dictatorship of public opinion; there is economic liberalism and those faceless multinational companies which cover a whole continent don't belong to anyone, but operate like a state within a state. In America, there are a thousand taboos that ban love outside marriage and there are those thousands of used condoms littering the back courtyards of university campuses, there are all those cars, lights switched off, parked by the road, there are all those men and women who need a stiff drink before making love, in order to copulate and forget all about it. Nowhere will anyone find such a discrepancy between myths and men, between life and its collective representation.[26]

"In this special issue," stated the introduction,

our aim has been to show men and women. Every one of them feels close to what he or she criticizes or praises. None thinks they say anything bad against America. In France, if one reveals an injustice, it is seen as a criticism of France because one sees her in the past or as unmovable. For an American, to reveal an injustice is to pave the way toward reform because he or she sees their country with eyes set on the future. Every article in this issue is like a human face, an anxious face, but a free and moving one. This is what we have wanted to offer readers who haven't crossed the Atlantic Ocean yet and who don't know the strange softness faces take, in New York, when the first lights are switched on over Broadway.

This special issue was, in fact, a love letter to America. However, a love that was honest. The issue also included articles by American writers who attacked European arrogance in dealing with America. In fact, Sartre liked nothing more than being contradicted by intelligent voices. An article on comic strips by David Hare[27] deciphered the new American comic hero: "The war has created a new American hero, superman, superhuman, and violent, in many ways antipoetic and vulgar. However, this is the product of an irresistible imagination, force and invention, but never of intelligence."

In his review of American art in the twentieth century Clement Greenberg saw that the most influential period of American art history had just taken place during the war, through the symbiosis between young American painters and artists in New York and exiled French Surrealists such as Matta, Ernst, Duchamp, Breton, and Tanguy. Greenberg thought that in 1946, "apart from Alexander Calder, a product of the Paris school, no American artist has international stature." In a few years, Action Painting, embodied in the works of Jackson Pollock and Robert Motherwell, a result of the symbiosis Greenberg described, would change this.

Richard Wright finished reading *Les Temps modernes'* special U.S. issue at the Paris American Hospital, where his wife, Ellen, had been taken for an appendectomy. Although not life threatening, her condition was serious enough, and they had decided to go back to New York for a while. Their flat on the boulevard Saint-Michel was too small, and it was a short lease anyway. Before packing, Wright had just enough time to send an enthusiastic note to Sartre, who had given him the manuscript of the play he had written on holiday, *La putain respectueuse*. Sartre wanted to know Wright's opinion as his play dealt with race relations in America and was inspired by the case of the Scottsboro Boys. In the 1930s, nine black teenagers had been wrongly accused of the rape of two white women on board a freight train heading to Memphis.[28] Wright thought Sartre had admirably captured the essence of racial segregation and was awed by Sartre's artful synthesis and powerful dialogue: "Black man: 'When white men who don't know each other meet to talk, you can bet a black man is about to die.'"[29]

Wright had gotten so used to Parisian color-blindness that he felt all the more shocked to be back in New York. In Greenwich Village, where the family lived, "there were several violent incidents when gangs of Italian youths took it upon themselves to punish interracial couples."[30] As a result, Wright never allowed Ellen to take his arm in the street. Also, perhaps because of Paris's less comfortable life, Wright was taken aback by how much a new materialism was reigning over the entire country. "In France, people were interested in your opinions, not your income."[31] He felt that the liberal spirit of Roosevelt had completely disappeared.

Wright was trying hard to be positive and turned to the city's cultural events as a way to escape. He was very much looking forward to

meeting Henri Cartier-Bresson. The photographer was busy preparing the first retrospective of his work for the Museum of Modern Art, which was opening five months later. Like Camus, Cartier-Bresson had declared to the U.S. authorities that he did not hold Communist sympathies. That was an outright lie, and his retrospective at the Museum of Modern Art would indeed completely, and intentionally, overlook that essential detail. His philo-Communism was, however, key to understanding his work. Cartier-Bresson was a fellow traveler of the French Communist Party and would vote Communist in every election for the next ten years.[32]

Among the French writers and intellectuals who had visited the United States after the war, Albert Camus cut a singular figure. America had left him indifferent. He had confided to his diary on board the *Oregon*, a cargo freighter with a few passenger cabins, that on finally entering New York Harbor after a ten-day journey, he had felt nothing. "Manhattan's skyscrapers are against a background of fog. My heart is calm and dry and I feel I'm watching a spectacle that does not affect me."[33]

His indifference turned sometimes to bewilderment. His five weeks of lectures had been five weeks of bafflement. Americans seemed so alien to him, friendly yet forgetful, hospitable yet indifferent, engrossed in frivolous things, afraid of seriousness. He had learned very quickly that "the secret to conversation is called small talk, the art of saying nothing meaningful."[34] He had wondered in his diary whether one was "among madmen or the most reasonable people on earth; if life was as easy as they say here or as foolish as it seems; if it is natural that they hire ten people instead of one, without improving the service; if Americans should be called modest, liberal or conformist."[35]

He had marveled at the cultural differences between New York and Paris, between America and France, from the shape of doorknobs to the popularity of vitamin pills. He had made notes about everything he had found strange: "large consumption of scotches and soda in the cultural milieu; the luxury and bad taste, especially in neckties; the love of animals; the habit of drinking fruit juice in the morning; millions of windows lit up at night; hot baths; vitamins; drugstores serving bacon and eggs."[36] America would remain an oddity for him, a mystery he was not much interested in cracking.

THE BOOK THAT BEAT THE COMMUNIST
PARTY AT THE BALLOT BOX

April 1946 had come early and the weather was so mild that Simone de Beauvoir wore neither stockings nor a coat.[37] Over lunch one day, her mother told her about *that* book everybody was reading at the moment, by a certain Hungarian ex-Communist named Arthur Koestler. His book was *Le zéro et l'infini* (*Darkness at Noon*). Simone had read it before it reached the bookshops, on New Year's Day 1945. It had come out a few months later and had been an instant success: seven thousand copies had sold in its first month of release, fifty thousand by April 1945, a quarter million by May 1946, and the number would reach half a million by the end of the year, Koestler's greatest publishing triumph anywhere.[38] After lunch the sun was shining and she did not want to go back to the hotel. She walked straight to Le Bar Vert on the rue Jacob to see Jacques-Laurent Bost. Unlike Juliette Gréco, Simone was not so fond of the place:[39] it had nice posters but awful red tables and green walls, so green it made her feel almost sick. Here, too, everyone was discussing Koestler's book.

Newspapers had announced in their gossip columns that Simone and Sartre were deserting the Café de Flore once and for all for the basement bar of the Hôtel du Pont Royal. "Let's celebrate!" she had told Bost when the news broke, just before taking him to have an ice cream at the Flore: now that people thought she was not going anymore, perhaps she could go back and enjoy peace again. There they had bumped into Giacometti and Tristan Tzara discussing *Darkness at Noon*. Giacometti was the only one talking about it with intelligence, she had thought.[40] When Beauvoir thought of Koestler's intensity as a writer, she thought writing was probably a little like sex for him—or, as she had said, "There are days, just after I have worked very hard for days on end, when I feel like those flatfish washed onto the rocks after they have fucked too much, moribund, emptied of their substance."[41]

May 5, 1946. Referendum day had come. Would the French say yes or no to the new constitution cooked up by the Communists? The new constitution the French were being asked to vote on was championed by the Socialists but disapproved of by the Gaullists and General de Gaulle, who still exerted a great influence despite his withdrawal from political life. It was based on the concept of an all-powerful parliamentary regime

with one chamber and little executive counterbalance. On the day of the vote, Simone had to close her window—Parisians were arguing on the pavement below and she could not work. She had missed the deadline to register to vote and would not be able to cast a ballot. She felt rather ashamed. Sartre had forgotten to register too. But as he kept telling her, "the important thing is not to vote; it is to know how one would vote." This was Sartrean rhetoric in all its glory: witty but questionable.

The result came as a surprise to foreign observers and to the French themselves. Fifty-two percent of the electorate voted against it. It was seen as a rebuff for the Communists. Washington was pleased and the Gaullists were both relieved and content, but now what? On the day after, a Monday morning, Beauvoir could not find any newspapers left at the kiosk. She heard from her newsagent that the Catholic writer François Mauriac had argued that the most important factor in tipping the vote against the Communists had been the publication of *Darkness at Noon*.[42] Could books make or unmake elections? She certainly hoped so.

However influential he was, the celebrated and powerful Koestler would find himself challenged as soon as he set foot in Paris a few months later, in October 1946, at the time of a second referendum on a second draft for a constitution. After checking in at the Hôtel Montalembert, which stood right next to the Hôtel du Pont Royal, Koestler went to buy a copy of *Les Temps modernes* at the news kiosk. In its October issue, Sartre had given Merleau-Ponty free rein to attack Koestler's *Darkness at Noon* and his latest book, a collection of essays, *The Yogi and the Commissar*.

Koestler arrived at a time when Camus was getting back into the journalistic fray, after completing *La Peste*, which would be published the following year. Camus felt Sartre and Beauvoir were not challenging Communist positions enough, while Camus' lecturing tone increasingly irked the philosophers. "*Combat* is too much into morals and not enough into politics," Sartre had told Camus, now back at the editor's desk of *Combat*. Unlike Sartre and Beauvoir, who felt at ease grappling with the many contradictions of their times and deciphering them like mathematical equations, Camus preferred to disengage from them when they proved too murky or too complicated. Camus did not like hesitation; he needed certainty. "Simone, why are you against French clarity?" he had asked Beauvoir.[43] The situation was far from clear; it was complex. She thought that Camus' thinking was too shortsighted and that he was

protecting himself by refusing to answer difficult questions. It was easier to hide behind moral principles than get oneself dirty in the mud of ideas and politics. Their relations had remained very friendly, but "shadows were looming on the horizon."[44]

The last three months of 1946 were to prove very volatile, contrarian, and exciting. The Surrealist poet Philippe Soupault, who had written an essay on American sexuality in the special U.S. issue of *Les Temps modernes*, had helped the Gaullist Resistance rebuild the network of French press agencies in North America during the war. He was still well connected and, on seeing how much Beauvoir wanted to follow in the steps of Sartre and Camus in America, suggested arranging a tour of university talks for her. "Am simply dying to go," she had replied.[45] Beauvoir's tour would prove even easier for Soupault to organize, as his essay had caught the eye of *Time* magazine with its shocking rudeness and made him an instant celebrity in the literary circles of the East Coast. Jacques-of-All-Letters Philippe Soupault, one of the founding fathers of surrealism, examined love-in-the-U.S., shuddered at what he saw, reported in the French review *Modern Times* that "Americans consider a love affair in the same light as a crime." The fear of love, he observed, produces nervous disorders, and "there are more maladjusted people in America than in any other country in the world."[46]

Critical successes and catastrophes came in quick succession. On October 23, the first night of Koestler's play *Bar du crépuscule* was a "disaster," according to Sartre, and a "God-awful flop," according to Mamaine. On October 25, Calder's opening exhibition was a triumph, with Matisse, Cocteau, Picasso, Braque, Sartre, Beauvoir, and Camus, among many others, flocking to view those "little fiestas" of mobiles, which Paris had never seen before. Simone, who was meeting Calder for the first time, stood in a corner and observed both the mobiles and their creator. This "big, corpulent and bellied man with fat cheeks adorned with thick white hair reminded us all of the laws of gravity," and therefore also of the miracle of his creations. After Sartre introduced Calder to Beauvoir, the sculptor took a little packet from his pocket; it was a brooch with a spiral he had made especially for her.[47] She would wear it often for decades to come.

Two weeks later, on November 8, Sartre's play *Morts sans sépulture* opened at the Théâtre Antoine. Was it a success or a failure? It was a proper scandal, the proportions of which frightened even its thick-skinned author.

The play was about collaboration and resistance and featured a torture scene. People shouted "Shameful!" during the performances and fistfights broke out in the stalls. On the opening night, Raymond Aron left at intermission, supporting his wife, who had fainted during the torture scene. "It seemed clear that the bourgeoisie did not want to be reminded of certain bad memories"[48] that it had managed to sweep under the carpet. Sartre was drinking more these days; whiskey helped him cope with his celebrity and the Communists' constant attacks on him as a philosopher and as a man. However, he could not get away from photographers, especially from the new gossip magazine *France Dimanche*, whose editor sent its latest recruit, Anne-Marie Cazalis, to spy on Sartre's mother with history's first paparazzo, the twenty-six-year-old Italian Walter Carone. Having failed to secure an authorized portrait of Sartre's mother, *France Dimanche* ordered Cazalis and Carone to go back and be less courteous: they were to press the doorbell, spring up like jack-in-the-boxes, shoot a picture, and take to their heels or they would lose their jobs. They did just that, and the next day Sartre discovered a picture of his startled-looking maid Eugénie in the newspaper with the caption AN EXISTENTIALIST'S ANXIOUS MOTHER.

Koestler was in Paris not only to make new friends; he also intended to try to convince the Left Bank movers and shakers, and key French politicians, that there was no greater threat in Europe than Communism. Could the Gaullist Koestler, the liberal non-Communist Camus, and the Existentialists Sartre and Beauvoir reconcile their views or find a common ground other than seduction, sex, and alcohol? Koestler certainly felt impatient with the younger generation who had embraced Communism, but Camus promised to be his ears in Paris and to defend him.

The night of December 12, 1946, Boris Vian and his wife, Michelle, were giving a tartine party. Everybody was talking about the new novel *J'irai cracher sur vos tombes (I'll Spit on Your Graves)* by Vernon Sullivan, a black American writer. Its sex scenes had landed its publisher in court. Raymond Queneau, standing in the corner of the kitchen, nursing a whiskey in his right hand, was staying strangely silent. Vernon Sullivan did not exist and he knew it. Boris Vian had invented him. He had been so disappointed by the failure of his first novel that he had decided to trick both his publisher and his readers. On appearing only as the great Vernon Sullivan's translator, Vian had been deluged with translation work offers, among them books by Raymond Chandler, no less. Camus' arrival at eleven o'clock put an end

to the Vernon Sullivan conversation. He was not in a good mood. He had just read another attack by Merleau-Ponty against his friend Koestler in *Les Temps modernes* and he was incensed by it. Sartre came to Merleau-Ponty's defense, which upset Camus even further. He put on his coat and slammed the door. Sartre and Bost ran into the street after him but it was too late; Camus had jumped into a cab. The friends would not talk for three months.[49]

Camus had returned to the helm of *Combat* to support his idea of a Third Way in French and world politics. He refused both soulless American capitalism and Stalinist dictatorship. He might have considered himself "a man without a kingdom," "a man without a party," but that did not mean he lived in Utopia. There was another way, and he explained it in a series of articles titled *Ni victimes ni bourreaux* (*Neither Victims nor Executioners*). He firmly intended to win Sartre and Beauvoir to his cause, but for the time being he was sulking. He was also in a bad way: he had fallen in love with a young singer and had asked Sartre to write a song for her. "He was handsome, attractive, people fell for him, and he thought himself omnipotent,"[50] diagnosed Beauvoir, harshly but perhaps accurately.

PART III

THE
AMBIGUITIES
OF ACTION

HOW *NOT* TO BE A COMMUNIST?

FRANCE HAD WOKEN UP ON CHRISTMAS DAY 1946 WITH A NEW republic and a bicameral form of government supposed to restore some stability. However, as Janet Flanner wrote, "France's Fourth Republic can sit perfectly paralyzed by what temporary Premier Léon Blum has described as 'those two great parties whose simultaneous presence in government is at once indispensable and impossible.'"[1] The two great parties were the Gaullists and the Communists—irreconcilable. There was a third force, which was hostile to both Charles de Gaulle and the Communists but proved too heterogenous a mélange to speak with one strong voice, at least for the time being. To incarnate this Third Way, this democratic alternative, was precisely what was at stake for Left Bank intellectuals. But would they ever agree among themselves?

LEFT BANK INTELLECTUALS' TIGHTROPE RHETORIC

Arthur Koestler, back in his damp Welsh cottage with Mamaine, still without a telephone line, had to wait for a week to receive his January 1947 copy of *Les Temps modernes* in the mail, and to discover the Existentialists' latest attack against him. After tearing open the envelope, he started reading the issue slowly. It began with an extract from Richard Wright's *Black Boy*, which he decided to read first. He was impressed. He found it sharp and hard and ultimately gripping. A four-year-old black boy, bored to death, sets fire to his room. The fire spreads rapidly through the house while his invalid grandmother lies in bed, unable to move. Next, Koestler

skimmed through Beauvoir's serialized essay *Pour une morale de l'ambiguïté* (*The Ethics of Ambiguity*) to get to Merleau-Ponty's latest piece in a series called "Le Yogi et le prolétaire" ("The Yogi and the Proletarian"), a pun on Koestler's latest book *The Yogi and the Commissar*. Koestler paused, got up from his leather armchair, closed the door of his study, and, as he always did, poured himself a glass of arak and lit a cigarette before he began reading.[2]

With the blessing of Jean-Paul Sartre, Merleau-Ponty was merrily keeping up a campaign of destruction against the author of *Darkness at Noon*. This was *Les Temps modernes'* fourth consecutive essay lambasting Koestler's politics. Sartre and Beauvoir, themselves the targets of vile attacks from the Communists, nonetheless let their phenomenologist friend defend a philo-Communist position within their magazine. They liked heated debates with friends, relished polemics and clashes, but hardly did they know that Merleau-Ponty's attacks on Koestler were entwined with personal considerations. He had fallen for Sonia Brownell, who happened to be Koestler's former lover. Sonia had revealed to him that Koestler was a "sadist."[3] She had also confided to Merleau-Ponty that she had had to abort Koestler's child during the Blitz, a terribly painful, dangerous, and lonely experience.

For the Marxist Merleau-Ponty, the war had proved that the world could not live on capitalism alone and that economic collectivism was a fairer system. Communism might thrive on violence, he granted, but while Communism's aim was the end of exploitation of man by man, capitalism was merely pretending to defend freedom and peace for all when it was, in fact, defending the interests of a few. In other words, the end justifying the means, Communism was, on balance and in theory, still preferable to capitalism. For Merleau-Ponty, and indeed for a large proportion of French and European intellectuals, it was impossible to be anti-Communist, and impossible to be Communist. The terrible and deep guilt felt by so many French people who did not take part in active *résistance* against the Nazi occupiers meant that they could not and would not criticize the Communists, the most active members of the French Resistance, even if news from the Soviet Union and Eastern Europe meant that they could not embrace Communism either. The Communist Party's claim of being the "Parti des 75,000 Fusillés" (The Party of the 75,000 Shot) was still sticking. In fact, it was closer to 10,000 *résistants* shot, and of all political

inclinations. But the fact that the Communist *résistants* had been the most effective still stuck everyone else in 1947 France with a bad conscience. And in 1947, French people with a bad conscience meant almost everyone in the country.

If criticizing the Communists seemed too painful an exercise, however, Merleau-Ponty was honest enough to concede that the Soviet Union had a police force that terrorized its citizens and put on trial any dissenters, falsely accusing them of spying, before sending them to rot and die in Siberian camps. Those were not, however, good enough reasons to condemn the whole system whose ultimate goal was laudable. It was tightrope rhetoric. Merleau-Ponty's position was clearly untenable, but at the time, many intellectuals on the Left shared it. They refused to condemn Marxism and Communism, not least out of respect for the eighteen million Russians who died during the war;[4] however, they could not keep quiet in the face of the abuse of power taking place in the Soviet Union. It was the old omelet argument used during the French Revolution: you can't make an omelet without breaking eggs.

The thirty-six-year-old British historian Isaiah Berlin was devouring *Les Temps modernes* on his regular visits to Paris. So was his old Oxford friend the philosopher A. J. Ayer, who was as interested in ideas as he was in chasing Left Bank gamines, among them Celia Paget, Mamaine's twin sister. Both men followed the battle of ideas closely.

Isaiah Berlin later recalled the atmosphere at the time of the Koestler–Merleau-Ponty spat.

> One cannot have everything one wants—not only in practice, but even in theory. The denial of this, the search for a single, overarching ideal because it is the one and only true one for humanity, invariably leads to coercion. And then to destruction, blood—eggs are broken, but the omelette is not in sight, there is only an infinite number of eggs, human lives, ready for the breaking. And in the end the passionate idealists forget the omelette, and just go on breaking eggs.[5]

Camus kept siding with Koestler against Merleau-Ponty's arguments, finding the phenomenologist's thought too convoluted and, more important in his eyes, immoral. He categorically refused to choose between capitalism and Communism, now firmly and publicly rejecting Marxism.

He advocated instead a reformist democratic Left, in other words, social democracy.

Meanwhile, the Communists considered them all—Koestler, Camus, Merleau-Ponty, Beauvoir, and Sartre—traitors, whatever their divergences. They may have been clashing over the philosophical and historical implications of Marxism and Communism, but the Party put them all in the same bag, and ferociously attacked them in its own mighty press. By 1947, with its twenty-seven daily newspapers, the Communist Party accounted for 25 percent of the French national press. Watching it all unfolding from Le Petit Saint Benoît bistro, where he had lunch every week, was the future sociologist and, for the time being, faithful Communist Party member Edgar Morin.

The young Edgar Morin who, in 1938, was looking in Dostoyevsky and Montaigne for answers, dreaming of a bright and happy future, had first been too afraid to become a *résistant*, afraid of dying before having ever lived. Little did he know that war would in fact teach him how to live. Democracy had yielded to Fascism and been destroyed by it, therefore, in his eyes, "only Stalinist Communism seemed to offer the remedy to Fascism."[6] At first, in 1941, Morin had thought of escaping to Switzerland or to Spain, but his fear and his cowardice had made him sick. One evening, listening to Wagner on the radio in his dark little room, the windows wide open, a cigarette between his lips, using the moonlight to write his diary, he had debated with himself: "Hypocrite. They are here, they are calling you." In January 1942, Morin had taken a leap of faith and become part of the comradeship. For two and half years Morin and his friends abandoned their habits, their homes, even their identities, and lived from day to day. "Clandestine life had given us a heady freedom: traveling, leather jackets, risks, woolen cardigans and fraternity. When liberation came, we felt unable to adapt to peace, to have a career, to obey conventions, to accept life's new monotony."[7]

It was now two years since peace had returned, but Edgar Morin and all the twentysomething Communists for whom war had been a university of life did not feel comfortable in their skins. Morin had been given a column in the Communist newspaper *Action*, but he did not have the right style or the right tone for his orthodox communist editors. His war friends had died, been deported, or simply disappeared. He had, however, made new friends within the Party, the writer Marguerite Duras, her husband,

Robert Antelme, and her lover Dionys Mascolo among them. They all spent a lot of time at her flat at 5 rue Saint-Benoît, debating, drinking cheap wine, and singing. The Communist Party and its press found work for its intellectuals and offered a large and captive audience for what they produced. Morin was sent to Germany to write a book about how the country had been faring since the end of the war. Commissioned by a Communist publisher, his conclusions had to follow the party's line. Upon its release, *Les Lettres françaises* reviewed the book favorably. Communist intellectuals lived in a self-sufficient, self-reliant, self-reviewing bubble—a whole economy and industry was built around them. Like Edgar Morin, writers who wrote according to the Party's *doxa* would get translated into the many languages of the Soviet bloc, and they would be invited to talk in every Eastern European country. "The more docile you were as a writer, the more celebrated. The Stalin award was our Nobel Prize. Most writers and intellectuals got used to this fake world, this byzantine society and its delirium. But let us not forget that those young men had originally enrolled in the Party to change the world and to change life for the better."[8]

For them to see clearly, act, and leave the Party meant a second rebellion for which many lacked the strength. "One can hardly rebel twice in one's life. First against the bourgeoisie and its corruption, and then against the very family which gave you hope." Being a young Stalinist in 1947 meant belonging to an "unprecedented magical and religious structure."[9] Besides, the Party had managed "to maintain a psychology of war in time of peace." It had mutated into "a brotherhood with its sacred texts and initiation rituals."[10] The Party was like a "Church which kept its members warm."[11]

To Morin and the Party, everyone who chose to stand outside that church was deemed an enemy. Later in life, Morin looked back with perspective: Camus' moralism was in fact the "distillation of his Communist hope."[12] Edgar Morin later understood that Camus, bitterly disappointed, almost "mortally wounded" by the reality of Communism, had chosen to reject political euphoria. Camus' stance was that of a solitary conscience. However, at the time, in 1947, Morin the Stalinist attacked Camus for being at best a poseur, at worse a defeatist. As for the Existentialists, they were the most dangerous of all because they had committed to wrestle with the ambiguities of action, but their lucidity, denounced as nihilism, did not fit the epic Communist vision. *Les Lettres françaises* relentlessly attacked Sartre for being pessimistic, but Sartre refused "a priori hope." In

his view, "writers shouldn't promise a better tomorrow, but by describing honestly the world as it is, they should trigger in people the will to change it for the better."¹³ The Communists feared Sartre the most as he was the only one to offer a real and new alternative to the youth on the Left. But Sartre did not have a party behind him, nor the Red Army.

Koestler finished reading Merleau-Ponty's riposte and shivered. The ancient oil stove in his study had broken down again. He got up and poured himself another glass of arak (he still had one bottle left from his last trip to Palestine, which he kept in a little oak cabinet). He knew Camus would defend him again. Arthur smiled at the thought of it, knowing why Camus was such a vehement ally of his. It was not only political or philosophical, but personal too, just as it was with Merleau-Ponty. Mamaine had confessed to it.¹⁴

It had started during the memorable night they had all spent at the Sheherazade with Sartre and Beauvoir in October 1946. Camus and Mamaine, the least inebriated of the group, had danced cheek to cheek and Albert had confessed how unhappy he was with Francine, how attracted he was to Mamaine, and how tormented it made him feel given that Arthur was his friend. Mamaine had arranged to stay for another week alone in Paris and let Camus know. An hour after seeing Arthur off at the station, Mamaine received the first of many bouquets of roses from Camus. One promenade in the Luxembourg Gardens during which Camus read to Mamaine from *La Peste* led to another in the Bois de Boulogne, and to a few days spent together in Provence, near Avignon. Gone was Camus' torment about seducing his friend's girlfriend. For a few days, Albert and Mamaine visited Romanesque churches and danced the tango in a Spanish nightclub. As soon as she returned home to Arthur, Mamaine confessed her affair. It was her way of putting an end to her relationship with Camus.

"The days I spent at your side were the happiest of my life and I will never be able to forget them," Camus later wrote to Mamaine. He had hoped for a long, secret liaison with Mamaine but accepted that they would now be friends. Koestler took it philosophically and let Camus know he did not bear him any grudges: "I take great liberties in my private life and concede the same liberties. Naturally, this leads sometimes to somewhat painful conclusions. On the other hand, it gives more basic

stability to a relationship than things done on the sly."[15] For Arthur, to concede liberties did not mean confessing to every little affair, or living according to a pact like Sartre and Beauvoir. Mamaine certainly did not know that Arthur had slept with Beauvoir or with Dominique Aury, his latest French translator, among others. Koestler did not confess to any dalliances unless he was caught red-handed. Mamaine was always more upfront about her own sporadic affairs.

POLITICAL PARALYSIS AND STREET PROTESTS: GAULLISTS AND COMMUNISTS AT LOGGERHEADS IN FRANCE AND INDOCHINA

Arthur Koestler was battling both the Welsh weather and the strike actions in ration-bound Britain and was split between wanting to go and settle temporarily in New York after their farmhouse's lease ended or stay in Europe and fight Communism from within. Koestler actually feared Europe would soon fall into the hands of the Communists. Depending on his mood, he gave Europe eighteen months or less to succumb to the red devil. On the other hand, he knew he would have great difficulty abandoning Europe. His favored scenario was to find a house in Paris or nearby, and settle there where, as the influential writer he had become, he could perhaps make an impact on national politics. He remained convinced that the future of Europe would be decided in the streets of Paris. His pessimism, though, was pointing to America as the ultimate refuge from tyranny.

There was another issue that troubled Koestler: he had ambivalent feelings about Britain. He may have embraced its language and applied to become a British citizen, but he was starting to realize that he would never become an intellectual force in Britain in the way he was already considered one across the Channel and across the Atlantic ocean. The literary critic V. S. Pritchett had pointed to the brutal truth in his *Horizon* essay earlier that year. Koestler was "separated" from the British "by the education and politics of the continent." He could easily "dazzle us because we have no café conversation and no café writers. We have no skill in playing with ideas. We are not trained to pretend that things which are entirely different may (for the pleasure of the effect) be assumed to be opposites. We have no eternal students."[16] Koestler had taken it badly but recognized

some truth in it. "For the French, these negatives were positive,"[17] but they never would or could be for the British.

V. S. Pritchett's forthright words echoed forcefully, but their condescension toward Koestler also revealed some bitterness at Britain's lack of intellectual effervescence. In comparison with the never-ending excitement of Paris, weary and bombed London seemed, as *Horizon*'s editor Cyril Connolly put it, "a grey sick wilderness on another planet." His deputy editor, Peter Watson, was blunter still, seeing England as a "prison." Sonia Brownell "found it hard to bear the narrowness and insularity that closed them in at home."[18] Why couldn't London be more like Paris? To cheer everyone up, Peter Watson resorted to decorating *Horizon*'s offices on Bedford Square in Parisian style. He took his Picasso paintings out of storage and hung them on the walls. Visiting the review's office in the spring of 1947, Evelyn Waugh could not suppress his trademark sarcasm and hurriedly wrote to his friend the aristocrat socialite turned gossip writer Nancy Mitford: "I saw the inside of the *Horizon* office, full of horrible pictures collected by Watson . . . Miss Sonia Brownell was working away with a dictionary translating some rot from the French."[19]

Unlike Evelyn Waugh, the Left Bank had little time for cynicism. Besides political paralysis, the Fourth Republic was beginning to have serious problems in its colonies, particularly in Indochina. *Les Temps modernes* was the first to report unequivocally on French endeavors in Indochina, relying on the Vietnamese Tran Duc Thao, a supporter of the Viet-Minh and Ho Chi Minh, to shed some light on the events. The war had now in fact begun. Janet Flanner explained the premises to her *New Yorker* readers: "France has been fiddling around in Indo-China since the time of Louis XVI, when he slipped an alliance round the Emperor of Annam. From Louis XVI to the first president of the Fourth republic is a long time for the French to have been in Indo-China without making friends."[20] In the March 1947 issue of *Les Temps modernes*, a special number dedicated to the situation in Indochina, Tran Duc Thao concluded: "Vietnam's independence is inevitable." Claude Lefort stated that "the Second World War has not triggered the current struggles against colonial domination; it only sped up a revolutionary process which had been perceptible for a long time"[21]—a view shared by other writers. A letter from a veteran, written on February 5, 1947, and published by the journal, drily

predicted: "After the dress rehearsal in Indochina, the première will be performed in other parts of the French Empire." Seven years before the Battle of Dien Bien Phu, which would lead to the withdrawal of French forces from North Vietnam and the Geneva peace agreements, the Existentialists had seen the future with exceptional clarity.

THE LOYALTY PROGRAM

While Koestler was reluctantly toying with the idea of leaving Europe for America, all Richard Wright could think about was going back to Europe with his family. Politics were changing in America and he did not like what he saw. A couple of months earlier, in November 1946, the Republicans had overwhelmingly won both houses of Congress. Theodore H. White, the former China correspondent of *Time* magazine and the author of the just-published and bestselling *Thunder out of China,* had seen the victory coming. He had spent the summer and early fall driving through the United States to spend some time with his old comrades of the 11th Bomb Squadron and to find out how they were fitting back into society. He was writing a long reportage, the story of the great homecoming. "In those post-war months thirteen million young Americans released from the military were returning to seek the place into which they could best fit back. For millions of men, now, if ever, was the time to change jobs, styles of life, homes, ambitions."[22] Those men brought the Republicans to power. They had "a mandate that America stand still, a plea that time stop its clock and reverse the pointers and bring America back to some unreal memory of how it had been before the war, a retreat through time to, say, 1925, or 1928, or 1936."[23] It was for the young veterans an attempt to erase the war. They wanted to be home, undisturbed, with mothers, new wives, and wanted a house, a car, and a job. Many of them ran for office, and "historically their entry into politics was the unremarked story of the elections of 1946."

> The returning veterans, having altered the outline of the world abroad, were preparing to alter the outline of politics in America for the next thirty years. John Fitzgerald Kennedy, Richard Nixon, both back from navy service in the Pacific, made their first runs in 1946. So too did

"Tail-Gunner Joe" McCarthy of Wisconsin. Few, if any, young black veterans ran for office that year; blacks had two Congressmen, Powell from New York, Dawson from Chicago, and so it appeared they must rest content with only two as far into the future as one could see.[24]

It was easy to attack Stalin and his State police, thought Richard Wright, but American politics was far from being civilized. It was cruel, corrupt, vicious, and sometimes murderous. Theodore H. White distinguished between the northern cities like Chicago, Boston, Philadelphia, and New York, where he deemed politics "corrupt; but not murderous," and the southern states, where "they condoned murder: the killing of blacks casually, the killing of whites only if they were really troublesome."[25]

On March 21, 1947, the U.S. president, Harry Truman, instituted a loyalty program that required all federal employees to swear they had never advocated or approved "the commission of acts of force or violence" that would "alter the form of the U.S. government." In other words, government employees had to take an oath that they had never held Communist beliefs. In truth, the program was prompted by overblown fears that the Communists were infiltrating universities, companies, schools, the ranks of administration and government, and Hollywood. Communism was feared to be exerting an increasing influence over the American youth.

Richard Wright heard the news on the radio. Seated on their flower-patterned divan in the Charles Street flat's large sitting room, he and Ellen decided they would go back to Paris as soon as they possibly could. They needed to put their apartment on the market first. In fact, Wright was not so much concerned with the political repercussions of the loyalty program for him personally. Only government employees were being targeted, at least for the time being. What he dreaded was a new suspicion creeping through American society as a whole, which might have a negative impact on racial relations.

Personally, he had wholeheartedly rejected his Communist past in an article in the *Atlantic* published in August 1944, a decision he now thought of as lucky. The essay opened with these lines: "One Thursday night I received an invitation from a group of white boys I had known when I was working in the post office to meet in one of Chicago's South Side hotels and argue the state of the world. About ten of us gathered, and ate salami sandwiches, drank beer, and talked. I was amazed to discover

that many of them had joined the Communist Party."[26] His mea culpa
had been widely reported and accepted, and he was not considered a Com-
munist or even a sympathizer any longer. Wright did not want to discuss it
anymore; it was the past.

Theodore H. White would, however, soon experience the effects of
that "creeping feeling" Wright had anticipated. It came slowly, and silently.
Once a much-sought-after writer, courted by American mass publications,
Left-leaning but not Communist, White could soon publish only in small
left-wing magazines.[27] He thought this would pass; he had received a good
advance for his book and the sales were healthy, everything would be fine.
He could live on royalties for many months. No need to worry unduly, he
thought at first.

Across the East River in Brooklyn, in his little apartment at 49 Rem-
sen Street, the twenty-four-year-old Norman Mailer was finishing his
first novel, *The Naked and the Dead*, based on his war experience in the
Philippines as an army cook. Mailer had learned about Truman's loyalty
program reading the newspaper. He had written to a friend on the same
day: "I've gone quite a bit to the Left since I've gotten out of the army. I'm a
Jew Radical from New York now."[28] Norman did not think highly of
Harry Truman's "containment policy." The American Congress was going
to send military and economic aid to Greece and Turkey, both threatened
by Communist-inspired insurrection. The problem, thought Mailer, was
that the pressure would continue elsewhere. By now the Republicans had
been in power for five months and neither Norman Mailer nor his wife
Bea enjoyed living in staunchly Republican America. What about sailing
to Europe and settling in Paris for a while? After all, Norman was eligible
for the GI Bill. If only he could have his novel published first. He liked the
idea of landing in Paris as a published novelist, not just an aspiring one.

"IF I STAYED I'D BECOME A COMMUNIST"

Richard Wright had been looking forward to welcoming Simone de Beau-
voir to New York, on the first leg of her American tour, and to discussing
politics with her. She had feverishly packed for her trip to America. For
the first time in her life, she had had to be frivolous and had hated herself
for it. It had made her friends laugh but she had cried when she broke
down and spent a small fortune on a dress for her American tour.

Beauvoir had rejected her bourgeois milieu; she did not belong to high society even if she mingled with it as a well-known writer. She snubbed their dress codes and had sworn never to own an evening gown.[29] "I refused to wear the livery, not of my gender, but of their class. The cult of elegance implies a system of values that I do not accept." However, for her American tour, and to avoid the humiliation of being taken to a tailor as soon as she stepped off the plane at LaGuardia, as had happened to Sartre, whose threadbare clothes had horrified his American hosts, she needed at least one new dress. She bought one in a little *maison de couture*, a finely knitted black dress, for the exorbitant price of 25,000 francs (the equivalent of about $1,650 today). She walked back to Sartre's flat and told him, pointing to her shopping bag: "This is my first concession,"[30] and burst into tears. But the purchase was a sound investment: no one in New York asked her to go and get new clothes. Janet Flanner even told her *New Yorker* readers: "Mademoiselle de Beauvoir is the prettiest existentialist you ever saw; also eager, gentle and modest."[31]

As soon as she arrived, Simone went straight to 13 Charles Street to visit Richard Wright and his family. She warmed to Ellen, whom she had met only very briefly in Paris, and, surprisingly for a woman who had always shown impatience and indifference to young children, she loved the five-year-old Julia, whom she thought "delightful." The Wrights introduced her to their friends, mostly Jewish and anti-Stalinists, and she attended parties every evening. Simone had also insisted on meeting Dolorès Vanetti, who was on her way to Paris to fill the vacuum left by her absence from Sartre's side. They met at the Sherry-Netherland bar quite late one evening and gulped down whiskey (Dolorès especially, terribly nervous at meeting Beauvoir) until three in the morning. Simone wrote immediately to Sartre to report back and to dub her a suitable companion: "I like her a lot, and was very happy because I could understand your feelings. She drank one whiskey after another, and this was reflected in a certain volubility, and some classic crazy behavior. She was fantastically moving."[32]

Talking, drinking, smoking cannabis in Greenwich Village with Wright's friends, Beauvoir was amazed to discover the chauvinism of the New York intellectuals she met. "Their chauvinism reminded me of my father's. As for their anti-Communism, it verges on neurosis."[33] She could not resist taking notes on all the details, the differences, the feelings she experienced. On January 31, 1947, she wrote: "Americans' politeness and

good humor make life so much easier and nicer." However, she could not help looking beyond the façade: "Yet, I'm starting to find annoying all those imperious invitations to 'take life on the bright side.' On every poster, everyone shows their white teeth in a grin that seems to me like tetanus. On the subway, in the streets, in every magazine, those obsessive smiles are chasing me. It is a system. Optimism is necessary to social peace and economic prosperity based on consumption and credit."[34]

On February 8, Simone went on Bernard Wolfe's arm to see Louis Armstrong in concert at Carnegie Hall. Richard Wright had introduced Simone to Bernard, seven years her junior, a writer and jazz fanatic who had briefly been Trotsky's secretary in 1937. Wolfe had managed to get two tickets to the Armstrong concert, no small feat. Just like Camus and Sartre before her, Simone was looking for the person who would give her America. She thought Bernard Wolfe would suit the role, except he was too slow in taking the bait. Before he realized it, Simone had left New York City.

She had time before she was due to begin her round of prestigious universities and her lecture tour, and she was determined to see as much of America as she possibly could, and to travel as widely as possible, by bus, by plane, by train, by car. On her way to Los Angeles to visit her former student and lover Nathalie Sorokine, now Nathalie Moffat, wife of the British-born screenwriter Ivan Moffat, Simone stopped at Buffalo and Niagara Falls (a disappointment, she noted wryly). In Los Angeles, Nathalie and Ivan introduced her to the film director George Stevens. They had lunch at Lucy's, a restaurant standing right between the RKO, where Ivan was under contract, Warner Bros., and Paramount studios. Stevens had made his name directing comedies and films with Ginger Rogers and Fred Astaire. Now forty-two, he was among the millions of young American veterans trying to fit back in. Still reeling from his experiences during the war—filming the D-Day landings, the liberation of Paris, and, even more dramatically, the liberation of the Dachau concentration camp—he was looking for dramas to direct; he could not do comedies anymore. His four years as lieutenant colonel and head of the U.S. Signal Corps' film unit had changed him forever.

While speaking to Stevens over lunch at Lucy's, Simone could not help looking around her, observing the "garish elegance of women, the platinum blondes dressed in candy-pink and baby-blue." Overabundance

is an American disease, she wrote. "One suffers here from too much noise, too much perfume, too much heat, and too much fake luxury."[35]

After driving to San Francisco, Sacramento, Reno, and Las Vegas with George Stevens, Simone left on a three-week bus tour of the United States with Nathalie. She took the Greyhound coach to Santa Fe, New Mexico, the first stop on her tour. She was relieved to find a little bit of Europe's mess and flesh there. "Streets are bent and have no right angles, thank God. Very few cars; people are walking in the sun. Women are not showing their perfect and thin long legs like on the West Coast."[36] Another twelve-hour bus ride through deserts and cactuses, and Simone arrived in San Antonio, Texas. There she found lunchrooms for "colored men" and for "white ladies," and although she had been expecting to find such places and signs, "something weighty has suddenly fallen on our shoulders." This weight would never leave her throughout her journey in the South.

In New Orleans, Simone and Nathalie stayed in a big, luxurious hotel, an "enclave" that didn't suit Simone. "You could live a whole life without ever going out: florists, candy vendors, booksellers, hairdressers, manicurists, stenographers and typists are at your service. There are four different restaurants, bars, cafés and dance floors. It's a neutral zone, like the international concessions in the middle of colonial capitals." As soon as they checked in, Simone ventured out with Nathalie. They wanted to eat Creole food and listen to "real jazz." After dinner, they stopped at the Absinthe House at 240 Bourbon Street, at the corner of Bienville Street in the French quarter, supposedly one of the residences of the pirate Jean Lafitte. "There are three black musicians on piano, guitar and bass. Suddenly, we're transported. The band does not try to please or dazzle anyone; it plays the way it feels like playing."[37]

In the small audience, listening religiously to the music, two young white men kept looking at Simone and Nathalie, who were sipping big Zombies cocktails, and finally introduced themselves. Simone was rather taken with one of them, a twenty-two-year-old Italian music student, and listened to him speak passionately about not only jazz but also Stravinsky, Ravel, and Bartók. "Of all the young people I've met in America, he's the first one who really seems young." Talking all night and parting as dawn rose over Bourbon Street, the new friends agreed to meet again the next

evening and find new black jazz haunts. The black musicians at the Absinthe House had slipped them addresses.

On their second night in New Orleans, the weather proved even more extraordinary than the evening before: "a pearly-grey fog shedding an extremely bright light, so that at two in the morning you'd have thought it was dawn," with "air as humid as in a greenhouse."[38] That night, the four European friends experienced jazz as never before. "In those modest bars, jazz reaches real dignity. This is jazz as a way of life, as a reason to keep on living. Jazz immediately pierces its listener and transfigures life. If those black musicians' life is often an arduous and tormented one, it is because instead of keeping death at bay like other artists, they precisely achieve the marriage between death and existence."[39] She wrote to Sartre, "it was the most poetic evening of my life."[40]

On April 1, her third day in New Orleans, Simone walked for hours in the streets to soak up the city. At one point she found herself in the black quarter and was met with hostile looks. She spent the evening at a university colleague's home; he had organized a party in her honor. There, everybody talked of the "reds" and seemed frightened by them. "The epithet 'red' is a rather elastic one. Every day, whether in the working or intellectual and political classes, I sense a slow erosion of freedom."[41] On April 2, Simone and Nathalie hopped on a Greyhound coach for another fifteen-hour journey through Louisiana, Mississippi, Alabama, and Florida, all along the Gulf of Mexico. "Wherever we stop, we can smell hatred in the air: the arrogant hatred of the whites, and the silent hatred of the blacks."[42]

Back in New York on April 10, Simone spent her afternoons and evenings with a small group of four or five young writers. Among them were her jazz chaperone Bernard Wolfe and Calder Willingham,[43] a twenty-four-year-old "Fred Astaire lookalike" who had just published a scandalous novel, *End as a Man*, about homosexuality in a military school in the South. Simone could now draw comparisons between the daily lives of young writers across the Atlantic Ocean.

> They hardly go out to have dinner and hardly travel through America. Their interiors are as modest as French writers' ones, their bathrooms though are comfortable and modern and they all have a fridge, which says much about the higher standard of American living. However, their real piece of luxury is their record players. Jazz is as

vital to them as bread. Their days are much more solitary and dull than ours in Paris. They do not have cafés to meet their friends, exchange ideas, relax, and be stimulated. Parties are a social obligation where nothing meaningful is said.[44]

She made brief trips to Philadelphia and Boston to give talks and meet people. Her lectures at Smith and Wellesley colleges, which "smelled both like a monastery and a clinic," left her unsure of young American women's dreams and aspirations. At Harvard, she realized that students were taught only very specialized subjects. "America produces linguists, chemists, mathematicians, sociologists, but does not train and shape minds."[45] Simone was surprised to see that philosophy, divided into specific categories such as psychology, logic, and sociology, was taught as hard science. As a result, the academic life seemed "divorced" from the intellectual life of the nation. "In France, writers have often taught at universities whereas in the US no writer has started their career as an academic. There does not seem to be any bridge between culture and life, which is most preoccupying. American youth prefers pretending that politics is for experts and specialists." She heard Harvard and Yale students talk coolly about the next war with Russia, completely resigned to it, even speaking about it with "positive tones that send a chill down your spine."[46] As left-leaning students, they confessed to her that they dared no longer say they were liberals for fear of being labeled Communists. "If I stayed, I'd become a Communist," she wrote to Sartre.

FRENCH COMMUNISTS STIR UP DISCONTENT

In the letters he sent to her in America, Sartre had told Simone about the strikes that had started to paralyze France sporadically, and his feeling was that they would grow in intensity. He was right, and they would last for seven months. Strikes had begun at the recently nationalized Renault car factory just outside Paris at the end of April 1947. Among the thirty thousand or so Renault workers, more than half were members of the Communist trade union, the CGT.[47] At first the French Communist Party, part of France's tripartite government, did not support the strikes. But with inflation running at 51 percent, the average wage increasing by only 19 percent, and food still being rationed, the Communists decided to

LEFT BANK 173

leave the government headed by Paul Ramadier, and to fully engage in insurrectional tactics and strikes throughout the country. As the weeks passed by, strikes extended to the other car manufacturers Citroën and Peugeot, to Michelin, to the railway services, to department stores and banks. Officially the main reason for the strikes was inflation, the high cost of living, and low wages, but nobody was fooled. They were politically motivated, a very clear expression of the Cold War within Western Europe.

As always, Janet Flanner gave her own idiosyncratic view to her American readers: "For the past months, France has been in the undignified position of an elderly lady doing the splits, her Right leg extended in one direction, her Left in the other, while everyone wondered how long she could hold it."[48] With the Gaullists, and André Malraux especially, blowing on the embers of fear over the Communists' action in the strikes, political tension was rising in Paris. Malraux, in a low and conspiratorial voice, looking over his shoulder and leaning heavily toward his interlocutor, had (again) spread rumors that Russian tanks were on their way to Paris. "In less than a week the Communists are going to take over Paris, or try to, by fire and blood," he told friends including the Catholic writer Georges Bernanos.[49]

In Beauvoir's absence, Sartre was developing his theme on committed intellectuals, or *intellectuels engagés*. In February 1947 he had started a long series in *Les Temps modernes* called "Qu'est-ce que la littérature?" [What is literature?], another magisterial essay on the situation writers faced in 1947 and on their moral, intellectual, and political duties. In the May issue, he compared the figure of the writer in France, America, and Britain.

> The French writer is the only one who has remained a true bourgeois, having got used, after 150 years of domination, to a language filled with and broken by "bourgeoisisms." The American writer, on the other hand, has often had other jobs before becoming a writer. He or she doesn't see in literature a way to proclaim his or her solitude but an opportunity to escape it. To their eyes, the world is new, and everything remains to be said. In Britain, intellectuals make up an eccentric and rather cantankerous caste with little contact with the rest of the population. They haven't had our luck. Because of the Revolution, we are feared by our political class. In Britain, intellectuals don't scare anyone, they are considered an inoffensive bunch.

In Bwlch Ocyn, Arthur Koestler felt this acutely. He also suffered from depression, writer's block, and mood swings. Koestler was obsessed with the thought that the Soviet army was only a few months from invading France. The recent implosion in France of the tripartite coalition born of the war was the sign for Arthur that the end was nigh. Mamaine kept writing to her twin sister to get some of her exasperation off her chest. On May 22, "K still can't get back into his work. It is over two months since he was working properly so you can imagine the state he's in." Five days later: "K interested (fascinated) by mysticism. Not back to his usual self. He bewailed the collapse of all his heroes, and said how awful it was to have nobody to look up to. His cynicism and pessimism and *mauvais caractère* are so overwhelming." The visit of his mother, whom he hated, did not improve the general mood. "K's mother when she was here, one day said: 'I see you have all the books of that Dr. Freund.' K: 'You mean Dr. Freud.' 'Yes, I used to know him well when I was seventeen. Tante Lore sent me to him as I had a nervous tic. He massaged the back of my neck and asked a lot of annoying questions. I stopped going.' The idea of how different Arthur's, and consequently my life would have been had his mother not stopped going to Freud is extremely fascinating."[50]

GEORGE MARSHALL AND HIS PLAN

On June 5, 1947, the day Albert Camus' *La peste (The Plague)* hit the bookshops in Paris, the U.S. secretary of state, George Marshall, was delivering a low-key yet historic speech in front of fifteen thousand Harvard graduate students. In fact, he had cunningly chosen the future elite of the country as his first public audience for his plan to help Europe's economic recovery. "I need not tell you gentlemen that the world situation is very serious. That must be apparent to all intelligent people," he began. He made a few matter-of-fact statements about Europe's dire economic condition: "Europe's requirements of foreign food and other essential products—principally from America—are so much greater than her present ability to pay that she must have substantial additional help, or face economic, social and political deterioration of a very grave character."[51]

The aim of Marshall's plan was simple: to prevent another worldwide economic depression of the kind the world lived through after 1929 by sup-

porting Europe's economic reconstruction. After lengthy hearings in Washington, the Economic Cooperation Act was passed by a vote of 329 to 74. The act that would become known as the Marshall Plan was signed on April 3, 1948, by President Truman. The financial aid would include Austria, Belgium, Denmark, France, Great Britain, Greece, Iceland, Luxembourg, the Netherlands, Norway, Portugal, Sweden, Switzerland, Turkey, and former enemies Germany and Italy. During the life of the Marshall Plan, the U.S. Congress would pump $13.3 billion into European economies, providing much-needed capital and materials for Britain and the Continent's recovery. The plan was beneficial to the U.S. economy in that it created markets for American goods by sustaining reliable trading partners. The plan was supposed to last four years and to terminate at the end of June 1952. In order to be eligible for assistance under the act, European partners had to individually sign an agreement with the U.S. government that bound them to the act's purposes: currency stabilization, trade cooperation, trade barrier removal, economic self-sufficiency, and industrial modernization. The Marshall Plan would later lay the foundation for the North Atlantic Treaty Organization (NATO) and the future European Economic Union.

Not once in George Marshall's speech at Harvard were the words "Communist" or "revolution" uttered. However, Marshall had thought it important to add: "our policy is directed not against any country or doctrine but against hunger, poverty, desperation and chaos. Its purpose should be the revival of a working economy in the world so as to permit the emergence of political and social conditions in which free institutions can exist." The C word might have been omitted, but never was there a clearer plan to entice Europeans into rejecting Communism, to contain the red evil by inducing them to embrace capitalism instead.

On hearing about Marshall's plan on the BBC, the British minister for foreign affairs, Ernest Bevin, reached immediately for his telephone and dialed his French counterpart, Georges Bidault. They agreed to call an emergency European conference in Paris with a view to accepting the Marshall Plan and discussing the terms. It was a historic opportunity that neither Britain nor France would want to miss. As feared and yet expected, Stalin soon made it clear that neither the Soviet Union nor any of its

"allies" in the Eastern bloc would accept American aid. Eastern European countries were coerced into rejecting the Marshall Plan and accepting Soviet aid instead, making them even more dependent on Moscow's goodwill.

The former *Time* magazine foreign correspondent Theodore H. White became fascinated by Marshall's proposal. It certainly had all the hallmarks of a "good story," as hacks would soon call it, a story worth reporting and investing time in, one that would undoubtedly keep giving over the next few years. Struggling in New York to have his articles published, blacklisted by former employers who feared his overliberal sensitivity, White was starting to think that perhaps he should leave America and resume his career as a foreign correspondent. The problem was that he could not go back to China and he did not know anything about Europe. He knew, though, that he would love "to cover the Marshall Plan and how America was to save Europe from Communism."[52] He had always been fascinated by the exercise of American power, and in that sense the Marshall Plan promised to be the greatest adventure there was.

LOVE, STYLE, DRUGS, AND LONELINESS

HUSBANDS, LOVERS, AND FRIENDS

The tall, handsome, and brooding Nelson Algren, of Jewish, Swedish, and German descent, whom Simone de Beauvoir had briefly met in Chicago on February 21, 1947, was about to distract the French philosopher from her incessant analyzing. She had spent only an evening and an afternoon with the thirty-eight-year-old novelist, who was struggling to write his third book, but it had left its mark on her. Algren had taken her to West Madison Street, also called the Bowery, on a tour of the city's downtrodden to meet the "bums, drunks and old ruined beauties." At a "sordid dance hall,"[1] ancient, ugly, and very poor couples danced, losing themselves, happy, as if time were suspended. Beauvoir, stunned, found the scene moving and beautiful. In America, Algren told her, "beautiful and ugly, grotesque and tragic, good and evil, each has its place. Americans do not like to think that those extremes can mingle." Algren then put her in a taxi, kissing her "clumsily but very seriously and intently."[2] Algren had found in Beauvoir a kindred spirit.

Sartre had asked Simone to delay her return to Paris by a week: Dolorès intended to fight her ground and would not budge. Little did Sartre know that she in fact hoped to stay indefinitely and replace Beauvoir in Sartre's heart. Simone jumped at the opportunity and flew to Chicago to see Algren for three days, and even persuaded him to accompany her back to New York so they could stay together longer. In New York, Algren was the tourist and Beauvoir his guide. Having traveled little outside Chicago, except during the war, when he was stationed in France, Algren was bewildered

to see New York and its colorful laundry hanging from the fire escapes, tailors for fat gentlemen, and they tattoo parlors. Together they toured the "ghetto" of the East Side, and they fell in love. On May 11, 1947, Algren slipped a cheap Mexican ring onto Beauvoir's finger, and she told him she would wear it till the day she died.[3]

Meanwhile, on the Paris boulevards, Sartre could be seen with Dolorès Vanetti at a showing of Vittorio De Sica's *Sciuscià* (*Shoeshine*), a forceful, anguished, uncompromising, and beautiful film about Italy's homeless and hungry children after the war.[4] Sartre and Dolorès were both deeply moved by it. Sartre, rather smitten with Dolorès, did not know how to persuade his lover to go back home, but neither could he ask Simone to delay her return a second time. They had written to each other every two days those last four months and Sartre was not prepared to break his life arrangement with his soul mate for Dolorès, no matter how much he loved his American girl.

When Beauvoir touched down at Orly airport at dawn on Sunday, May 18, he was still in bed with Dolorès. The American woman had decided that she would not exit the stage for Simone unless Sartre promised to marry her. Beauvoir had given Sartre the extra week he'd requested, precisely so that he could "properly" see Dolorès off. In her last letter to him, Beauvoir had been clear: "I really do want to feel completely calm and free of problems in Paris, at least during the first days. I beg of you, my love, fix everything nicely so that we can be on our own for a long time, and nothing spoils the happiness of being back with you." Before finishing with "My love, I know I'll be happy this Sunday when I see you again. I love you."[5] When she reached the Gare des Invalides at ten thirty in the morning, after a long and exhausting flight and with two huge leather suitcases bursting at the seams, she was shattered to learn that the woman she would from now on refer to only as "M" in her writing had not left. She knew better than to press Sartre with questions. She had to endure it until vindication time. Despite the cool hand she played, she was unsettled and depressed, especially as she had left a man with whom she had fallen in love. She had never considered betraying her pact with Jean-Paul, even for a great passion. But what about Sartre? Did he want to end their relationship? Beauvoir coped with antidepressant pills. Meanwhile, Algren wanted her to commit to him. She was torn.

Often preached but rarely put into practice, sexual faithfulness is usually experienced by those who abide by it as a mutilation: they try to get over it by way of sublimation, or with wine. Many couples, like Sartre and myself, make a pact, that is to maintain a certain fidelity despite some misbehavior. Sartre and I were even more ambitious, we wanted to engage in "contingent loves," but there was one question we had overlooked: how would the third party react to our mutual arrangement?[6]

For Paris's existentialists, friendship seemed as complicated as love. Fallings-out and reconciliations came in quick succession, politics and sex playing a central part. Albert Camus' *La peste* had been published in June 1947 and was his first real commercial success. After a week, his publisher Gallimard was already reprinting and predicting sales of at least eighty thousand copies before the end of the summer. Now reconciled with Sartre and Beauvoir, Camus, who had just quit the editorship of *Combat* again, was seeing more of his old friends. Sartre was corresponding with Koestler and they, too, were back on amicable terms. Camus could see that Sartre was the butt of vicious attacks from the Communists and he admired him for tirelessly confronting them with their own contradictions. "Between Sartre and the Communists, ties were severed. The Party's intellectuals were hounding him precisely because they feared he would steal their influence on the youth. The Communists thought Sartre all the more dangerous because he actually felt close to their cause."[7]

Janet Flanner had received an advance copy of *La peste* from Gallimard and had devoured it. She was eager to let her readers know about it before the American translation hit the New York bookstores. "Camus and Sartre have set a new protagonist pattern. Human mediocrities are used, like a very common denominator, to decipher the problem of present-day life. This new French novel style represents the greatest break yet with the Balzac style, though Balzac's most important theme was also the pestiferous corruption of French society."[8]

Sonia Brownell eagerly followed the latest Left Bank spats and loved *La peste* as much as anyone. She arrived back in the French capital in early July. The married Maurice Merleau-Ponty was expecting her with trepidation. He had fallen for her a year earlier, and this time there was no letting

her go. They spent all their evenings together in Saint-Germain-des-Prés' jazz clubs. There, in the midst of the heavy tobacco fug, Sonia fell in love.

After a few weeks jiving wildly with the dance-obsessed Merleau-Ponty, Sonia was not looking forward to returning to burned-out London and "courtship à l'anglaise with its homegrown tactics of pounce and grab,"[9] the kind practiced by Koestler. However, when she eventually left Paris, Merleau-Ponty promised that they would meet again in the autumn. He said he would try to find her a job in Paris. Alternatively, if he failed, he would come to London. Beauvoir and Sartre, who liked Sonia, cheered her up by announcing they would soon be on their way to London and were relying on her to introduce them to interesting people. They had been invited to the opening of the London production of Sartre's plays *The Respectful Prostitute* and *Men Without Shadows* (the British title of *Morts sans sépulture*). The West End Lyric Theatre had assigned the plays to a twenty-two-year-old theater director named Peter Brook.

Beauvoir and Sartre did not stay long in London, but they insisted on visiting the Gargoyle Club at 69 Dean Street in Soho. Sonia had protested, apologizing in advance and warning that the Gargoyle was a poor substitute for Parisian cafés and jazz clubs, but Simone was adamant, she had to go. The three friends settled on little stools in the coffee room one evening. They were merrily complaining about Englishmen when the intense-looking, curly-haired young painter Lucian Freud entered the room. Sonia, who knew him, invited him to join them. Simone soon revised her opinion of Englishmen and appropriately left the Gargoyle on Lucian's arm.[10]

A few weeks later, Richard Wright was facing existentialist dilemmas in his private life, not unlike the one Sartre and Simone's agreement had caused. He had embraced Parisian life and its many ambiguities perhaps a little too readily. In Paris, his literary star continued to rise. *Native Son* had been published in French just before his arrival, and now *Uncle Tom's Children* and *Black Boy* were being released in quick succession in France, to excellent reviews. The non-Communist French intelligentsia embraced him with all its might, in the same way they had lionized Arthur Koestler. Wright was thrilled to be treated as a public intellectual; as an outsider, he felt he could see things more clearly. Being an intellectual in France was, however, a full-time job: French journalists were seeking his opinion on almost all American subjects and wanted his perspective on French matters, too. Wright took it in his stride with a newly found confidence.

In fact, he had fallen head over heels for the Parisian life. Fêted and invited everywhere, the Wrights were going out almost every night. Ellen didn't fail to notice her husband's susceptibility to the charms of other women. There was a Dr. Polin, a female gynecologist. "I can't help but marvel at how intensely feminine and at the same time intellectual the French woman is," he wrote in his diary on August 17, 1947.[11] And two weeks later: "I must hide this journal. Ellen is looking at me as though she has read some of it."

The temptations were manifold. Everybody, it seemed, wanted to meet Richard Wright, the famous American writer. While Ellen and Julia were vacationing in the South of France, Richard received a telephone call from a young stranger. Her name was Edith Anderson Shroeder and she was a Jewish girl from the Bronx and a Communist. She was in Paris, with little money, waiting for authorization to join her husband, Max Shroeder, in Berlin. Was it the texture of her voice? Was it what she said or how she said it? The same afternoon Richard invited her to tea at his empty home. They talked politics and then he tried to kiss her. She resisted. "Is it my color?" he immediately quipped. "Dick fell in love with me just because I said no,"[12] Edith Shroeder later recalled. She eventually said yes, though. After Ellen's return, Richard and Edith would meet at night to talk and kiss in his Oldsmobile, which he parked in a dark spot near the Bois de Boulogne.

LE TABOU

Sartre's and Beauvoir's students and lovers, the younger generation of the Left Bank, the war's children, loved pranks and plotting. After their favorite lair, Le Bar Vert on the rue Jacob, closed at one in the morning, they had nowhere to go except the sidewalk, where they sat and talked until dawn, and this drove the locals crazy, especially the artisans who had to get up early in the morning to go to work. They had become used to spilling the contents of their chamber pots onto the heads of the youngsters below to make them leave. Juliette Gréco, Anne-Marie Cazalis, and their cohort of friends soon started going to another café, which was open all night and catered to the printing workers on the rue Dauphine. The place smelled of ink, coffee, and croissants served from the nearby bakery. One very cold morning, while looking for her coat, Gréco discovered a small

door giving onto very steep wooden stairs leading to a vast and empty vaulted cellar.

Gréco and her friends talked the owners of the café, the Guyonnets, a couple from Toulouse, into letting them run what they said would be a rehearsal room in the underground space. After four months, the Guyonnets finally relented. Le Tabou was about to be born. "This taste for underground places, for vaulted cellars, was strange," admitted Gréco in her memoirs. "Was it a habit taken up during air raid alerts during the war? Was it a secret desire to remain outside the daily grind of life, to remain at the margins of society in places that smelled of old, forgotten wines and worm-eaten old furniture?"[13]

In the spring of 1947, Le Tabou opened its doors at 33 rue Dauphine. "I sometimes acted as the doorwoman," explained Gréco almost seventy years later, "and I was ruthless, believe me. There were nights when I only let philosophers in!"[14] After a few weeks of gramophone music, Boris Vian moved in every night with a little band formed for the occasion that he called Les Grrr. The bathrooms were covered in graffitied slogans like "Go to the bar and ask for an arsenic with mint, this will quench your thirst for eternity," or "I would like to be reborn as a train crash."[15]

Anne-Marie Cazalis thought of mounting a rather cheeky self-promotional operation. Perhaps the former youngest award-winning poet who had once lunched with Paul Valéry was eager to get her own picture in the newspaper? On May 3, 1947, *Samedi Soir* dedicated its front page to a long story headlined THIS IS HOW THE TROGLODYTES OF SAINT-GERMAIN-DES-PRÉS LIVE. It ran beside a picture of a tall, handsome, disheveled, dark-haired nineteen-year-old man (the aspiring film director Roger Vadim) holding a candle to a young woman wearing trousers, her long black hair covered with cobwebs (Juliette Gréco). *Samedi Soir*'s journalist Robert Jacques asked them: "What do you believe in?" Anne-Marie Cazalis knew what she was doing when she fired back: "Existentialism." "Those poor young Existentialists," wrote the journalist, "are drinking, dancing and loving their lives away in cellars until the atom bomb—which they all perversely long for—drops on Paris."[16] No need to say more, a whole generation was nailed in just two lines: indigent, indecent—in other words, Existentialist.

Beauvoir and Sartre were more annoyed than amused. They were getting so much flak already from the Communists and the bourgeoisie, now

they were pointed at for perverting the youth. Existentialism was about a body of philosophical ideas, not about jazz-soaked beboppers. Too late. The news had spread fast and its effects rippled all the way to Beijing, Jerusalem, New York, London, Berlin, and of course, most important of all perhaps, Moscow. Two Soviet journalists who claimed to have visited Le Tabou just after its opening wrote in the *Literaturnaya gazeta* [Literary Gazette]: "These poverty-stricken young people live in squalor and ask you to pay for their drinks. It is a youth reveling in the most vulgar sexuality."

LA FEMME FRANÇAISE

Despite its detractors, Le Tabou would eventually become a tourist attraction, with people flocking from all over the world to observe Paris's perverted youth. However, for twelve months Le Tabou remained a place for friends, and friends of friends, and not for the world at large. As Juliette Gréco recollected in her memoirs: "Cocteau and Christian Bérard, Gaston Gallimard and François Mauriac, Jean Genet and Simone Signoret, Orson Welles and Truman Capote, and so forth. They were in turn dazzled by the beauty of the teenage models from the fashion couture houses, known by their first names."[17] There was the androgynous, short-haired Annabel (future wife of the painter Bernard Buffet), the blond, ballet-trained Sophie (later married to Hollywood film director Anatole Litvak), the feisty red-haired Bettina (future companion of Prince Aly Khan), and the divine sapphire-eyed Hélène (future wife of the perfume tycoon Marcel Rochas).

Those very young women, who turned heads wherever they went, were about to embody the Parisian woman and become, for at least the next decade, among the most photographed mannequins in the world. French couturiers were ready to roar again. Now that Parisian couture houses were starting to get back on their feet with the lifting of fabric and material restrictions, Paris was abuzz with creativity. The French capital was about to reclaim its title as the world headquarters of fashion. Two months before the opening of Le Tabou, the first couture collection of a plump and bold forty-two-year-old had sent shock waves through the fashion world. His name was Christian Dior. The American Carmel Snow, editor of *Harper's Bazaar,* branded his collection "le New Look." The expression stuck. Colette liked referring to it in writing as "le nioulouque."

Christian Dior had had another life before the world discovered him as a couturier. In 1928 he had opened, with the help of his wealthy parents, an art gallery where he had exhibited Henri Cartier-Bresson's first (and rather bad) paintings but also Giacometti, de Chirico, Calder, and Dalí. Ruined by the financial crash of the late 1920s, Dior, who liked drawing as a pastime, looked for a job and started selling fashion patterns and sketches to couturiers and film and theater producers. Lucien Lelong's *maison de couture* then hired him. Just after the war, the textile industrialist Marcel Boussac, also known as "the cotton king," saw his talent and struck a deal with him. He set up the Maison Dior, 30 Avenue Montaigne, and gave him as much fabric as he wished in exchange for his designs.

His first collection had been presented to a select crowd and world fashion editors on February 12, 1947. After years of hardship and rationing, Dior had suddenly reintroduced glamour and luxury, with full skirts made of twenty yards of fabric instead of just three, aptly named corollas. He had also invented a new sexy silhouette of nipped-in waist, high, round bosom, narrow shoulders, and legs uncovered up to the calves. The waist and hips played an important part in his designs: skirts, shirts, and dresses flared out from the waist to dramatic effect, giving anyone wearing them a very curvaceous shape. Hollywood stars started demanding to be dressed by Dior as part of their contracts. Marlene Dietrich had been in the front row at the presentation of his first collection, and from that day on she would wear only Dior in real life, onstage, or on-screen. A few months later, when Alfred Hitchcock offered her the leading part in *Stage Fright*, she had replied, "Yes, on one condition." "What is it?" Hitchcock had asked wearily. "No Dior, no Dietrich."

POPPING PILLS

In June, her mind distracted by Sartre's indecipherable intentions, Beauvoir had thrown one last party at the Cave des Lorientais on the rue des Carmes before it closed down and the twenty-two-year-old "jazz hot" clarinetist Claude Luter joined Boris Vian at Le Tabou. For the Beaver's homecoming party, Boris Vian decided to run the bar himself. The engineer-trumpeter-novelist mixed and stirred "implacable" cocktails that knocked everyone out from the first glass. The alliance of alcohol and Orthédrine, of which she was taking too much, put Beauvoir in a stupor.

Giacometti passed out on the floor. Supported by Sartre and le petit Bost, Beauvoir managed to get back to her hotel room, but without her bag and wallet. One guest (a friend of Boris Vian's) had even left behind his glass eye.[18] The following afternoon, nursing a terrible hangover, Beauvoir collected both the glass eye and her purse. None of her guests could quite remember what they did that evening.

The first summer days of 1947 in Paris proved stiflingly hot, with peaks in the triple digits. Simone had all the windows and doors of her hotel room open for ventilation; however, she still found it almost impossible to work, so she often lay down on her bed, motionless, her eyes fixed on the ceiling, thinking of Algren and Sartre. She had not felt so depressed in her life and was prone to panic attacks, which she nursed with whiskey and pills. Dolorès had finally gone back to New York without any marriage prospects, and the philosophers' relationship had withstood the storm, but it remained somewhat strained.

Beauvoir was not alone in mixing alcohol, tobacco, sleeping pills, and amphetamines on a daily basis. Sartre, too, was taking drugs. In fact, everybody seemed to be at it in Saint-Germain-des-Prés. Orthédrine was a freely available "upper," or *excitant* as it was known in French. It had been the stimulant of choice of the *résistants* during the war. Sartre preferred Benzedrine or Corydrane, another stimulant freely available over the counter, which he said he was taking to both relax and focus.[19] "But whereas journalists would take a tablet or half-tablet to get them going, Sartre took four. Most people took them with water; Sartre crunched them."[20] Besides Corydrane, Sartre smoked two packets of unfiltered Boyards a day and gulped down liters of coffee and tea. At night, he usually drank half a bottle of whiskey before taking four or five sleeping pills to knock himself out.

There were other freely available amphetamines with exotic names: Luminax, Leviton, Tranquidex, Psychotron, Lidepran. Developed in the 1930s, they were particularly used during the war years and used not only by Left Bank intellectuals on a writing spree but notably by cyclists on the Tour de France. In 1955, they were available only by prescription, and many were later banned from sale, though Corydrane was declared toxic and dangerous only in 1971.[21]

Those drugs not only were a way to unwind or sharpen the mind, they were literally work tools for Left Bank intellectuals and writers. Drugs turned them into work machines. "Under the influence of the drug, instead

of writhing in anguish, Sartre wrote at white heat."[22] One cannot explain their incredible prolificness other than by their drug habits. They would unfortunately pass this habit on to the younger generation.

"THE SIEGE IN THE ROOM"

Two solitary figures in Paris, almost oblivious to the sizzling-hot days and suffocating Paris nights that summer of 1947, were Édith Thomas and Samuel Beckett. The Irish writer had returned in June from his annual visit to his mother in Dublin and was experiencing what he later described as "the siege in the room." In his sparsely furnished home on the rue des Favorites, with a silent Suzanne in the room next door darning old stockings, Beckett was busy writing a new novel, in French, which he would call *Molloy*. He had had some small success on the publishing front. His painter friend van Velde's sister, who gave Suzanne a hand in trying to interest publishers in his work, had managed to get his unpublished English novel *Murphy* translated into French and published by Bordas. The miracle was short-lived, though, and turned into a disaster. Only a dozen copies were sold in the first twelve months. Used to failure, the news did not upset Beckett too much. In fact, he was feeling almost good about writing *Molloy*. Of course, for the American students who sometimes recognized him in Left Bank cafés he remained "James Joyce's secretary, a survivor of something that was over, a beached and pathetic figure who was something of a joke."[23] The problem for Beckett was that he did not belong to any circles anymore. He might have been published twice in *Les Temps modernes*, but he did not belong in Existentialism. Camus' *L'étranger* might have started with Beckett-like sentences—"Mother died today. Or perhaps yesterday"— but Camus had traded the absurd for action. In fact, "Beckett was nobody's hero and he had no followers, or even readers."[24]

Still, Beckett was plowing on. With *Molloy*, and without realizing it, he was working alongside budding anti-novelists like Nathalie Sarraute, Michel Butor, and Alain Robbe-Grillet. Except that he had humor and they did not. With *Molloy*, Beckett's antihero was born, following in the steps of other familiar figures of European literature such as Flaubert's Madame Bovary and Joyce's Leopold Bloom. Beckett's antihero, however, was "the one from whom all vestiges of the heroic or the admirable have been most thoroughly eliminated. The Beckett man is a lone individual

who regards others with fear, hatred, impatience or contempt."[25] But were Beckett's characters familiar enough for readers to feel close to them, or were they too abstract and aloof as literary inventions? Fully using his comic talent for the first time, and with exaggeration as the main technique, Beckett made his readers feel the humanity of his character Molloy. It was a breakthrough for the struggling Irish writer.

The breakthrough in Édith Thomas's life had taken place in the arms of a woman, Dominique Aury, and was of a purely sexual and emotional nature. Their passion had been going on for ten months now but had stopped being an exclusive one. The seductress Dominique had fallen for Jean Paulhan, twenty-three years her senior but her perfect intellectual match. Their paths often crossed at Gallimard and the inevitable gentle stroking in the publishing house's narrow corridors had led to more serious cavorting behind closed doors. Besides, he was about to give her a proper editorial position at Gallimard. They were clear from the start. Paulhan would never leave his wife, seriously ill with Parkinson's disease, and Dominique was neither the marrying nor the exclusive kind. She lived with a seventeen-year-old son from a previous marriage and had her mother to look after; there was no room in her life for a full-time consort. Their affair had to remain completely secret to the world, which suited them both. Resistance had made discretion second nature to them. The terms of their affair did not, however, preclude passion and lasting love, quite the opposite. They remained lovers and soul mates for more than twenty years, until Paulhan's death in 1968.

Édith had developed a mystical attachment to the woman who introduced her to pleasures she never thought existed. She wrote Dominique letters of an almost metaphysical nature: "You're my illness, my love, I am ill of never having enough of you. I couldn't care less whether you're a man or a woman. I love your caresses, the beauty of your body, the beauty of your brow and of your eyes, and this abandon with which I give myself to you, and you give thyself to me."[26]

Although Édith knew there would be a moment when her fickle lover would fly away, when the time came she was not ready. Dominique started, rather astutely and *en passant*, to mention Paulhan's name in her letters to Édith. On August 6, 1947, while Dominique and Édith were vacationing separately, Dominique wrote to her: "My love, write to me, even if it's just a few lines . . . I take you with me for a walk in my garden-jungle and I lock

you in my room, warm and blue. You half-close your eyes, like a cat, but I can see your sparkling eyes, black and ironic. I love you. Dominique. PS: Paulhan tells me our magazine project has fallen through."[27]

Édith understood the subtle hint, and there was little she could do. She knew better than to try to fence Dominique in; she would have to endure it, swallow her pride, repress her jealousy, and share her lover with others. It was a painful thought, but it was more painful still to think she might lose Dominique. Besides, she had always rejected bourgeois conventions such as sexual fidelity, why should she now profess it simply because she felt hurt? To forget, she buried herself in her work and even chose to pick a fight with a powerful Communist colleague. Édith was growing tired of being told whom to hate and whom to approve of by Aragon and the Party's intellectual leadership. She felt more and more uncomfortable in the Party but, like a practicing Catholic, she might criticize the clergy but still believe in God. Yet on one subject she bravely resolved to go head-to-head with Jean Kanapa, the Party's rottweiler, in charge of savaging anyone deemed anti-Communist in the press. Kanapa had attacked *Les Temps modernes* for its celebration of Richard Wright, but Édith rose to the American's defense. She had been captivated by *Black Boy*. She went as far as to write that discovering Richard Wright had proved "a revelation comparable to the illumination of Pascal and the dream of Descartes."[28] She was taking risks, and her Communist friends, the ones abiding by the ever more rigid Party lines, were noticing. She still enjoyed the aura of the great *résistante* she had been, but how long would they accept her idiosyncratic ways?

c~

ACTION AND DISSIDENCE

ZHDANOV AND HIS DOCTRINE: THE GLACIAL AGE

At the end of September in 1947, when Beauvoir landed back in Paris at six in the morning after spending two weeks with Nelson Algren in Chicago, she popped two pills and gulped down four cups of coffee to stay awake. Back to work. As it happened, Beauvoir had touched down in Paris only a few hours before Andrei Zhdanov developed the fateful principles of what would be known as the Zhdanov Doctrine, a riposte to the Truman Doctrine articulated in Washington six months earlier and a response to George Marshall and his famous plan.

Zhdanov had been appointed by Stalin as the head of the newly founded Cominform, a bureau controlling the cultural policy of the Soviet Union and coordinating all the Communist parties in Europe. Zhdanov had established for the whole Eastern bloc the canons of the only acceptable art possible, a kind of universal conception both positivist and pseudoscientific in which every symbol represented a determined moral value. His cultural policy had to be strictly and ruthlessly enforced, with censorship and punishment for all dissenters. In the USSR, composers such as Shostakovich and Prokofiev would soon have to repent publicly for their too "hermetic" music, while the poet Anna Akhmatova would be expelled from the Union of Soviet Writers for being "half harlot, half nun"[1] and condemned for "eroticism, mysticism and political indifference."[2] Editions of her poems were withdrawn from sale and destroyed.

Zhdanov also ordered the Communist parties of Western Europe to drum up insurrection on behalf of their working classes. The Cold War

was not only pronouncing its name loud and clear but entering the Glacial Age. As Zhdanov had presented it, the world was now divided into two blocs, the "imperialist and anti-democratic" one controlled by America and the "anti-imperialist and democratic" one led by the Soviet Union.

Party member Édith Thomas finished reading Zhdanov's full speech in *Le Monde* on October 7, 1947, while finishing her coffee at the Café de Flore, where she was about to meet her colleagues from Éditions de Minuit. "Cézanne had been for the Nazis the product of Judaeo-freemason decadence, and now, for the Stalinists, he was the expression of bourgeois rot. What a load of bollocks,"[3] she wrote that day in her diary. A hundred yards away, at Marguerite Duras' flat on the rue Saint-Benoît, Edgar Morin was burying his head in his hands, and for the same reason. What was the way forward for former *résistants* like him who had become Communists only to fight fascism and change the world for the better? To obey blindly and without thinking the Party's new lines, decided in Moscow, or to abandon politics and return to private passions? Or . . . ? Thomas and Morin were not alone in feeling paralyzed, completely torn apart.

Louis Aragon and Laurent Casanova, a former charismatic *résistant* whose wife had died in Auschwitz and who was now in charge of the Communist Party's relationship with the French intellectuals, had drawn up a kind of "death list" of intellectuals. Attacks had to be concentrated on Malraux, Gide, Camus, Sartre, Beauvoir, Mauriac, Aron, Wright, and Koestler.[4] No holds were barred. The Communist press had free rein to attack them in any way it deemed necessary.

The Cold War turned intellectual discourse in France into permanent adversarial theater. It was extremely hard for anyone to keep cool when the Communists' paroxysmal tactics had transformed the public debate into a never-ending psychodrama. Some, however, still believed in a radical Third Way.

Beauvoir and Sartre both hated "the lies of Communism and of anti-Communism"[5] and were resolved to expose both camps' contradictions and bad faith. They did not quite believe in the old Socialist Party, "very corny, very old and weak," but they started meeting some Socialist Party members to discuss a rapprochement between Existentialists and Socialists. "It is the only chance left for us, squeezed as we are between the conservative Catholic Left and the Communist Party,"[6] Beauvoir wrote to Algren.

Richard Wright had been rather taken aback by the French Communists' attacks against him and his novels. On the other hand, he felt it was almost a rite of passage. He was now a real Left Bank intellectual, he could show his scars, he joked with Beauvoir and Sartre when they came to his Neuilly apartment for dinner at the end of September. Beauvoir particularly enjoyed the Wrights' company, listening to Bessie Smith records and drinking brandy. One evening, as she left, she pleaded with them: "You must really come back to the Left Bank." They reassured her. The Wrights had their eyes on a beautiful flat just next to the Luxembourg Gardens; they were planning to move very soon.

Albert Camus had decided not to spare his Communist friends any longer. They might have fought together in the Resistance but they were going astray, and Camus had resolved to say it and write it loud and clear. Arthur Koestler had for a long time urged him to be more vocal. So had Mamaine. In a letter to her sister, she had deplored French anti-Stalinists' fearfulness. "Now I do wonder why it is that even anti-Stalinist French writers such as Malraux and Camus, who have done enough to put themselves definitely in the anti-Russian camp, don't go the whole hog while they're about it and denounce Russia *à haute voix* as K does. They do, it is true, attack Russia indirectly but a) rarely by name and b) always with some counterbalancing attack on the US."[7]

However, unlike the doomsdaymongers Malraux and Koestler, Camus did not think that war was imminent or that the Red Army was a few months away from rolling down the boulevard Saint-Germain. Camus was certainly worried about the state of the world, but he thought that instead of preparing for the worst, it was better to wake up public opinion and offer alternatives.

"THE FIRST APPEAL TO INTERNATIONAL PUBLIC OPINION"

One rainy morning in October 1947, Camus' secretary at Gallimard, Mademoiselle Labiche, left a pile of letters on his desk. The one on the top came from the editor of the monthly Left-leaning review *Esprit*, founded in the early 1930s. *Esprit* was about to publish a manifesto, "the first appeal to international public opinion," and needed the support of intellectuals like Camus.[8] "We all know that the new world order cannot be national or

continental, western or eastern, it must be universal," stated the magazine. Camus called Sartre, who agreed to take part. The third solution, third force, Third Way that these intellectuals had kept searching for in the years after the war was taking shape in Left Bank minds and from there to the wider world. When the appeal was published in *Esprit*'s November edition, it made wide ripples, at least within Western Europe. "Bloc politics" did nothing to guarantee peace, for "armed peace is no peace," argued the signatories. The idea of a united and independent Europe as a counterbalance and counterpower to the bloc politics was emerging, a Europe that would adopt non-Communist socialism and divest itself of its colonies.[9]

Koestler could not keep away from Paris any longer; he needed to be there, to take part in the effervescence and try to weigh in and influence people. On their first day back in Paris on October 1, Arthur and Mamaine met the novelist turned General de Gaulle's right-hand man André Malraux and his wife, Madeleine, at the bar of the Plaza Athénée hotel, where they ate caviar and blinis, *balyk* and *soufflé sibérien*, and drank too much vodka. Malraux confided that "in using his reputation as a man of the Left to help the reactionaries, he was taking a big gamble."[10] It was true and brave of him: he had placed all his hopes in Charles de Gaulle and the Gaullist movement and wanted it to transcend the traditional right versus left, conservatives versus progressives divide.

Early the next morning, despite a slight hangover, Arthur and Mamaine, buoyed by the Paris air, took a walk from their room at the Hôtel Montalembert to the Café de Flore.[11] Beauvoir was there and the three friends fell into each other's arms. They decided to spend the morning together. After their coffee and tartines, and a little glass of dry white wine, they set off to see an exhibition of paintings by Monet, Manet, Renoir, and Toulouse-Lautrec that had just opened at the Jeu de Paume. All was well in Left Bank land, old friends reunited, and united, it seemed, against the Cold War, everybody being "sincere, simple and friendly"[12] and not "arrogant and conceited," as had been too often the case. All was well—until they had dinner at Albert and Francine Camus' new flat on the rue Séguier on October 7.

The atmosphere was very amicable to start with. Mamaine and Arthur had carefully chosen the best food on the rue de Buci and arrived with a cold roast chicken, a lobster, and some champagne. Sartre and Beauvoir

had brought "many bottles of brandy and wine," and Francine had cooked some delicious dishes. Koestler, however, wished to talk about politics. The friends, hoping to enjoy, for once, a politics-free evening, began by gently dodging his questions. The evening turned sour only when Koestler's friend Harold Kaplan and his wife rang the bell. Koestler did not know that Sartre and Beauvoir were convinced Kaplan was "a kind of spy" for the American government. "We all loathe him," Beauvoir wrote to Algren immediately after the dinner. "He is Jewish yet Anti-Semitic and he hates negroes," she observed, adding, "Koestler likes him because he's anti-Communist, I think it becomes as bad as being a Communist when the only reason you like somebody is because he is anti-Communist." Kaplan, feeling the tension, departed early. This triggered a fierce discussion between Sartre and Koestler over who Kaplan really was and what cause he really served. Alcohol did not help, and Koestler stormed out with a drunken "Now we are enemies."[13] Mamaine wrote about the incident to her sister: "Later in the evening, when all had drunk quite a bit and the Kaplans had left, Sartre started attacking Kaplan in violent terms. K got so cross that he let fly at Sartre and said who are you to talk about liberty when for years you've run a magazine which was *communisant* and thus condoned the deportations of millions of people from the Baltic States and so on? Sartre was a bit taken aback by this. We left."[14]

Beauvoir and Sartre were probably right about Harold Kaplan's being a kind of agent. Kappy, as Koestler called him, had passed the exams to become a Foreign Service officer, and he had become, in effect, a diplomat attached to the American embassy. However, according to Kaplan himself, he had a certain freedom to work and report back as he pleased. "The embassy understood that I was somehow special and let me run a kind of unofficial cultural centre from home"[15] in his vast and gorgeous flat just above Matisse's studio on the boulevard du Montparnasse. Officially, he worked in tandem with the embassy's cultural and press officers; his turf was the Paris literary scene and everybody who was part of it. Kaplan's wife would have preferred for him to follow in the steps of his friends, such as Saul Bellow, and become a writer rather than, as Kaplan put it himself decades later, "a passionate Cold War warrior." His job could easily be considered within the realm of the CIA cultural activities of the time, including attempting to influence Europe's present and future elite and win them to the American administration's cause. "My job was to find out

who the most promising writers, scientists, artists and intellectuals in France were and to offer them to study and travel in the United States. The idea was to make new friends."[16] Decades later it would be called Soft Power; at the time of the Cold War, it was rather more than persuasion.

The morning after their argument at the Camus' apartment over Kappy, Arthur wrote an apologetic letter to Sartre to which the Existentialist in chief replied in warm and friendly terms, so all was well in the end. Like Camus, Sartre, Beauvoir, and many others, Koestler was indeed trying to promote a Third Way and to save the Left from Stalin, at least when sober. The entire reason for his presence in Paris was to launch various projects, both editorial and political. Over time, though, he leaned further and further toward the Gaullists, thanks to his friendship with Malraux, and this irritated Beauvoir and Sartre hugely.

NORMAN MAILER FOLLOWING THE WASHINGTON TRIALS FROM A PARIS CAFÉ

Norman Mailer, having just delivered the manuscript of his war novel *The Naked and the Dead* to publisher Rinehart and pocketed his advance, sailed to Le Havre with his wife, Bea, and arrived in Paris the day Koestler and Sartre parted company. Norman had planned to stay in Paris for a year, to learn French and write and party no end, all at once. According to his biographer J. Michael Lennon, "It was one of the happiest seasons of his life, shadowed only by his anxiety about the future."[17] The Mailers were not living on a grand scale in Brooklyn—far from it—but they did not expect to be so uncomfortable in Paris. Along with the strikes, there were electricity shortages and a generally gloomy atmosphere. They shivered through their first few weeks while staying at the Hôtel de l'Avenir, 65 rue Madame in the 6th arrondissement, a hundred yards from the Luxembourg Gardens. When they first saw their bed, the young couple looked at each other with wide eyes: a pull-down bed! As for the bathroom, it was along the hall, rudimentary, to say the least, and had to be shared with all the other hotel guests.

One evening, after coming back from one of his first French classes at the Sorbonne, Norman found a note slipped under his door. A friend had found them a three-room apartment. Their future flat was not very far, standing at 11 rue Bréa, a little street linking the boulevard Montparnasse and the rue Notre-Dame-des-Champs. The place was a typical turn-

of-the-century sandstone five-story building, and although the façade had not been cleaned since its construction in the 1870s it felt terribly Parisian. They went to visit the next day, and neither the red wallpaper nor the orange rug nor the bathtub in the kitchen managed to dent their joy. At less than one dollar a day it was a great find, exactly where they wanted it to be, and, besides, the gas stove worked.

The Mailers began classes at the Sorbonne in early November. Every morning, wearing layers of woolen sweaters, they walked through the Luxembourg Gardens toward the boulevard Saint-Michel and the Sorbonne, all the while conjugating subjunctive verbs and kissing. Along with several hundred other ex-GIs, the Mailers had enrolled in the Cours de Civilisation Française, designed to garner American tuition dollars. If they flunked, they'd lose the $180 a month from the GI Bill.[18] Compared with French students and young writers, they were well off.

The Mailers made friends very quickly, starting with other GI Bill students. Some had briefly served at the end of the war, some had just been in military training in the United States but not deployed. There was a young Jewish man from Brooklyn, Mitchell Goodman. A scholarship student at Harvard, Goodman had not been deployed overseas during the war but had traveled to Europe following the war and met the poet Denise Levertov, whom he had just married in Paris. There was a friend of Norman's from Harvard, Mark Linethal, who had served as a navigator during the last months of the war and been taken prisoner by the Germans, before being liberated by the Russian army. Linethal was in Paris with his wife, Alice Adams, a writer. And there were the aspiring writers Stanley and Eileen Geist, who lived with the rich Americans on the Right Bank. In Paris, Norman and his friends embraced politics in a new way, both vigorously and rigorously. In other words, more seriously than they had ever done before. When he arrived, Norman was a "naïve fellow-traveler," a "liberal with muscles," to use the social critic Dwight Macdonald's expressions.[19] Paris would change Mailer, his politics, and his writing, for better and for worse.

For ten days, at the very end of October and early November, Mailer often left the flat early to stop at the news kiosk right at the corner of the boulevard Saint-Michel and the rue Soufflot on the way to the Sorbonne and sit at the café opposite to read the account of the Washington trials. The French press had called it "*épuration à Washington*" to reprise the French term for "purge" used in 1945 for the hunting of Nazi collaborators.

French journalists were following closely the nine-day hearings of the House Un-American Activities Committee in Washington into alleged Communist propaganda in the motion picture industry, and they reported back every word. In fact, many of Hollywood's most talented were singled out for having once felt sympathy to the Communist cause, usually at the time of the Great Depression of 1929, and thus for being "un-American," a concept that would never be defined.

French correspondents in Washington covering the event were fascinated by the fact that for some, including Walt Disney and a few other staunch American Republicans, voting Democrat was akin to being a Communist. The House Un-American Activities Committee had, since its creation in 1919, been principally concerned with pro-German and then pro-Nazi sentiments and propaganda in the United States and had asked for stricter immigration and deportation laws against such propagandists. In 1945 it had turned its attention to Communist sympathizers considered to be in positions of influence in American society.

The witch hunt started in the glare of the world's media; four hundred seats had been reserved for the public, and a hundred twenty journalists were present at the hearings, which were broadcast on the radio. At home, sometimes in the middle of the night owing to the time difference, Americans on the West Coast gathered around the radio, as they had during the war. Would some of the glitziest stars of the silver screen admit to their liberal sins? Gary Cooper, called as a witness and very ill at ease, testified before Ginger Rogers's mother and Walt Disney, both red-baiters advocating a purge of liberals in Hollywood. The Committee for the First Amendment, composed of Humphrey Bogart, Lauren Bacall, Orson Welles, Rita Hayworth, John Huston, Katharine Hepburn, and Gene Kelly, among others, was set up to support those incriminated. Many witnesses refused to answer the question "Are you now or have you ever been a member of the Communist Party?" citing their rights to freedom of speech and assembly. Ten screenwriters and directors, later known as the Hollywood Ten, were charged with the crime of contempt of Congress. Hollywood studios had agreed to abide by the committee's diktats, so the Ten all lost their jobs, but it also meant that nearly three hundred artists working in Hollywood felt the urge to go and work in Europe, Charlie Chaplin, Irwin Shaw, and Orson Welles among them. They no longer enjoyed living and working in a country where blacklists and fear were now permeating the whole soci-

ety and getting hold of newspaper editors, theater and radio directors, and publishing houses.

A FAILED INSURRECTION

After the French Communists' attempt at a popular insurrection through general strikes had failed to spark a revolution in 1946, the Communist Trade Union (CGT) chose increasingly violent tactics against the police. The government retaliated by creating a specific riot police also known as the CRS (Compagnie Républicaine de Sécurité) to control protesters' violence. In early December 1947, Communist militants went as far as to sabotage and derail a train they thought full of riot police, with devastating results: sixteen dead and fifty badly injured. Suddenly frightened, the Communist Party secretly negotiated the end of the strikes with the government in exchange for freedom for four of their saboteurs.[20] The Communist trade union CGT consequently imploded, with a substantial minority leaving to set up the reformist and non-Communist FO (Force Ouvrière), with the financial help of American trade unions and the recently created CIA (Central Intelligence Agency).

The French Communist Party had played with fire and been burned. *Les Temps modernes*, in its December 1947 issue, was quick to point to the Communists' contradictions and bad faith, and to admonish them in no uncertain terms.

> *L'Humanité* [the official daily newspaper of the Communist Party] has been telling us for some time that we must choose between freedom and fascism, but since it attacks every single other political movement, it is in fact saying very clearly that we must be either Communists or Fascists. To say this at a time when the RPF [Gaullist Party] is getting more and more popular and the Communist Party is in relative decline at elections, it is precisely like pushing every undecided non-Communist toward the RPF. This reckless attitude is a provocation. To declare war on a so-called "American party" and include in it 70 percent of French citizens is asking for a backlash. More than ever, we ask the question: Is a reasonable socialism possible today? And which one exactly? In our European countries, is there any room for anything other than the clash of the world's two big armies?[21]

Sartre and Beauvoir were refusing bloc politics and increasing the urgency of the political debate both in France and in the Western world.

The same week as *Les Temps modernes* was confronting the Communists' incendiary and fruitless tactics, Sartre's essay "Anti-Semite and Jew" was released in America. The *Partisan Review* writer Lionel Abel, who had met Sartre during his American tour, was left reeling. "The effect it had was quite sensational. It was more talked about than any other intellectual effort of the period."[22] In his essay, Sartre stated clearly that anti-Semitism was not an opinion that could be discussed and argued about, analyzed as true or false; it was a crime. For Abel, "the tenacity of your anti-liberal opponent forces a certain degree of anti-liberalism on you. To act, whatever your commitment to clarity, you may have to begin to think *darkly*."[23] And this proved an incredible discovery.

Across the Atlantic and over the Channel, another hero of Lionel Abel's had started to think darkly too. Back in his drafty, damp little cottage in north Wales, Arthur Koestler was in a foul mood, with Mamaine trying to bear it calmly. "Am afraid he's starting a period of very bad temper. I just try to shut my eyes and ears and withdraw into my shell. I feel pretty dismal,"[24] she wrote to her sister Celia. The weather was as dreadful as ever: extremely cold inside, snow outside, and despite new heating pipes and new stoves the house felt icy. There had been one small improvement, though: the purchase of a "radiogram with automatic change," which meant they could listen to the Third Programme of the BBC every evening. This however did not much raise Koestler's spirits. He was nagging all the time, making life difficult for his partner and secretary. In fact, Koestler had come back from Paris hurt and deeply annoyed by Sartre and Beauvoir's snub. He would get his revenge, he swore, albeit a literary one. He had an idea for a futuristic fantasy piece about the "Existenchiks," in which le Petit Vieux Ivan Pavelitch (Sartre), leader of the Existenchiks, and Simona Castorovna (Simone de Beauvoir) and other friends play their parts. Koestler asked Mamaine whether her sister Celia, an editorial assistant at a new monthly and trilingual magazine in Paris called *Occident*, might be interested in publishing it. "It is pretty violent politically but will make the fame of any mag which publishes it,"[25] Mamaine wrote to Celia.

He was writing it with such fury, it would have no real plot and the basic

idea would never be fully realized. It did however make Camus laugh when he received the first draft and even gave him an idea. Like Koestler, Camus had a lot to get off his chest, and he secretly started penning a satirical story about Sartre and Beauvoir, which he titled "L'Impromptu de Philosophes."[26]

Koestler was in fact not finished with Paris and politics, quite the opposite—he was planning to go back and settle there. He had just persuaded the editor of the British newspaper the *Observer* to send him there on assignment for a few months to write about France.

Koestler's title for his eight-thousand-word satirical piece on Parisian Existentialist life under Communist rule was "Heroic Times."[27] He had fiddled with Beauvoir's nickname for a long time and changed it from Castorovna to Bovarovna. Before mailing the manuscript to Paris, Arthur Koestler had read the first lines one last time: "Entering the house of Gallimardov, Miss Bovarovna had a slight palpitation of the heart. Twice, between the former Café de Flore and the bar of the Pont Prolétaire (formerly Pont Royal), she had fallen into the cordons of the Liberty Police."[28]

SOCIALIST REALISM VS. EXISTENTIALIST ARTISTS

The Zhdanov Doctrine had reached Paris, and Aragon was implementing it to the letter. He had imposed Socialist Realism as the only acceptable art form, promoting talents he had carefully groomed for the purpose. The painter André Fougeron was one of them and would from now on become the French Communists' official artist. Fougeron's reign would last as long as Stalin lived, which was another five years. In the meantime, his fellow Party member Picasso could not help but laugh at his paintings. Inevitably, positions polarized and arguments became more strident in the arts, reflecting political points of view. Campaigns in the powerful Communist press glorifying Socialist Realism were astonishingly aggressive against the enemy, Geometric Abstraction, heir to the pioneers Mondrian, Kandinsky, and Malevich and considered bourgeois art.

In the arts, too, Existentialism was offering an alternative. It called itself the Informel movement. This "open" representation in free gesture fed discussions of the new painting and sculpture with echoes of Sartrean

"authenticity." It rejected political diktats. Informel, Abstract Expression-ism, Action Painting, and Lyrical Abstraction were emerging at the same time on both sides of the Atlantic. In France, Nicolas de Staël, Jean Fau-trier, Jean Dubuffet, Wols, Hans Hartung, Jean-Paul Riopelle, and Pierre Soulages were the artists who defied party politics.

And of course there was Giaco, as Simone called him. A Surrealist before the war, Giacometti was now his own man and had declined to exhibit alongside his old Surrealist friends at the Galérie Maeght in the summer of 1947. Having rekindled his relationship with Matisse's son Pierre, the celebrated gallery owner in New York, Giacometti had agreed to show his latest work, tall, thin figures cast in bronze. There was one condition, though: he wanted Sartre and nobody else to write the catalog's preface.

Beauvoir had urged Algren, who had never heard of him, to go and see his exhibition in New York. She had introduced Giaco in this way:

A friend of us is a sculptor, we see him often and he may be the only one we always see with pleasure. I admire him as an artist immensely. Twenty years ago he was very successful and made much money with kind of surrealistic sculpture. Rich snobs payed expensive prices, as for a Picasso. But then he felt he was going nowhere. He began to work all alone, nearly not selling anything. He works 15 hours a day, chiefly at night, and when you see him, he has always plaster on his clothes, his hands, and his rich dirty hair. He works in the cold with hands freezing, he does not care. Now, I think he has really achieved something: I was deeply moved by what I saw yesterday.[29]

In his studio at 46 rue Hippolyte-Maindron in the 14th arrondissement, "a kind of hangar, big and cold, without furniture or stove, just walls and roofs,"[30] Beauvoir had seen the first cast of the six-foot-tall *L'homme qui marche* (*Man Walking*). Accompanied by Sartre, she had moved silently around the wiry, spindly man in midstride, his right foot jutting forward, and had felt a strong emotion, one that would soon resonate across the world.

That same evening, after bidding Simone goodnight, Sartre sat at his desk overlooking the Saint-Germain-des-Prés church. He filled his rose-wood pipe, arranged a few sheets of squared paper, held his fountain pen between his index and middle finger, and began to write.

One doesn't need to stare very long at Giacometti's antediluvian face to understand his pride and will to place himself at the world's beginning. He doesn't care about Culture and does not believe in Progress, at least Progress in the arts; he doesn't consider himself more "advanced" than his chosen contemporary, the Altamira caveman. At this stage of extreme youth of nature and men, neither the beautiful nor the ugly exist yet, neither taste nor people of taste, not even criticism: everything is waiting to be created. For the first time, the idea comes to man to carve the figure of a man in stone. Here is the model: man. Neither dictator nor general nor athlete, he doesn't have the dignities and glittery trimmings that will seduce future sculptors. It is only an indistinct figure of a man walking on the horizon.[31]

For Sartre, the fact that Giacometti neither believed nor followed any dogma in art, life, or politics was the source of his creative power, and his genius.

SARTRE: PARTY LEADER

By the beginning of the year 1948, Sartre had resolved to take political action even further. Signing manifestos, writing essays and editorials, producing plays, editing a magazine, giving lectures and talks throughout Europe, speaking to the nation for an hour every week on the radio,[32] supporting causes, helping new voices to be heard and published—the prodigiously prolific and indefatigable intellectual *engagé* already had a number of commitments, but he was now ready to cross the Rubicon: he would make the ultimate radical pledge and found a political party.

The idea came from David Rousset, the author of the eight-hundred-page *Les jours de notre mort* (*The Days of Our Death*). A chillingly detailed and lucid account of the machinery of Nazi concentration camps, the first by a former prisoner ever published,[33] the book had earned Rousset considerable prestige in France and abroad. At thirty-five, he struck anyone he came across by his sheer physicality. Call it charisma or personality, Rousset looked half ogre and half pirate. A tall man who had regained his ample prewar girth, he had only one eye, and many of his teeth were missing, none of which he bothered to replace. Together with Georges Altman, a fellow *résistant* and editor of the non-Communist socialist

daily newspaper *Franc-Tireur*, Rousset asked Sartre to join forces to create the RDR, Rassemblement Démocratique et Révolutionnaire (the Democratic and Revolutionary Alliance), and present as many candidates as possible at the next elections. The RDR would appeal to "everyone who does not think that war and totalitarianism are inevitable." "The idea was to unite the non-Communist Left under one banner and to promote an independent Europe"[34] as a bridge between the two blocs, the United States and the USSR. Sartre dived headfirst into the adventure and momentarily left Merleau-Ponty at the helm of *Les Temps modernes*. He had a political party to create and also a play to finish and produce.

Beauvoir had little time for this new political adventure of Sartre's even if she fully supported him. She was feverishly trying to wrap up the research and writing of her "very short essay," which had now grown to become a voluminous study of women's situation, *Le deuxième sexe* (*The Second Sex*). She was also more interested in the play he was writing for the Kosakiewicz sisters. Wanda had demanded that Sartre write her a leading part and he had kindly obliged. *Les mains sales* (*Dirty Hands*) would prove to be one of his finest plays.

The RDR, Sartre's party, quickly became the talk of the town. The press conference to launch it, attended by more than a thousand people, including many French and foreign journalists, was followed just a week later, on March 19, by the party's first public meeting. Four thousand members of the public turned up at the Salle Wagram, Paris's biggest concert hall. "People were enthusiastic, applauded and gave money and their names to become members of the party. But then, what now? There is a possibility to do something, indeed, but things go too quickly,"[35] wrote Beauvoir to Algren a few hours later. The Communists, sensing the danger, increased their attacks against the Existentialist couple. Many Communist newspapers such as *Action* and *Les Lettres françaises* published salacious stories about their private lives, alluding to orgies. The Communists were clearly afraid of the RDR.

The RDR did indeed seem to be gaining in popularity. While not a member, Albert Camus publicly gave it his support. Raymond Aron was a Gaullist and an editorialist for the conservative daily newspaper *Le Figaro*, but he still wrote favorably about the RDR. He had just published a very sharp essay, "Le Grand Schisme," in which he argued that "French intellectuals on the Left fear above all not to be seen as revolutionary."

Their attraction to Communism came from the "bad conscience they felt in front of men of action, i.e., Bolsheviks, who alone have the capacity to change the world."[36] If Aron was critical, and an incisive observer of the French Left, he was, however, well inclined toward the RDR, and he truly admired Sartre's energy at fighting both the Gaullists and the Communists. Richard Wright also joined forces with the RDR and so did André Breton. *Le Monde* chose to support it too. A strong and independent Europe was at the heart of "L'alternative," stated one of its editorials.

"DEADLY FALLACIES"

Koestler, back in Paris, had attended a few Gaullist rallies and was seeing a lot of Malraux, "now official chef de propaganda of the Gaullists."[37] Arthur was helping him raise money, for he thought it important to strengthen the left wing of the RPF. Malraux did not beat about the bush: "I desperately need between ten and fifteen million francs," he had told Arthur. That was for his anti-Communist propaganda. Arthur called on his friend Guy de Rothschild and was straightforward with him: Could he cough up the money? Guy was not sure his family could give so much, but he nevertheless invited both men to dinner. Mamaine went with them and just watched, as everyone else did, even Koestler, Malraux being Malraux, master of his own pyrotechnics. "Malraux was more extraordinary than ever. He spoke for four hours non-stop. Usual brilliance," summarized Mamaine in a letter she wrote the same evening to her sister. Malraux spoke with his "strange, indirect tenacity," "his somber eyes apparently seeing nothing but his own thoughts."[38] However, this made Arthur increasingly ill at ease: "Malraux has now given up his line on de Gaulle being *un homme de gauche* and K says that despite Malraux's new job, his left wing has clearly lost to the right wing of the Gaullist movement."[39] It took another three months for everyone else to realize this. As Janet Flanner later shared with her *New Yorker* readers: "Malraux is now the General's right-hand man. There is no left-hand de Gaulle man."[40]

To the editor of the *Observer*, who was eagerly awaiting Koestler's take on French politics and growing impatient, Koestler replied sternly: "I don't think I can write the articles. You see, I can't write the only things worth saying."[41] Koestler had chosen his camp, the Gaullists, and yet he was already disillusioned with them, though he couldn't actually say it. Terribly

frustrated, and quarreling with Mamaine all the time, he let her go to Italy while he set off for New York to give a series of lectures at the invitation of the former antifascist, but now firmly right-wing, International Relief and Rescue Committee. Koestler had not realized quite how famous he was in the United States and quite how polarized American politics had become. The FBI initially blocked Koestler's entry to the States on account of his being a staunch Communist, but the American ambassador in Paris had urgently briefed J. Edgar Hoover that that was not the case anymore, quite the opposite. The FBI's files were seriously in need of updating. This first trip to America, following in the steps of Sartre, Camus, and Beauvoir, was an eye-opener for Koestler.

Koestler tailored his talks around one theme: the dilemma of the radical. He often summarized the issue in this way:

> The Communists today present the same dilemma to France as the Nazis to Germany in 1930: whether democratic privileges should be extended to a party which aims at the destruction of democratic privileges. The dilemma is complicated by the fact that, while Nazism frankly professed its intention to abolish democracy, the Communists pose as its defenders; their disenfranchisement could only be justified by indirect evidence and deduction by analogy.[42]

Unlike Sartre, Camus, Beauvoir, and many others in Paris, Koestler refused to put Stalinism and American Imperialism in the same bag. For him, "deadly fallacies" were hindering the "Babbitts of the Left" from understanding the true nature of the Communist threat. Above all, he rejected the "false equation: Soviet totalitarianism is bad, American imperialism is bad, there is nothing to choose between them."[43] One had to choose the lesser evil. There would be Pax Americana or there would be no pax. His words certainly fell on fertile ground in the United States, but he was dismayed at the general feeling of hysteria, rising in intensity as he made his way from New York to Washington and from Washington to Hollywood. In a letter to Mamaine he confided: "It is quite impossible to give you any impression. It is a kind of delectable nightmare. Five times a day I am telling myself this is a country where I want to be forever, five times a day that I would rather be dead than live here."[44] In fact, annoyed at being used by his very conservative hosts for their right-wing red-baiting maneuvers,

Koestler tried to cut his trip short. After talks in San Francisco, Chicago, and Boston, he returned to New York. There were farewell parties with Hannah Arendt and Mary McCarthy, whom he swore he would seduce one day. On his last night, he toured Harlem's jazz clubs with Marlene Dietrich on his arm. He did not know what he enjoyed more that evening: speaking German all night or peering closely into those piercing blue eyes.

THE THIRD SEX

After a trip to her native New York, Janet Flanner had sailed back to France just before the launch of the RDR and was following its eruption on the European political stage with much attention. "Two of the best known literary figures, Jean-Paul Sartre and David Rousset have founded a political party, heaven help us. Sartre's political ideas are less clear, if more optimistic, than his novels. His talent, his scholarly mind, his French essence, and his hypersensitivity to Europe's dilapidation give momentary importance to his political hopes. The Sartre-Rousset party declares that it expects to collect, in the next six months, a hundred thousand followers. If words were all, its followers should number millions, from all over this earth."[45] Janet had lived in France for more than twenty-five years now, and, as veteran foreign correspondents often do, she sometimes viewed her favorite topic, France, with a world-weary eye.

At fifty-six, she had finally reached that most French stage in life, the phase of being blasé. She had just been made a knight of the Légion d'Honneur and was wearing the bright red ribbon on her lapel, but some-how she felt both *parvenue* and frustrated. She was tired of journalism. She was tempted to tackle the Paris Commune of 1871 in a proper book, but would she stick to it? "I have manufactured journalism for nearly a quarter of this century; nowadays everyone manufactures. Few create. If an indi-vidual knows the difference, and I do, the failure to create leaves only one conclusion: one has manufactured,"[46] she confided to her ex-lover and secretary Solita. Her private life was also a source of conflict and pain, and she was trying to restore some order to it. Early in 1948, her lover Natalia Danesi Murray had settled back in Rome. Janet had decided to divide her time between Natalia in Rome and her old lover Noeline in Paris, spending nine months a year with Noeline and the rest of the year with Natalia. With all this talk about a Third Way in politics, she wondered

whether there could not be a third sex, too. She had half-humorously asked her very old and very liberal mother in a letter, "Why can't there be a third sex, a sex not dominated by muscle or the inclination to breed?"[47] Janet had in fact invented for herself a "third sex" in the public world: she signed her articles with the androgynous pen name Genêt. "Neither masculine nor feminine, passive or active, Genêt was androgynous, anonymous, invented. The persona offered Janet security and identity; it gave her a form, a discipline, even what she later called a formula."[48]

Samuel Beckett had finally found his stride, and as for sex, he was happy with Paris's *filles de joie* (prostitutes)—much happier, it seems, than with Suzanne, his companion, sister, mother, and best friend. Beckett looked at politics, the Existentialists, and the new party in town, the RDR, from afar, or rather from the other side of Montparnasse Cemetery, in his spartan one-bedroom flat on the rue des Favorites. The "siege in the room" was going on and he seemed to be taking some pleasure from it. He had now written four novellas in French: *La fin, L'expulsé, Premier amour*, and *Le calmant* (*The End, The Expelled, First Love*, and *The Calmative*). He was thinking about a second play, too. He had a title in mind and asked Suzanne what she thought of it. What about *En attendant Godot*? She looked puzzled. Waiting for Godot? And who was this Godot? Of course, Beckett could not tell her. He mumbled something about a wordplay on "God." He would later confide to his friend Con Leventhal the real origin of the title. Beckett often went to the rue Godot de Mauroy, in the 9th arrondissement, popular with prostitutes. One day a girl asked if he needed her services; when he turned down her offer, she replied sarcastically, "Oh yeah, and who are you waiting for, then? Godot?"[49]

Nobody had wanted to produce his first play, *Eleutheria*, which Suzanne kept mailing to theater directors, but this did not bother him. He had recently met Matisse's son-in-law, Georges Duthuit, an art critic and the editor of a new magazine, *Transition*. He had found in him a kindred spirit and a partner with whom he could engage on matters of art and artists. And also an employer. Beckett was tired of giving English lessons and his allowance from his brother was decidedly meager. He lived on forty francs a week, half of which went to rent, and Suzanne's dressmaking jobs were not always enough to make ends meet. Georges Duthuit gave him interesting translation work and provided him with a new social circle. From now on, Beckett would get a regular income, contributing every

month to Duthuit's magazine and its English sister edition (catering to the young literary Anglophones now thronging the Left Bank). Beckett translated authors such as Sartre or Apollinaire—what more could he ask for? Besides, thanks to Georges, he also stopped being a hermit and allowed himself to have a social life, going to editorial meetings organized by Duthuit in his flat at 96 rue de l'Université, just off the boulevard Saint-Germain. Georges and his wife, Marguerite Matisse, the leaders of a little circle, were presiding over Tuesday lunches attended by Informel artists such as Nicolas de Staël and Bram van Velde but also the twenty-four-year-old Canadian painter Jean-Paul Riopelle whose future wife, the young American Abstract Expressionist painter Joan Mitchell, would soon fascinate Beckett.

DISSIDENCE IN LITERATURE AND FILM:
LA RUE SAINT-BENOÎT AND ANDRÉ BAZIN

In January 1948, Elio Vittorini, a well-known Fascist intellectual, published an open letter to Palmiro Togliatti, head of the Italian Communist Party, questioning the Zhdanov Doctrine and Stalin's cultural policy. Vittorini was a translator of William Faulkner and John Steinbeck, head of the influential monthly review *Politecnico*, and a great admirer of Sartre and Beauvoir. In his letter, published in the French review *Esprit*, he argued that art and culture should be left out of politics. Artistic creativity should be autonomous and free. The review was hoping to stir up the same debate within French Communist circles. The young Communists around Edgar Morin, Marguerite Duras, her ex-husband Robert Antelme, and her second husband, Dionys Mascolo—known as "la rue Saint-Benoît"—embraced Vittorini's cause and brought it to Commissar Aragon, hoping to influence the Party's policies. La rue Saint-Benoît was thus gaining a reputation for being a den of young "Communist reformists"; the contradiction in terms would not become obvious to them until a couple of years later. Marguerite Duras' flat, the group's epicenter, was "one of those houses out of the Russian novels of the period of the intelligentsia, where one sees coming in or going out, at every instant, three ideas, five friends, twenty papers, three indignations, two jokes, ten books, and a samovar of boiling water."[50] It was a beehive in which Duras was the queen, a beautiful queen. Her fellow writer Claude Roy remembered her vividly: "She had an abrupt

mind, a baroque and often droll vehemence, an infinite capacity for fury, appetite, warmth and astonishment."[51] Duras, Mascolo, and Morin had actually managed to publish a long interview with Vittorini in *Les Lettres françaises*.[52] They thought they could persuade their elders in the Party to yield some ground, at least as far as culture and the arts were concerned. But no matter how hard they tried, they failed. Artists were soldiers like any other Party member and they had to obey the Party line blindly, pronounced Aragon. Though this was the end of the argument, Vittorini's letter had far-reaching repercussions in Paris and would prove as decisive as the Yugoslav prime minister Tito's excommunication a few months later.

Along with the Vittorini affair, the Czech coup in February 1948 had also contributed to shake many Communists' faith in the Party and in Stalin, and young intellectuals and writers like those of la rue Saint-Benoît could not fail to notice "the growing resemblance between the Nazi enterprise and the Stalinist one."[53] Edgar Morin and Marguerite Duras may still have felt like Communist missionaries but they were not blind, nor were they deaf. "We belonged to the Party but also to the Left intelligentsia. Ideas flowed freely and whenever we met Sartre, Merleau-Ponty, Camus and Rousset, we chose to discuss rather than vaticinate."[54]

For longtime foreign Paris residents and visitors, it was obvious that the rigidly dogmatic Communism of the 1940s suddenly no longer countenanced the vague, revolutionary liberalism of the 1930s, when it was possible to combine individual fantasy and Party membership. "The Communist Party boys have no nonsense about them these days. Their papers brand Existentialism and the intellectual life of Saint-Germain-des-Prés as the ultimate expression of bourgeois decadence. You won't catch them compromising their orthodoxy by taking an apéritif in this enemy territory," wrote John L. Brown, in charge of the "Paris column" for the *New York Times Magazine*. The tribe of la rue Saint-Benoît would eventually have to choose sides, even if they would have preferred not to.

Artists were not the only ones to see their world invaded by dogma and they were not the only ones having to position themselves for or against; art critics too had to choose sides. The thirty-year-old André Bazin, a rising star of cinema criticism, was one of them. Bazin had embraced the Resistance motto "Culture is a human right and should be freely accessible to all" with passion. More than a critic, Bazin was also an

educator and a youth leader. Through *Travail et Culture* [Work and Culture], a Communist-leaning association and a magazine, he was setting up film clubs in factories and in schools, in France but also in Germany and Algeria, and writing about films. For Bazin, presenting and explaining great works of art to the working class would help emancipate them from purely commercial cinema ventures. Bazin was eclectic in his choice of collaborations with publications and wrote for many magazines such as *Esprit, Les Temps modernes,* and the newly created *La Revue du cinéma.* A champion of Italian Neorealism and Orson Welles, he wrote and spoke about films in a radically new way, forcing his readers and listeners to consider cinema seriously on a par with literature and philosophy. Cinema was not frivolous, he argued, it was meaningful and was taking part in the social changes of the times.

In his review of *Citizen Kane* for *Les Temps modernes,* he discussed Orson Welles's genius: "Flaubert didn't invent the imperfect, nor André Gide the pluperfect or Camus the past perfect, but the way they use them belongs to them, and to them only. If Orson Welles has not discovered the tracking shot, he has however invented its meaning."[55] In praising Orson Welles, André Bazin was aiming his review against Georges Sadoul, the Communist Party's official film critic, as the party was anti-Welles, too free a talent.

Tensions rose, especially at *Travail et Culture,* where Bazin's love of American cinema, his overriding interest in aesthetics, and his criticism of some Communist films put him at odds with his more militant colleagues. Bazin had not quite officially positioned himself against Socialist Realism in cinema, but the time would come when he could no longer remain silent. It took great courage to make a stand as Stalinists not only were very intimidating but also controlled a good part of French culture and the many jobs attached. For the time being, though, Bazin decided to dedicate his energy to setting up ciné-clubs aimed at the youth, who were rightly more interested in cinema as an art form than as a political discourse. Ciné-clubs popped up everywhere, showing classics but also premieres of recent works, with panel discussions, public debates, and dedicated journals such as *La Revue du cinéma.*

Sixteen-year-old François Truffaut, spurred by the ciné-club mania that was gripping Paris, ventured to set up his own ciné-club called Cinémane, a "Cinema Club for Film Addicts," in the Latin Quarter. At the

time, he already had a police record for petty thefts and had run away from home. In books and films he had found a refuge from an unloving mother and a harsh upbringing. One afternoon, Truffaut went to complain to Bazin that one of Bazin's ciné-clubs was interfering with his own. They ended up speaking about films all afternoon. Bazin was amazed by Truffaut's encyclopedic knowledge and by his enthusiasm, which matched his own. When Bazin learned that Truffaut's father, having finally traced the teenager, had arranged for his arrest by the police, he intervened. "I was imprisoned at the minor delinquents' centre of Villejuif, south of Paris," recalled Truffaut. "At the time, the place was half lunatic asylum, half remand home. André Bazin literally saved me."[56] Bazin began a campaign to free the young Truffaut. He contacted Truffaut's parents, who agreed to his early emancipation, and persuaded the police and the child psychologist to release him into his care. Bazin found Truffaut a job at *Travail et Culture*: the teenager wrote notes on the films being released every week and organized screenings in factories at lunchtime. François Truffaut was truly saved.

Richard Wright often went to the ciné-club screenings of the Latin Quarter, especially since he and his family had moved back to the Left Bank. He had found a spacious eight-room family flat a stone's throw from the Luxembourg Gardens and the boulevard Saint-Germain. It stood on the fourth floor of 14 rue Monsieur le Prince, an 1850s stone and brick building with a tall wooden door adorned with two feminine figures, one a libertine woman, the other a studious *jeune fille*. The building looked across to the aged limestone walls of the Sorbonne's École de Médecine. The composer Camille Saint-Saëns had lived there in the 1880s.

Their visitors, whether French or foreign, were amazed by the opulence of the Wrights' home, at least compared with how most Parisians lived. Soon-to-be Paris resident Chester Himes, another fellow black American writer whom Richard Wright helped, just couldn't believe his eyes when he first set foot at the Wrights'.

> Their flat occupied the entire 4th floor and to me it appeared sumptuously furnished. The first room to the right of the entrance foyer was his book-lined study, with two large modernistic paintings, dozens of copies of his own books, several typewriters, his desk, a tape recorder, and overstuffed leather armchairs. Beyond it were the dining room, the

living room, the master bedroom, and at the back, the bath, all over-looking the street. On the other side were a storeroom, pantry, kitchen, nursery and children's bedroom.[57]

Ellen Wright was expecting their second child, and the decision had been made that they would not return to live in the United States. Paris was the family home now. The Wrights had even decided to invest in the ultimate luxury: central heating.

Richard Wright was happy in Paris, basking in literary success and enjoying the friendship of the most prominent French and European intellectuals while conducting brief affairs with a string of women. How-ever, he had felt unable to start work on a new novel for nine months now. Wright convinced himself he needed to find the perfect café before he could begin to write again. He had rigorous criteria: soft electric lighting, sunlight at the right time, and not too intrusive a patron. He settled on the Monaco, a slightly shabby café at the south end of the rue de l'Odéon, next door to Adrienne Monnier's bookshop and Sylvia Beach's flat. The clientele was both local and international and he liked the mix. He had also negotiated a new delivery date for his next novel with his American publisher, Harper and Brothers, so all was well. Yet despite all this he would not, could not, start writing. He spent more and more time going to the ciné-clubs of the Latin Quarter. The particular brand of cinephilia raging in Paris had gripped him in the same way it had gripped the young François Truffaut.

In fact, Wright did not want to write yet another novel; what he wanted was to make a movie. Since Orson Welles and Roberto Rossellini, two lead-ing lights of cinema, had contacted him a year earlier about adapting *Native Son* to the screen, Wright had dreamed of taking part one way or another in moviemaking. After all, Sartre had written a few scripts already that had been made into films, and even Simone de Beauvoir had been contracted to write dialogue, all of which was better-paid work than writing novels. When Rossellini wrote to Wright to say that he had to give up on adapting *Native Son* because a film criticizing the United States at the beginning of the Marshall Plan was simply impossible to produce in Europe,[58] Wright felt terribly frustrated.

Still, life was sweet for any American living in Paris. One could now buy in shops nearly anything one wanted, and if the average Frenchman

did not have the means of paying for it, Americans did. Many important items were still rationed for the French. Except for doctors and taxi drivers, the French did not get a drop of gasoline. However, because the government needed tourist dollars, "gasoline flowed in fountains for American tourists, as well as for abashed American journalists (French journalists got none), for whom the liberated franc made life nice and cheap anyway."[59] Janet Flanner enjoyed telling her *New Yorker* readers about how Parisians lived. It certainly made folkloric reading for Americans now used to such a high standard of living and to modern comfort: "Parisian adults had had no butter ration since Christmas and in April 1948 their quarter-pound monthly coffee ration was to be skipped, but they received a government Easter present—a rationed tin of sardines, at thirty times the pre-war price."

ℰ ∽

"PARIS'S GLOOM IS A POWERFUL ASTRINGENT"

HOTEL LIFE

"Paris looks sadder and sadder every day: dark, cold, damp, empty. Maybe I should have a real home; I should not feel so chilly. Spring seems so far away,"[1] Simone de Beauvoir had written to Nelson Algren on January 9, 1948, the day she turned forty. She was writing with the red fountain pen he had given her, seated at her little desk in her round room at the Hôtel La Louisiane, her home since 1943. She had just come back from the *Temps modernes* office where she had picked up the English translation of her novel *Le sang des autres* (*The Blood of Others*), lying in the pile of mail. On the way back, walking down the rue Jacob, she had been drenched in "something which was neither snow nor rain but an icy, dark, sad water."[2] In her badly heated room she was shivering with cold. She poured herself a glass of whiskey, "not 'scawtch' but bourbon," and looked out the window. The crossroads of the rue de Buci and rue de Seine were eerily calm for a Friday afternoon. A strike had closed down shops and restaurants for the day.

Hotels had been her home for more than twenty years now, and like Sartre she had always enjoyed the complete freedom this lifestyle gave her and the negation of domesticity it represented. Living in hotels had been a positive choice for both of them, an ethical decision. They earned this freedom through writing. This "cameral philosophy" came from Christian asceticism but also from a certain "separatist elitism."[3] Sartre had reluctantly agreed to move in with his widowed mother, but he had remained true to his convictions: he owned nothing, the furniture was

not his, neither was the flat. He would have felt completely lost if he had owned anything. For him, and for Simone, domesticity, privacy, having a home were synonymous with the bourgeoisie, the class that they came from but had wholeheartedly rejected. A home also represented family, matrimony, and children, three things they had turned their backs on once and for all. This had not been easy, especially for Simone, and it had required great mental and moral strength, but they would stick to it. Many secretly admired them for it. Their way of life had become a holy grail for generations of intellectuals to come.

And unlike in other countries such as Britain, home ownership in France was not considered a great personal achievement, or a landmark in one's life. The choice in Paris in the late forties was usually either renting a decrepit small flat with ancient bathroom and kitchen facilities or living in a hotel out of a suitcase. When one was young, intellectual, and unattached, the second solution was by far the preferred option. However, for Simone de Beauvoir, a forty-year-old single woman, still to be living in this way, despite her fame and financial independence, was truly original. It also made it easier for sensationalist and Communist publications to pry into her colorful private life. Perhaps it was time for her to rent a studio flat somewhere on the Left Bank.

"A LONG LEAKY FRENCH WINTER"

Although elated to have received a letter in December 1947 from his New York publisher telling him that revision of his first novel would be minimal and that publication would be brought forward to early May, Norman Mailer, too, had felt the gloom of what he called "a long leaky French winter,"[4] as had—and would—many of his compatriots. The screenwriter and novelist Irwin Shaw, a liberator of Paris and soon to be a resident for the next twenty years, studied that very peculiar brand of seasonal melancholy: "Paris in the wintertime is the city for misogynists, misanthropes, and pessimists, for students of history who believe that the whole thing is all one long downhill ride. Winter, like unhappiness, is more biting in Paris than elsewhere."[5]

Mailer had just returned from a short skiing trip in the Alps with his wife Bea but was feeling restless. He could not decide on a subject for his second novel, while Bea was pretending to be a writer, too, supposedly

working on a novel about Russian immigrants when in fact she was spending her days enjoying Paris, learning French, and taking painting lessons from an impoverished French artist friend. Norman turned to reading; he might as well read since he had not yet found anything to write about. He read everything by Sartre he could find in English, getting his supplies from the *bouquinistes* along the Seine. He read at home, in his flat on the rue Bréa; he read in heated cafés, he read during his lectures at the Sorbonne, and he read on the benches of the Luxembourg Gardens during rare sunny spells. He thought he should force himself to write something. Anything. After meeting a "vapid young American man" in a café "who asked a lot of dull questions"[6] and whom Norman never saw again, he got an idea for a story. He provisionally titled it *Mrs. Guinevere* (it was later known as *Barbary Shore*). A young man, wounded in the war and suffering from amnesia, rents a room in Brooklyn with the intention of writing an autobiographical novel, except of course his past is a secret to himself. Norman did not go far with it, though; he wrote fifty pages and ran aground. In his own words, his "novelistic tanks ran out of gas."[7]

At night, to compensate for their writer's blocks, the Mailers assiduously went out. One evening in January 1948, either at Harold Kaplan's[8] or at Stanley Geist's[9] small flat on the posh avenue Gabriel in the 8th arrondissement, near the Champs-Élysées, Norman was introduced to Jean Malaquais, who, at forty, was fifteen years his senior. Not old enough to be a father figure, but certainly charismatic enough to be a mentor.

Malaquais, tall and thin with short, curly black hair, looked severe and haughty, but there was something in his eyes that drew Mailer to him. A glass in his hand, Mailer casually introduced himself. After a few minutes of conversation, Mailer went straight to his friend Stanley Geist: "Who's that arrogant bastard?" he asked. Geist took him aside and told him about Malaquais. Born Malacki Wladimir Israel Pinkus in Warsaw, a Polish Jew, Jean had left Poland in 1925 to travel the world. He had embraced Leninism, gone to Africa, enrolled in the International Brigades against Franco, worked as a miner and manual laborer, and finally settled in France. Like Joseph Conrad, another Polish emigrant, and Arthur Koestler, he had taught himself to write in a foreign language. And while working nights unloading crates in Les Halles, he had immersed himself in French literature at the Sainte Geneviève library, an imposing 1850 palace standing on the place du Panthéon.[10] André Gide, to whom Jean Malaquais had

written, had encouraged him to record his experience as a miner and helped him publish it in 1939. As the war broke out, *Les Javanais* (*Men of Nowhere*) won the Renaudot literary prize against Sartre's *Le mur* (*The Wall*). Stateless and Jewish, Jean, who had adopted the family name of Malaquais after the Quai Malaquais on the Left Bank facing the Louvre, had managed to escape France via Marseilles. From there he had reached Mexico and then New York, where he had spent the war years and acquired an American passport. Malaquais, now back in Paris, was a fierce anti-Stalinist and an intellectual heavyweight. "Now you're warned," Geist told Mailer.

Norman Mailer and many of his fellow GI Bill students in Paris meant well: they were antifascist and wanted to prove it with deeds, as well as with words. Now imbued with Existentialist thinking, Norman had resolved to be a writer *engagé*, a doer rather than just an observer. Spanish Republican refugee friends in Paris had asked him whether he would agree to "go on a mission" to Barcelona to help arrange prison escape for comrades. Mailer had eagerly embraced the adventure. After changing francs into pesetas in Geneva, he had driven with Bea and his younger sister Barbara to the Spanish border. They had previously rolled the money for their comrades in tight wads and put them into condoms, inserted the condoms in toiletry tubes, and stuffed propaganda in the spare tire of Norman's Citroën. In Barcelona they found the contacts, delivered the money and the leaflets, and then returned to Paris feeling absolutely elated.[11] However, Norman's political thought was thin and verging on the naively romantic. He had been a Sartrean even before reading Sartre and he believed himself a Marxist without having read Marx. This was all going to change after meeting, and eventually befriending, Malaquais.

Malaquais, a Trotskyite, could not accept Stalin's regime with its Siberian labor camps, repression, and purges. He also thought that capitalism was as great an evil as fascism and Stalinism and that Western democracies had as great a capacity for dictatorship as the Soviet Union. This allowed for a larger and far more complex worldview than Norman previously considered. At first annoyed by the arrogant Parisian, then intrigued and soon enthralled, Mailer quickly fell under the spell of what he viewed with envy as intellectual sophistication. From January 1948 on, their exchanges would sometimes be tetchy and heated, but Mailer acknowledged Malaquais as his mentor and his life coach in politics, and later he

would be proud to acknowledge him as his translator. Mailer firmly intended to be a success in France, and he pushed Rinehart to sell the French rights and to establish Malaquais as the translator of *The Naked and the Dead* and all the books he might write in the future. In fact, Malaquais was a sought-after translator. He had just been approached to translate Nelson Algren's second novel, *Never Come Morning*. Simone had found a French publisher for Nelson and was actively promoting his work in Paris, where it appeared in *Les Temps modernes*, as ever an incubator and a platform for talent.

Malaquais' worldview, a rebuttal of both capitalism and Stalinism, did not leave any clear line of political action open except for the Third Way advocated by Sartre, Camus, Koestler, Wright, Beauvoir, and their army of followers. The world situation, with its slow slide into the Cold War mentality, called for action. At a time when old friends were going their different ways, feeling compelled to choose one camp or the other, even if reluctantly, when the Gaullists were borrowing the tactics and language of the Communists to spread fear, when Communist reformists were being expelled from their own party, feeling orphaned and lost—the alternative the Existentialists offered became more and more appealing.

JAZZ—FROM NEW ORLEANS'S "INHERITED COMPLAINT OF SLAVERY" TO "BEBOP'S JOYOUS AGGRESSIVENESS"

Instead of butter, Parisians increasingly fed on jazz. Jazz clubs were opening every month, providing further venues for French and visiting foreign jazz musicians while world-famous names performed in more prestigious concert halls. Boris Vian, "the young man with a horn," as Beauvoir called him in her letters to Algren, had become not only a successful writer since he had revealed he was in fact Vernon Sullivan, the author of the scandalous *J'irai cracher sur vos tombes*, but also a very sought-after jazz impresario and concert organizer. In late February 1948, Louis Armstrong filled the Salle Pleyel, "our own Carnegie Hall,"[12] as Beauvoir explained to Algren. "It was full of screaming people, chiefly young people mad with enthusiasm. People half killed one another to get seats."[13] In a typical French cross-fertilization, Boris Vian and the publisher Gallimard had a party for Louis Armstrong and his orchestra so they could meet the poets of négritude Aimé Césaire and Léopold Senghor, along with Beauvoir, Camus,

Sartre, Richard Wright, "and many other American intellectuals," writers, and artists living in Paris; "Paris is crowded with them," Beauvoir told Algren.

Dizzy Gillespie had preceded Armstrong by a few days and had also performed at the Salle Pleyel, in front of Parisian bebop fanatics. Picasso's neighbor and friend the art critic and anthropologist Michel Leiris, just back from a six-month trip to Africa, was in the crowd and was intrigued to listen to the "most sensational jazz musician since Duke Ellington." In his diary, he could not help analyzing Gillespie's jazz in terms that would surely have interested if not fascinated many American jazz reviewers.

> 1) Extreme virulence of the brass instruments and force of the drummers, one American and one Cuban. 2) Great freedom of expression and treatment of the musical themes with successive instrumental soli. 3) Africanisms (or rather, most probably, West-Indianisms). Deliberate and sometimes verging on exoticism of poor taste. It is however true that some trumpet ensembles made me think of certain things heard in Cameroon. Those Africanisms have led some people to talk about the influence of atonal music on Bebop but it seems to me baseless. 4) Correlation between Bebop and Cab Calloway's scat-singing. To sum up, Bebop seems to me more extreme than truly original. I wonder whether its *negrism* proceeds from a spontaneous desire of jazz musicians to return to jazz origins, or simply from the white public's demand for exoticism.[14]

Four days later he felt compelled to return to the subject.

> Gillespie's jazz is novel in that it seems to have almost killed off Blues, and overcome the inherited complaint of slavery (in which Armstrong still sort of indulgently basks). Gillespie has replaced the harrowing nature of jazz with Blues as its foundation, by something akin to joyous aggressiveness. It might be reflecting the change of blacks' mentality, less resigned to their plight and now more ready to protest.[15]

As Janet Flanner confided to her *New Yorker* readers: "French jazz fans are as intellectual in talking about *swingue* as if they were discussing Schoenberg."[16]

Jazz seemed to be bursting out of every ventilation shaft in Paris. Even Janet Flanner had to start covering jazz concerts, and she had to do it "seriously," the same way she reported on de Gaulle's latest speech, Picasso's exhibitions, and Sartre's plays. She eventually broke the news to her readers: Paris had become the new world capital of jazz. It was impossible, though, to cover every concert and jazz-related event. She decided to stick to festivals, at least for the time being. "The Old Marigny Theatre has seen a week of frenzied jazz concerts, American Negroes like Coleman Hawkins, Slam Stewart and Howard McGhee." She of course relayed the intense and warlike dispute between different schools, "a struggle between diehard New Orleans style, also known in France as 'jazz hot,' and 'Bebop,' mentioning the athletic clarinetist Claude Luter 'on the French front.'"[17] A few months later, however, Janet could no longer avoid going underground and visiting jazz clubs in caves.

> Claustrophilia is the Saint-Germain-des-Prés fashion, with the *boîtes* in basements—some of them authentic eighteenth-century cellars that are still unventilated. The best new club of the kind is in the basement of the Vieux Colombier Theatre, with Claude Luter's "jazz hot," and black French African natives singing home songs. The Club Saint Germain and le Tabou, the first of the troglodyte caverns called Existentialist are still feverishly popular.[18]

Paris was being invaded by hordes of tourists and foreign students. Was it the unexpected pre-effect of the Marshall Plan? As Janet wrote at the end of May 1948: "the tourists are regarded as shiploads of precious material not specified in the Marshall Plan."[19]

Many of them were "intellectual" tourists. Beauvoir could spot them straightaway, as she told Algren: "Young existentialist boys now grow a beard; American intellectual tourists grow beards too. All these beards are awfully ugly! But the existentialist caves are a wonderful success. It is funny, just two blocks—that is all Saint-Germain-des-Prés—but within these two blocks you cannot find a place to sit down, neither in the bars, cafés, night clubs nor even on the pavement. Then all around it is just darkness and death."[20] In this square mile, different generations mingled. There were "the group of the first villagers in the 1930s, the Prévert band, the Sartrean family, the young birds of the night whom the newspapers

called existentialists, and the Communist cell. Their common denomina-
tor was anti-Fascism, and Communism their reference: either they had
been Communists, were presently Communists, would soon cease to be
Communist or would become Communists."[21]

RESEARCHING *THE SECOND SEX*

In the intellectual and artistic world of Paris in 1948, if your skin color,
your religion, and your nationality were irrelevant to the way you lived and
were seen, your gender had far-reaching repercussions for your happiness,
ambitions, and health. To be a woman, even in liberated Paris, was a con-
genital predicament. The freest of women, Simone de Beauvoir, who was
brought up as a woman but lived like a man, was still investigating the
question. The more she researched the topic—delving into mythology
and anthropology and starting to conduct interviews with women, both
friends and strangers—the more fascinated she became with what had
now become a massive endeavor. After the elation of traveling with
Nelson Algren down the Mississippi and on to Mexico, the Yucatán pen-
insula, and Guatemala in May and June 1948, she returned to her book
with immense eagerness.

Just before leaving Paris she had published a few pages on "Woman and
Myths" in *Les Temps modernes* as a cautious way to test the water. The first
line read: "He is The Absolute, and she is The Other." Simone de Beauvoir
had at her disposal a plethora of cases she could analyze. She had only to
look at her friends and acquaintances, ask them questions, and draw her
own conclusions on the place of women in society. Sonia Brownell, for
instance, was head over heels in love with Merleau-Ponty. When in Paris,
the lovers spent their nights in jazz clubs, dancing until dawn, sometimes
accompanied by another dervish of a philosopher and Sonia's compatriot,
A. J. Ayer, newly appointed chair of philosophy at University College
London, and a frequent visitor to Paris. Both men, of great intellect,
immense charm, and finesse, regarded their dalliances slightly differently.
Merleau-Ponty, a married man with children, had no intention of (ever)
divorcing, just like Albert Camus, while Ayer was happy to marry, divorce,
remarry, and father children with passing partners. Sonia could easily have
accepted Merleau-Ponty's position, even embraced it. After all, she was a
strong-willed individual, and—a crucial detail—she earned her living. She

even acted as the unofficial editor of *Horizon*. With both its editors heading off to France for months at a time, she was often left in charge of running the office and commissioning contributions. "Do accept anything you think good," Cyril Connolly wrote to Sonia in July 1948 from his summer residence at Somerset Maugham's villa in the south of France.[22] It would have been nice to be acknowledged as such, with a deputy editor title and the salary that went with it, but she did not ask. She convinced herself that she liked being *une éminence grise*. And anyway, matters of the heart seemed more important. As she confided to Simone, Sonia simply longed to live with Merleau-Ponty, "the love of her life." She was turning thirty and wanted to settle down. Beauvoir knew Merleau-Ponty very well: they had been classmates, and her best friend Zaza had been in love with him. Until death did them part, as it happened. Beauvoir blamed Merleau-Ponty for Zaza's sudden death at the age of twenty-two.[23] And to her mind, Sonia's love story with Merleau-Ponty would also end in tears and ill health—which it did.

Mamaine was another perfect case study for Beauvoir. Mamaine, who had just taken Albert Camus and his wife, Francine, on a short trip to London in May and was staying at Sonia Brownell's flat at 18 Percy Street, could claim to live with the man of her heart. However, she was very unhappy with Arthur Koestler. And she had great difficulty admitting it. Having forfeited a career of her own, despite a fine polyglot education, she had entered into a relationship with Koestler in which she was constantly bullied. She had agreed not to have any children in exchange for a hypothetical marriage that was a rather long time coming. It was now three years since he had promised to marry her (and it would be another couple of years before he finally did so). Meanwhile, she continued to work as his secretary, translator, copy editor, governess, and *souffre-douleur* (punching bag) while receiving no credit for her work and being completely dependent on him financially. Mamaine thought she had to endure Koestler's moods and whims. She thought it was her moral duty and the lot of all life companions. She would soon develop "asthma attacks," or so a succession of perplexed doctors told her. Was it asthma, or was she growing allergic to Koestler?

When the British mandate for Palestine was officially terminated and the independent State of Israel proclaimed (and was at once invaded by the armies of five sovereign Arab states, strongly opposed by the Jewish defense force Haganah), Koestler left immediately to report for *Le Figaro*,

the *Manchester Guardian*, and the *International Herald Tribune*. He did not forget to take Mamaine with him, however. He intended to make her work hard for him. The couple arrived in Haifa on June 4. While Koestler met and dined with the luminaries, "dealing with Haute Politique,"[24] he cunningly sent Mamaine to do all the fieldwork in Jerusalem. Koestler even gave her a Leica, on their friend the world-renowned war photographer Robert Capa's advice, in order to take pictures—pictures that would illustrate *his* articles, though her name would not appear alongside his. Mamaine thought it normal; she was just helping her partner, who was the brain, after all. In Jerusalem, Mamaine unfortunately failed to get hold of a copy of *Les Temps modernes*' June 1948 issue. If she had, she might have been intrigued by Beauvoir's second essay on "Woman and Myths." "The woman is both Eve and Virgin Mary. She is an idol, a servant, the origin of Life, the power of darkness; she is the elementary silence of Truth, she is artifice, gossip and lies; she is the healer and the sorceress, she is man's prey, she is his ruin, she is everything he is not and wants, his negation and his raison d'être. She is the Other, she is Evil through which Good can exist."

Women had to be very strong in 1948 to be able to assert themselves, and, plainly, to exist. Beauvoir had undoubtedly offered a mirror into which young, ambitious women could peer. The image Beauvoir reflected was a powerful and scandalous one. She offered a new holy grail in the trinity of intellectual ambition, financial independence, and sexual freedom. Maria Casarès and Juliette Gréco, fifteen and twenty years her juniors, were following in her steps. On June 18, 1948, just after lunchtime, Albert Camus bumped into Maria Casarès on the boulevard Saint-Germain. The now twenty-six-year-old Casarès was accompanied by her current beau, the charismatic Jean Servais, like her a formidable actor. Camus and Casarès looked at each other, exchanged a few words, and parted but, as they walked away, they both turned and looked back at the same moment. This was it; they had missed each other too much. Maria left Jean, Albert did not leave Francine. From then on, Albert called Maria *"L'unique."* Their relationship was public and their modus vivendi based on the absoluteness of their love. They shared their lives without living together. As Albert would sum it up later to Maria: "I may have cheated on you, but I have never betrayed you." In other words, he was unfaithful but always loyal.[25] Maria would embrace this unconventional arrangement until Albert's untimely death

twelve years later. But what about Francine? Albert might have been spending some of his nights with his wife and children, along with family holidays in the summer, but she knew, as well as everybody else, that Maria was his true love, or rather his equal in love, while she was the wife at home and mother of his children, a lesser love. She had once had ambitions to be a concert pianist, but that was now a fading memory. Her family had originally been very happy that she married a promising writer. Now, her mother and sister had to fly from Algiers and keep her company and help with the children as she felt less and less well. Like Mamaine, Francine would eventually develop chronic ailments of a severe nature. Albert's behavior was, quite literally, a violent poison in Francine's life; however, she consciously agreed to swallow it, sip by sip, day after day.

EXISTENTIALIST *CHANSON*

Juliette Gréco was not going to let anyone poison her life, and certainly not men. Merleau-Ponty (and already many others) had tried to woo her, and she had certainly found the phenomenologist "terribly charming," as she freely admitted seventy years later. But the point for her was always to be her own woman. She had wanted to be a tragedian, like Maria Casarès, except she had twice failed the entrance exam for the national drama school. She would be a chanteuse. A new kind of chanteuse, her own kind. Her friend Anne-Marie Cazalis, the curly-red-haired poet turned self-publicist, had talked her into it. So had Sartre. "But I have never sung," she told them. "*Et alors?*" they replied. *Et alors*, indeed. "Come and meet me at nine o'clock tomorrow morning," said Sartre on a spring day in 1948, "and I'll have a song ready for you." There was no arguing with fate.

At nine o'clock sharp, Juliette walked up to the fourth floor of 42 rue Bonaparte and knocked on the door. Sartre had not forgotten about her and had prepared many different sheets of papers. "I have selected a few poems for you. And here is a song for you, I wrote it, it's a gift. Go and see Joseph Kosma, he'll write the music for you." Sartre had written "La rue des blancs-Manteaux" [The street of white coats] in 1944 for his play *No Exit* but had not used it. Gréco started reading while walking down the stairs. It talked about an executioner who had had to wake up early for a long day of work; there was a scaffold, and army generals, beautifully

attired ladies and bishops whose heads were about to roll, and all this was taking place in the rue des Blancs Manteaux, a quiet street in the 4th arrondissement at the time of the French Revolution. Not exactly cheerful, but an Existentialist song if there ever was such a thing. Gréco needed more songs to start a repertoire. She looked at the poems Sartre had suggested. There was one by Raymond Queneau she loved immediately: "Si tu t'imagines"[26] ("If you imagine"). Here was another Existentialist song, this time on the brevity and naïveté of youth. Youngsters, don't be fooled, wrote the poet, you may be in love today but love never lasts; you may look fresh and pretty today, but you won't tomorrow. Just like love, youthful beauty always ends in tears. Gréco was overjoyed. She needed a third song, though. Jacques Prévert would do.

She rushed to the Café de Flore and asked to use the phone to call Joseph Kosma: "Can I come later today? I need music for poems," she said. Kosma, the celebrated film score composer, lived with his wife in a single attic room, or more precisely a *chambre de bonne* (a maid's room), on the sixth floor of a sandstone building on the rue de l'Université. Kosma had managed to get a piano, a chair, a sofa bed, and a coffee table into his studio. He read the texts and sat at the piano while Juliette stood, her elbow resting on the piano. In two hours, he composed the music. Now Juliette needed to sing the poems turned songs, something she had never done before. She walked to her decrepit hotel, Le Montana, 3 rue de Bourgogne, went up to her room, locked herself in, stood in front of the mirror, and started reciting.

Gréco was not convinced. She did not think she could pull it off, she confided to her friend Cazalis at the Méphisto bar in the evening. "You have four days to rehearse. We have a place. Le Boeuf sur le Toit has reopened and given us a slot. You're on." Juliette protested. She had nothing to wear. Cazalis lent her some money and told her to go to Pierre Balmain and get herself the cheapest garment in the couture shop. Juliette bought a little black dress. She then spent four days in her hotel room, standing in front of the mirror. She was experimenting with hand gestures, pronunciation, diction, phrasing. After all, she was singing poetry and reciting great texts by famous names. She was an interpreter, the prism through which words, ideas, and images would reach an audience. In four days she created a style, her style. Juliette was happy to try her luck in a

cabaret on the Right Bank, in the 8th arrondissement, far from her world. She was hoping nobody would notice her debut. Le Boeuf sur le Toit had opened its doors in the early 1920s and had become a favorite *lieu de rendez-vous* for the young Cocteau, Picasso, Diaghilev, Satie, Stravinsky, Chanel, Braque, Dior, and many others. It was now being relaunched by the Left Bank kids.

On the night Gréco started her career, there was a twenty-four-year-old American in the audience who had just starred on Broadway in a new play by Tennessee Williams called *A Streetcar Named Desire*. Cocteau, also in the audience, would adapt it for the French stage a year later. Cocteau was looking at Marlon Brando looking at Juliette Gréco. Marlon Brando was even more attracted by the act following Gréco, a black American singer named Eartha Kitt who sang "Chéri, je vous aime beaucoup, je ne sais pas what to do."[27] Gréco and Brando became friends, and he gave her a ride back to her hotel on a Solex-powered bicycle after the show. Brando was at a crossroads in his career. He had starred in plays on Broadway for five years now, among others the New York productions of Jean Anouilh's *Antigone* and Cocteau's *L'aigle à deux têtes* (*The Two-Headed Eagle*), and Hollywood was courting him both for his incredible beauty and for his acting talent. In Paris he did not reply to any of the cables sent by his agent and producers. He seemed to observe, with as much terror as pleasure, the effect he had on both men and women. In Hollywood, Fred Zinnemann was thinking about offering him the lead role in *The Men*, which would establish Brando as a movie star. Meanwhile, in Paris, unknown but not unremarked, the young Brando was trying to grapple with his existence. With Juliette Gréco and his French homosexual friends he spoke too much, drank very little, and did not smoke. "He was very charming, very voluble but he was suffering, it was obvious," thought Juliette Gréco, "and it was of a sexual nature."[28]

Through his life, Marlon Brando would keep coming back to Paris, to visit friends, female and male lovers such as Christian Marquand, to tell Norman Mailer to stop dabbling in screenwriting and return to novels, to help out a penniless James Baldwin, and to go out on the town with the wunderkind of French literature Françoise Sagan. He would occasionally cross paths with Juliette Gréco, who, like him, was to achieve world fame, in her case touring Latin and North America in her little black dress, singing

Existentialist songs and fascinating Hollywood moguls, all too eager either to marry her, like Darryl Zanuck, or to offer her a seven-year contract, like David O. Selznick. Much courted and celebrated, both Brando and Gréco, of the generation "born in 1925,"[29] would, however, always be mavericks. Paris had made them that way.

PART IV

SHARPENING
THE SENSES

ℰ

"THEY OWNED ART WHILE WE WERE JUST FULL OF DOLLARS"

BORN IN 1925

"The vanguard of the biggest influx of American tourists since the great season of 1929 is now becoming visible and audible everywhere in Paris," announced Janet Flanner at the end of June 1948. "They are as welcome as they are valuable. Saint-Germain-des-Prés has become a campus for the American collegiate set. The Café de Flore serves as a drugstore for pretty upstate girls in unbecoming blue denim pants and their Middle Western dates, most of whom are growing hasty Beaux-Arts beards."[1] Sartre enjoyed a real authority among foreign students. Existentialism had become an institution by now, an official article of export, on a par with Christian Dior gowns. "Members of the tourist intelligentsia patronize the Pont Royal Bar which used to be full of Existentialists and is now full only of themselves, often arguing about Existentialism."[2] June 1948 is exactly when, according to Anne-Marie Cazalis, the Left Bank youth lost their innocence. Le Tabou had withstood worldwide publicity for a year, but by that summer of 1948, when the tourists started to outnumber the indigenous Existentialists, it had lost its cachet. "Our youth lasted four years,"[3] wrote Cazalis. "Adults stole our youth in 1948," she continued. "When the first adult started dancing with a professional beauty, our reign ended."

The generation born around 1925 was coming of age and felt slightly out of place, unsure and unsettled. An article by Roger Stéphane in *Les Temps modernes* titled "Born in 1925" had looked into precisely this palpable generational malaise.

We, born in 1925, must be cautious: we must not believe in anything, we must not feel close to anyone or anything for we know we can lose everything and everybody, truths and opinions. Then, we realise, with a new freshness, that there is no solution, only "may-be." We, twenty years old in 1945, are wise people. We have nothing to learn from religions and from philosophy. We know how to savour the deepest and most durable joys in the middle of a demented world.[4]

John L. Brown, the Paris columnist of the *New York Times Magazine*, on one of his numerous visits to the city, had felt that generational *mal être* and put it this way to his readers:

This Bohemia has ceased to believe in style, has ceased to believe in art and, to a serious degree, has ceased to believe in man. They find a savage anti-humanism more honest than a party-dictated doctrine of "brotherhood." But in the midst of this despair, life goes on. At twenty, metaphysical anguish is a torment that comes and goes, that can even be rather pleasant and distinguished in understanding company. "See you at the Flore at five?"[5]

LIKE A FRENCH FIDDLER ON THE ROOF

Twenty-two-year-old Art Buchwald was among those thousands of students flocking to Paris's Left Bank that summer. Traveling to the city on the GI Bill program, he disembarked from the *Marine Jumper* in Le Havre on June 12, 1948. The ship was loaded with rosy-cheeked American students just like him. "We carried hardly any luggage, but if we'd declared our dreams to French customs, they would have been worth thousands of dollars in duty,"[6] he later wrote. The son of an Austrian-Hungarian Jewish curtain manufacturer, Buchwald spent his early years in New York's Hebrew Orphan Asylum after his father lost his business in the Great Depression, but he had high hopes for the rest of his life. After deceiving the U.S. Marine Corps about his age, he had served in the Pacific in the last years of the war. The Marines, however, had not had much use for him; perhaps Paris would be different.

On his first night there, he found a cheap hotel in Pigalle. The next morning he realized the hotel rented most of its rooms by the hour, except

for penniless tourists like him. He enjoyed Pigalle enormously; he thought
he was a character in an Utrillo painting with his string bag to carry vege-
tables from the food stalls. After enrolling at the Alliance Française on the
boulevard Raspail, he found a studio flat on the place Clichy in the 9th
arrondissement for five dollars a month. He did not know his right bank
from his left and could not have cared less. Unlike Norman Mailer, he did
not dream of conjugating subjunctive verbs for the next twelve months.
When an ex-GI told him he could bribe the girl checking attendance every
morning at the Alliance Française for two dollars a month, he seized his
chance: no French lessons and still his monthly stipend from the U.S.
government. He would not have to sweat over Molière. "If all the GIs in
Paris who are supposed to be enrolled went to class, they would need a soc-
cer stadium to accommodate them,"[7] laughed his friend. The very resource-
ful Buchwald discovered other ways to add to his kitty. As an American
citizen, he was entitled to gasoline stamps in exchange for dollars. He sold
his gas coupons to taxi drivers for $25 a month. "So with $75 from the GI Bill
and $25 from gasoline stamps, I was as rich as a French fiddler on the roof."[8]

With no Sorbonne lectures or French grammar lessons, Buchwald
had all the time in the world to flirt. Jovial and charming, he was also
chubby and nearsighted. He was not the sort of man that women fell for
at first glance. He needed to make them laugh before offering to buy
them a drink, so café terraces were not the best places for Buchwald to try
to seduce girls. He accidentally discovered that the best honeytrap in
Paris was the Louvre Museum. "Women of all nationalities went there
alone because they considered it safe and assumed that anyone looking at
the Tintorettos could be trusted,"[9] and be talked to. Art, however, was about
to wake up from his Utrillo fairy tale. One morning in July 1948 he was
summoned to a meeting at the U.S. embassy. The Veterans Administration
knew he was not attending classes, and this meant the end of his monthly
allowance. If Art wanted to stay in Paris, he would have to find a job, and
quickly. He wanted to write for newspapers. If he had managed to trick
the U.S. Marines, surely he could trick the *International Herald Tribune*?

Art first moved to the Left Bank and found a cheaper room in a "Poles'
coop," as he called it. The Hôtel des États-Unis, at 135 boulevard du Mont-
parnasse, right across from where Matisse and Harold Kaplan lived, was
run by Polish veterans who had fought with the Allies. His room, on the
third floor, had a sink, a bidet, a bed, a desk, and "a light-bulb so low in

wattage that mice went blind trying to find something to eat."[10] His canteen was Wadja's,[11] across the boulevard, a favorite of Samuel Beckett, too, at 10 rue de la Grande Chaumière. The owners allowed their young clients to eat on credit as long as they did not spread the word. No à la carte, just one menu for all. The traditional dish was "steaming platters of meat and potatoes,"[12] which they served in big dishes and placed on tables shared by all the patrons.

Art mixed with his fellow American students on the Left Bank and with anyone who could reply in English or who could translate for him. He asked people if they knew of a job vacancy, preferably in the publishing or newspaper industry. He soon landed a job as a stringer for *Variety*, the American entertainment industry publication. This would be enough to survive. "It paid nothing but got me entrée into all the show-business enterprises, including movies and vaudevilles. It also gave me the chance to attend fancy cocktail parties where I served myself dinner."[13] Throughout the time he spent working for *Variety*, though, his eyes were on the *International Herald Tribune*.

THE CAPITAL OF SIN AND LIBERTINAGE

In New York, the *Partisan Review*'s jack-of-all-trades Lionel Abel was eagerly awaiting his turn to leave for Paris. He already had many friends there whom he had met during the war when they were in exile or when they had toured the United States just after the war. They were the painter Jean Hélion, Sartre, Beauvoir, and Camus, the philosopher Jean Wahl who had taught Beauvoir, André Breton, and Roberto Matta. Call him prudish, but there was one thing Lionel Abel had never felt comfortable with in the presence of his famous French friends, and that was their "cynical view of sentimental and sexual relations."[14] Would he find Paris and Parisians as devoid of morality as his Surrealist friends' mores suggested? Perhaps it was the self-righteous Jewish Trotskyite in him, but he recoiled at the thought. His Chicago friend Saul Bellow, also on his way to Paris with his wife, Anita, and four-year-old son, Gregory, in tow, shared the same prejudice. He, too, had only contempt for French libertinage despite his own philandering.

Lionel Abel had had a taste of French lust in recent months and had found it disgusting, or simply too disturbing, or too heady, perhaps. His

friend Roberto Matta had broken up with his wife, Ann, and they divorced just after the birth of their twin boys. Matta went on to marry his lover Patricia, who had already started an affair with Pierre Matisse, the art gallerist and son of the great painter. Pierre consequently divorced his wife, Teeny, the mother of his three children, for Patricia, who left Matta. He felt fine about it as he was himself having a liaison with Agnès, the wife of the painter Arshile Gorky. This ring of love would have ended rather pleasantly with the marriage of Matisse's first wife, Teeny, to Marcel Duchamp a few years later, if tragedy had not struck in the midst of it. In the heat of the summer of 1948, after Gorky had confronted Matta in Central Park over his affair with Agnès, Gorky returned to his studio in Connecticut and hanged himself. He was forty-four. André Breton called Matta a murderer, and Pierre Matisse refused to be Matta's art dealer any longer. For Lionel Abel, "the Surrealist movement died that summer."[15] Still, the thirty-eight-year-old New York intellectual remained intent on going to Paris and living there, in the capital of sin and moral ambiguity.

THE GI BILL PROGRAM INVASION

Perhaps attracted by libertinage, six hundred young Americans crossed the Atlantic on board the USS *Tiger* that summer, heading for Cherbourg. Beneficiaries of the GI Bill program, they slept on hammocks and used military latrines as toilets. With an average speed of 300 nautical miles per day, this was an eleven-day trip. On board were Patrick Hemingway, the twenty-year-old second son of Ernest, shy and diffident, and the twenty-one-year-old Richard Seaver, a student of French and American literature who had won the American Field Service fellowship to France, just like Ernest Hemingway and E. E. Cummings before him. Richard told Patrick of his plan to walk the 220 miles from Cherbourg to Paris. The young Hemingway looked at Richard's shoes and gave a painful smile. Richard later wondered what had made him undertake such an arduous trek: to atone for his absence in Normandy on D-Day? Richard had joined the navy in 1944 at age seventeen. He had been sent to an officers' training program called V-12 in Alabama and had been released in spring 1946. "In short, though I had worn the uniform for two years, I had really missed the war."[16]

Seaver had been given a piece of paper bearing the address of an old

hotel in the rue de l'Ancienne Comédie at the Odéon. It had small rooms to rent for a dollar a day with views over chimneys and roofs, 70 square feet in total. Tight but fine. Jack Youngerman, an American student at the Beaux-Arts, lived nearby. They had a friend in common, and soon Jack and Dick were hanging out together. "I told him about Joyce, he turned me on to the writings of Louise Labé, a female French poet of the Renaissance,"[17] recalled Richard Seaver in his memoirs. At first, Richard dutifully attended his classes on comparative literature at the Sorbonne, but he found the lecture halls stuffy and the teaching dull, with ancient-looking, doddering teachers reading from notes probably unchanged since the First World War. "I quickly decided to move my education out of the classroom and into the streets and cafés. Where the action was. Where life was."

In his first year at the Beaux-Arts, Jack had to go through relentless drawing practice and academic teaching under the supervision of Picasso's friend Jean Souverbie. The idea was that in order to transcend order, in order to attain originality and perhaps genius, in order to revolutionize the arts, one first needed to master the rules. According to French belief, creativity did not spring from chaos but could be achieved only through discipline and knowledge. This way of thinking was something Youngerman and his American fellow students would have to get used to. It explained the mood at the Beaux-Arts school, which had stood at the corner of the Quai Malaquais and the rue Bonaparte since 1816. For Youngerman and his foreign peers, "it was an unbelievable return to the past." Each time Jack took his place in the overcrowded room, with only a stove next to the model, he could not help looking around him. "I was amazed that they could preserve a sense of atmosphere down to every detail. The way the professor looked, his dress and all his mannerisms, were all very nineteenth-century. And the studio that I was in had been Toulouse-Lautrec's and van Gogh's. As though it had been yesterday." Youngerman and his colleagues would have to get used to living with such ever-present ghosts. Jack tried to mix with the French students, but at first relations were a little frosty. "They owned art while we were just full of dollars."[18]

Jack Youngerman and his fellow students were encouraged to go and observe art in the streets of Paris, so Jack often took Richard for long walks to study art history. This was perhaps their favorite activity, and they pursued it assiduously. Richard's hotel faced the studio of Balthus; the two friends passed it twice a day and sometimes they took a peek inside at

night, hoping to discover some secrets. Jack thought that soon, when he felt more assured, he would summon up the courage to go and knock at Balthus's door. There were other artists nearby whom he would have loved to meet as well: Picasso, Matisse, Brâncusi, and Jean Arp. His compatriot Ellsworth Kelly, a newcomer at the Beaux-Arts, nurtured the same hopes. Together, perhaps, when they both felt ready, they would go and meet the masters. Meanwhile, if they were not in class, drawing, or in the streets, looking up, they were in museums, sketching. Kelly, a twenty-five-year-old New Yorker who had taken part in the Normandy landings and had just graduated from the Boston Museum School with an arts degree, had promised himself he would return to the country where he had spent the most exhilarating year of his life. He had in fact gotten his first art training in the U.S. Army, where he served in a deception unit known as the ghost army. They were the camouflage artists and designer soldiers of the 603rd Engineers Camouflage Battalion, whose inflatable trucks and tanks, among other painted subterfuges, were used to mislead the Wehrmacht as to the position and direction of the Allied forces during D-Day operations.

He found a room just next to the Beaux-Arts school, at the Hôtel Saint Georges, 36 rue Bonaparte. From his room he could catch a glimpse of Sartre going in and out of his building. Like Youngerman, Kelly was not in Paris just to have a good time and then return home after his allowance came to an end. He very seriously intended to find himself as an artist there. Like Youngerman, he followed the advice of his antiquated yet wise art teachers and went every day to the Louvre. He also loved the Musée de Cluny, the National Museum of the Medieval Age, and the Asian art museums Guimet and Cernuschi. For six months Kelly and Youngerman went every day, sketching, copying, soaking up others' style like sponges. Kelly painted half-length portraits that combined the influence of Picasso and Byzantine art, while Youngerman was experimenting with Geometric Abstraction, Kandinsky on his mind.

"MORE STUBBORNLY BARBARIAN THAN EVER"

A slightly older Canadian-born American who had lost the enthusiasm of his student years was also on his way to Paris, and he was in a foul mood. Aboard the French liner *De Grasse*, Saul Bellow was seasick, "feeling that his sweetbreads had changed places with his brain."[19] But more

than anything else, he was furious. He had chosen to spend his Guggenheim Fellowship year in Paris, and he resented it already. He feared Parisians would mock his Canadian-accented French, to start with. Anita, his wife, was really the one behind their move to France. She had insisted, telling him it would be good for their four-year-old son, Gregory. He had commented to a friend that Paris would be "too exciting and disturbing." Bellow was intent on not falling into the trap of Paris romanticism. Was Paris still "the holy place of our time," as the art critic Harold Rosenberg was calling it? He doubted it. "Paris was not going to be my dwelling place, it was only a stopover. There was no dwelling place,"[20] he kept repeating to himself.

"I was not at all a Francophile, not at all the unfinished American prepared to submit myself to the great city in the hope that it would round me out or complete me."[21] He laughed at his friends from Chicago like Harold Kaplan and his wife, Celia. Kappy had become "a virtual Parisian—spoke impeccable French, wore French gloves and drove a French car."[22] For another infatuated friend, Julian Behrstock, Paris was "the answer to a dream nurtured from his boyhood in Chicago."[23] Ridiculous, thought Bellow.

Saul told Anita that they would not live on the Left Bank like their friends the Kaplans. He much preferred the idea of the clean, neat, comfortable, and bourgeois Right Bank, preferably near the Champs-Élysées. This seemed more appropriate for his young family, away from the grime of Saint-Germain-des-Prés. Anita had seldom seen him so spiteful. "When Bellow was intimidated, he went on the offensive."[24] Bellow was, rather naturally, fretting about following in the footsteps of such illustrious compatriots. Stubborn as he was, he just would not admit it. He would leave it to his future characters to be slightly more honest with their feelings: "But who would complain of this pert, pretty Paris when it revolved like a merry-go-round—the gold bridge-horses, the Greek Tuileries heroes and stone beauties, the overloaded Opéra, the racy show windows and dapper colors, the maypole obelisk, the all-colors ice-cream, the gaudy package of the world."[25]

The venom he freely displayed about his new home was, in a warped way, proof of admiration if not of love. It also betrayed his fear of not succeeding, of not finding his voice, for he, too, had come to Paris to find himself.

Bellow had set the stakes very high. He believed in himself and, even more than this, he believed that he had a special talent and destiny. He was not going to be another Fitzgerald or another Hemingway—no, he was going to be another Dostoyevsky. He expected the world to come to him in Paris, but for this to happen he knew that he needed to work very hard and was afraid, at times, that he might not be able to pull it off. Now thirty-three, he had written two novels, *Dangling Man* and *The Victim*, but sales had been poor—only twenty-five hundred copies of *The Victim*, and half as many of *Dangling Man*. This fellowship was providing him with crucial time off from academe during which he had to prove himself, once and for all. Failing this, it would be back to teaching at a university and writing, occasionally, a few short stories and reviews for journals and magazines.

Bellow's bad temper and animosity toward Paris and Parisian intellectuals also reflected his conviction that American literature needed to free itself from European influence, a European influence that, obviously and ironically, shaped him. He revered both Joyce and Flaubert, but for him a writer should not be invisible or indifferent, nor should he or she be a kind of god. On the contrary, a writer should enter the fray, be ready to improvise as in jazz or Action Painting, and his or her struggles should be on display. Movement, and not stasis, should be the American novelist's aim. "We must leave it to inspiration to redeem the concrete and the particular and to recover the value of flesh and bone."[26]

Bellow was satisfied to find Paris exactly as he had wanted it to be: "a sullen, grumbling, drizzling city." The weather was oppressive, the riverbanks smelly: "An unnatural medicinal smell emanated from the Seine." He loathed the fog that kept the city's smoke and fumes flowing in the streets in brown and gray currents while conceding that "Paris's gloom is a powerful astringent."[27] Even the comfortable furnished flat a friend found for him and Anita at 24 rue Marbeuf, in a typical Haussmannian building near the Champs-Élysées, did not please Saul. The flat was "fussy," crammed with antique furniture. In fact, it was just the kind of flat that Augie March—a character about to be born—would sublet on the Right Bank: a "moldy though fancied-up" flat. Saul had brought a new Remington portable typewriter in his luggage, but the French landlady (married to a British car racer) had demanded it as a gift. She had to have the rent in dollars too. It was steep.[28] Saul hated Chippendale and Empire-style furniture, and he could have set fire to the dreary dark, heavy curtains that adorned every

window, but he still put up with it. Anita wanted a full-time maid to look after Gregory and got one. Greg wanted a French poodle and got one. The little boy named it Malou. Saul was buying domestic peace, if not peace with himself, so that Anita could tell all her friends back home, "We live like kings."[29]

Just like his friend Lionel Abel, Saul Bellow resented—despised, even—what they both viewed as French promiscuity. What was the problem with living the life of a *bon bourgeois*? Why should a great writer live like a childish bohemian? Months after he had settled in, Saul was particularly infuriated by his chance encounter one morning with Arthur Koestler on the boulevard Saint-Germain. Bellow regarded the Hungarian writer highly. He had reviewed Koestler's *Arrival and Departure* for the *New York Times* in 1943 in glowing terms: "Arthur Koestler is one of the very few living novelists who attacks the most difficult and troubling issues of private and political morality and who, having raised serious questions, never tries to satisfy us with ready-made answers or evasions."[30] However, on seeing Bellow with his son, Greg, Koestler could not suppress his surprise: "Ah? You're married? You have a kid? And you've come to Paris?" Bellow deeply resented what he took as a reproach. Could one not hold traditional values, such as family and marriage, and still be modern, and a great writer? He intended to prove everybody, and Mr. Koestler in particular, wrong.

However, for all his denying it, Bellow was no better cut out for domesticity than his fellow writers, French or American. He seemed only more hypocritical. And more conceited. Once his family was settled in the rue Marbeuf, Saul looked for a room of his own, to work in every day. He would soon find his "room off to one side," as he described it to his publisher, Monroe Engel at Viking, right in the heart of filthy Saint-Germain-des-Prés at the Hôtel Académie at 32 rue des Saints-Pères. Precisely where he did not want his family to live. He could not have been closer to the many beautiful girls he wished he had more time to get to know, and the arrogant French intellectuals he claimed to scorn. He "liked to wander over to the basement bar of the Pont Royal and observe Sartre from a distance"[31]—but did not want anyone to know.

Bellow was a contrarian. While boasting to his friends, on a postcard of Notre Dame, that he had not been "at all Frenchified" yet and was feeling "more stubbornly barbarian than ever,"[32] he was on a quest for self-

definition. A Canadian Jew who had immigrated to Chicago, he was hoping to feel and be seen as American.

For the time being, though, he was struggling, terribly. He was working on "The Crab and the Butterfly," a moody philosophical story about two invalids in Chicago lying in adjacent hospital beds. Bellow felt the need to prove that he was not a provincial writer, that he was au fait with Western thought. But he was not getting anywhere with this story and he felt frustrated as hell. He labored over the story, rewrote at length, but he knew it was no good. Would it ever be? "I do not get out very often now and when I think of it resent this voluntary encapsulation and damn writing as an occupation."[33] Bellow, irritable and tense, would occasionally get up from his chair and pace up and down the room. He was "depressed and sunk in spirit." Like many people in Paris, living in badly heated flats and rooms, he suffered from *la grippe*, while "many more suffered from melancholy and bad temper." Bellow was quick to identify the culprit behind his problems: Paris itself. He later tried to explain his feelings: "Paris is the seat of a highly developed humanity, and one thus witnesses highly developed forms of suffering there. Witnesses, and sometimes, experiences. Sadness is a daily levy that civilization imposes in Paris. Gay Paris? Gay, my foot!"[34]

In November 1948, Bellow told Anita that he was off to Switzerland and Italy, alone, for a few weeks "for a change of luck." His struggle with a society from which he felt, and wanted to feel, excluded would eventually prove extremely stimulating. Putting distance between himself and his past, his origins, would soon give him clarity and freshness. Being an outsider enriched the great writer he was to become. He would soon find that Paris was, after all, "a great machine for stimulating the nerves and sharpening the senses"[35]—and a great place for discreetly conducting extramarital affairs.

$\mathcal{C}\!\!\sim$

STIMULATING THE NERVES

RIGHT BANK AMERICANS

In 1948, Theodore H. White was a household name in New York journalism, except every editor in town seemed to have forgotten about him. The reason was simple. To many of his colleagues, he was a Red. White considered himself a liberal, certainly, but had never been a Communist, and he was now stuck writing for obscure little publications that were, ironically, much more left-wing than he was. If he stayed in America, he would become a Communist, he joked to himself, not knowing Beauvoir had thought exactly the same a year earlier during her trip to New York. When a little-known news feature service, the Overseas News Agency, phoned him one afternoon to offer him a job as its Paris correspondent, with the task of covering the Marshall Plan and "how America was to save Europe from communism,"[1] he punched the air with joy. His young bride, Nancy, was also elated at the news. Speaking of himself, he wrote: "He had no idea what Europe meant. He would discover how Europeans tormented each other and continued to torment each other, all the while creating the values by which civilized men live."[2]

Theodore and Nancy opted for the nineteen-hour flight rather than the six-day sea passage. The thirty-three-year-old White found Paris unchanged from a brief visit ten years earlier: "The old lavender and pewter buildings rose in the familiar fin-de-siècle shades and shapes of gray, the mansard skyline of the Impressionists still unspiked and unspoiled by new skyscrapers."[3] The summer of 1948 was, in fact, a summer that would

last several years. "Frenchmen were beginning to feel French again, but with a returning pride that still embraced Americans."[4]

Like all his compatriots, Theodore discovered with amazement all the privileges bestowed upon American citizens, and foreign correspondents in particular: "the embossed press card of the accredited correspondent was a laissez-passer anywhere."[5] The French Ministry of Information made tickets to state concerts, festivals, municipal opera, and theater available at all times and instantly; cabinet offices were open to all American reporters, "down to the lowest crawling order of our species. We enjoyed semi-diplomatic privileges—such as participation in the American National Interests Commissary, where we could buy American luxuries which the still-strangled French economy could not provide, as if we were war correspondents at an army outpost in Bavaria."[6] An American reporter did not have to wait for a year for an automobile, as did most Frenchmen, who had to put their names on waiting lists; his passport and his dollars let him purchase one in a matter of days, fresh off the Citroën factory line in suburban Paris. The Whites could not believe their luck and, in the springtime of their marriage, young and feeling rich, they were "silly in the way they lived."[7]

Theodore was not only married, he was also a name. He did not have to attend Sorbonne lectures, he was not penniless, he liked comfort and could afford it. In other words, the Left Bank was not for him. He could only look for a flat to rent on the Right Bank, and as close to the Champs-Élysées as possible, an old American habit. He was not, could not ever become, a Left Bank kid. He found an apartment for $100 a month, at 24 rue du Boccador in the 8th arrondissement. When he learned that Guy de Maupassant had lived there in the early 1890s, he asked where to sign on the lease papers. He might have had a rental contract but he was paying his rent in cash and had found the flat on the black market. A draft of dollars issued in New York could be cashed for French francs that summer at the rate of 500 to one. Every American had his own money changer in Paris. White's was a "jolly old lady full of gossip and good will who became a friend of the family. She would bustle in with a large parcel of paper francs, slip us the penciled named of a Swiss bank account to which our New York check must be sent—and disappear."[8] The Whites kept the paper francs in a satchel under their bed, and into this satchel "Nancy and I dipped at will,

with no sense of budget or restraint."[9] They dined out every night, gorging on fine meals costing a thousand francs (two dollars at their rate); they even bought a second car, hired a servant, and looked for a nurse when Nancy found out she was pregnant. In other words, the Whites fitted "not only happily but shamelessly into this returning rhythm of life, knowing it to be ineffably bourgeois, inexpungeably Right Bank in quality, obnoxiously self-indulgent and sneered at by our unmarried friends who were artists and musicians of the Left Bank."[10]

THE UNITED NATIONS' FIRST GENERAL ASSEMBLY
AND THE LAUNCH OF THE MARSHALL PLAN

The United Nations had its first general assembly at the Palais de Chaillot, place du Trocadéro, in October 1948, exactly where, eight years earlier, Hitler had paraded in front of photographers with the Eiffel Tower right behind him. At first sight, the historic meeting felt dull to the newly arrived Theodore H. White. The Americans were busy targeting the Dutch: "we were getting the Dutch out of the East Indies, as, in those days, we were busily urging white empires out of everywhere," recalled White, who soon left the hall to sit on the broad white stone steps that creep down from the Trocadéro to the banks of the Seine. On his right stood the Musée de l'Homme, on his left the Musée de la Marine. He could see on the horizon, slightly to the left, the golden dome of the Invalides, Napoleon's mausoleum. Everywhere he set his gaze, history was tempting him to walk into the past rather than write about the present. "To live and report out of Paris was like trying to do business in a museum. I found I could not hurry. Here were numberless pockets of memories in stone, anthems in gray, celebrating past stories I had known only in books. All these stories connected somehow but the buildings would not speak, and I had to string episode and panorama together, to make past connect to present."[11]

History was in fact a cornerstone of the Marshall Plan and the choice of Paris as its headquarters could not have been more appropriate. Through a very practical problem, the allocation of the first $5 billion granted by the U.S. Congress, the American administration was forcing Europeans to look at their continent as a whole, to envision Europe not just as a beautiful abstraction but as a concrete reality. The Marshall Plan administrators had set up the Organization for European Economic Co-operation (OEEC),

which was to supervise the way America's money was to be distributed. Each of the sixteen[12] European nations that were beneficiaries of the Marshall Plan had a vote in the OEEC. At first, when the sixteen met at the Château de la Muette, "a lovely old yellow and beige mansion with high scalloped windows, and floors that creaked properly"[13] in Paris's plush 16th arrondissement, their voices were simply "babble" to American ears. Theodore H. White listened to each member in disbelief. He thought he was back "in conversation with Charlemagne; the Duke of Alba; traditional fishing rights; the three sons of Louis I, the Pious."[14] For him, Europe carried too much history, split by too many boundaries.

The mechanism of the Marshall Plan needed to be put in place before the whole machine could be set in motion. One needed to be efficient and straightforward. As White explained:

> The Americans took a simple tack. Let the Europeans first diagram their own problems, deciding who could physically supply whom on the Continent with what they needed for each other, ignoring the payment difficulties in European currencies. Then, all should bring to the Americans, Dispensers of the Great Purse, what the net margin of their needs was in dollars and supplies from the outside world, which the Marshall Plan would cover.[15]

In other words, Americans would yield dollars only to the consensus of all claimants. Sensible and practical. And without actually imposing one, the Marshall Plan was, in effect, inconspicuously mapping out a future European Common Market. A common market that would go hand in hand with a united Europe, one that Sartre and the non-Communist Third Way proponents were ardently calling for, as a solution to counterbalance the world's two great powers. To think of a united Europe, both politically and commercially, was in 1948 an audacious thought but not one reserved to a minority of naive dreamers. A few months earlier, in June 1948, Janet Flanner had witnessed a vote in the National Assembly that had impressed her vividly.

> A mere handful of 130 upsurging intelligent Deputies of many parties have formally laid before the Parliament a resolution demanding "the immediate meeting of a European constituent assembly, having as its

mission the founding of the permanent institution of a Federated Europe." Whatever else happens in Parliament, now or tomorrow, this is the one vital political proposal of the moment, of the year, of the century.[16]

From his flat on the rue du Boccador to the *International Herald Tribune* building at 21 rue de Berri, on the other side of the Champs-Élysées, it was just a ten-minute walk. Every day Theodore H. White would greet his concierge, Germain, a Spanish Republican veteran, with a loud *Bonjour!*, walk past Saul Bellow's building on the rue Marbeuf, and go to the head-quarters for all American correspondents in Paris. He would start his day by reading the French and international press, an education in itself. "The Paris press of 1948 was so beautifully written, engraved with such incision of phrase, enameled with such subtlety of sarcasm and subjunctive, that I did not realize for months after my arrival that its literary talents were devoted chiefly to the embroidery of trivia."[17]

Every morning, White would also squint through his horn-rimmed glasses at news reports that looked to him highly partisan in tone and extremely light on facts. French editors, journalist heroes who had risked death in underground publications during the war, "still believed that fact could be subordinated to passion and polemic."[18] They felt "entitled to drive their own particular logic through the facts, fearlessly presenting their arrangement as the real truth."[19] French newspapers were also universally suspicious of the Marshall Plan. Depending on the political color of the publication, the plan was variously described as "a capitalist plot, a finance plot against French industry, a plot against French workers, a plot against Russia, a plot against French culture. But what the plan was, and what it was doing, was scarcely ever reported factually in the Paris press."[20] How-ever, the story of the Marshall Plan, once Theodore White had found his way to it, beyond the trivia, polemics, and untruths, would prove to be the most intellectually exciting thing he was to report on for the next decade.

A ROOM WITH A VIEW

By October 1948, Simone had found a room for rent and finally left the hotel life she had tired of. Considering the housing calamity that plagued Paris, a room was all she could afford, but it would do. She found a room

by word of mouth. It was a typical maid's room, about ten by fifteen feet, on the fifth floor of 11 rue de la Bûcherie, a little medieval street snaking along the Left Bank and facing the south flank of Notre Dame. She decided to paint the walls and ceiling red and have red curtains. Giacometti designed oxidized bronze lamps especially for her and she hung on the exposed beam some exotic and colorful objects she had brought back from her travels in Portugal, Tunisia, Mexico, Guatemala, and Scandinavia. Fernand Léger had given her a watercolor, and she had bought a print from Picasso, which was handy, as she otherwise lacked pictures to decorate the walls. One of her windows looked out on the rue de l'Hôtel Colbert; "I can see the River Seine, some ivy, trees and Notre Dame."[21] Many friends would have killed for such a view. The other window gave onto a hotel for poor Arabs and Africans, who often fought at night. The hotel had a café opening out onto the sidewalk, Le Café des Amis, where fighting between immigrants went on during the day. To complete the picture, a few tramps, or *clochards* as the Parisians called them, who had their favorite spot right below Simone's window, enjoyed gulping down their liters of cheap red wine sitting on the pavement's three steps leading to the riverbank, the Quai Montebello. "They spent their days drinking, dancing, soliloquizing, and bickering."[22] On the roof's gutters, an army of cats kept Simone company at night, meowing away.

In a corner of her room was a tiny space with a sink, some kitchen utensils, and a tiny stove. The kitchen space also served as the bathroom. Simone was lucky: she had a fireplace, her only means of heating. She bought a couple of white armchairs, grapefruit juice and a bottle of gin, jam, bread, and tea. From her tiny, plain wooden table, which she used as a desk and placed in front of the window with the Notre Dame view, she wrote on the morning of Sunday, October 24, to her dear Nelson, her "cunning crocodile": "I begin to be in love with my room."[23] And the day after: "I stay at home, I light up the fire, I make tea, and work and work, and I like my little nest more and more. I have people home for lunch and dinner and I cook nice meals: chiefly, already cooked vegetables and cold ham. But I do not know very well how to manage the can-opener, I broke already two of them. I should need a nice house-keeper husband to open the cans for me."[24] Simone sometimes asked for help from the woman who lived next door, in another small maid's room. Her name was Nora Stern. Her mother, Betty Stern, whom Simone often invited for tea, was a close friend of Marlene

Dietrich. In the 1920s, married to a fur and textile tycoon, Betty had held one of the most influential artistic and literary salons in Berlin and had fled to Paris when the Nazis rose to power, only to find she had to go into hiding during the Occupation.

Like Saul Bellow, Simone de Beauvoir was sensitive to the Paris weather, but instead of resenting it she embraced it. "It has been a strange weather in Paris all these last days, a thick grey fog from morning to night, and at night so deep it is dangerous to ride a cab. It is so thick that it comes inside houses—the library for instance is all foggy!"[25]

She was working hard finishing her study on womanhood. Her publisher, Gallimard, had decided to publish it in two volumes, with only four months between the two releases, the first in June 1949 and the second in November 1949. Le petit Bost had come up with the title: *Le deuxième sexe* (*The Second Sex*). She had chosen to dedicate it to him, the ex-lover turned brother. As she later explained, "I dedicated it to Jacques-Laurent Bost because he was the least macho of the men I had ever known."[26]

When advocating equality between men and women in matters of love and sex, Simone de Beauvoir was taking risks. She was taking even greater ones when exposing her views on abortion. She had dedicated a whole chapter on the subject of abortion in *Le deuxième sexe*; she wondered how it would be received, but she felt she had no choice after doctors she knew in Paris had been arrested and tried for criminal activities. In a letter to Nelson she had explained: "There are a lot of abortion scandals just now in France and I feel quite indignant about them. There is no kind of birth control here; it is forbidden. They just arrested a doctor I knew very well and to whom I sent a lot of worried girls. He helped them all, poor and wealthy ones."[27] *Les Temps modernes* had made its position on abortion clear through eloquent and searing reportages and testimonies, showing both the hypocrisy and inhumanity of criminalizing abortion.

Twenty-five beds in a long hospital ward painted green. For twelve days, I am Madame number 10. Out of the fifteen miscarriages, I will soon discover that a dozen have been "triggered." It only took Madame number 9's announcement that it was her fifth self-inflicted abortion for everyone else on the ward to start speaking up. Doctors and nurses

know about it all, of course, and so do not use anaesthetics. The operation is short, between seven and twelve minutes, but extremely painful. Society gets its revenge the way it can.[28]

Jean-Paul Sartre was constantly being asked to help pay for the abortions of his former students or impoverished friends' lovers and wives, not to mention his own mistresses. One of Boris Vian's brothers, a doctor, performed them for friends and friends of friends, risking arrest and prison.

BRINGING THE LEFT BANK TO NEW YORK
AND HOLLYWOOD

In the spring of 1948, Norman Mailer had experienced the greatest joyful shock of his life in France, one he would relish for the rest of his life. His first novel, *The Naked and the Dead*, had come out a few months earlier in the United States and the first reviews had been glowing. Driving back to Paris from Italy with his mother, Fanny, his wife, Bea, and his younger sister, Barbara, in a small Peugeot with too little horsepower for his taste, Norman had stopped at Nice's central post office to gather his *poste restante* mail. A huge pile of letters had been awaiting him. Back in the car, he had started happily tearing away *par avion* blue envelopes and brown packages and begun reading their content: there were his book's reviews. Dozens of them. From the *New York Times* to the *Daily Worker*, praise was flowing from page to page, and for the eleventh consecutive week his novel had been number one on the *New York Times* bestseller list (it would stay on the list for a total of sixty-two weeks). He was about to lose his anonymity and felt funny about it. "I knew I'd be a celebrity when I came back to America . . . I'd always seen myself as an observer . . . I was going to become an actor on the American stage."[29] He would always look back and cherish his last months in Paris as an observer.

When he packed his suitcase after the end of the academic year and bade farewell to Paris on July 21, Mailer took Paris's fiery appetite for the political with him. He had already made plans for Jean Malaquais, his coach, guru, translator, and mentor, to follow him to New York and then to Hollywood. For better and for worse, he was to take Paris's spirit back with him to the United States.

In New York, with Malaquais now a lecturer at the New School for Social Research, Mailer embraced politics with the passion of a Left Bank student. He had chosen sides and decided to work on the campaign of the Progressive Party's Henry Wallace in the forthcoming presidential election. Wallace, Roosevelt's former vice president, advocated universal health insurance and the end of racial segregation and did not mind being associated with the Communist Party. Mailer wrote speeches for Wallace, and his first journalism consisted of pieces for the party's newspaper, the *National Guardian*. In October 1948, he took Malaquais with him to Hollywood to woo the movie liberals. At a party at the home of Gene Kelly and his wife, Betsy Blair, Mailer improvised a passionate speech in front of Shelley Winters, Edward G. Robinson, Farley Granger, and Montgomery Clift, but when Mailer quoted Malaquais and mentioned raising money to help the blacklisted Hollywood Ten, Edward G. Robinson shouted at him: "You little punk!"

Mailer continued campaigning tirelessly while being taught by Malaquais, who had drawn up a reading list for him. The two men lived next door to each other in Brooklyn—Malaquais was on Montague Street while the Mailers had a little flat at 49 Remsen Street. Mailer's friends did not like Malaquais at all. The playwright Lillian Hellman, who wanted to adapt Mailer's first novel for the stage, found him "cocksure, opinionated and dogmatic." In other words, they found him too French. But Mailer had been transformed once and for all by his Parisian experience.

Malaquais' reading list obliterated what remained of Mailer's belief in the Soviet Union as the foundation of a new world culture. The political tutorials Malaquais gave Mailer that summer convinced the young American novelist not only that Stalin was a monster but also that both the Soviet and American economic systems were implicitly geared for war. And to complete his education, Mailer read Marx's *Capital*. As he later recalled: "I spent a year living more closely in the history of Russia from 1917 to 1937 than in the events of my own life."[30]

GARRY DAVIS, FIRST CITIZEN OF THE WORLD

Meanwhile, a "carrot-topped, pleasant, shrewd and slightly corny Air Force veteran"[31] named Garry Davis entered the Parisian arena and made world news. He was the son of Meyer Davis, the bandleader who played

for American presidents and high society. The twenty-seven-year-old idealist Garry was a roommate of Art Buchwald's at the Hôtel des États-Unis. He thought the solution to the Cold War and a looming third world war was to create a world government, in order to dilute nationalism once and for all. The UN needed to have its power extended. To preserve the peace was not a good and broad enough mandate; the UN needed to be able to impose peace. "To dramatize this," Art Buchwald later wrote, "he decided to become the first World Citizen by giving up his American passport in front of the Palais de Chaillot where the UN was meeting." In 1948 an American passport was the most cherished document on earth. "Anyone who would give one up was regarded as crazy."[32]

The plans for the passport surrender were formulated in the bar of the Hôtel des États-Unis between Davis, Buchwald, and all their roommates.

> We weighed the pros and cons of Garry's act. If he did it, we warned him, Garry would be arrested by the French for not having proof he existed. He said that was exactly what he had in mind. He wanted to prove how ridiculous any sort of identification papers really were. Since there wasn't much going on that day, we encouraged him to do it. The next morning he went to Palais de Chaillot and tore it into pieces. The police arrested him for not having proper identification. A star was born.[33]

Davis then decided to camp opposite the UN headquarters at the Trocadéro. Everyone from Albert Camus to Parisian teenagers embraced Davis's cause with the passion of the newly converted, transfixed by this young American's *coup de génie*. On November 18, 1948, Pierre Bergé, Yves Saint Laurent's future life and business partner, was celebrating his eighteenth birthday. He had managed to obtain entrance to the UN afternoon session for three dozen friends of Garry Davis. UN sessions were open to the public, and seats in the balcony of the Palais de Chaillot were allocated to whoever made a request. Everything had been carefully plotted. When the Soviet Union's high representative took to the podium to speak, Garry Davis got up and spoke loudly of the urgent need for a world government, "one government for one world," while his young comrades threw leaflets on the UN delegates seated below. The military police arrived and the youngsters decamped, but three of Garry Davis's acolytes did not run fast enough and were arrested: the war reporter and former *résistant* Jean-François

Armorin, Pierre Bergé, and Albert Camus. A night at the police station did not dent their energy, though—far from it. A few days later Camus, accompanied by André Breton, who delighted in the Surrealism of Davis's concept, improvised a press conference in a café at the Trocadéro. They and myriad other intellectuals supported Davis and announced a public meeting at the Vélodrome d'Hiver, a covered cycling track standing in the shadow of the Eiffel Tower. On November 22, twenty thousand people flocked to the velodrome to hear Garry Davis, Albert Camus, and Richard Wright speak. The world media reported their every word in print and on the airwaves. There was no escaping this new Parisian utopia.

It was late on the evening of November 28 when a shocked-looking Art Buchwald walked toward Garry, a cablegram in his hand. It was from Albert Einstein and it was for "Monsieur Davis." This was the longest cablegram the two young men had ever seen. They both asked for a double shot of vodka before opening it. It said, among other things:

> I am eager to express to the young war veteran Davis my recognition of the sacrifice he has made for the well-being of humanity, in voluntarily giving up his citizenship-rights. He has made out of himself a "displaced person" in order to fight for the natural rights of those who are the mute evidence of the low moral level of our time. The worst kind of slavery which burdens the people of our time is the militarization of the people, but this militarization results from the fear of new mass-destruction in threatening world war. The well-intentioned effort to master this situation by the creation of the United Nations had shown itself to be regrettably insufficient. A supra-national institution must have enough powers and independence if it shall be able to solve the problems of international security. Neither can one nor has one the right to leave the taking of such a decisive step entirely to the initiative of the governments.[34]

A few days later, praising Davis's scheme, Eleanor Roosevelt wrote in her famous newspaper column "My Day": "How very much better it would be if Mr. Davis would set up his own governmental organization and start then and there a worldwide international government."[35]

Art Buchwald felt both slightly responsible and concerned for his idealist compatriot. Letters from the whole world started pouring in, and

soon Davis was renting ten rooms in the hotel to accommodate his staff, all volunteers. Art, himself struggling to get by in Paris, was looking at the whole affair with unavoidable sarcasm: "Clad in his leather bomber jacket, Garry became a hero and instant celebrity. For fifteen minutes, people were transfixed by the idea of World citizenship. We were the beneficiaries of Garry's noble deed. The Hôtel des États-Unis was suddenly besieged by foreign correspondents and newsreel cameramen. I volunteered assessments on Garry to anyone who offered to buy me a drink."

Until sarcasm turned into anger. Just before Christmas, Art and all the other residents of the hotel found a note in their mailboxes. "It was a terse letter from the management, announcing that Garry planned to take over all the rooms in the hotel for the administration of his World Citizenship movement." Art knocked at everyone's door, and an informal emergency council was held at the bar: "we all agreed that it was a bunch of pork sausage, and we announced we were not going to leave for some crazy peace movement."[36] Art and his beleaguered friends told the Poles in charge of the hotel management that they would not move. The face-off lasted until it became clear that Davis could not come up with the rent. Art kept his small room and the world lost its government, for now. Garry Davis would fight on.[37]

ANGER, SPITE, AND FAILURE

EVERYBODY'S PROTEST NOVEL

Young, angry North American men with accounts to settle kept washing up on Paris's shores. After his friend Eugene had left America by jumping into the Hudson River,[1] twenty-four-year-old James Baldwin chose Paris instead of death. Had he stayed in New York, he, too, would have gone under: "I had to get out. I knew what it meant to be white and I knew what it meant to be a nigger, and I knew what was going to happen to me. I was going to go to jail, I was going to kill somebody or be killed."[2] His one-way plane ticket to Paris was his safe-conduct to life. Baldwin might have had only forty dollars in the pocket of his jacket when he landed in Paris on November 11, 1948, but to his surprise he already had friends there. One of them, Asa Benveniste, a Parisian Sephardic Jew from Istanbul and a poet turned typographer and book designer, left lunch at Deux Magots with Richard Wright and Jean-Paul Sartre to greet Baldwin at the Gare des Invalides.

Benveniste took Baldwin straight back to the boulevard Saint-Germain to give him a first whiff of Parisian life, and to finish lunch. Richard Wright, an old acquaintance of Baldwin, had helped the young man get his first writing grant in 1945, $500, which had been "one of the most wonderful things that had ever happened to me,"[3] he commented at the time. It had kept him alive, it had launched his literary career, and it had saved him from despair. Always generous with fellow black writers in need, Wright was more than happy to keep helping Baldwin get published, this time in Paris. Sartre had already left the table when they arrived. George

Solomos was still there. Also known as Themistocles Hoetis, he was the Greek-American editor of *Zero*, a brand-new English-language literary review whose ambition was to publish simultaneously in Paris and New York. Themistocles, a B-17 radioman during the war, had hoped to interest Sartre and Wright in contributing to the first issue of his magazine. Wright had readily accepted but had added: "Why don't you also ask young Jimmy here to write a piece for you?" Little did Wright know that Jimmy's essay, published in *Zero*'s first issue in spring 1949, would end their friendship once and for all. Baldwin was about to bite the hand that fed and helped him. His first Parisian essay was an attack on Richard Wright and everything he represented. Sons had to kill fathers, and Paris was the place to commit literary patricide.

As a book reviewer in New York, a position he owed to Richard Wright's help, he had had to read all the books, or "tracts" as he called them, about black and Jewish issues. The color of his skin had made him an expert, it seemed, on the discriminated in the United States; this left him feeling extremely resentful. Why was he not asked to review books by Koestler or Sartre? "Most of the books I reviewed were Be Kind to Niggers, Be Kind to Jews, while America was going through one of its liberal convulsions."[4] He channeled these frustrations into the essay, which he titled "Everybody's Protest Novel." Berating the genre, he wrote, "Those sorts of books do nothing but bolster up an image. As long as I was a victim they could pity me and add a few more pennies to my home-relief check. That essay was the beginning of my finding a new vocabulary and another point of view."[5] It was also his way to shove Richard Wright off his pedestal as the founding figure of the protest novel.

Paris seemed an ideal place for bridge burners like Baldwin. He had read too much Balzac to think of Paris as the most courteous and peaceful city in the world. "Whenever I crossed Place de la Concorde, I heard the tumbrels arriving, and the roar of the mob, and where the obelisk now towers, I saw la guillotine."[6] Baldwin had no intention of acting in a civil way; he would operate his own literary guillotine. His obsession with and rage against Richard Wright sprung from his own "explosive relationship"[7] with himself and America. As he put it later: "At the time, most of all, I could not deal with *me*."[8]

Moreover, Baldwin was poor. His first forty dollars lasted just two days. After that, he lived off the generosity of friends and lovers. He was

not idle, though. The young man had so many pent-up emotions and so many things he needed to get off his chest that he wrote tirelessly what would become his first novel, not surprisingly a son and father story, *Go Tell It on the Mountain*. He immediately elected the upstairs floor of the Café de Flore as his writing hole, like Beauvoir before him. And he wrote, for himself and for others. He accepted every commission from any editor with a review, even from the American embassy's gazette *Rapports France-États-Unis*. This helped him to practice writing, eat, and pay the rent.

He found a room at 8 rue Verneuil, in a hotel owned by a Corsican family known for being very understanding with its lodgers and managed by the arthritic Madame Dumont. They not only tolerated the eccentricities of their young penniless bohemian tenants, but also accepted that they paid whenever they could. Jazz could be heard in the hotel's corridors around the clock. When Mme Dumont wanted to sleep, she simply switched off the entire building's electricity.

As Richard Seaver, a fellow lodger at the Hôtel Verneuil, recalled, the place "reeked of cabbage and urine. The tenants living in the attic rooms had to climb five flights of rickety stairs, mostly in the dark because that great electricity-saving convention the French had devised, the minuterie—literally 'the minute-long light switch'—here lasted at most ten seconds before plunging the climber once again into Stygian darkness."[9] It was a typical Left Bank hotel, with small and dimly lit rooms and scuffed and peeling Art Nouveau flowered wallpaper. In one of the attic rooms, "a four poster bed occupied a goodly portion of the room, whose only other furnishings were a bulky armoire, and in front of the window, a small wooden table bare except for a vintage typewriter."[10] Typewriters were the only valuable items in Left Bank hotels and were particularly prized by burglars.

Like almost all his contemporaries on the Left Bank, James Baldwin lived a double life. There had always been two sides to him: "the high school writer and the boy preacher. How to reconcile the elegantly dressed and mannered expatriate with the uncompromising and brutal spokesman for the downtrodden of black America?"[11] He started being a regular guest at the homes of liberal, white, mostly Jewish middle-class Americans living in Paris such as the Kaplans and the Geists. The Kaplans and the Geists were generous matchmakers and extraordinary *passeurs* of talents; they enjoyed introducing their French friends, writers and artists, to their foreign counterparts. A year earlier, they had engineered the lifelong

friendship between Norman Mailer and Jean Malaquais, and they were now educating Baldwin in the same way, by introducing him to Albert Camus, Raymond Queneau, Sartre, and David Rousset. Stanley and Eileen Geist also fed the perpetually hungry young man and expanded his literary horizons. "Apart from Shakespeare and the Bible, Jimmy has read little else,"[12] confided Geist to Saul Bellow one evening. That was not exactly the case, but Geist suggested Jimmy read Henry James. Baldwin was amazed to find in Henry James a kindred spirit. Here was another homosexual American expatriate in Europe who wrote in order to remain sane.

In January 1949, Jimmy fell seriously ill. Madame Dumont nursed him for three months. The "great matriarch" used folk remedies. She had to climb up five flights of stairs every morning to make sure Jimmy was still alive. "I went through this period where I was very much alone, and wanted to be."[13] All he could do was lie in bed, reading Dostoyevsky and Henry James and writing his first angry piece for *Zero*.

"PARIS *IS* SAVAGE"

Saul Bellow was angry too, feeling as unsettled as ever. Every morning he walked to the Hôtel de l'Académie, 32 rue des Saints-Pères, where he wrote most days in the hotel's smallest room. He was careful always to scrutinize the terraces of the nearby cafés, the Flore, Le Rouquet, and Lipp in particular. He almost never stopped to greet people he knew; he far preferred to observe them, his piercing gaze hidden by the brim of his Borsalino hat. Bellow never missed an opportunity to report on what he had seen, though, in his letters to colleagues. His tone was almost always mocking, whether commenting on friends or foes.[14] Of his fellow Chicagoan Lionel Abel, who had arrived on the Left Bank on Christmas Eve 1948, he sneered: "You should see Abel in Paris!! C'est assez cocasse [It is rather funny]. Dress coat, monocle. Works the restaurants."[15] In fact, Bellow had passed Lipp the day before and through the window had seen Abel having lunch with Sartre and Beauvoir. Envy was probably what Bellow felt. He kept repeating that he found the Paris Existentialists dubious and felt contemptuous of, as he saw it, their naively pro-Communist and anti-American line; the truth, however, was that he would have liked to be part of their inner circle.

Jealousy, along with the fear of rejection and of failure, consumed Bellow. Instead of going out of his way to socialize with Parisian intellectuals, he preferred to engage within a reassuring Chicago crowd while bitching about them: the Kaplans; the Geists; Lionel Abel; William Phillips, the editor of *Partisan Review* in Paris on a Rockefeller grant; all the *Partisan Review* contributors flocking to Paris such as Mary McCarthy, James T. Farrell; or even the Chicago painter Jesse Reichek, with whom he played casino in the café Le Rouquet on the boulevard Saint-Germain. Saul was still furiously working on "The Crab and the Butterfly," not knowing what to think of it. "I don't know how good it is but it's a book, and it's my vocation to write books and I follow it with the restlessness of true egomania,"[16] he wrote to his friend Henry Volkening at the end of February 1949. Bellow thought that what he was writing was "dark and funny"; it was neither. In fact, his arrogance hid a profound malaise that he tried to forget, more often than not, in the arms of French women, his only contact, it seems, with the indigenous population. In fact, Harold Kaplan and Saul Bellow shared a beautiful young mistress named Nadine with an impeccable pedigree. The twenty-one-year-old blonde with long wavy hair and blue eyes was the latest offspring of a well-known family of senators, magistrates, and entrepreneurs, the Raoul-Duvals. Her older brother Claude was a war hero. He had joined de Gaulle in London as early as June 1940 and had carried out seventy-six missions as a pilot in the RAF. Nadine was the gentile dream. Saul had met her at one of the Kaplans' lavish soirées in their top-floor apartment on the boulevard Montparnasse. Among the fine furnishings, the piano, the hovering servants in white gloves, Nadine looked like a golden trophy that Saul did not mind sharing. To Nadine, Saul never mentioned his wife or his son. In his delirious denial he even suggested that they elope to Africa.[17]

Bellow was busy trying to cope with a culture that escaped him, and which fascinated and irritated him in equal measure. "Paris *is* savage,"[18] he wrote to his agent, David Bazelon, in January 1949. "Wonderfully beautiful but savage in an unexpected quarter; in its calculating heart." He also often felt contempt for his competitors, all the other American writers in Paris. Bellow had met James Baldwin at yet another party at Kaplan's and, on sensing his simmering talent perhaps, he had felt compelled to dismiss him in a letter to his agent. "One sees a lot of collapsed Americans here. There's Jimmy Baldwin who seems to be down and out and is sponging

mercilessly. He does not do a great deal. Whenever I pass the Flore or Deux Magots, he's in company, drinking beer."[19] James Baldwin was simply incubating. He would emerge, as the writer the world would soon discover, a few months later. "Throughout 1948 and 1949 I just tore up paper," later acknowledged James Baldwin. "Right around 1950 I remember feeling that I'd come through *something*, shed a dying skin and was naked again. I certainly felt more at ease with myself. And then I was able to write."[20]

Lionel Abel was a more congenial settler than his friend Bellow. As a translator, he had embraced both the French language and culture while a student in America, and had been able to observe close up the French exiles in New York during the war. His curiosity for his new home was not fraught with anger or scorn. He absorbed everything he saw and heard with benevolent neutrality and amusement. Everything surprised him, in fact: the layout of Paris, "the color and oddity of its shops and signs, its comfortably graying 19th century architecture, and the profound mixture of places for business and places to live in."[21] He found Paris as beautiful as it was strange. "It is a city that must have been designed for meeting others. Chance meetings had taken in Paris the power of design." In a small and battered black-leather notebook Abel had the addresses and telephone numbers of Sartre, Camus, the composer René Leibowitz, the painter Jean Hélion, and, of course, André Breton. Life would do the rest and introduce him to everybody else, he thought. And it did.

The philosopher Jean Wahl, "a sixty-year-old fairy with a twenty-five-years-younger wife,"[22] according to his former student Simone de Beauvoir, who did not like him much, introduced Lionel Abel to the intense-looking Romanian philosopher Lucien Goldmann. This Marxist theoretician knew a thing or two about capitalism: he owned a string of decrepit studio flats and rooms on the Left Bank that he rented out. Lionel chose "one room and a half" at 49 rue de la Montagne Sainte-Geneviève, in a medieval "old house with a winding staircase of crumbling stone."[23] To wake up every morning in the shadow of the Pantheon was a transcendental experience for Abel. Goldmann, although busy writing *Hidden God*, which Roland Barthes would later brand "the most fertile and finest critique" of Marxism, still had time to look after his tenants. Besides, he was a benevolent capitalist when it came to rents. He charged Abel only four dollars a month.

Lionel was a keen observer. Unlike his friend Saul Bellow, he did not study people in order to gossip about and ridicule them; he did so in order

to better understand them and assimilate into his new environment. He quickly understood that he had to stand for something. As Lucien Goldmann had told him, "In Paris, you can't just walk in a café, flash white teeth and say, 'I'm Lionel, the American.'" "In the small community of Saint-Germain-des-Prés, one lived in a kind of moral mirror in which one saw one's own actions and also the manner in which others responded to these actions."[24]

Lionel also understood very well that there were times for performing in front of that special crowd, and times for working. Without an iron discipline, the trompe l'oeil indolence of café life in Saint-Germain-des-Prés could easily distract innocent aspiring artists and writers and nip their careers in the bud. Some of the brightest stars of the Left Bank managed to see people at night *and* in the daytime, *and* to work. Sartre and Beauvoir had an unflinching discipline. They worked from nine in the morning until one in the afternoon, had lunch and saw people until five, then went back to their desks until nine at night, after which they would have dinner and often go out. They stuck to their routine, even on holidays. As for love, Sartre rigorously allocated different weekly slots to his cohort of mistresses. Lionel Abel decided on a schedule that was not too harsh on himself: he would work in the mornings and socialize in the afternoons and evenings.

DISILLUSIONED AND RESTLESS

On the evening of January 27, 1949, a chilly wind was blowing through the narrow, serpentine streets of the 5th arrondissement, but Simone braved the Siberian cold to celebrate with her friend Dick Wright, whose wife had just given birth to their second child, a daughter named Rachel. They went to have "couss-couss"[25] in their favorite Algerian joint on the rue Galande. She found her friend happy but "awfully tired."[26] "He does not seem to work much," she wrote to Nelson Algren the day after.

Richard Wright had hungrily embraced the role of public intellectual, but he had found it increasingly difficult also to exist as a writer the way he used to in New York. He kept postponing the date he would hand in his next manuscript to his American publisher, Harper and Brothers. So far, foreign editions of his books were selling well and royalties kept pouring in, but one day this would stop and he knew it. What he was trying to write in Paris was in fact his own Camusian *L'étranger*—he had even

chosen this very title, *The Outsider*, for it and written a hundred thousand words—but as he confided to a friend, the book "had frozen on him."[27] He felt deeply unsatisfied. He wished he had been freer, just like Beauvoir and Sartre. He was trying to find causes for his writing block, and domestic life was an easy culprit.

The same week, Beauvoir bumped into Boris Vian. He, too, had just had a second child with his wife, Michelle. A disaster. Neither of them was fit for parenthood. Luckily, grandparents had stepped in again, but tensions were palpable between Michelle and Boris. Boris was trying to forget his marital problems and mortality by spending his nights playing the horn in jazz clubs "for American tourists,"[28] as Beauvoir sarcastically pointed out. Michelle wanted Boris to be a "serious" writer, interested in politics and *engagé*, but Boris had no time for seriousness. He knew he was slowly dying. Why should he waste time being serious? He cared only for his own brand of poetical fiction, and for jazz. The rest was futile. In fact, Michelle wished Boris were more like Sartre, whom she found increasingly charming. She often bumped into him whenever she visited the office of *Les Temps modernes*, for which she occasionally worked, providing English translations.

Many people in Paris seemed exhausted and disillusioned. The city was smothered in snow, and Parisians felt numb with cold. At the end of February 1949, Sartre and Beauvoir had dinner with Camus, but a certain lassitude had overcome them all. As Simone confided to Nelson in a letter, "everybody was nice and friendly but we had nothing more to say to each other. Camus, though he is not for de Gaulle or the Communists, disagrees with us on almost every topic. He took the Garry Davis affair very seriously. He cannot stand failure."[29] Camus was depressed. Unlike Sartre, he found it increasingly difficult being the butt of personal and political attacks. He secretly admired Sartre for being so robust and stoical.

Helped and supported by the Gaullists, Claude Mauriac, François Mauriac's son, had launched a monthly review, *Liberté d'esprit*. In its first issue of February 1949, Roger Nimier, a twenty-three-year-old right-wing novelist who would soon marry Saul Bellow's lover Nadine Raoul-Duval, had attacked both Camus and Sartre with below-the-belt viciousness.[30] Nimier had written on the tensions on the international stage: "France is probably not going to go to war considering Sartre's shoulders and Camus' lungs." Hurt, Camus had wished he could just withdraw from sight. Even after finding a large and comfortable four-bedroom flat for his family at 29

rue Madame in the 6th arrondissement, a few yards from the gates of the Luxembourg Gardens, all he could dream of was to escape somewhere he could write and breathe unconstrained. He now received a hundred letters every week and his assistant at Gallimard, Suzanne Labiche, could not cope with it all. Would he attend the celebration of the eight hundredth anniversary of the City of Munich as a guest of honor? Could he sign a petition in favor of Henry Miller, accused of pornography? Could he meet Jean Renoir, interested in adapting *L'étranger* for the screen? Would he agree to go on a lecture tour of South America this summer?

Anything, as long as he could find himself alone, away from the Parisian tumult for a while, away from his depressive wife, away from duties, away from attacks from the Communists or the Gaullists. How he wished he could retreat far away, hidden, alone, in a hotel. "The place where I most enjoy living and working, and where I would not mind dying, is a hotel room," he wrote in the preface of his first collection of essays published in 1937, *L'envers et l'endroit (Betwixt and Between)*. "I have never been able to adapt to what is called home or domestic life (which is most of the time the exact opposite of the inner life); bourgeois happiness bores and scares me." Against his doctor's advice, he told Miss Labiche to accept the invitation to South America and committed to a two-month lecture tour there. He reassured his wife Francine by promising that he would join the family on his return and go straight to Cabris, a village of three hundred inhabitants just north of Cannes where André Gide and Jean Marais often stayed. Albert and Francine both had fond memories of sunny, quiet Cabris, where they had once been happy.

Richard Wright was as restless and dissatisfied as Camus. Now that he had found the perfect café to start the day, a café that was neither too chic nor too modest and was only a few yards down his street, he thought he could put his house and head in order. Le Monaco was this perfect blend of localism and internationalism. Elderly locals played *belote* as the sun set, sipping their Pernod, just as Saul Bellow did at Le Rouquet a few streets away, while at the other end of the zinc bar stood black Americans, Swedes, British, Swiss, and Canadians animatedly speaking English in half a dozen accents. Le Monaco opened at seven, and until nine, when American students started pouring in on their way to the Sorbonne, only artisans, employees, and locals occupied the place. Richard Wright observed these

different crowds, of all races and social milieux, with attention, trying to find literary inspiration.

One morning, as he was making his way to Le Monaco, his concierge handed him a cable. He tore it open while walking. It was from John Fischer, his editor at Harper and Brothers in New York. Fischer was asking him to contribute an essay to a volume of autobiographical sketches by prominent ex-Communists. Arthur Koestler and André Gide had already accepted, the book would be tentatively, or rather wishfully, titled *The God That Failed*, and the release date was already planned for September 1949. The cunning thing, argued Fischer, is that Richard did not have to write his contribution. Why not use his 1944 *Atlantic Monthly* essay, "I Tried to Be a Communist"? *Good idea*, thought Wright. Although he had vowed never again to write for or against Communism, as he "felt that being anticommunist was as much a case of psychological slavery as being communist," the times sadly called for ever-clearer battle lines to be drawn. A few days later he told Sartre about the offer. Sartre jumped at the opportunity: *Les Temps modernes* would beat the Americans to it and publish Wright's essay in French in the July 1949 issue. Richard Wright distractedly consented. His mind was already far away. Something else had come up. He had received another cable, this time from Buenos Aires. He had not told Ellen yet.

Wright had confided in Beauvoir instead. "Have you ever heard of somebody named Pierre Chenal?" he asked her one afternoon as they bumped into each other on the boulevard Saint-Germain. Of course she had. Chenal had made a few French films in the 1930s with leading stars such as Louis Jouvet. She remembered that he liked plots with a social twist. "Doesn't he live in Argentina now?" Simone asked. Pierre Chenal, born Philippe Cohen in 1904, had fled Paris in 1940 and found refuge in Chile and then in Argentina, where he kept making films through the war. "He does and has written to me: he wants to adapt *Native Son* to the screen, and to start shooting in six months." Simone stared back at Richard. "Six months!" Chenal would use the theater adaptation Orson Welles had made in 1941. "And wait. There is more. He wants to recreate Chicago and South Side black homes in a studio in Buenos Aires. And he wants me to star in it." Simone laughed: "But the protagonist, Bigger Thomas, is twenty and you are forty! You'll have to start losing weight. No more

couss-couss!" She suddenly stopped laughing: "Have you told Ellen?" "I have not. Chenal wants me to join him in Buenos Aires in August. I shall be gone at least nine months, perhaps more." Simone pursed her lips and said "I see."[31]

Richard Wright had providentially found an escape route. He would become a movie star. No more writer's block. He had dreamed of cinema for such a long time and now the opportunity was presenting itself on a plate. His marriage would perhaps never recover, but that was a risk he selfishly thought worth taking. Besides, he was tired of being attacked constantly, by the Communists and now by the same black writers he had helped, like James Baldwin. The younger guard were aiming at their idols, just as the young French Hussars,[32] as they would soon be known, were aiming at Camus and Sartre.

I CHOSE FREEDOM: COMMUNISM ON TRIAL

Sartre was obsessed with the Russian defector Victor Kravchenko. When he and Simone had lunch with Lionel Abel at Brasserie Lipp on the first day of the Kravchenko trial, on January 24, 1949, there was little else they discussed. Victor Kravchenko had been an official in the Soviet Purchasing Commission in Washington, D.C., when he defected in 1944. He went on to write *I Chose Freedom*, which was published in 1946 and in which he denounced and revealed many of the atrocities of Stalin's regime, among others the prison and labor camps. *I Chose Freedom* was an instant success both in the United States and in Europe, and especially in France. The powerful Communist *Lettres françaises* organized a riposte and attacked Kravchenko twice, accusing him of lying and of not having written the book.[33] Kravchenko filed a complaint in France for criminal libel. Branded "the trial of the century" by the press, this libel suit put the Soviet system in the dock for the first time. Moscow took it very seriously, as did Kravchenko's supporters. The night before the trial started, Kravchenko had appeared at a rally at the Société de Géographie, 184 boulevard Saint-Germain, almost opposite Brasserie Lipp. "A first night rather than the opening of a trial!"[34] snorted *Les Lettres françaises*. With movie cameras, photographers, and journalists from the whole world, the rally did indeed have the air of a film premiere. However, what was to follow across the next ten weeks would be fierce.

Victor Kravchenko did not elicit much sympathy even in non-Communist quarters such as *Les Temps modernes*, not even from Arthur Koestler, who was staying with Mamaine at the Hôtel Montalembert while they completed the purchase of their house near Fontainebleau. Koestler, just like Beauvoir and Sartre, followed the trial closely. They even attended some of the hearings. None of them trusted Kravchenko, but they could see how the French Communist Party behind *Les Lettres françaises* was being assisted by Moscow, which transported intellectuals and former colleagues by the planeload to testify against their former comrade.

Kravchenko's lawyers struck a decisive coup when they called to the witness box Margarete Buber-Neumann, a tall, strong forty-eight-year-old survivor of both the Soviet Union's Siberian gulag and the Ravensbrück concentration camp under the Nazis. She corroborated every point of Kravchenko's allegations. Buber impressed everyone she met. Beauvoir was fascinated by her dignity during her testimony, her lack of self-pity, and her clarity. Her presence was electrifying, her calm and perceptiveness extremely powerful. She exposed the totalitarian cruelty that had killed her husband and cost her seven years in concentration camps in a dispassionate and even-handed way. Koestler was so taken by her that he and Mamaine invited her to stay at their new home for a few days before she traveled back home to Sweden, where she had found refuge after the war.

The couple's house, Verte Rive, was full of boxes in rooms otherwise empty apart from two beds. They discovered several major snags that they had not been aware of, such as a leaking septic tank "emitting a pungent odour," but Greta paid no attention to such trivial details, and Koestler and Mamaine forgot about it all during her stay. In their living room, with its fireplace and view over the river, Mamaine had quickly laid out two Moroccan rugs and an Algerian carpet that she had bought the week before at the Arts Ménagers exhibition in Paris.[35] Seated in their two Chesterfield armchairs, Koestler and Mamaine listened to their guest for hours. "We had Greta Buber stay with us for two days, which was absolutely fascinating. She has a manic desire to talk about her seven years in the camps. She gets it off her chest by talking about it."[36] Before Greta traveled back to Stockholm, Koestler pressed her to keep bearing witness and to keep writing. She had just completed her memoirs *Under Two Dictators: Prisoner of Stalin and Hitler*,[37] the first of many books on her unique experience.

There was no longer any denying the facts and the existence of work

camps in Soviet Russia. On April 4, 1949, Kravchenko won; he could thank Greta Buber. The defector's victory gave Moscow one more reason to step up both pressure and propaganda.

"THE THIRD FARCE":
THE END OF SARTRE'S CAREER AS PARTY LEADER

By now Sartre had reached satanic star status, with the Vatican and the pope officially banning the reading of his books by Catholics. Attacked on all fronts, Sartre managed to withstand storm after storm. He was too big to fall. Blows were getting fiercer, though. Malraux, the Gaullist propagandist in chief, blackmailed Gallimard, demanding that it stop financing and publishing *Les Temps modernes*. Malraux was threatening to reveal certain things Gaston Gallimard had done during the Occupation, such as commissioning an elegiac essay on Hitler.[38] Gallimard reluctantly relented, but another publisher, René Julliard, stood up in his place: *Les Temps modernes* had only to cross the street, from the rue Sébastien Bottin to the rue de l'Université, to find a new home. The Catholics, the Gaullists, and the Communists kept attacking Sartre and the Existentialists, but to no avail. Meanwhile, tensions were simmering *within* the RDR: for how long could they still occupy the political middle ground? David Rousset was ever more ardently anti-Communist, while Sartre was passionately anti-Gaullist. Could they work together in the long run?

In March 1949, Sartre was busy convening his own party's congress, the organization of which he was personally financing. Despite a promising start, the party was not drawing crowds and new members. Rousset had just returned from a trip to the United States, pro-American as ever. He told Sartre that what was needed was to stir the RDR more firmly against the Communists; Sartre opposed that course. On April 30, during the party's congress, David Rousset asked the members to vote on the direction the RDR should take; his motion received a vote of no confidence. The party was broken up, the neutralist attempt had failed, and that was the end of the RDR. There was no Third Way—at least in practical politics.

After dinner with Beauvoir, Sartre returned home, not exactly defeated but more thoughtful than usual. He went to his study and switched on the light on his desk. He took out his brown *carnet* and wrote: "The RDR has imploded. Tough. New and definite lessons in Realism. One doesn't give

birth to a movement. Circumstances only appeared to favour its creation. It did correspond to an abstract necessity, defined by an objective situation; however, it didn't answer an actual and real need in people. This is the reason why, in the end, they didn't support it."[39]

Sartre slept well that night, and in the morning, when his secretary Jean Cau knocked at his door at ten o'clock, he asked to see the schedule for his next trip, this time to Mexico. He was leaving in a few days, a good way to turn the page on the RDR. As he later put it, "we assassinated the RDR and I left for Mexico, disappointed but serene."[40] Sartre was putting a brave face on things. The end of the RDR was the end of a dream. Could Sartre hold the fort alone, and how long could he hold it? Everyone around him seemed to accept that they had to choose sides, the lesser of two evils, as they told him. For some it was Gaullism, for others it was Communism; for some America, for others the Soviet Union. His intelligence and thirst for freedom above all urged him to keep fighting. The end of the RDR may have left Sartre "serene," but it deeply transformed how he felt about politics, which he withdrew from as an active player. No more party membership. From now on, there would be only literature. Sartre was preparing a long portrait of the poet and thief Jean Genet, his protégé, whom he wanted the world to discover; he had also accepted to do a series of interviews with the young Vietnamese Marxist philosopher Tran Duc Thao. And there was *Les Temps modernes*, which he felt he had neglected for too long. From now on, his political action would exist purely through writing.

❧

VINDICATED

"LIVING LIKE THE SALAMANDER IN THE FLAMES"

With some reluctance, Saul Bellow accepted Anita's repeated request to move the family home to the Left Bank in the spring of 1949. Their lease on their flat on the rue Marbeuf was coming to an end, and Anita was very keen to transfer to the Existentialist watering hole; she also probably wanted to be able to monitor her philandering husband more closely. Bellow was not so happy to have his wife and son so close to his writing den and bachelor pad; he had enjoyed being a family man on the Right Bank and a single writer on the Left Bank. He complied, though, to buy domestic peace. He found a short rental at 24 rue de Verneuil, where the Geists now lived, just next to the Hôtel Verneuil. In the spring of 1949, this small street of refined bourgeois discretion and eighteenth- and nineteenth-century buildings was taking on a distinctly American air.

Saul was plowing on, as ever unsatisfied. He now lived only a few hundred yards from the Hôtel de l'Académie, a very short distance to walk from his new flat to his study. To break the monotony he alternated the routes, either through the rue de Beaune and rue Jacob, or turning right into the rue des Saints-Pères at the end of his street. With the regularity of a metronome, he passed the same people on their way to work in the morning, including the street sweepers, who carried brooms and special square wrenches that allowed them to open the sidewalks' water taps and let little streams gush out and wash away the dirt along the gutters. On sunny days, the water reflected the light brightly and offered a striking vision of shimmering silver running down the streets.

On the first bright day of spring 1949, the Paris street cleaning system gave Saul Bellow the breakthrough that would lead him directly to the Nobel Prize in Literature. This was a revelation of a transcendental nature, he wrote to his friend Julian Behrstock, a former journalist who had found a cozy job at UNESCO in Paris: "One day, I saw the water trickling down the street and sparkling as it trickled."[1] Or, as he would explain it to students decades later: "Every morning in Paris they would flush the streets with water and divert the current with strips of burlap. One morning I watched the current being diverted and thought, 'Why do I have to be tied down to this awful thing which is killing me?'"[2] Saul had in fact started writing a new book while trying to finish "The Crab and the Butterfly" and it "was bothering the life" out of him. He was on the verge of a mental breakdown.

"The free flowing rivulet triggered an epiphany."[3] Bellow had found what he had been searching for, the way to write his other book, the form he would make his own: exuberance, long sentences, the profusion of adjectives, the seemingly effortless cascade of prose in his distinctive American idiom. "In the water flowing down a Paris street he found a visual analogue for his style."[4]

The more he lived in Paris, the more he was obsessed with his hometown of Chicago, but as he himself put it: "I also discovered that in Chicago I had for many years been absorbed in thoughts of Paris." He had been a longtime reader of Balzac and of Zola, and he knew the city at which Rastignac had shaken his fist, swearing to fight it to the finish, the Paris of Zola's drunkards and prostitutes, of Baudelaire's beggars, and the children of the poor whose pets were sewer rats. The Parisian pages of Rilke's *Malte Laurids Brigge* had taken hold of his imagination in the 1930s, as had the Paris of Proust. As he said, the place had moved in on him.

The two cities were telescoping in his mind and perhaps the sparkling, trickling water in the Paris gutter led him quite naturally and organically from one to the other and allowed him to bridge a gap. Paris in 1949, with its cold statues and its streams of water running along the cobbled stones, had transported him to Chicago before the Depression and to the novel that would become *The Adventures of Augie March*. From that morning on, the words just flowed from him onto the paper, untamed and unabashed. Across the street from his hotel room pneumatic drills were at work on the concrete of a hospital whose construction had been abandoned at the

outbreak of the war. The noise did not disturb his thoughts, though. He lived in it "like the salamander in the flames."[5] *Augie March* was spilling out of him.

On April 10, 1949, he wrote to his agent, David Bazelon, "This is the best thing I have ever written."[6] For once he had nothing to complain about.

FRENCH STYLE: STYLE AS SUBSTANCE, STYLE IN ACTION

In his "room and a half" in the shadow of the Pantheon, Lionel Abel was spending most mornings devouring Sartre's *La mort dans l'âme* (*Iron in the Soul*), the third installment of his *Roads to Freedom* trilogy,[7] which was being serialized in *Les Temps modernes*. In it, Sartre "grieved, like an author and a man, for the loss of someone he loved, with all her faults; he grieved for France after her rapid fall in 1940."[8]Abel was not the only one hooked on it; Janet Flanner, too, was mesmerized.

They both found his style unlike any other; "hypnotic" was probably the best word to describe its effect on readers. Whether in his essays, his literary biographies like the one he was writing about Jean Genet, or his novels, Sartre never let his words rest. Reading Sartre often felt like watching a breathless chase or a daring high-wire act. For Abel, the "piling up of tautologies in an ecstasy of analysis" was at the basis of "Sartre's prolixity." It had many effects. "When we have been told the same idea some 25 times in 25 different ways, we are clearer, first of all of its meaning, and in addition we feel the intense interest in it of the writer. The reader feels his emotion. So we can say he has invented a rhetorical and literary use for a philosophical habit of mind."[9]

What Lionel Abel was grappling with was style as substance and style in action. It had always been easy to dismiss French style as a case of artifice and shallowness over gist, but what Abel and many young foreign artists and writers in Paris discovered was style as life: a way of living, a way of writing, a way of looking at things, and a cultural curiosity and appetite that was not academic. They also found in Paris a style of argument and a characteristic taste for formal play. French style was not so much a matter of pleasure, but something more enduring, as the U.S. Army pilot turned novelist James Salter discovered during his first trip to Paris a few months later: "a ranking of things, how to value them."[10] What Paris provided was

an education, "not the lessons of school but a view of existence: how to have leisure, love, food, and conversation, how to look at nakedness, architecture, streets, all new and seeking to be thought of in a different way."[11]

Beaux-Arts American students Jack Youngerman and Ellsworth Kelly had scrupulously followed their teacher's advice when they had enrolled a year earlier: to spend their free time haunting the Louvre and other Paris museums to copy the masters tirelessly, to imbibe every detail until they could do it with their eyes closed.

They had accepted that France was a land where tradition is perhaps the greatest single factor of existence, reinforced by constant individual invention. The Beaux-Arts school was "extremely demanding, and academic to a high degree, the theory being that those who have originality, and an overwhelming impulse to express it, would be able to bring that originality to fruition, not by dashing off at a tangent in their immaturity, but by passing first through a severe discipline, which they were at liberty to modify or abandon, once they were trained in all its intricacies."[12]

After months of digesting old and less old masters, from Byzantine art to Kandinsky and Picasso, they both set off to discover their own style with their new Parisian eyes. Paris had taught Ellsworth Kelly exactly what it would soon teach the budding writer James Salter: how to look at things and at people. In May 1949, Ellsworth quit figurative art and crossed the Rubicon toward abstraction. Observing how light dispersed on the surface of water, he painted *Seine*, made of black and white rectangles. Paris's architecture slowly became the young artist's basis for inspiration. His own epiphany took place not looking down at a Paris gutter like Saul Bellow, but looking up at the windows of the Museum of Modern Art in the 16th arrondissement, near the Trocadéro. "Instead of painting an interpretation of an object, real or invented, I found an object which I represented as it was. My first such object was my first real work of art, 'Window, Museum of Modern Art, Paris.'"[13] He made it with two canvases and a wooden frame. His works of art would from now on be objects, with no signature, no name.

He still had not mustered the courage to go and meet the artists he most cherished, Jean Arp, Picasso, and Brâncusi, whose studios were open to everyone, but he had learned from them invaluable precepts: the potential of chance as an ingredient in art, and of collage as a way of building an image. Ellsworth, going about Paris aimlessly, nose in the air, collected

ideas in the form of sketches. He found inspiration in the underside of a bridge, a walled courtyard, the arch of a door, a building's reflection in the water, street patterns seen from Notre Dame, stonework on the church of Saint Germain l'Auxerrois facing the Louvre, rows of chimneys on the sides of buildings, posters in the métro, and the grilles of pavements. Just like Saul Bellow, Ellsworth was uninterested in the romantic notion of Paris. For him, poetry came from Paris's gritty urban details.

Very few people saw Ellsworth Kelly's work in 1949, except for his new friends Merce Cunningham and John Cage, who stayed in the same hotel, the Hôtel de Bourgogne on the Île Saint-Louis. The American dancer and composer, both in their early thirties, introduced the shy young painter to Pierre Boulez, barely twenty-four and already the composer of a well-received sonata. All of them had an interest in chance, or "controlled chance," as Boulez would put it, in their respective art. For Kelly, it was only the beginning of his six-year Parisian apprenticeship, but he was making great leaps toward his style. He was only eighteen months away from his first solo exhibition in Paris at the Galerie Arnaud Lefebvre,[14] where Georges Braque stopped in his tracks in front of his *The Meschers* and paused for a long moment. Braque would later confide to the wife of the art gallerist Aimé Maeght that Ellsworth's *Meschers* had given him a valuable idea for his *Atelier IX*, one of the great paintings of the postwar era.

FINDING GODOT

The young Ellsworth Kelly was also seeing a lot of his friends Jack Youngerman and the literature student Richard Seaver. Seaver had decided to take a break from the Sorbonne and learn life in the streets of Paris. He had not given up on his doctorate on James Joyce and Benjamin Constant, he just wanted to experiment and enlarge his knowledge of French culture in Paris's open playground.

Seaver had left the Hôtel de l'Ancienne Comédie for the Hôtel des Marronniers, a few streets away, closer to the Seine, at 21 rue Jacob. He had found a maid's room on the seventh floor for ten dollars a month. "The only inconvenience was that the ancient red-tiled floor was roughly 20 degrees off the horizontal."[15] Bricks liberated from a nearby construction site propped up both bed and table. "As for the wooden chair that was meant to go with the table, I had solved that minor problem by sawing two

inches off the front legs."[16] Richard Seaver needed to complement his sti-
pend from the army to make ends meet. Like most of the literature stu-
dents on the Left Bank, he tried to place a newspaper article here, a book
review there, teaching English at Berlitz to make ends meet.

Seaver was paid in francs and therefore lived like a true Parisian. He
was poor, but then everybody was poor on the Left Bank. "There was, we
knew, a whole other world across the river, the world of diplomats and
business men, of journalists and politicians, who lived high on the hog and
experienced a whole other Paris than ours." Seaver did not envy them,
though. He wanted to become French, as did his friend Jack Youngerman,
who had fallen in love with a former pupil of Richard's. At just seventeen
she was an "aspiring young dark-haired fine-featured Garbo look-alike
budding actress, as bright as she was young." She was Delphine Seyrig, a
future French star known as much for her beauty as for her talent, her
raspy voice, and her choice of original and challenging films and plays.
A drama student and a close friend of the actor and director Roger Blin,
Delphine Seyrig spoke perfect English. Her father, a leading archaeologist,
had gone to New York as the cultural attaché of the Free French govern-
ment during the war, along with Claude Lévi-Strauss, and she had spent
her formative years, between the ages of eight and thirteen, at school in
New York.[17] She did not know it yet, but a few months later she would
play a key role in introducing Samuel Beckett's *Waiting for Godot* to Rich-
ard Seaver,[18] who in turn played a part in introducing Beckett's works to
the whole Anglophone world, leading to Beckett's belated triumph and
Nobel Prize.

Samuel Beckett had just turned forty-three. Suzanne Déchevaux-
Dumesnil had greatly enjoyed reading Sam's latest play, *Waiting for Godot*,
which he had finished writing at the end of January 1949, and she was
resolved to interest the theater director Roger Blin in producing it for the
stage, or at the very least for the radio. Roger Blin, a former pupil of Antonin
Artaud, was an actor-director and manager of the Gaîté Theatre. One
afternoon, Suzanne went to the theater to leave the manuscripts of *Wait-
ing for Godot* and *Eleutheria* with Blin. The good news was that Blin
wanted to produce *Godot*, the bad news that he was to lose the Gaîté
Theatre. His three productions there had been critical successes but com-
mercial failures. Still, Blin wanted to meet with the author. Lunch at the
rue des Favorites was arranged. "The two men bonded. Blin's love for

Synge and Irish whiskey helped."[19] *Godot* would first be a radio play, but it would take some time.[20]

Sam and Suzanne were making ends meet, but they both felt exhausted. Their small flat on the rue des Favorites was becoming too noisy. The neighbors had acquired a brand-new radio, and Samuel was distracted by the now constant noise whenever he tried to write. Sam also had in mind a series of thirteen short pieces, which he thought of naming *Textes pour rien* (*Texts for Nothing*). And to write those "texts for nothing," Sam needed a change of scenery. They heard that many decrepit farmhouses near Paris could be rented for very little. One afternoon they took the train from the Gare de l'Est to Ussy-sur-Marne, a village of five hundred inhabitants and one of the battlefields of the Great War. They wandered in the village and the nearby fields and set their sights on a run-down farm. They agreed with the owners to rent just one room on an annual lease for £6 a year. It was almost barren save for a bed, a table, a stove, and a chair, but it had a view over fruit trees and lilac bushes that were just in blossom. Frugality was their way to deal with the absurdity of life.

Six months later, his mother's death, and his consequent inheritance, would make life more comfortable for Beckett, as would Suzanne's encounter with the new head of Les Éditions de Minuit, Jérôme Lindon. Suzanne gave him *Molloy* to read: "I read it in a few hours, as I had never read a book before."[21] Lindon cabled Suzanne to say that he wanted to publish everything Beckett had ever written. This was the breakthrough Suzanne had worked so hard to achieve for her partner. With Roger Blin as his theater manager, Jérôme Lindon as his publisher, and Richard Seaver as his devout fan and promoter in English-language magazines, Samuel Beckett had at last been "discovered" and would soon be celebrated in the whole world.

THE MARSHALL PLAN'S FIRST BIRTHDAY

On the evening of April 15, 1949, Simone de Beauvoir, just back from Cagnes, where she had proofread the second volume of *Le deuxième sexe*, had absentmindedly switched on the radio on her little desk in the rue de la Bûcherie. She was writing to Nelson Algren and counting the days, less than four weeks now, until his plane would land at Orly on May 11.

Simone suddenly stopped writing—the speaker on the radio had

caught her attention with a birthday tribute to the one-year-old Marshall Plan: "A great lifting of the heart goes from us toward the generous American people and toward their leaders," said the speaker. There was no denying the positive impact of the Marshall Plan on everybody's lives in France. Nelson had inquired whether soap was still so difficult to find in Paris. She had replied that with the Marshall Plan, Parisians had everything, even American fruit juices.[22] France had turned the corner at last. The black market was expected to be officially declared extinct when milk, butter, cheese, oil, and chocolate would be available without ration tickets. This was probably only a matter of weeks away.

Although its effects were felt everywhere in France, the Marshall Plan had its home on Paris's Right Bank. Its headquarters had filled every room of the former mansion of Talleyrand, one of the most influential diplomats in European history. This mansion, also known as the Hôtel de Saint-Florentin, with an oak-paneled salon that had come from Madame du Barry's own Pavillon de Musique, was the property of the Rothschild family. They were grateful for the cash from the U.S. administration, especially after having lost a significant part of their art collection in the war, stolen by the Nazis. The magnificent neoclassical Hôtel de Saint-Florentin stood proudly at the corner of the rue de Rivoli and rue Saint-Florentin, practically on the place de la Concorde, one of the most regal squares of Paris, and one of its most dramatic, too.

Foreign journalists reporting on the Marshall Plan, like Theodore H. White, now had an aperitif routine: they met at the Crillon hotel, on the place de la Concorde. Their British counterparts had established this daily rendezvous of drink and gossip at dusk, in an attempt to decipher the day's story. Theodore could not help mocking his British colleagues. The wartime spirit was cracking even between close allies. He divided the Brits into three groups: scholars, pomposities, and jollies.

> Scholars lived on Île Saint Louis or the Left bank and wrote with enormous erudition seemingly with a goose quill pen. The pomposities were unaware that the Empire had perished. The jollies were workaday reporters who could invent, inflate or embroider any scrap of fact or gossip into overnight excitement beyond the talent of any American. The scholars sought history, the pomposities sought nothing and the jollies sought circulation for their masters on Fleet Street.[23]

Theodore H. White strolled every day from his flat on the rue du Bocca-
dor to his office at the *Herald Tribune* building on the rue de Berri and to
the Marshall Plan headquarters, by way of the Crillon bar and back. This
meant going up and down the Champs-Élysées many times a day. It was
during those walks that Theodore H. White, the future chronicler of
American presidential elections and presidencies, tried to define the very
essence of the Marshall Plan.

He had to start with the idea of money. "In western culture, money con-
ceals the idea of command." What was novel about the Marshall Plan was
that "the command quality of money, used on such a scale between nations,
was being used for the first time not to kill but to heal."[24] For White the
situation read like this: Europeans could neither command nor pay for what
they needed to live decently. Worse, they had no wheat for bread, no cotton
for clothing, no petroleum to fuel cars. "People were hungry; some starved;
others stole; most hoarded; everyone cheated." The U.S. Congress had
agreed to help Europe one more time to save it from both starvation and
Communism. On an economic level, the plan had worked without a glitch:
by June 1949, "the tough mechanical, distribution and payments problems
within Europe had been solved."[25]

THE HAPPIEST SPRING OF OUR LIVES

On May 11, 1949, Simone de Beauvoir woke elated. This was the day. She
chose to wear the white coat she had bought two years earlier in Chicago
and hopped on the bus to the Gare Saint-Lazare to welcome the man she
loved. Nelson had no difficulty spotting her. The train station was so filthy,
covered with century-old grime and soot, that in her white coat Simone
shone like the sun at the end of a dark tunnel. They embraced in silence for
what felt like an eternity but must have been less than half a minute, then
started talking. They could not stop. Simone had prepared a busy program
of festivities for him, there were so many friends she wanted to introduce
him to, all the people she wrote about in her letters—he felt he knew them
intimately already. They kept talking over each other and laughed each
time they did. In his trunks were chocolate for her mother, whiskey for
Sartre, a flowered dressing gown for Simone. And many books and pic-
tures he had had developed from their previous holiday together.

Algren had managed to finish his latest novel, *The Man with the*

Golden Arm, just before setting off for a four-month holiday with his "French wife," and he had landed in Paris at the beginning of the first Paris International Jazz Festival, which played every night to adoring jazz fans. Among the American musicians performing at the Salle Pleyel was a twenty-two-year-old black trumpeter named Miles Davis. It was his first trip abroad, and he was to perform alongside jazz luminaries including Charlie Parker, Dizzy Gillespie, Sidney Bechet, and Claude Luter. One evening that May, Miles Davis crossed paths with the merry clique from Saint-Germain-des-Prés. He had never felt like this before, and never would again. "Paris changed the way I looked at things forever. I loved being in Paris and loved the way I was treated. Paris was where I understood that all white people were not the same; that some were not prejudiced."[26] Boris Vian introduced Miles to his Parisian friends, who treated him like the gifted musician he was. As for Juliette Gréco, she looked at him like a girl in love. She had watched his first concert from the wings with Boris and Michelle Vian, as she could not afford a seat, and had felt deeply moved by Miles's talent and beauty. She fell for his silhouette: "I saw him in profile for a whole evening. A real Giacometti."[27] Human relations suddenly felt so simple. Miles fell for Juliette and for her friends. After a few days he had almost forgotten about his sweetheart Irene back in New York, their five-year-old daughter, Cheryl, and three-year-old son, Gregory. Miles and Juliette spent their evenings walking in the streets of Paris, hand in hand, going from one jazz club to another, café to bistro, friend to friend, without anyone staring at them. Juliette did not speak English, Miles did not speak French. "I have not a clue how we managed. The miracle of love,"[28] explained Juliette years later. For Miles, such life and such freedom were intoxicating. "Juliette was the first woman that I loved as an equal human being."[29]

Boris Vian introduced Miles to Juliette and also to Simone, Nelson, Jean-Paul, and Pablo, who was back from Antibes for a few days. One evening, as they were all having dinner late in a bistro on the boulevard Saint-Germain, Sartre said to Miles: "Why don't you and Juliette get married?" Miles replied matter-of-factly, "Because I love her too much to make her unhappy."[30] At first, Juliette did not understand what he meant. Could it be that he was a womanizer and would not want to leave the mother of his two small children for her? No, it was simply a question of color. "If he'd taken me back to America with him, I would have been called names,"[31] Juliette

realized years later. In the 1950s, at the Waldorf in New York, where she was a guest, Gréco invited Miles to dinner. "The face of the maître d'hôtel when Miles came in was indescribable. After two hours, the food was more or less thrown in our faces."[32] At four in the morning, Juliette got a call from Miles, in tears: "I do not ever want to see you again here, in a country where this kind of relationship is impossible."[33] Gréco suddenly understood that she had made a terrible mistake. "I'll never forget this strange feeling of humiliation. In America, his colour was made blatantly obvious to me, whereas in Paris I had never noticed it."[34]

Those days of May and June 1949 went by so quickly. Like Miles Davis, Algren was living the happiest months of his life, but not exactly for the same reasons. Waking up every morning under the benevolent gaze of Notre Dame deeply affected this son of a Swedish convert to Judaism. Paris proved for him both a spiritual and an earthly experience. The fruit and vegetable market on the place Maubert, minutes from the rue de la Bûcherie, filled Algren with joy. He loved the French ritual of daily greetings: "Bonjour monsieur, comment ça va, très bien, merci, et vous, quel beau temps, au revoir, merci monsieur." Absorbing those vignettes of Parisian life, Algren had whispered into Simone's ear one late morning, "You see, in Chicago, people buy in silence." Everybody loved Nelson in turn. Michelle Vian found him very attractive and became his personal interpreter; he liked her, too, and called her Zazou. Sartre greatly appreciated the whiskey Nelson had brought him, and Nelson warmed to the philosopher's humor. Le petit Bost shared war stories while Olga listened to them, utterly charmed by the tall Chicagoan. There were tartine parties at the Vians'; dinners with Juliette Gréco and Miles Davis; evenings spent drinking whiskey and grapefruit gin with Richard Wright at the Montana bar in the rue Saint-Benoît; cocktail parties at Gallimard; a visit to the wax museum, the Musée Grévin; another to the van Gogh and Toulouse-Lautrec exhibitions at the Jeu de Paume; and one evening listening to Yves Montand perform in a cabaret. There were studious afternoons, too, with Jean Guyonnet, his French translator, who found Chicago slang particularly hard to decipher and render into French.[35] They would settle for hours on the top floor of the Café de Flore and discuss the semantics of the slums.

The release of the first volume of *Le deuxième sexe* felt like an unwanted distraction for Simone. Nothing could divert her attention from Nelson; she wanted to devote herself to him and to play the part of

the dedicated wife[36] for at least a few months in her life. There would be plenty of time to respond to the critiques of her book in the autumn when the second volume, even more brutally honest and graphic about sex, would no doubt stir even more controversy. For the time being, she was living a kind of honeymoon. In her studio flat on the rue de la Bûcherie there were maps spread on the floor and the bed. Algren wanted to visit Italy and North Africa. Late at night, in the shadow of Notre Dame's spire, they made plans and drew up itineraries. Rome, Naples, Amalfi, Ravello, Sorrento, Ischia, Tunis, Algiers, Fez, Marrakech, and then Marseilles and Cabris in Provence.

Four months later, on September 13, when Simone took Nelson to Le Bourget airport to catch his plane back home, he whispered in her ear: "I have never been so happy, I have never loved so much."[37] On touching down at Idlewild Airport in New York, he learned that the reviews for his novel *The Man with the Golden Arm* were excellent. Ernest Hemingway had written: "Algren can hit with both hands and move around and he will kill you if you are not awfully careful . . . Mr. Algren, boy, you are good."[38] Nelson would indeed never be so happy again, or so celebrated as a writer. Paris 1949 would remain for him a personal apotheosis never to be equaled.

While Simone and Nelson were cooing, Sartre had finally broken up with his "New York girl," Dolorès Vanetti, who kept making demands on him. So Dolorès remained married to her doctor husband, and Sartre remained unmarried to all his mistresses. Dolorès remained in her flat full of African masks and artworks by Duchamp, Breton, Calder, and Delvaux and would never talk about Sartre again. Jean-Paul, meanwhile, was busy making Michelle Vian laugh; everybody around him knew what it meant, except Boris, the soon-to-be-cheated-on husband.

ↄ

FAREWELLS AND A NEW DAWN

THE END OF MARRIAGES

Before setting off to Rome with Nelson, Simone had seen Richard Wright and asked him whether he was certain this film project of his was really a good idea. Simone was very fond of the Wrights and had the feeling that his going to Argentina for several months, perhaps even a year, could be the end of them. There had been tensions, and Ellen Wright would not endure Richard's dithering and existential malaise forever. In fact, Richard had not at all thought of Ellen or his daughters. He was going to become a movie star and had started a diet to look leaner and younger, as Simone had suggested. He had twenty years to shed; this made him laugh.

Cinema was the future for writers like them, he told Simone. Look at the young Norman, he said. Mailer had just relocated to Hollywood from New York with his mentor Jean Malaquais as his coscreenwriter. The film adaptation of *The Naked and the Dead* had just been released in Great Britain, where it had been praised and caused a scandal for its depiction of the reckless brutalities of American GIs during the Second World War; the sales had been prodigious, and the studios were assiduously courting Mailer. He had persuaded Montgomery Clift to play the part of Julien Sorel in what, he said, would be his first screenplay, an adaptation of Stendhal's *Le rouge et le noir*. Norman Mailer, Jean Malaquais, and their wives swiftly moved from the Château Marmont to a seven-room house at 1601 Marlay Drive in the foothills just beyond Sunset Boulevard. On August 28, 1949, Susan Mailer was born; Malaquais was her godfather.[1]

Beauvoir did not believe for a moment that Hollywood, or screen-

writing in general, was the way forward for talented writers like them. More like a trap, albeit an alluring one, of course, with more money and more glamour than in publishing. Simone would look after Ellen, she told Richard. She had also bidden farewell to Camus, who had escaped Parisian domestic life and a growing dissatisfaction with politics for a tour of Brazil, Argentina, Uruguay, and Chile; and to Sartre, on his way to Mexico, also for a lecture and book-signing tour. Difficult to say which of the two famous French writers was walking in the other's steps. However, in Argentina, where his plays were being produced and *L'étranger* and *La peste* had just been released in translation, Camus was known as "el numero 2 del existencialismo."[2]

With Beauvoir, Camus, Sartre, and Wright deserting Saint-Germain-des-Prés to go on their respective adventures, some of those left behind found life in Paris increasingly difficult. Summer 1949 would mark the time when relationships and marriages started silently unraveling. Francine Camus was slowly slipping into depression, Ellen Wright was wringing her hands at her husband's selfishness, and Mamaine, the future Mrs. Koestler, had been flown to a nursing home in Hampstead, London, for her mysterious bouts of severe asthma.

When she returned to Verte Rive after a few weeks of complete rest, Mamaine was feeling much better but still rather frail. Despite her precarious health, Arthur Koestler, who was working "on a secret novel," *The Age of Longing*,[3] could not suppress his habitual physical violence. When they argued, which was often, he beat Mamaine. Nobody called it domestic violence or abuse in those days. In a letter to her sister, Mamaine rather matter-of-factly wrote: "Arthur struck me a stunning blow on the head (for the third time)."[4] The English rose thought that such treatment came with the "job" of being the wife-in-waiting of an influential public figure and world-famous writer.

Other unpleasantness came with her particular job of being Arthur Koestler's other half. Arthur was about to hire Cynthia Jefferies, a twenty-two-year-old South African escaping from an abusive relationship with an older man. Koestler had finally agreed to marry Mamaine, and the date was fixed for April 1950, but this did not stop him from making the young and impressionable Cynthia his occasional mistress as well as his secretary. Mamaine's health would slowly deteriorate as time went by. Four years after their marriage, aged only thirty-seven, Mamaine died suddenly. Koestler

wrote to a friend, "I killed Mamaine." Cynthia replaced Mamaine at Arthur's side, only to know a tragic end herself thirty years later.[5]

The combative and independent-minded English muse Sonia Brownell had finally married out of despair. After the love of her life, Maurice Merleau-Ponty, refused to divorce his wife for her, Sonia decided to accept George Orwell's latest proposal. He had been extremely ill at a sanatorium in Cranham, Gloucestershire, in the spring of 1949, but had managed to finish writing his novel *1984*, whose female lead had been inspired by Sonia.[6] Her decision to marry Orwell had to do with her own deep unhappiness, but George found in her strength and tenderness. She did not love him the way she had loved Merleau-Ponty, but "the pact between them grew from mutual honesty, humour and compassion."[7] Sonia's Parisian friends learned with dismay that she was about to marry a figure whose reputation as an arch-anti-Stalinist was already beginning to filter through France. However, they recognized his talent as a writer, and the reviews for *1984*, in both Britain and the United States, were extraordinarily good; they also shared her pain when they learned that her wedding had taken place in Orwell's hospital room at University College Hospital, London, on October 13, 1949. On a flying visit to London to have a bronchoscopy, Mamaine was among the very few who attended the ceremony. Everybody was trying their best to be as merry as possible, but Sonia's friends knew she was going to be more nurse than wife—not a happy prospect for such a young, beautiful, and vibrant woman.

Both the nursing and the marriage proved brief, however, lasting only three months until Orwell's death on January 21, 1950. To her detractors, who would accuse her all her life of being Orwell's black widow, she would forever be Sonia Orwell, but to her friends she would remain Sonia Brownell, the friend and translator of many writers whom she always observed with a tender smile, a glass of bitter Campari in her hand. Two months after Orwell's funeral Sonia headed back to Paris, to be looked after by her friends. She soon found a way to spend as much time in Paris as she possibly could, working as an editor and talent scout for the British publisher Weidenfeld and Nicolson and the Swiss publisher Skira. Actively contributing to the international fame of Saul Bellow, Mary McCarthy, Elizabeth Hardwick, Norman Mailer, Michel Leiris, and Marguerite Duras, she struck everyone she encountered with her "melancholy that sparkled like crisp white wine."[8]

NEW WAVES

The mass exodus of the Left Bank's greatest minds in the summer of 1949 left many vacancies to be filled. A much younger generation, still in their teens, fed by Existentialism from an early age, were seething with impatience to live life to the full, to experiment with it and to play an active part in the Parisian turmoil of life, arts, literature, and politics. Interestingly, they favored the Right Bank over the Left Bank; it was their way to distinguish themselves from their glorious elders. For the young and rebellious François Truffaut, 1949 had been eventful, the end of an era and the beginning of a new one—at least he had hoped so. The angry seventeen-year-old cinephile had reached rock bottom: he had contracted syphilis. Too many visits paid to a brothel sheltered behind a chic neo-Gothic façade at 9 rue Navarin, near Pigalle, was the reason for it. Although rather proud to share the same affliction once suffered by his favorite poet, Charles Baudelaire, he was, however, much luckier. Thanks to daily shots of penicillin administered in his buttocks, the young François finally recovered. His mentor André Bazin hired him at his magazine *Travail et Culture*. François, at last in a steady job, learned how to run a successful and innovative movie club and how to write film criticism. He was Bazin's assistant and grateful friend, a kind of younger brother, too. He helped with Bazin's endless cinematic projects, such as the first staging of a film festival in Biarritz called the "festival of doomed films,"[9] audaciously aimed at competing with the Cannes Film Festival. Jean Cocteau and Bazin had come up with the idea of promoting films that were not purely commercial but were true artistic endeavors and works of art. Truffaut hopped on the night train at the beginning of July 1949 and found a bed in the dormitory of the Biarritz Lycée, used as the festival's main hotel for its not too important guests. There he met Cocteau and bumped into a group of committed cinephiles, slightly older than him: among them, Claude Chabrol, Éric Rohmer, and Jean-Luc Godard. La Nouvelle Vague, the French New Wave, was born there and then, on a Biarritz beach. The films on show included *The Lady from Shanghai* and *The Magnificent Ambersons* by Orson Welles, *Jour de fête* by Jacques Tati, *The Long Voyage Home* by John Ford, *L'homme du sud* (*The Southerner*) by Jean Renoir, *The Shanghai Gesture* by Josef von Sternberg, and *Ossessione* by Luchino

Visconti—magnificent films that would inform and shape the imagination of generations of cinemagoers, critics, and film directors.

The summer heat was slaughterous, but in the plush 16th arrondissement some children of the bourgeoisie were working hard. The nearly fifteen-year-old Brigitte Bardot had just been chosen by the editor of *Elle* as the magazine's mascot or favorite *jeune fille.* Her posture was superb, her innocence and modesty breathtaking. Brigitte dreamed of becoming a ballerina at the Paris Opéra and was training intensively at a dance school. Every day, after her classes at the Lycée, her governess took her for a rigorous two-hour ballet lesson that she often left with bloody feet. One of her slightly older schoolmates, Leslie Caron, had passed the entry exam to the national ballet school, the Conservatoire. A few months later Leslie would be spotted by Gene Kelly for a "Gershwin film project." "A what?" Leslie had laughed. "*An American in Paris*," came the answer.

Brigitte Bardot wanted to be like Leslie Caron and dance through life. A young photographer named Roger Vadim had noticed her on the cover of *Elle* and asked her to audition for a small part in a film. After asking her parents' permission, Brigitte accepted the offer. In fact, she did not care much for cinema, but she did care for this tall, dark stranger who did not look at her as if she were a complete idiot, the way her ruthless mother, Anne-Marie, had always done. The audition did not lead anywhere, and Brigitte kept working hard at her pirouettes and entrechats. For a while.

Roger Vadim had in fact seduced the teenager. And Brigitte, the daughter of the 16th arrondissement Catholic right-wing bourgeoisie, fell for the Saint-Germain-des-Prés bohemian dilettante with an absolute passion, the one she had so far dedicated to her dancing. A few months later, at the beginning of 1950, Brigitte gave up all pretense of becoming a professional dancer. She would, however, always retain the body of a dancer, the grace and demeanor that so mesmerized people wherever she entered a room. She would simply become a phenomenon of a sexual, social, moral, and philosophical nature, "a thing of mobile contours,"[10] as the *New York Times* would soon declare, one that Simone de Beauvoir would later study and write about. French intellectuals understood that there was much more to Bardot than just the lovely curves of a young star; she embodied this new generation, children of Existentialism, who were going to live free at all costs. Free of prejudices, free from morality, free from social con-

straints. François Truffaut and Jean-Luc Godard would soon shoot in the streets of Paris with a camera on their operator's shoulder or placed at the back of a convertible car, without any authorization, while Bardot would soon entrance the world with her body moves.

In an essay about Bardot,[11] Simone de Beauvoir immediately saw in the teenager a product of Existentialism. Beauvoir would present Bardot as the first and most liberated woman of postwar France. Beauvoir wrote: "Her flesh does not have the generosity that symbolizes passivity. She walks, she dances, she moves. In the hunting game, she is both hunter and prey. Males are an object for her, as much as she is an object for them. This is precisely what hurts males' pride."[12]

Bardot's naturalness seemed more perverse than any kind of sophistication. Bardot was offering the Western world a new kind of woman. "To despise as she does jewels, makeup and high heels is to refuse to transform oneself into an idol. It is to assert oneself the equal of men."[13]

Bardot would refuse to be "a good wife" and "a good mother." She fell in and out of love, married four times, broke hundreds of hearts, stayed, left, gave birth to a boy, and discovered she was not cut out for motherhood, leaving her son to be brought up by his father. But she was not acting out any rebellious impulses. As Beauvoir put it: "Desire and pleasure seem to her truer than precepts and conventions. She does what she pleases and this is what is so troubling."[14] Looking at Bardot's posture and gaze in this light, it is easy to see why she became an Existentialist icon.

Françoise Sagan, ten months younger than Bardot, was another daughter of the Paris bourgeoisie, and an heir to Left Bank thinking. She lived with her parents at 167 boulevard Malesherbes in the patrician 17th arrondissement. She usually spent the summer at the family house at Hossegor near Biarritz, but that summer of 1949 she had insisted on going first to visit the Picasso exhibition organized by the Communist arts center Maison de la Pensée Française. It was Picasso's own selection of his previous two years' production: sixty-four canvases in total. Françoise, née Quoirez, had always wanted to become a writer. Literature would provide her nom de plume, Sagan. She found it in her favorite author, Marcel Proust. Boson de Talleyrand-Périgord, Prince de Sagan, a famous dandy in the nineteenth century, had inspired the character of the Duc de Guermantes and Baron Charlus in *À la recherche du temps perdu*. "Françoise Sagan." She liked the ring to it. She, too, would be a dandy in her own way.

For the time being, though, with her friend Florence, daughter of André Malraux, she spent her free time listening to Billie Holiday and reading—Sartre, Beauvoir, Stendhal, and the young American literary phenomenon Carson McCullers, with whom she'd share the same talent for writing and living too fast.

The young Sagan, too, was keen on freedom and pleasure: the pleasure of reading and the new one of writing. This gave her happiness and the headiness of freedom. In the summer of 1949 she was timidly but already feverishly discovering the key to her future existence: joy. Sagan would become the virtuoso of a new hedonism. She discovered that she was attracted to young women and older men, and was resolved to make love for pleasure and nothing more. Monogamy, an alien concept, served only to enslave people, she thought. Three years later, her first novel, *Bonjour trist-esse*, would prompt an international scandal and millions of sales through-out the world. *Paris Match* would brand her the new Colette, and the future Nobel Prize writer and critic François Mauriac declared her "a charming little monster." With her royalties she would buy, in cash, her first sports car, a black XK140 Jaguar, and never look back.

Sagan and Bardot, adolescents in the summer of 1949, were just a few months away from international fame. The two faces of a new France, they were about to become the emblems of a generation that would speak as fast as they would drive, and whose lightness of being and non-chalance, paired with a dazzling intelligence and beauty, would become a blueprint for generations to come. They were the offspring of Beauvoir, Sartre, Camus.

They were the France that had not been responsible for the war, having had to live through it only with their children's eyes. They had been young hostages of the war but now wanted to forget it all, and if possible at full speed. Their generation showed more casualness than their elders and behaved even more freely and dangerously. France's economic recovery provided them with new desires they could now fulfill.

Future icons, they were also about to invent a new style: loose hair bleached by the sun over a Breton-style top, a pair of blue jeans, walking barefoot or in espadrilles with a cigarette between the lips, oozing impudence. Jean Cocteau, the eternally young poet and mischief maker in chief, would

soon look at them with as much awe as irritation: "Today's youth possesses an incredible cheek, an immodesty that resembles genius. Great genius. Too much genius. A machine gun of genius. This youth could also do with some talent."[15] However, in the summer of 1949, Truffaut, Bardot, Sagan, and the new waves they represented were still gathering and hadn't yet crashed on French shores.

"I NOW KNOW EVERYTHING THERE IS TO KNOW ABOUT YOUR BOSS'S VAGINA"

Simone de Beauvoir, feeling invincible after four blissful months spent with Nelson Algren—as it happened, the last truly happy moments they would ever share—was ready to confront her many critics, some of them old friends, and to enter a new stage in her life. The second volume of *Le deuxième sexe*, just released, had unleashed the furor of many a Parisian male, even in the heart of Saint-Germain-des-Prés, and with this book, Beauvoir was going to be at last considered worldwide as an equal to Sartre and Camus.

Had Simone gone too far with *Le deuxième sexe*? For the first time, through a meticulously researched work and accessible philosophy essay, a female writer was showing how men oppressed women. The forceful central argument developed in book 1, subtitled "Facts and Myths," had focused on the fact that men had managed to confine women to the role of *Other* while they remained the *Subject*. Women were therefore relegated to being the *Object*, hence their subordinate position in society. Looking at biology, psychoanalysis, and history, she had found numerous examples of women's "inferiority" taken for granted but never had she found a convincing justification for it. Beauvoir had also shown how myths and mythology imprinted human consciousness to the detriment of women, weaving tale after tale about the "eternal feminine." In book II, subtitled "Woman's Life Today," she analyzed very concretely women's situation through their sexual education from infancy to adulthood.

She had certainly been direct in making the points she wanted to make, and had liberally used the words "vagina" and "clitoris." Her matter-of-fact tone had greatly shocked and her straightforwardness had been deemed obscene. In her chapter on sexual initiation she had written: "Erection is

the expression of his need; sex, hands, mouth, man's body is erected toward his partner, but he remains at the heart of this activity."[16]

> Woman's eroticism is far more complex and expresses itself by the opposition between two organs: clitoris and vagina. All her life, woman retains this erotic autonomy (clitoris): the clitoral spasm is on a par with the male orgasm, a kind of intumescence which can be reached in a quasi automatic fashion; however, it is via her vagina that woman is penetrated and fecundated. It becomes an erotic center only by the intervention of a male and it always constitutes a kind of rape.[17]

Beauvoir was simply trying to prove that women are not born "feminine," but are conditioned by society into accepting a passive, dependent, objectified existence, deprived as they are of subjectivity and the ambition to emancipate themselves through financial independence and work. Whether daughter, wife, mother, or prostitute, women are made to conform to stereotypes imposed by men. For Beauvoir, only through work, and thus economic independence, can women achieve autonomy and freedom.

At *Les Temps modernes*, but also at her flat on the rue de la Bûcherie, Beauvoir received thousands of outraged letters, some signed, many anonymous. "People branded me a nymphomaniac, an abortion-fiend, a lesbian, frigid." Even the great writer François Mauriac, two years away from receiving the Nobel Prize in Literature, wrote to a younger male friend of Simone: "I now know everything there is to know about your boss's vagina." Albert Camus, trying to rest in the Alps after his exhausting and disappointing South American book tour, was simmering with rage. He accused Simone of demeaning French men and making them look ridiculous. Albert was macho, he hated being judged by women, intelligent women in particular. Saul Bellow was also among those males who felt threatened by an intelligent woman like Beauvoir. His love-hate feelings for France, his resentment at not having been able to impress Parisian intellectuals, inspired these lines to his friend Alfred Kazin: "Stendhal would do as I do, that is feed Simone's literature on sex to the cat to cure her of heat."[18] The rightwing and Gaullist press hated *The Second Sex*, the Communists ridiculed it, and the Vatican put it on its banned books list. None of this surprised Simone. Janet Flanner, however, was among her few allies. To her *New*

Yorker readers, Flanner warned: *"Le deuxième sexe*, a long, thoughtful work by Madame Simone de Beauvoir on the peculiar, even awkward place in civilization that first nature and then man have put the human female, is a serious, provocative study, unlike any ever produced by a French femme de lettres before."[19]

Her chapter on abortion triggered a strange phenomenon. People started queuing in front of *Les Temps modernes'* office to ask the secretary, Madame Sorbet, for the details of doctors who would discreetly perform this illegal medical act. One particularly desperate young man braved the concierge at 11 rue de la Bûcherie early one morning, ran up the five floors, and hammered on her door. Simone opened it, half awake, wearing her Japanese kimono. He fell on his knees and asked her for the name of a doctor who would abort his girlfriend. "People saw me as a kind of professional procuress."[20]

After a month of this daily diet of invective and abuse, Beauvoir left Paris with Sartre for Provence and the village of Cagnes. It was very warm for October, with a blazing autumn sun. Simone was keen to press ahead, to reconnect with fiction and start a new novel. She felt the need to write on the "disappointing immediate postwar period" after the elation of the liberation. Her novel would be set among Parisian intellectuals and dedicated to Nelson Algren. She would call it *Les mandarins (The Mandarins)*.[21] This roman à clef would also feature everyone she knew and had slept with, from Arthur Koestler to Nelson Algren, Jean-Paul Sartre to Albert Camus, Merleau-Ponty to le petit Bost, hiding behind false names. Nelson Algren would never forgive her, but she would receive France's highest literary distinction for it.[22]

ADIEU COMMUNIST PARTY

Edgar Morin and Édith Thomas had reached a point of no return. They had finally decided to leave the Communist Party and burn their bridges with their youth and dreams, as Marguerite Duras had done before them. Édith had had to renounce so many things in just a year, including her passion for Dominique Aury, and now the head of the National Archives was about to commit political suicide. In the light of her clandestine activities for the Resistance during the war, *Combat* gave her a whole page to explain, in her own words, why she was leaving the Party. However,

L'Humanité, the Party's powerful daily newspaper, crucified her in a short and scathing article on December 19, 1949, announcing her "departure." To half the French press she was now dead, invisible and unemployable. Like Edgar Morin, she was *heimatlos*, stateless. To the bourgeoisie they were Communists; to the Communists they were bourgeois. Edgar Morin was jobless almost overnight; as for Édith, her publisher's doors slammed shut and the anthology on women writers she had been working on for months was postponed indefinitely. All that remained in her life were her work and her friendship with Dominique Aury. Dominique had been careful not to let Édith know of her brief and violent affair with Arthur Koestler, and she was being as ever very discreet about her relationship with Gallimard supremo Jean Paulhan; she had, however, confided to Édith that she was writing a secret novel, an erotic work of pornographic mysticism. Dominique had chosen the pseudonym Pauline Réage; the novel she was writing was *Histoire d'O (Story of O)*,[23] a story of female sadomasochistic submission in the tradition of the Marquis de Sade. The first hundred copies were seized by the police, and the book was consequently banned for years for obscenity, but it ended up selling more than one million copies a few years later and being translated into twenty languages. Jean Paulhan wrote the preface as if the author, his lover, were unknown to him. Dominique Aury would reveal that she was the author of *Story of O* only four years before her death in 1998.

AN IDEA WITH A PLAN: A EUROPEAN UNION

If most of the hopes laid at the feet of Paris intellectuals, writers, and artists just after the Second World War were partly dashed by the force of bloc politics, and their own ideological and moral ambivalence, it remains that seldom before had a generation tried so hard to reinvent themselves and reenchant the world. In the end, they may have failed to counteract the Cold War and to create a Third Way in world politics; however, they did leave an impressive legacy, one that is still felt today in many walks of life. They crushed bourgeois morality and elevated vaudeville to an art. Only the strongest of women survived, but those who did shook the old male order. Utopian plans such as world citizenship revived political audacity and pushed back the limits of political imagination. Their wizardry with words, images, and concepts revolutionized not only philosophy and litera-

ture but also film and modern art. Their irreverence paved the way for the next generation's insouciance in a thriving France rediscovering the idea and reality of pleasure and wealth. And if there was no stopping Cold War politics, a new project for Europe would nonetheless soon take form.

Christmas 1949 in Paris had been the first in a decade without food restrictions, and Parisians spent all the extra money they had on food. Not for a quarter century had the food markets of Paris been fuller or more tempting. In the charcuteries Janet Flanner spent a long time studying "turkey pâté, truffled pigs' trotters, chicken in half-mourning, whole goose livers, boar's snout jelly, and fresh truffles in their fragile bronze husks."[24] In poultry and offal shops she was simply lost for words— "Strasbourg geese and Muscovy ducks, indescribable inner items and blood sausages"—before heading for the fish stalls, where she finally settled for some "costly deep-sea oysters and enormous, hairy sea spiders, to be buried in mayonnaise."[25]

Janet's compatriot the young Art Buchwald may have managed to get a job as a stringer for the entertainment weekly *Variety*, but he still could not afford hairy sea spiders in mayonnaise. He had a plan, though. The *New York Herald Tribune* had no entertainment column and he was going to suggest one to the editor Eric Hawkins, an Englishman who had been running the "Trib" for thirty years. Art got an appointment and lied through his teeth about almost everything: his credentials, his education, and his ability to speak fluent French. Still Hawkins said no and left for England for a holiday. Buchwald returned the next week to meet the deputy editor Geoff Parsons and said: "Mr. Hawkins and I have been talking about me doing an entertainment column, which would be generating more advertising." His lies worked magic. Art was hired on the spot to write two columns, one on films, the other on Paris's night life called "Paris After Dark," for $25 a week. In his columns, Art cast himself as the clumsy American tourist in Paris who could not "shoot straight." They caught on quickly and got people on both sides of the Atlantic talking. They would ultimately win Buchwald a Pulitzer Prize and were syndicated in more than 550 newspapers at the height of his career.

Art had never been a Left Bank kid, and as soon as he pocketed his first paycheck he moved to a maid's room on the Right Bank, three floors above Theodore White's flat at 24 rue du Boccador,[26] a few minutes' walk

from the newspaper's office at 21 rue de Berri, on the other side of the Champs-Élysées.

On a gray spring morning in 1950, Theodore White decided to walk to his meeting at 18 rue de Martignac in the 7th arrondissement, a street running along the Roman-looking Sainte Clotilde basilica. He particularly enjoyed the opportunity to cross the Seine at the place de la Concorde, toward the National Assembly. This would take him half an hour, just enough time to prepare for his interview. He had a meeting with the senior civil servant Jean Monnet. "A full-chested, round-faced, acid Frenchman with a needle-pointed nose,"[27] Monnet was among the statesmen he met in his career who impressed him the most.

> Jean Monnet introduced me to a craft which I have since come to consider the most important in the world: the brokerage of ideas. Monnet was a businessman by origin, cool, calculating, caustic; but he did love ideas and could sell ideas to almost anyone. Ideas were his private form of sport—threading an idea into the slipstream of politics, then into government, then into history. He talked about how and when to plant ideas like a gardener. He coaxed people in government to think. There were few counterparts to Monnet in other countries.[28]

Theodore White invented the phrase "idea broker" about Monnet in 1950; later he changed it to "power broker," an expression that passed into general use.

Six weeks before the invasion of Korea, Jean Monnet placed on the agenda of world politics the idea of a United Europe, "an old idea but this time clothed with a plan." France was ready to release its clamp on Germany's steel production if Germany shared its resources with its neighbors. What Monnet was proposing was this: a new coal and steel community in which not only Frenchmen and Germans but Italians, Belgians, Netherlanders, and Englishmen would share resources, facilities, and markets. In other words, Monnet was suggesting the creation of a common market. Jean Monnet sold the idea to the French foreign minister Robert Schuman, who in turn sold it to the U.S. secretary of state Dean Acheson.

> Washington recognized that Jean Monnet, this businessman turned dreamer, turned planner, was the most imposing, though officeless, leader

in his country. Monnet's prestige in French politics was akin to that of George Marshall in American politics. He belonged to no political party and enjoyed the confidence of all (except the Communists). Thus only he had the temerity and prestige to present to both American and French governments the plan that would give flesh to an idea which, ultimately, both would have to accept as the substitute for a grand settlement of peace.[29]

That night, across the Seine, while packing for her two-month trip to America during which she would be reunited with Algren, Simone de Beauvoir was mulling over the idea of a United Europe. Her mind was distracted by thoughts of Nelson, whose latest letters had been rather aloof, by her burning desire to hold him in her arms, and by her worries about not being in Paris while great political events were taking place. She parted the red curtains, opened her window, and let in the fresh air of the spring night. She liked her view over the riverbank and Notre Dame. The city was quiet, the river wind cool, and the trees in full blossom, intermittently illuminated by the headlights of cars driving on the *quais*. She leaned slightly over the ledge: the local *clochards* were fast asleep on the little steps of the rue de l'Hôtel Colbert, their wine bottles lying empty in the gutter of this crevice of a street off the Quai Montebello. And as she placed a tube of Belladénal, a sedative, and a secondhand copy of *The Crack-Up* by F. Scott Fitzgerald on top of the clothes in her suitcase, she looked once more at Notre Dame slumbering and "the starlit centuries surrounding her on the dark water."[30]

NOTES

Introduction

1 Brenda Wineapple, *Genêt: A Biography of Janet Flanner* (Lincoln: University of Nebraska Press, 1989).

2 Tony Judt, *Past Imperfect: French Intellectuals 1944–1956* (New York: New York University Press, 2011).

3 Ibid., p. 11.

4 Richard Seaver, *The Tender Hour of Twilight: Paris in the '50s, New York in the '60s* (New York: Farrar, Straus and Giroux, 2012), preface.

5 60 rue de Seine, in the 6th arrondissement.

6 The password to the free wifi is (or was when I visited) PulpFiction.

7 Simone de Beauvoir, *La force des choses* (Paris: Gallimard, 1963), vol. 1, p. 132.

I. WAR WAS MY MASTER

1 Yvonne Baby, first woman editor of the daily newspaper *Le Monde*, a teenager during the war, the goddaughter of Alberto Giacometti. Yvonne Baby interview with Agnès C. Poirier in Paris on January 29, 2014.

1. The Fall

1 The first space in the Louvre to be open to the public, in November 1793.

2 Simone Signoret, *La Nostalgie n'est plus ce qu'elle était* (Paris: Éditions du Seuil, 1975).

3 First published in France in 1938, it was translated into English in 1949 as *The Diary of Antoine Roquentin* (London: John Lehmann, 1949) and in 1965 as *Nausea* (London: Penguin Books, 1965).

4 Anthony Cronin, *Samuel Beckett: The Last Modernist* (New York: HarperCollins, 1996), p. 306.

5 Ibid., p. 307.

6 Needless to say, the film was not well received at the time of its release. It was heralded as a masterpiece on a par with *Citizen Kane* only after its rerelease in 1956.

7 Letter shown in the film documentary *Illustre et inconnu*, by Jean-Pierre Devillers and Pierre Pochart (Ladybird Films, France 3, 2014).

8 *Le Figaro*, September 24, 1939.

9 He wrote about it magnificently in Arthur Koestler, *Scum of the Earth* (Jonathan Cape, 1941).

10 Wineapple, *Genêt*, p. 161.

11 Villa Gerbier.

12 The MoMA held the first American Picasso retrospective, in collaboration with the Art Institute of Chicago, *Picasso: Forty Years of His Art* (MoMA Exh. #91, November 15, 1939–January 7, 1940). The exhibition included approximately three hundred works, some of which had never been exhibited before. Attendance at the museum peaked at approximately fifteen thousand visitors per week. Source: MoMA.org.

13 A Paris school of thought and historiography founded in the late 1920s, highly influential especially in Europe and Latin America. It stressed the importance of social scientific methods for historians, with a strong emphasis on social history.

14 She had opened her bookshop on November 17, 1919. It faced another bookshop, that of her lover Adrienne Monnier, at number 7 rue de l'Odéon.

15 Charles Glass in *Americans in Paris: Life and Death Under Nazi Occupation 1940–1944* (New York: Harper Press, 2009), p. 32.

16 Cronin, *Samuel Beckett: The Last Modernist*, p. 315.

17 Ibid., p. 69.

18 Ibid., p. 73.

19 Speech in the House of Commons, June 4, 1940.

20 Ibid., p. 73.

21 An operation that required confirmation from the Irish side that the money was there. Cronin, *Samuel Beckett: The Last Modernist*, p. 315.

22 Glass, *Americans in Paris*.

23 A. J. Liebling, *The Road Back to Paris* (New York: Paragon House, 1980), p. 80. Introduction by Raymond Sokolov, his biographer.

24 Hazel Rowley, *Tête-à-tête: The Lives and Loves of Simone de Beauvoir and Jean-Paul Sartre* (London: Chatto and Windus, 2006).

25 Glass, *Americans in Paris*.

26 Florence Gilliam, *France: A Tribute by an American Woman* (New York: E. P. Dutton, 1945).

27 As he referred to her in his correspondence to his friends.

28 Gilliam, *France: A Tribute*.

29 "La ville sans regard."

30 The American diplomat George F. Kennan tried to find the right metaphor: "Was there not some Greek myth about the man who tried to ravish the goddess, only to have her turn to stone when he touched her? That is really what has happened to Paris. When the Germans came, the soul simply went out of it; and what is left is only stone." Extract from his diary written on July 3, 1940, and published in George F. Kennan, *Sketches from a Life* (New York: Pantheon Books, 1989).

31 Liebling, *The Road Back to Paris*, p. 155.

2. The Choice

1 The Crillon on the place de la Concorde; the Ritz Hotel on the place Vendôme; the Majestic, on the avenue Kléber; the Raphael, rue de la Pérouse; and the George V, avenue George V, all of them a stone's throw from Napoleon's Arc de Triomphe. Some small satisfaction: William Bullitt had beaten the Germans to the Hôtel Le Bristol (as the old American embassy had been requisitioned by the Germans).

2 As reported in the documentary film *Illustre et inconnu*, by Jean-Pierre Devillers and Pierre Pochart (Ladybird Films, France 3).

3 The equivalent of 460€ today, or $565, or £360.

4 Signoret, *La Nostalgie n'est plus ce qu'elle était*.

5 Cronin, *Samuel Beckett: The Last Modernist*, p. 319.

6 Agnès Humbert, *Notre Guerre: Souvenirs de résistance* (Éditions Emile-Paul Frères, 1946; reissued by Tallandier, 2004), published in English as *Résistance: Memoirs of Occupied France* (New York: Bloomsbury, 2009).

7 Cronin, *Samuel Beckett, The Last Modernist*, p. 322.

8 Herbert R. Lottman, *The Left Bank* (New York: Houghton Mifflin, 1981).

9 Ibid.

10 Ibid., p. 141.

11 Musée de l'Homme resistance group, etc.

12 Paulhan hid the Musée de l'Homme resistance group's duplicating machine, according to Lottman, *Left Bank*, p. 147.

13 Cronin, *Samuel Beckett: The Last Modernist*, pp. 322–23.

14 Signoret, *La Nostalgie n'est plus ce qu'elle était*.

15 Their intimate knowledge of this particularly treacherous mountainous region allowed them to keep tricking the Gestapo and the Wehrmacht.

16 Lottman, *Left Bank*, p. 180.

17 Ginette Guitard-Auviste, *Jacques Chardonne* (Paris: Albin Michel, 2000), p. 193.

18 Lottman, *Left Bank*, p. 180.

19 Ibid., p. 181.

20 Today the antiquarian bookseller Scheler is still standing, only Thomas has replaced Lucien.

21 Published by Viking Press in March 1942.

22 Ibid., p. 210.

23 "Contraband coffee cost $8 a pound, eggs $2 a dozen, chickens $5 each and cigarettes about $2 a pack—almost 10 times their pre-war prices. Average bottle of wine 60 cents instead of 8 cents." Glass, *Americans in Paris*, p. 217.

24 Glass, *Americans in Paris*, p. 234.

25 Ibid., p. 90.

26 Ibid., p. 93.

27 In *Conversations avec le vieil Harold Kaplan. Un américain peu ordinaire. À voix nue avec Harold Kaplan*, a series of interviews with Philippe Meyer broadcast on October 27, 28, 29, and 30, 2010, on France Culture Radio. Those interviews were published verbatim in the magazine *Commentaire*, nos. 129 and 130, summer 2010.

28 The premiere took place on November 26, 1942, at the fifteen-hundred-seat Hollywood Theatre in New York City.

29 *New York Times*, November 27, 1942. Bosley Crowther finished his article with "*Casablanca* is one of the year's most exciting and trenchant films. It certainly will not make Vichy happy—but that's just another point for it."

30 Opening night on November 23, 1942, at the Metropolitan Opera House, New York.

31 As reported by Oscar Thompson in his review published in the *Musical America* of November 25, 1942.

32 Released in the United States in 1942 as *The Devil's Envoys*.

33 *La Mort de Marie* (Paris: Gallimard, 1934) and *L'Homme criminel* (Paris: Gallimard, 1934).

34 Édith Thomas, *Le Témoin compromis* (Paris: Viviane Hamy, 1995), p. 112.

35 As described by the *New Yorker*'s Paris correspondent Janet Flanner, in her letter dated November 9, 1952.

36 Paul Eluard, "Liberté" in *Au rendez-vous allemand* (Paris: Les Editions de Minuit, 1945). "Liberté" was subsequently learned by heart by generations of French schoolchildren, forever ingrained alongside poems by Ronsard, Baudelaire, Rimbaud, and Prévert.

37 After one of his former student-lovers, Olga, had asked him to write her a part so she could establish herself as an actress.

38 The French title comes from Voltaire's translation of Hamlet's soliloquy "To be or not to be":
 Demeure, il faut choisir
 Et passer à l'instant
 De la vie à la mort
 Et de l'être au néant.
 (*Lettres philosophiques*, letter 18, 1734.)

39 Dan Franck, *Minuit: Les aventuriers de l'art moderne (1940–1944)* (Paris: Livre de poche, 2012), pp. 446–47.

40 This was the former Sarah Bernhardt Theatre, whose name had been changed because of the famous tragedian's Jewish origins.

41 Ingrid Galster, *Le théâtre de Jean-Paul Sartre devant ses premiers critiques*, vol. 1 (Paris: L'Harmattan, 2001).

42 She confided this during an interview on January 7, 2014, at her home in Saint-Tropez.

43 As reported in Nathalie de Saint Phalle, *Hôtels littéraires* (Paris: Édition Quai Voltaire, 1991).

44 Brassaï, *Conversation avec Picasso* (Paris: Gallimard, 1964), p. 138.

45 Ibid., p. 155.

46 Ibid., p. 151.

3. The Fight

1 By the Association du Secours National, first created during the First World War.

2 As reported in the documentary film *Illustre et Inconnu*, by Jean-Pierre Devillers and Pierre Pochart (Ladybird Films, France 3).

3 Ibid.

4 Olivier Todd, *Albert Camus: Une vie* (Paris: Gallimard, 1996), p. 479.

5 Gerhard Heller, *Un Allemand à Paris* (Paris: Le Seuil, 1981), p. 157.

6 Ibid., p. 128.

7 Ibid., pp. 202–6.

8 Cronin, *Samuel Beckett: The Last Modernist*, p. 330.

9 Heller, *Un Allemand à Paris*, p. 153.

10 *Le journal d'Hélène Berr* was published in 2008 by Éditions Taillandier in Paris with a preface by Patrick Modiano, and in English as *The Journal of Hélène Berr* by MacLehose Press, 2009.

11 The Jewish lesbian Surrealist muse whose face would forever be familiar to the world thanks to Man Ray's 1937 picture of her with Nusch.

12 Marcel Mouloudji, *Le petit invité* (Paris: Balland, 1989), p. 67.

13 In Jean-Paul Sartre's short essay "Paris sous l'occupation," published in London in 1945 as "France Libre" and later edited together with other short essays in *Situations III* (Paris: Gallimard, 1949).

14 Ibid.

15 La Grande Chaumière has not changed and has not moved, being still located at 14 rue de la Grande Chaumière in the 6th arrondissement; www.grande-chaumiere.fr.

16 Geneviève Laporte in *Sunshine at Midnight* (London: Weidenfeld and Nicolson, 1975), translated by Douglas Cooper, p. 4.

17 Jean Paulhan hopped on the métro and went straight to 17 rue Marbeau, in the 16th arrondissement, and laid low at Georges Batault's, a Swiss anti-Semitic writer, a mutual friend of Docteur Le Savoureux who hid many *résistants* in his house at Châtenay-Malabris, the former home of Chateaubriand, which can be visited today. The homes of well-known collaborators and anti-Semites, who had despite everything remained friends, proved ideal places to hide from the Gestapo. Frédéric Badré, *Paulhan, le juste* (Paris: Grasset, 1996), p. 218.

18 In an article penned by Jean-Paul Sartre, "La république du silence," *Les Lettres françaises*, 1944.

19 Today, 6 rue Georges Braque.

20 Pierre Assouline in his biography of Henri Cartier-Bresson, *Cartier-Bresson: L'oeil du siècle* (Paris: Plon, 1999). However, *Zen in the Art of Archery* not having been published until 1948, Assouline might in fact be referring to a shorter essay on the same subject that Eugen Herrigel had published in October 1936, in a German magazine specializing in Japanese studies.

21 Thomas, *Témoin compromis*, p. 153.

22 Ibid.

23 On February 1, 1944, many secret Resistance organizations merged into the Forces Françaises Intérieures for the sake of efficiency. In June 1944, the FFI represented two hundred thousand members; in October 1944, four hundred thousand. The FFI were key in helping the Allied forces in the D-Day operations and the liberation of Paris. After being disbanded by Charles de Gaulle, a third of the FFI members enrolled in the official French army to keep fighting with the Allied forces in the rest of Europe.

24 Glass, *Americans in Paris*, p. 386.

25 At 186 rue de Rivoli, opposite the Louvre, and 100 rue Réaumur, just one mile north.

26 Liebling, *The Road Back to Paris*.

27 *Combat*, August 21, 1944. "Qu'est-ce qu'une insurrection? C'est le peuple en armes. Qu'est-ce que le peuple? C'est ce qui dans une nation ne veut jamais s'agenouiller."

28 Robert Doisneau was given the area of Belleville to cover but he disobeyed orders and went straight to where the battles were the fiercest: around Notre Dame and the Latin Quarter. In *Paris, libéré, photographié, exposé* (Paris: Musée Carnavalet, 2014), p. 216.

29 As the historian Ian Buruma argued in "The Argument That Saved Paris" in the *New York Review of Books*, October 15, 2014: "Refusing to let Paris burn would be a most effective way to cover up his more sordid past. By making it seem as if only his brave decision saved the city from total destruction, von Choltitz entered the history books as a kind of hero instead of a war criminal."

30 Ernest Hemingway, *Hemingway on War* (New York: Scribner, 2004).

31 Glass, *Americans in Paris*, p. 400.

32 Léon Werth, *Déposition, journal 1940–1944* (Paris: Viviane Hamy, 1995).

33 Yves Cazaux, *Journal secret de la libération* (Paris: Albin Michel, 1975).

34 Sartre's recollection, published in *Combat* on September 2, 1944.

35 On coming across it, Charles de Gaulle commented, "A hell of a task."

36 Twenty-eight hundred civilians were killed between August 19 and August 25, 1944, during the liberation of Paris.

37 Glass, *Americans in Paris*, p. 408.

38 To which Hemingway is famously supposed to have replied: "Oh no, I have to liberate the cellar of the Ritz first." Glass, *Americans in Paris*, p. 400.

39 As recalled by Françoise Gilot, *Life with Picasso* (New York: McGraw-Hill, 1964), p. 61.

40 As he recalled in Irwin Shaw and Ronald Searle, *Paris! Paris!* (Harcourt, 1976), p. 13.

41 Ibid., p. 19.

42 Ibid., p. 20.

43 On the black market, bread cost 35 francs and butter 600 francs a kilogram, ten times their prewar prices.

44 Anne-Marie Cazalis, *Les mémoires d'une Anne* (Paris: Stock, 1976), p. 33.

45 Albert Camus, "La nuit de la vérité," *Combat*, August 25, 1944.

46 In its editorial published on September 4, 1944.

47 Charles de Gaulle, *Mémoires de guerre* (1954–59; repr. Paris: Pocket, 2010).

48 Thomas, *Témoin compromis*, p. 171.

49 Assouline, *Cartier-Bresson*, p. 209.

50 Brassaï, *Conversation avec Picasso*, p. 223.

51 "Nous ne les reverrons plus. C'est fini, ils sont foutus."

4. The Desire

1 To know more about their life in Sigmaringen: Louis-Ferdinand Céline, *D'un château l'autre* (Paris: Gallimard, 1957), and Pierre Assouline, *Sigmaringen* (Paris: Gallimard, 2014).

2 Sartre, "Paris sous l'occupation."

3 Ibid.

4 Beauvoir, *La force des choses*, vol. 1, p. 21.

5 In French, "Le parti des 75.000 fusillés," literally, "the party of the seventy-five thousand people executed at gunpoint."

6 Twenty-five thousand French people, of different political affiliations, were executed or deported and killed during the war, according to Stéphane Simonnet, *Atlas de la Libération de la France: Des débarquements aux villes libérées* (Paris: Autrement, 2004), p. 68.

7 Charles de Gaulle held Brasillach among those responsible for the abduction and assassination of the French politician and *résistant* Georges Mandel on July 7, 1944.

8 Beauvoir, *La force des choses*, vol. 1, p. 30.

9 Ibid., p. 31.

10 Janet Flanner, *Paris Journal, 1944–1955* (New York: Harvest/HBJ, 1988), January 17, 1945, p. 15.

11 Todd, *Albert Camus*, pp. 503–8.

12 Thomas, *Témoin compromis*, p. 175.

13 Beauvoir, *La force des choses*, vol. 1, p. 31.

14 The forty-two-year-old Natalia Danesi Murray, an Italian-language broadcaster who spent the war years in New York. In Wineapple, *Genêt*, p. 170.

15 Flanner, *Paris Journal, 1944–1955*, December 15, 1944, p. 4.

16 Beauvoir, *La force des choses*, vol. 1, p. 32.

17 Flanner, *Paris Journal, 1944–1955*, p. 25.

18 Ibid.

19 Today's Musée d'Orsay.

20 Beauvoir, *La force des choses*, vol. 1, p. 51.

21 Juliette Gréco in conversation with Agnès C. Poirier on January 7, 2014, at her home in Saint-Tropez.

22 Beauvoir, *La force des choses*, vol. 1, p. 46.

23 Flanner, *Paris Journal, 1944–1955*, p. 23.

24 Beauvoir, *La force des choses*, vol. 1, p. 48.

25 She became a naturalized American in 1941.

26 Flanner, *Paris Journal, 1944–1955*, p. 26.

27 Ibid., p. 27.

28 Beauvoir, *La force des choses*, vol. 1, p. 48.

29 Yvette Szczupak-Thomas, *Un Diamant brut* (Paris: Points, 2009), p. 332.

30 Cronin, *Samuel Beckett: The Last Modernist*, pp. 340–58.

31 The text has been published by Éditions de Minuit in 1989 as *Le monde et le pantalon*, followed by another text by Beckett on the van Veldes titled *Peintres de l'empêchement*.

32 Assouline, *Cartier-Bresson*.

33 Ibid.

34 Brassaï, *Conversation avec Picasso*, p. 225.

35 Ibid., p. 263.

36 Beauvoir, *La force des choses*, vol. 1, p.54.

37 Brassaï, *Conversation avec Picasso*, p. 265.

38 Her husband was a medical student when she met him at the American Center in Paris; his name was Theodore Ehrenreich. In Manhattan, they settled in a flat at the corner of Fifty-

Seventh Street and First Avenue. Dolorès Vanetti continued to live there until she died on July 13, 2008.

39 Annie Cohen-Solal, "Dolorès Vanetti," *Le Monde*, July 19, 2008.

40 Archives from the Calder Foundation. Reference: Calder 1966, 188; CF, Carré to Duchamp; CF, Duchamp to Calder, July 3.

41 Brassaï, *Conversation avec Picasso*, p. 333.

42 Flanner, *Paris Journal, 1944–1955*, p. 32, and as seen, but in black-and-white newsreel, at http://www.ina.fr/video/AFE86003186.

43 Ibid., p. 38.

44 Ibid.

45 Archives from the Calder Foundation. Reference: Calder 1966, 188. CF, Calder to Carré, August 14; CF, Duchamp to Calder, July 3.

II. MODERN TIMES

5. A Philosophy of Existence

1 *Les Temps modernes* has never ceased publication since its first issue of October 1945. The head of the publication today is Claude Lanzmann, one of its first contributors as a philosophy student.

2 *Les Temps modernes*, October 1, 1945, no. 1.

3 Ibid.
"Nous vivons une agonie. On passe de la paix à la guerre, en notre siècle, par un jeu continu de dégradés. La guerre en mourant laisse l'homme nu, sans illusion, abandonné à ses propres forces, ayant enfin compris qu'il n'a plus à compter que sur lui. C'est la seule bonne nouvelle."

4 Beauvoir, *La force des choses*, vol. 1, p. 65.

5 Rowley, *Tête-à-tête*, p. 169.

6 Beauvoir, *La force des choses*, vol. 1, p. 165.

7 Flanner, *Paris Journal, 1944–1955*, p. 48.

8 Beauvoir, *La force des choses*, vol. 1, p. 66.

9 Ibid., p. 61.

10 Ibid., p. 63.

11 *La Croix*, June 3, 1945, quoted in *Les Temps modernes*, November 1945, no. 2.

12 Beauvoir, *La force des choses*, vol. 1, p. 70.

13 Ibid., p. 74.

14 *Les Temps modernes*, December 1945, no. 3.

15 *Les Lettres françaises*, December 28, 1945.

16 Beauvoir, *La force des choses*, vol. 1, p. 88.

17 Hazel Rowley, *Richard Wright* (New York: Henry Holt, 2001), pp. 315–23.

18 Michel Fabre, *La rive noire* (Paris: Éditions Lieu Commun, 1985), p. 147.

19 Rowley, *Richard Wright*, p. 307.

20 Ibid., p. 323.

21 Beauvoir, *La force des choses*, vol. 1, p. 32.

22 Ibid., vol. 1, p. 32.

23 It eventually did, thanks to a preface by Sartre. *Portrait d'un inconnu* was published in Paris in 1948 by Robert Marin.

24 Beauvoir, *La force des choses*, vol. 1, p. 90.

25 "Opposite numbers to our zoot-suiters," Janet Flanner, *Paris Journal, 1944–1955*, p. 16.

26 A tartine is a slice of bread with butter. These parties were frugal, but there was alcohol aplenty.

27 Flanner, *Paris Journal, 1944–1955*, p. 51.

28 Beauvoir, *La force des choses*, vol. 1, p. 90.

29 Translated and published in the United States as *The Other Kingdom* in 1947, and in the UK as *A World Apart* in 1951.

30 Beauvoir, *La force des choses*, vol. 1, p. 95.

31 Flanner, *Paris Journal, 1944–1955*, p. 58.

32 Rowley, *Tête-à-tête*, p. 161.

33 Lionel Abel, *The Intellectual Follies: A Memoir of the Literary Venture in New York and Paris* (New York: W. W. Norton, 1984), p. 116.

34 Ibid., pp. 118–19.

35 Rowley, *Tête-à-tête*, p. 161.

36 *Les Temps modernes*, no. 11–12, August–September 1946, special double issue USA.

37 Todd, *Albert Camus*, p. 549.

38 Rowley, *Richard Wright*, p. 330.

39 Ibid., p. 331.

40 In a letter to Dorothy Norman, quoted in ibid., p. 333.

41 According to the University of Chicago Press, which reissued the book in 2015.

42 Also translated as *Foam of the Daze*.

43 Beauvoir, *La force des choses*, vol. 1, p. 123.

44 Rowley, *Richard Wright*, p. 334.

45 Flanner, *Paris Journal, 1944–1955*, p. 57.

46 Ibid., pp. 57–58.

47 Rowley, *Richard Wright*, p. 337.

6. Lust and Emancipation

1 Claude Lanzmann, *Le lièvre de Patagonie* (Paris: Gallimard, 2010), p. 208.

2 Journal d'Édith Thomas, October 27, 1946, Fonds Édith Thomas, Archives Nationales.

3 *Living with Koestler: Mamaine Koestler's Letters 1945–51*, edited by Celia Goodman (New York: Littlehampton Books, 1985). "Arthur arrived from Palestine . . . very brown, with a bag full of arak and brandy. Dined at Scott's. Felt very elated and rather tight. A says he'd like to marry me but refuses to have children."

4 *L'étranger*, under the title *The Outsider*, had come out on April 11, 1946, in a translation by Stuart Gilbert, a friend of James Joyce, and although the *New York Times* critic had been irritated by its "Britannic" quality, it had on the whole been deemed a fine translation and a "brilliantly told" novel. *The Outsider* gathered praise almost everywhere it was reviewed. Of course, it helped when personal friends wrote the reviews. The Italian philosopher and *résistante* Nicola Chiaromonte, whom Camus had helped to flee to Morocco in 1941, wrote a glowing review for the *New Republic*, calling it "admirable."

5 Todd, *Albert Camus*, p. 559.

6 Ibid., p. 565.

7 Ibid., p. 572.

8 Ibid., p. 574.

9 Beauvoir, *La force des choses*, vol. 1, p. 152.

10 Householders had a seven-day supply for each person in the family for the entire winter; most were saving it for the week when they fell sick.

11 Camus is reported to have made this joke to Koestler, according to Olivier Todd.

12 Beauvoir, *La force des choses*, vol. 1, p. 153.

13 Olivier Todd, Camus' biographer, does not think it happened: "Camus was too afraid of the kind of pillow-talk they might have had. He was afraid of intelligent women while clearly attracted to Beauvoir physically."

14 Thinks Olivier Todd, Camus' biographer.

15 The play had been universally panned by the American critics a year earlier. *Vassar Chronicle*'s

Mary Walker, who had reviewed the play, had been prescient: "Here is Arthur Koestler's first and, God willing, only play." She had concluded her review by saying: "Koestler writes with the subtlety of a plough horse. Because he has done good work in the past, we may hope that this is not a swan song but merely the angry croaking of a dispossessed robin."

16 Michael Scammell, *Koestler: The Literary and Political Odyssey of a Twentieth-Century Skeptic* (New York: Random House, 2009), p. 287.

17 Beauvoir, *La force des choses*, vol. 1, p. 155.

18 Mamaine Koestler, *Living with Koestler*, p. 40.

19 According to different sources, such as Simone de Beauvoir, *La force des choses*, vol. 1, p. 157, and Mamaine Koestler, *Living with Koestler*, p. 43.

20 Manès Sperber was born in Austrian Galicia in 1905 in a Jewish Hasidic family. He joined the Communist Party in 1927 in Berlin, and immigrated to Paris in 1934. He left the Party because of the Stalinist purges in 1938 and started writing about totalitarianism. He volunteered for the French army in 1939 and had to flee to Switzerland when deportations of Jews started in France. He returned to Paris in 1945 where he worked as senior editor at Calmann-Lévy publishing house and as a psychoanalyst and writer. He was a close friend of Arthur Koestler.

21 Angie David, *Dominique Aury* (Paris: Éditions Léo Scheer, 2006), p. 400.

22 Journal d'Édith Thomas, November 7, 1941. Quoted in ibid., p. 393.

23 David, *Dominique Aury*, p. 397.

24 Journal d'Édith Thomas, October 27, 1946.

25 Letters from Dominique Aury to Édith Thomas, Sunday, October 27, 1946. Fonds Édith Thomas, Archives Nationales.

26 Journal d'Édith Thomas, November 2, 1946.

27 Ibid.

28 Journal d'Édith Thomas, November 28, 1946.

29 Cazalis, *Les mémoires d'une Anne*, p. 54.

30 Ibid., p. 17.

31 Ibid., p. 75. Phonetically, "Allo" resembles "À l'eau" (let's go into the water).

32 Lanzmann, *Lièvre de Patagonie*, p. 203.

33 Ibid., p. 206.

34 Rowley, *Tête-à-tête*, p. 167.

35 Today called the Hôtel des Carmes.

36 In the preface written by Noël Arnaud to Boris Vian, *Manuel de Saint-Germain-des-Prés* (Paris: Éditions du Chêne, 1974).

37 Cazalis, *Les mémoires d'une Anne*, p. 84.

38 Beauvoir, *La force des choses*, vol. 1, p. 145.

39 Ibid., p. 147.

40 *Étude de femmes* published by Éditions Colbert and *Le champ libre* published by Gallimard.

41 Édith Thomas, *Jeanne d'Arc* (Paris: Éditions Hier et Aujourd'hui, 1947).

42 Édith Thomas, *Les Femmes de 1848* (Paris: Presses Universitaires de France, 1948).

43 Dominique Aury, "Par delà tout espoir," *L'Arche*, no. 13, February 1946, p. 157, as quoted in David, *Dominique Aury*, p. 399.

44 The then forty-nine-year-old avant-garde poet, performer, and essayist Tristan Tzara was one of the founders of the antiestablishment Dada movement. Antifascist, he was a Communist but distanced himself from the Communist Party, of which he was a member in the 1950s.

45 Mamaine Koestler, *Living with Koestler*, p. 27.

46 Ibid., p. 29.

47 Ibid., p. 28.

48 Cazalis, *Les mémoires d'une Anne*, p. 74.

49 Juliette Gréco, *Jujube* (Paris: Stock, 1982), p. 111.

7. A Third Way

1 Ariane Chebel d'Appollonia, *Histoire politique des intellectuels en France 1944–1954* (Paris: Éditions Complexe, 1991), vol. 1, pp. 130–36.

2 Todd, *Albert Camus*, p. 530.

3 Flanner, *Paris Journal, 1944–1955*, p. 45.

4 Ibid., p. 52.

5 In the October 1945 elections, the Communist Party had garnered 27.1% of the votes while the Gaullists and the Socialists received 25.6% and 24.9%, respectively.

6 To salute Léger's return home, *Les Temps modernes* asked Daniel-Henry Kahnweiler, who now lived with his stepdaughter and her husband, the art critic Michel Leiris, at the Quai des Grands Augustins, to write a long piece about the birth of Cubism for the January 1946 issue.

7 Laurence Dorléac, *Après la guerre* (Paris: Gallimard, 2010), p. 29.

8 Ibid., p. 11.

9 Ibid., pp. 11–12.

10 Ibid., p. 31.

11 Ibid., p. 33.

12 Hilary Spurling, *The Girl from the Fiction Department: A Portrait of Sonia Orwell* (London: Hamish Hamilton, 2002), p. 73.

13 Philip Toynbee, "Lettre de Londres," *Les Temps modernes*, no. 4, January 1946. "Nous n'avons pas une philosophie. Nous sommes moins sujets que vous aux élans, aux enthousiasmes intellectuels passionnés. Notre manque de fanatisme n'est en ce moment que le gage de notre apathie."

14 Philip Toynbee, "Lettre de Londres," *Les Temps modernes*, no. 8, May 1946.

15 Spurling, *Girl from the Fiction Department*, pp. 56–57.

16 Beauvoir, *La force des choses*, vol. 1, p. 147.

17 Ibid., p. 145.

18 Ibid., pp. 147–49.

19 Ibid., p. xx.

20 Iron Curtain speech given at Westminster College in Fulton, Missouri, on March 5, 1946.

21 Ibid.

22 Beauvoir, *La force des choses*, vol. 1, p. 149.

23 Calder was preparing the opening on October 25, 1946, of "Alexander Calder: Mobiles, Stabiles, Constellations" at Louis Carré's gallery.

24 Jean-Paul Sartre, "Les Mobiles des Calder," in *Alexander Calder: Mobiles, Stabiles, Constellations*, exhibition catalog (Paris: Galerie Louis Carré, 1946), pp. 9–19. English translation by Chris Turner, from Jean-Paul Sartre, *The Aftermath of War* (Calcutta, India: Seagull, 2008).

25 Ibid.

26 *Les Temps modernes*' first double summer issue of 1946.

27 David Hare was the young American painter who had seduced André Breton's second wife, Jacqueline, during their stay in New York.

28 As explained by Ed Pilkington in the *Guardian*, November 21, 2013, after the Scottsboro boys received posthumous pardons: "The nine black boys entered into an altercation with some white youths as they were on the freight train passing through Alabama, on the night of 25 March 1931. When the train stopped at Scottsboro a posse of local white men boarded the train and took the teenagers captive; they also found two white women on board, who said they had been raped . . . Wrongfully accused of raping two white girls, the nine came close to being lynched by an angry mob, were rushed to trial in front of an all-white jury, and ended up serving many years in jail, eight of them on death row."

29 *La putain respectueuse*.

30 Rowley, *Richard Wright*, p. 349.
31 Ibid.
32 The Budapest uprising in 1956 killed his affection for Communism. Assouline, *Cartier-Bresson*, p. 379.
33 "J'ai le cœur tranquille et sec que je me sens devant les spectacles qui ne me touchent pas." Todd, *Albert Camus*, p. 549.
34 "Le secret de toute conversation ici est de parler pour ne rien dire." Ibid., p. 559.
35 Ibid., pp. 559–62.
36 Ibid., pp. 562–65.
37 Beauvoir, *La force des choses*, vol. 1, p. 111.
38 Scammell, *Koestler*, p. 287.
39 Beauvoir, *La force des choses*, vol. 1, p. 113.
40 "2 mai 1946. J'ai entendu au moins cent discussions sur le Zéro et l'infini. La critique la plus juste c'est celle qu'en faisait Giacometti." Beauvoir, *La force des choses*, vol. 1, p. 115.
41 Ibid., p. 154.
42 Scammell, *Koestler*, p. 289.
43 Beauvoir, *La force des choses*, vol. 1, p. 154.
44 Ibid.
45 Ibid.
46 *Time* magazine, December 1945.
47 Beauvoir, *La force des choses*, vol. 1, p. 168.
48 Ibid., p. 160.
49 Ibid., p. 158.
50 Ibid., p. 159.

III. THE AMBIGUITIES OF ACTION

8. How *Not* to Be a Communist?

1 Flanner, *Paris Journal, 1944–1955*, p. 71.
2 Any of various alcoholic liquors of the Middle East, distilled from grapes, raisins, or dates and flavored with anise.
3 Quoted in Scammell, *Koestler*, p. 301.
4 According to the historian Hélène Carrère d'Encausse, *Staline* (Paris: Flammarion, 1979).
5 Isaiah Berlin's acceptance speech at the University of Toronto upon receiving his honorary degree of Doctor of Laws, November 25, 1994.
6 Edgar Morin, *Autocritique* (Paris: Gallimard, 1970), p. 35.
7 Ibid., p. 70.
8 Ibid., p. 100.
9 Ibid., p. 107.
10 Chebel d'Appollonia, *Histoire politique*, vol. 2, p. 14.
11 Claude Roy, *Nous* (Paris: Gallimard, 1972).
12 Morin, *Autocritique*, p. 86.
13 Beauvoir, *La force des choses*, vol. 1, p. 163.
14 Scammell, *Koestler*, p. 304.
15 In a letter from Koestler to Camus, December 16, 1946, quoted in Scammell, *Koestler*, p. 303.
16 Quoted in ibid., p. 304.
17 Ibid.
18 Spurling, *Girl from the Fiction Department*, p. 81.
19 Ibid.

304 NOTES

20. Flanner, *Paris Journal, 1944–1955*, p. 70.

21. *Les Temps modernes*, March 1947, no18.

22. Theodore H. White, *In Search of History* (New York: Warner Books, 1978), p. 246.

23. Ibid., p. 251.

24. Ibid.

25. Ibid.

26. "I Tried to Be a Communist," *Atlantic Monthly*, vol. 174, no. 2, August 1944.

27. White, *In Search of History*, p. 260.

28. In a letter to his friend Fig Gwaltney, quoted in J. Michael Lennon, *Norman Mailer: A Double Life* (New York: Simon and Schuster, 2013), p. 99.

29. Beauvoir, *La force des choses*, vol. 1, p. 170.

30. Ibid., p. 171.

31. Rowley, *Tête-à-tête*, p. 175.

32. Simone de Beauvoir, *Letters to Sartre* (New York: Arcade Publishing, 1991), p. 415.

33. Beauvoir, *La force des choses*, vol. 1, p. 171.

34. Her diary was later published as a series in *Les Temps modernes* (from the issue of December 1947, no. 27) and then as a book, *L'Amérique au jour le jour* (Paris: Gallimard, 1948), later translated into English as *America Day by Day*.

35. Her diary entry on February 27, 1947, published in the second installment of "L'Amérique au jour le jour," *Les Temps modernes*, no. 28, January 1948.

36. Beauvoir, "L'Amérique au jour le jour."

37. Beauvoir, *Letters to Sartre*, p. 446.

38. Ibid., p. 447.

39. Beauvoir, "L'Amérique au jour le jour."

40. Beauvoir, *Letters to Sartre*, p. 447.

41. Beauvoir, "L'Amérique au jour le jour."

42. Ibid.

43. Calder Willingham became a screenwriter for, among others, Stanley Kubrick (*Paths of Glory, Spartacus*), Richard Fleischer (*Vikings*), Mike Nichols (*The Graduate*), and Arthur Penn (*Little Big Man*).

44. Beauvoir, "L'Amérique au jour le jour."

45. Ibid.

46. Beauvoir, *Letters to Sartre*, p. 453.

47. The Confédération Générale du Travail was founded in 1895.

48. Flanner, *Paris Journal, 1944–1955*, p. 70.

49. Lottman, *Left Bank*, p. 265.

50. Mamaine Koestler, *Living with Koestler*, p. 52.

51. The text of George C. Marshall's speech is available at www.oecd.org.

52. White, *In Search of History*, p. 261.

9. Love, Style, Drugs, and Loneliness

1. Beauvoir, *Letters to Sartre*, p. 434.

2. Ibid.

3. Which she did. She was buried with it in 1986, five years after his death and twenty-two years after they last spoke.

4. A study of despair and corruption, *Sciuscià* was no entertainment but "a brilliantly executed social document," as the critic for the *New York Times* reluctantly had to admit.

5. Beauvoir, *Letters to Sartre*, p. 454.

6. Beauvoir, *La force des choses*, vol.1, pp. 176–77.

7 Ibid., p. 182.

8 Flanner, *Paris Journal, 1944–1955*, p. 79.

9 Spurling, *Girl from the Fiction Department*, p. 82.

10 Little did Simone de Beauvoir know that Lucian's future wife, Caroline Blackwood, a Guinness heiress, would years later elope with her dear friend Nathalie Sorokine's husband, the Hollywood screenwriter Ivan Moffat.

11 Rowley, *Richard Wright*, p. 363.

12 Ibid., p. 364.

13 Gréco, *Jujube*, p. 104.

14 Interview with Agnès Catherine Poirier on January 7, 2014, at her home in Saint-Tropez.

15 As related by Elisabeth Quin in *Bel de Nuit* (Paris: Grasset, 2007).

16 "This is how the troglodytes of Saint-Germain-des-Prés live" by Robert Jacques, in *Samedi Soir*, May 3, 1947.

17 Gréco, *Jujube*, p. 104.

18 Beauvoir, *La force des choses*, vol. 1, p. 181.

19 According to Olivier Todd during an interview with the author at the Café Le Sélect on December 11, 2013.

20 Rowley, *Tête-à-tête*, p. 205.

21 Marie-Dominique Lelièvre, *Sagan à toute allure* (Paris: Denoël, 2008), p. 228.

22 Rowley, *Tête-à-tête*, p. 205.

23 Cronin, *Samuel Beckett: The Last Modernist*, p. 386.

24 Ibid., p. 387.

25 Ibid., p. 378.

26 Fonds Édith Thomas, Archives Nationales, quoted in David, *Dominique Aury*, p. 402.

27 Letter from Dominique Aury to Édith Thomas, August 6, 1947, Fonds Édith Thomas, Archives Nationales, quoted in David, *Dominique Aury*, p. 406.

28 Quoted in Dorothy Kaufmann, *Édith Thomas, passionnément résistante* (Paris: Autrement, 2007), p. 186.

10. Action and Dissidence

1 The expression is Zhdanov's, in a report he wrote about the poet in 1946 for the Politburo. Quoted in Michael Ignatieff, *Isaiah Berlin: A Life* (New York: Vintage, 2000), p. 166.

2 Ibid.

3 Quoted in Kaufmann, *Édith Thomas, passionnément résistante*.

4 Chebel d'Appollonia, *Histoire politique*, p. 142.

5 Simone de Beauvoir, *Beloved Chicago Man* (London: Victor Gollancz, 1998), p. 69.

6 Ibid., p. 70.

7 Mamaine Koestler, *Living with Koestler*, p. 53.

8 Todd, *Albert Camus*, p. 610.

9 Lottman, *Left Bank*, p. 277.

10 Mamaine Koestler, *Living with Koestler*, pp. 57–60.

11 According to Simone de Beauvoir it was at the Café de Flore; according to Mamaine Koestler in *Living with Koestler*, pp. 57–60, it was at the Café des Deux Magots.

12 Speaking of Koestler and Camus. Beauvoir, *Beloved Chicago Man*, p. 75.

13 Ibid., pp. 78–79.

14 Mamaine Koestler, *Living with Koestler*, pp. 57–60.

15 *Conversations avec le vieil Harold Kaplan.*

16 Ibid.

17 Lennon, *Norman Mailer*, p. 1.

18 Ibid., p. 98.

19 Peter Manso, *Mailer: His Life and Times* (Simon and Schuster, 1985), p. 113.

20 Rémy Kaufer, "Les grèves insurrectionnelles de 1947," *Historia Magazine* 733, January 2008.

21 *Les Temps modernes*, no. 27, December 1947.

22 Abel, *Intellectual Follies*, p. 73.

23 Ibid.

24 Mamaine Koestler, *Living with Koestler*, p. 65.

25 Ibid., pp. 62–70.

26 It was not published until much later.

27 A wordplay, of course, on *Les Temps modernes*.

28 Scammell, *Koestler*, p. 307.

29 Beauvoir, *Beloved Chicago Man*, pp. 97–98.

30 Ibid., p. 98.

31 "La Recherche de l'absolu," *Les Temps modernes*, no. 28, January 1948.
"Il n'est pas besoin de regarder longtemps le visage antédiluvien de Giacometti pour deviner son orgueil et sa volonté de se situer au commencement du monde. Il se moque de la Culture et ne croit pas au Progrès, du moins au Progrès dans les Beaux-Arts, il ne se juge pas plus 'avancé' que ses contemporains d'élection, l'homme des Eyzies, l'homme d'Altamira. En cette extrême jeunesse de la nature et des hommes, ni le beau ni le laid n'existent encore, ni le goût, ni les gens de goût; ni la critique: tout est à faire. Pour la première fois l'idée vient à un homme de tailler un homme dans un bloc de pierre. Voilà donc le modèle: l'homme. Ni dictateur, ni général, ni athlète, il ne possède pas encore ces dignités et ces chamarrures qui séduiront les sculpteurs de l'avenir. Ce n'est qu'une longue silhouette indistincte qui marche à l'horizon."

32 Sartre had been offered a weekly one-hour series to produce and present on French state radio in September 1947, but "La Tribune des *Temps modernes*" was canceled on December 3, 1947, after Sartre's anti-Gaullist tone went too far for the public broadcaster's taste.

33 David Rousset, a *résistant*, had been a prisoner, first at Buchenwald then at Neuengamme, between 1943 and 1945.

34 Beauvoir, *La force des choses*, p. 206.

35 Beauvoir, *Beloved Chicago Man*, p. 188.

36 Quoted in Chebel d'Appollonia, *Histoire politique*, p. 162.

37 Mamaine Koestler, *Living with Koestler*, pp. 72–74.

38 Flanner, *Paris Journal, 1944–1955*, April 2, 1948, p. 82.

39 Ibid.

40 Ibid.

41 Mamaine Koestler, *Living with Koestler*, letter of January 13, 1948, pp. 72–74.

42 As reported by Harvey Breit, the *New York Times* journalist in charge of covering Arthur Koestler's U.S. trip. "A Visit with Arthur Koestler," *New York Times*, April 4, 1948.

43 Scammell, *Koestler*, p. 318.

44 In a letter dated April 1, 1948, quoted in ibid., p. 320.

45 Flanner, *Paris Journal, 1944–1955*, June 14, 1948, p. xx.

46 Wineapple, *Genêt*, p. 213.

47 Ibid., p. 207.

48 Ibid., p. 209.

49 Cronin, *Samuel Beckett: The Last Modernist*, pp. 386–94.

50 The writer Claude Roy, quoted in Lottman, *Left Bank*, p. 241.

51 Ibid.

52 Chebel d'Appollonia, *Histoire politique*, vol. 2, pp. 32–37.

53 Morin, *Autocritique*, p. 68.

54 Ibid.

55 "La technique de Citizen Kane," in *Les Temps modernes*, no. 17, February 1947.

"Flaubert n'a pas inventé l'imparfait, non plus que Gide le passé simple, ou Camus le passé composé, mais l'emploi qu'ils font de ces temps leur est personnel. Encore faudrait-il ajouter à l'actif de Welles que s'il n'a pas découvert ces procédés, il a du moins inventé leur sens. Son écriture cinématographique lui appartient incontestablement.

"Évoquer comme le fait Georges Sadoul, l'emploi antérieur de certains procédés, pour en contester la propriété à Orson Welles, c'est oublier que l'invention appartient à ceux qui s'en rendent maîtres."

56 Aline Desjardins, *Aline Desjardins s'entretient avec François Truffaut* (Paris: Ramsay, 1987).

57 As recorded by Himes in his 1972 autobiography *The Quality of Hurt: The Early Years*, quoted in Rowley, *Richard Wright*, p. 373.

58 Rowley, *Richard Wright*, p. 373.

59 Flanner, *Paris Journal, 1944–1955*, June 14, 1948, p. 82.

11. "Paris's Gloom Is a Powerful Astringent"

1 Beauvoir, *Beloved Chicago Man*, p. 142.

2 Ibid.

3 Michelle Perrot, *Histoires de chambres* (Paris: Éditions du Seuil, 2009), p. 244.

4 Lennon, *Norman Mailer*, p. 103.

5 Shaw, *Paris! Paris!*, p. 94.

6 Norman Mailer, "The Art of Fiction," no. 32, interviewed by Steven Marcus, *Paris Review*, Winter/Spring 1964.

7 Ibid.

8 Mary V. Dearborn, *Mailer: A Biography* (Boston: Houghton Mifflin, 1999), p. xx.

9 Lennon, *Norman Mailer*, p. 103.

10 Ibid., p. 99.

11 Dearborn, *Mailer*, p. 59.

12 Beauvoir, *Beloved Chicago Man*, p. 179.

13 Ibid., p. 181.

14 Michel Leiris, *Journal 1922–1989* (Paris: Gallimard, 1992), pp. 462–63.

15 Ibid., p. 463.

16 Flanner, *Paris Journal, 1944–1955*, October 1, 1953, p. 215.

17 Ibid., May 26, 1948, p. 87.

18 Ibid., May 11, 1949, p. 101.

19 Ibid., May 26, 1948, p. 103.

20 Beauvoir, *Beloved Chicago Man*, p. 208.

21 The writer Claude Roy, quoted in Lottman, *Left Bank*, p. 241.

22 Quoted in Spurling, *Girl from the Fiction Department*, p. 89.

23 Simone de Beauvoir thought for years that Zaza had died of a broken heart after Merleau-Ponty refused to marry her. In fact, it was her parents who didn't deem Merleau-Ponty's family respectable enough for their daughter. In Deirdre Blair, *Simone de Beauvoir: A Biography* (New York: Simon and Schuster, 1990), p. 153.

24 Mamaine Koestler, *Living with Koestler*, p. 87.

25 Todd, *Albert Camus*, p. 665.

26 Raymond Queneau, "Si tu t'imagines," in *L'instant fatal* (Paris: Gallimard, 1948).

27 François Forestier, *Un si beau monstre* (Paris: Albin Michel, 2012).

28 She confided this during an interview on January 7, 2014, at her home in Saint-Tropez.

29 Marlon Brando was born in 1924, Juliette Gréco in 1927.

IV. SHARPENING THE SENSES

12. "They Owned Art While We Were Just Full of Dollars"

1 Flanner, *Paris Journal, 1944–1955*, June 23, 1948, p. 91.

2 Ibid., p. 92.

3 Cazalis, *Les mémoires d'une Anne*, p. 106.

4 "Nés en 1925," *Les Temps modernes*, no. 32, May 1948.

5 "Chief Prophet of Existentialism" by John L. Brown, in *New York Times Magazine*, February 2, 1947.

6 Art Buchwald, *I'll Always Have Paris* (New York: Ballantine, 1996), p. 2.

7 Ibid., pp. 2–9.

8 Ibid.

9 Ibid.

10 Ibid.

11 Wadja was still there when I last checked in the spring of 2016. Art Buchwald went back thirty years later and cried when he saw that it was still run by the same owners. Buchwald, *I'll Always Have Paris*, p. 20.

12 Ibid., pp. 2–9.

13 Ibid., p. 34.

14 Abel, *Intellectual Follies*, p. 106.

15 Ibid.

16 Seaver, *Tender Hour of Twilight*, pp. 82–90.

17 Ibid., p. 103.

18 Jack Youngerman in interview: Jack Youngerman talks with Collette Robert, Archives of *American Art Journal* 17, no. 4, 1977.

19 In a letter to Henry Volkening, September 27, 1948. In *Saul Bellow: Letters*, edited by Benjamin Taylor (New York: Viking, 2010), p. 63.

20 Saul Bellow, "My Paris," *New York Times*, March 13, 1983.

21 James Atlas, *Saul Bellow: A Biography* (New York: Random House, 2000), p. 140.

22 Ibid., p. 139.

23 Julian Behrstock settled in Paris for life and had a three-decade-long career with UNESCO. He entered the Department of Mass Information of UNESCO in 1948 as head of the World Programme for Book Development.

24 Atlas, *Saul Bellow*, p. 138.

25 Saul Bellow, *The Adventures of Augie March* (1953; New York: Penguin Books, 2006).

26 Bellow in the *New York Times Book Review* in 1959, as quoted by Sam Tanenhaus in his review of Zachary Leader's *The Life of Saul Bellow: To Fame and Fortune*, published in the *New York Times Sunday Book Review* on April 27, 2015.

27 Bellow, "My Paris."

28 Saul Bellow, "The French as Dostoevsky Saw Them," *New Republic*, February 23, 2010.

29 Atlas, *Saul Bellow*, p. 148.

30 Saul Bellow, "A Revolutionist's Testament," *New York Times*, November 21, 1943.

31 Atlas, *Saul Bellow*, p. 142.

32 On a postcard to Sam Freifeld, quoted in Atlas, *Saul Bellow*, p. 139.

33 In a letter to Monroe Engel, October 25, 1948. *Saul Bellow: Letters*, p. 64.

34 Bellow, "The French as Dostoevsky Saw Them."

35 As Malcolm Cowley described it in *Exile's Return*, his memoir of Paris literary life between the wars. Quoted in Atlas, *Saul Bellow*, p. 137.

13. Stimulating the Nerves

1 White, *In Search of History*, p. 261.

2 Ibid.

3 Ibid., p. 263.

4 Ibid.

5 Ibid., p. 264.

6 Ibid.

7 Ibid., p. 265.

8 Ibid.

9 Ibid., p. 266.

10 Ibid.

11 Ibid., p. 269.

12 As well as Trieste and West Germany, states under Allied military occupation.

13 White, *In Search of History*, p. 278.

14 Ibid.

15 Ibid..

16 Flanner, *Paris Journal, 1944–1955*, June 14, 1948, p. 88.

17 White, *In Search of History*, p. 278.

18 Ibid., pp. 272–73.

19 Ibid., p. 273.

20 Ibid., p. 272.

21 Beauvoir, *La force des choses*, p. 231.

22 Ibid., p. 231. "Clochards et clochardes assis sur le trottoir en escalier buvaient des litres de vin rouge, ils chantaient, dansaient, monologuaient, se querellaient."

23 Beauvoir, *Beloved Chicago Man*, p. 235.

24 Ibid., p. 237.

25 Ibid., p. 240.

26 Rowley, *Tête-à-tête*, p. 194.

27 Beauvoir, *Beloved Chicago Man*, p. 266.

28 Geneviève Seneau, "Salle commune," *Les Temps modernes*, no. 25, October 1947.

29 Lennon, *Norman Mailer*, p. 2.

30 Ibid., p. 112.

31 As described by *Time* magazine in an article published on January 10, 1949.

32 Buchwald, *I'll Always Have Paris*, pp. 29–30.

33 Ibid.

34 Albert Einstein, *Einstein on Peace*, edited by Otto Nathan (New York: Random House, 1988), p. 704.

35 December 15, 1948.

36 Buchwald, *I'll Always Have Paris*, p. 33.

37 In January 1949, Davis opened an international registry of world citizens; 750,000 people from more than 150 countries registered. When he went back to the United States in 1950, he came back as an immigrant, without legal documents.

14. Anger, Spite, and Failure

1 Eugene Worth, James Baldwin's best friend, committed suicide by jumping off the George Washington Bridge in New York in 1946.

2 James Baldwin, "The Art of Fiction No. 78," *Paris Review* no. 91 (Spring 1984), interview by Jordan Elgrably.

3 Quoted in Rowley, *Richard Wright*, pp. 315–79.

4 Baldwin, "Art of Fiction."

5 Ibid.

6 James Baldwin, *No Name in the Street* (New York: Dial Press, 1972), p. 39.

7 Baldwin, "Art of Fiction."

8 Ibid.

9 As recalled a year later by Richard Seaver, *The Tender Hour of Twilight*, chapter 2, p. 10.

10 Ibid.

11 David Leeming, *James Baldwin: A Biography* (New York: Arcade, 2015).

12 Fabre, *La rive noire.*

13 Baldwin, "Art of Fiction."

14 Although he would later defend himself from this personal shortcoming. In a letter to his friend Julian Behrstock written on January 19, 1996, he felt the need to say "I'm just chronicling, not bitching." Bellow, *Letters.*

15 In a letter to his agent, David Bazelon, on January 25, 1949, in Bellow, *Letters*, pp. 76–77.

16 On February 27, 1949. Bellow, *Letters*, p. 77.

17 Atlas, *Saul Bellow*, p. 141.

18 Ibid., p. 73.

19 On April 10, 1949. Bellow, *Letters*, p. 80.

20 Baldwin, "Art of Fiction."

21 Abel, *Intellectual Follies*, p. 160.

22 Beauvoir, *Beloved Chicago Man.*

23 Abel, *Intellectual Follies*, p. 165.

24 Ibid., p. 166.

25 Ibid., p. 264.

26 Ibid., p. 204.

27 Toru Kiuchi and Yoshinobu Hakutani, *Richard Wright: A Documented Chronology 1908–1960* (Jefferson: McFarland, 2014), p. 251.

28 Ibid., p. 265.

29 Beauvoir, *Beloved Chicago Man*, p. 270.

30 Todd, *Albert Camus*, p. 686.

31 I have phrased this exchange between Richard Wright and Simone de Beauvoir based on her memoirs: Beauvoir, *La force des choses*, and her letters to Algren, in Beauvoir, *Beloved Chicago Man.*

32 Les Hussards was a literary movement in the 1950s and 1960s made of young right-wing writers who opposed the Existentialists and Sartre in particular. They valued style above all. Roger Nimier's novel *Le hussard bleu* in 1950 gave its name to this movement. The term was ironically coined by Bernard Franck in an article he wrote for Sartre's *Les Temps modernes.*

33 Once in its edition of November 13, 1947, and the second in its edition of April 25, 1948.

34 Lottman, *Left Bank*, p. 271.

35 She tells her sister Celia in a letter dated Saturday, February 26, 1949, written from the Hôtel Montalembert, in Mamaine Koestler, *Living with Koestler*, p. 100.

36 Ibid.

37 *Under Two Dictators: Prisoner of Stalin and Hitler* begins with her search for her second husband, Heinz Neumann, a well-known German Communist victim of Party infighting, arrested in Moscow and jailed in the Lubyanka prison in 1937. Margarete did not discover what had happened to him until 1961.

38 Which, luckily for Gallimard, was never published. Source: Claire Sarti, Paul Eluard's granddaughter, in conversation with the author in Paris.

39 Beauvoir, *La force des choses*, vol. 1, p. 275.

40 Lottman, *Left Bank*, p. 281.

15. Vindicated

1 Atlas, *Saul Bellow*, p. 144.

2 Remarks by Saul Bellow to Padgett Powell's graduate class in fiction writing at the University
 of Florida, Gainesville, February 21, 1992.

3 Atlas, *Saul Bellow*, p. 144.

4 Ibid.

5 Saul Bellow, "How I Wrote Augie March's Story," *New York Times*, January 31, 1954.

6 Bellow, *Letters*, p. 80.

7 Conceived as a tetralogy, but Sartre never finished the fourth part. He wrote only two chapters,
 which were published in *Les Temps modernes* later in 1949.

8 As summarized in Flanner, *Paris Journal, 1944–1955*, April 28, 1949, p. xx.

9 Abel, *Intellectual Follies*, p. 133.

10 James Salter, *Burning the Days* (New York: Random House, 1997), p. 239.

11 Ibid., p. 240.

12 Florence Gilliam, *France: A Tribute by an American Woman* (New York: E. P. Dutton, 1945).

13 Catalogue of exhibition *Ellsworth Kelly: The Years in France 1948–1954*, National Gallery of Art
 in Washington, DC, 1993.

14 Still standing at 10 rue des Beaux-Arts, in the 6th arrondissement.

15 Seaver, *Tender Hour of Twilight*, p. 16.

16 Ibid.

17 Ibid., p. 32.

18 Ibid., p. 34. "Delphine Seyrig asked if I'd like to come to the recording by Roger Blin of Beck-
 ett's *Godot* at Club d'Essai de la Radio, rue de l'université."

19 Cronin, *Samuel Beckett: The Last Modernist*, p. 406.

20 February 1952, part of *Godot* broadcast on radio, which helped secure a grant for Roger Blin's
 theater production of it a year later.

21 Cronin, *Samuel Beckett: The Last Modernist*, p. 410.

22 Beauvoir, *Beloved Chicago Man*, p. 275.

23 White, *In Search of History*, pp. 270–71.

24 Ibid., p. 275.

25 Ibid., p. 286. White continues on the subject of Britain: "By June 1949, the tough mechani-
 cal, distribution and payments problems within Europe had been solved; at which point the
 planners ran into the insoluble problem—which was England. Of the first 18 months of
 the Marshall Plan it can be written that the USA saved Western Europe and discarded
 England." White adds on page 291: "In the summer [of] 1949, one could sense that the shove
 was on. On the week-end of September 17–18, the British dropped the value of the pound
 from $4.03 to $2.80. I went on Monday 19th, boarding the Golden Arrow out of Paris. But in
 London, I found that the British had set out on the long road leading off and away from the
 mainstream of world affairs with complete, affable and cheerful indifference. The world was
 distant. Whether Labour had managed or mismanaged the pound meant nothing here."

26 Miles Davis, *The Autobiography* (New York: Macmillan, 1990).

27 Conversation with the author on January 7, 2014.

28 Interview by Philippe Carles, translation by Richard Williams, published in the *Guardian*,
 May 25, 2006.

29 George Cole, "Miles Davis: His Love Affair with Paris," in the *Guardian*, December 10, 2009.

30 Interview by Philippe Carles, translation by Richard Williams, published in the *Guardian*,
 May 25, 2006.

31 Ibid.

32 Ibid.

33 Ibid.

34 Ibid.

35 Beauvoir, *La force des choses*, vol. 1, p. 250.

36 Simone de Beauvoir fantasized about Nelson Algren being her "Beloved Husband," as she called him in her letters. She wore the cheap wedding ring he made for her until the day she died and was buried with it.

37 Rowley, *Tête-à-tête*, p. 199.

38 Earl Rovit and Arthur Waldhorn (eds.), *Hemingway and Faulkner in Their Time* (New York: Bloomsbury, 2005), p. 136.

16. Farewells and a New Dawn

1 Lennon, *Norman Mailer*, p. 119.

2 This introduction both surprised and dismayed him: he was no lieutenant of Sartre.

3 "In *The Age of Longing* he deals not only with the Bolshevik mind, once again fellow-traveling with the human spirit, but with a number of other peculiarly conditioned minds—among them the democratic, the French, the religious, the literary, the apostate and the American," writes the critic Richard H. Rovere in the *New York Times*, February 25, 1951, in a very favorable review of the book.

4 Mamaine Koestler, *Living with Koestler*, p. 112.

5 Although twenty-two years younger than Arthur Koestler, and in perfect health, Cynthia decided to commit suicide beside the terminally ill Koestler on March 1, 1983.

6 Spurling, *Girl from the Fiction Department*, p. 93.

7 Ibid., p. 96.

8 According to the French writer and poet Georges Limbour.

9 Festival du Film Maudit.

10 The *New York Times* critic Bosley Crowther wrote in 1958 about her part in Roger Vadim's *And God Created Woman*: "In fact, it is not what Mademoiselle Bardot does in bed but what she might do that drives the three principal male characters into an erotic frenzy. She is a thing of mobile contours—a phenomenon you have to see to believe."

11 Simone de Beauvoir, "Brigitte Bardot and the Lolita Syndrome," an essay first published in *Esquire* magazine in August 1959.

12 Ibid.

13 Ibid.

14 Ibid.

15 Jean Cocteau, *Le Passé défini* (Paris: Gallimard, 2005), vol. 4, July 1955.

16 As serialized by *Les Temps modernes* in its May 1949 issue, no. 43.

17 Ibid.

18 A letter to Alfred Kazin dated January 28, 1950, quoted in Atlas, *Saul Bellow*, p. 154.

19 Flanner, *Paris Journal, 1944–1955*, January 25, 1950.

20 Ibid., p. 266.

21 She had first titled it *Les survivants* [The survivors], then *Les suspects* [The suspects]. Sartre had suggested *Les griots* [The griots]. Claude Lanzmann, Simone de Beauvoir's new young lover, came up with *Les mandarins* (*The Mandarins*). Beauvoir, *La force des choses*, vol. 2, p. 36.

22 Le Prix Goncourt, on December 6, 1954. On hearing the news during a trip to Rome, Albert Camus, ill and feverish, wrote in his *Carnets* on December 12, 1954: "I came across a newspaper. I had forgotten about the Parisian comedy. The farce that is the Goncourt Prize. I hear I'm the hero in it. Filth."

23 *Histoire d'O* was published in 1954 and translated into English for Olympia Press in 1965 by Richard Seaver, who took the pseudonym Sabine d'Estrée. Eliot Fremont-Smith, the *New York*

Times's book critic, wrote in 1966 that *Story of O* fractured "the last rationale of censorship, our late and somewhat desperate distinction between 'literary' pornography and 'hard-core' pornography," and described the book as "revolting, haunting, somewhat erotic, rather more emetic, unbelievable and quite unsettling."

24 Flanner, *Paris Journal, 1944–1955*, January 25, 1950.

25 Ibid.

26 24 rue du Boccador was a special place to live. The twenty-eight-year-old Belgian film producer Raoul Lévy lived directly opposite Theodore White on the third floor. He was producing his first film and was about to trick the Paris police force into turning out for riot call as extras. A few years later he would produce his friend Roger Vadim's film *And God Created Woman*, with the young Brigitte Bardot. There were other colorful neighbors: the mistress of the most important jeweler in Paris; the British arms salesman who sold outworn American combat aircraft to shadowy regimes; and a Spanish Republican veteran, Germain, the building's concierge. A few months later, Irwin Shaw and his wife, Marian, arrived there.

27 White, *In Search of History*, p. 333.

28 Ibid., p. 332.

29 Ibid., p. 334.

30 This last paragraph is a tribute to the writer Irwin Shaw and an article he wrote titled "Remembrance of Things Past" (formerly titled "Paris! Paris!" and originally appearing in the American magazine *Holiday* in 1953): *"The city is quiet on both sides of you, the river wind is cool, the trees on the banks are fitfully illuminated by the headlights of occasional automobiles crossing the bridges. The bums are sleeping on the quais, waiting to be photographed at dawn by the people who keep turning out the glossy picture books on Paris; a train passes somewhere nearby, blowing its whistle, which sounds like a maiden lady who has been pinched, surprisingly, by a deacon; the buildings of the politicians and the diplomats are dark; the monuments doze; the starlit centuries surround you on the dark water . . . You turn, hesitantly, toward the girl at your side . . ."*

ACKNOWLEDGMENTS

I would like to particularly thank Bill Swainson for his unwavering support and heartwarming erudition; Simon Trewin, a wonderful born trouper; Dorian Karchmar for her laser-sharp eye and attention to details; Gillian Blake, favorite publisher grande dame; Caroline Zancan, editor supremo alongside Kerry Cullen; and Michael Fishwick at Bloomsbury for his shrewd comments.

I would also like to thank my first reader, Linden Lawson, whose enthusiasm proved a great support, and Anna Hervé, a most astute *poisson pilote* and adviser.

In the course of researching this book, I think I fell in love with both writer Irwin Shaw and the Louvre's savior Jacques Jaujard, I sympathized with Janet Flanner's quest for a third sex, smiled at Saul Bellow's superiority complex, and was awed by Simone de Beauvoir and Jean-Paul Sartre's brazen intelligence. I didn't drink the way they used to on the Left Bank in postwar Paris, nor did I take any drugs, but sometimes I wish I had.

And to Nicole Parrot, the great inspiration behind this book, I'd like to say: "We will always have Paris."

INDEX

ABOUT THE AUTHOR

AGNÈS POIRIER is a Paris-born and London-educated journalist, broadcaster, critic, and writer. A regular contributor to the British and American media (*The Guardian, The Observer, The Times* [London], *The Nation*, BBC, Sky News, CNN, among others) and the UK editor for the French political weekly *Marianne*, she is the author of four books about how France and Britain do things in opposite ways, including *Touché: A French Woman's Take on the English*. She has taught at the Paris Institute of Political Studies (Sciences Po) and preselects British films for the Cannes Film Festival. She divides her time between Paris and London and loves cycling and listening to Charles Trenet.